William Blake
The Painter at Work

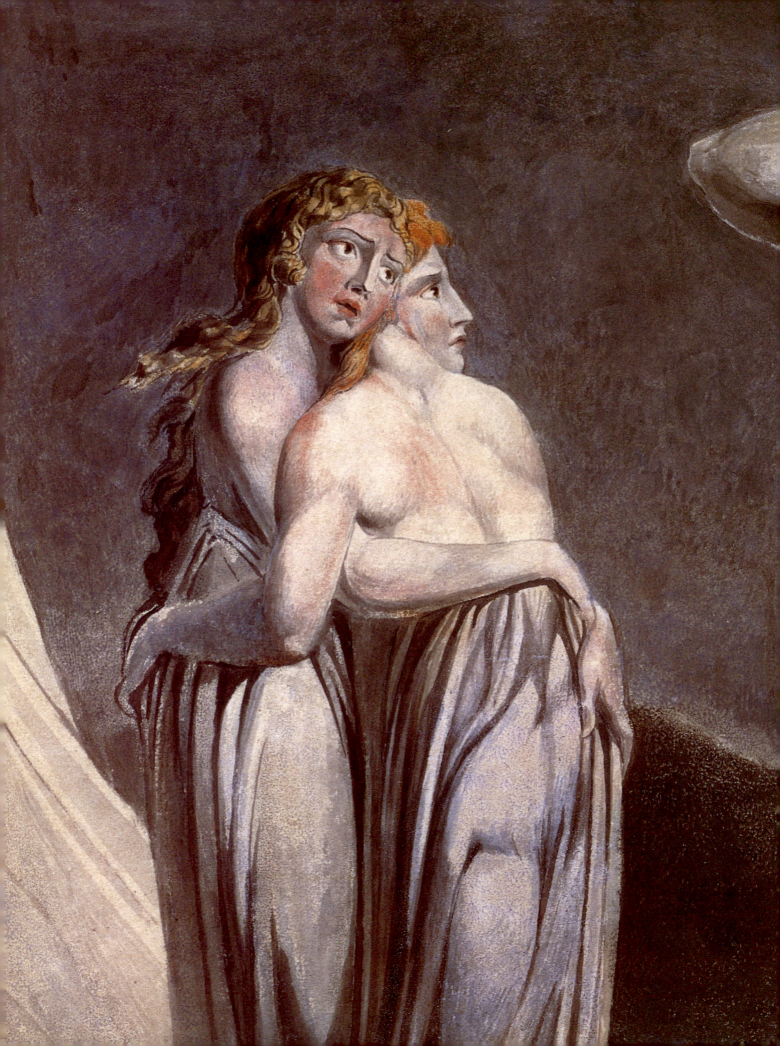

William Blake
The Painter at Work

Edited by

Joyce H. Townsend

Consultant Editor
Robin Hamlyn

PRINCETON UNIVERSITY PRESS

First published 2003 by order of the Tate Trustees
by Tate Publishing, a division of Tate Enterprises Ltd,
Millbank, London SW1P 4RG
www.tate.org.uk

Published in North America by
Princeton University Press
41 William Street
Princeton, New Jersey 08540
www.pupress.princeton.edu

ISBN 0-691-11910-4

Library of Congress Control Number: 2003110696

Designed by Susan Wightman at Libanus Press

Printed in Hong Kong by South Sea International Press

Cover: *Newton* 1795/*c*.1805 (fig.50, detail)
Title page: *Lamach and his Two Wives* 1795 (fig.63, detail)
pp.10–11: *Frontispiece* to *Visions of the Daughters of Albion* 1793–*c*.1795
 (fig.5, detail)
pp.52–3: *Satan in his Original Glory: 'Thou wast Perfect till Iniquity was
 Found in Thee'* *c*.1805 (fig.39, detail)
pp.80–1: *Satan Exalting over Eve* *c*.1795 (fig.71, detail)
pp.108–9: *Adam Naming the Beasts* 1810 (fig.104, detail)
pp.160–1: *God Judging Adam* 1795 (fig.53, detail)

Contents

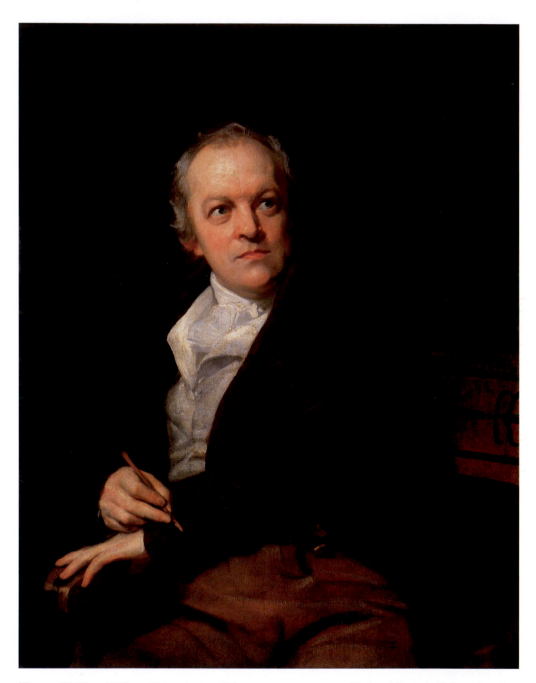

Thomas Phillips, *William Blake* exh.1807. Oil on canvas 92.1 x 72cm. National Portrait Gallery, London. Blake is holding a *porte crayon*, a device for holding 'black lead' for drawing. The same material is used in graphite pencils.

Preface

William Blake's unique oeuvre has always attracted attention, and many have tried to understand, describe, and utilise his printing methods for text. Much has already been written about this. In contrast, very little has been written about Blake as a practising painter. Nor have his materials been analysed comprehensively. Artists and designers have used his paintings as inspiration for their own designs. Conservators have to treat his temperas, which he described as 'fresco', a significant number of which have not survived to our time. This leads naturally to questions about his painting methods. How did Blake create the colour prints and the temperas? Exactly what materials should be used to emulate his work? And which materials should be used to conserve it? Have some of the watercolours lost colour? Why are some of the temperas so brown and gloomy in appearance? Were they all once as colourful as the finished watercolours?

The research for this book was carried out to provide answers to these questions, to enhance our appreciation of Blake's paintings, and to understand whether, and if so why, some of his paintings look very different today.

This research could not have been carried out ten years ago, for suitably sensitive analytical methods were, quite simply, not available. It forms part of a programme of research into artists' materials begun at the Tate Gallery in 1987, when the first full-time conservation scientist in the Conservation Department began to examine and analyse the paintings and watercolours of J.M.W. Turner (1775–1851). That work led to an exhibition,[1] a conference,[2] and some frustration that it was impossible then to characterise some of the colours and all of the paint media used on Turner's delicately painted watercolours. As potentially useful analytical methods have evolved more recently, research funding has been sought to enable the examination techniques used here on Blake's watercolours and paintings to be developed and applied, with the co-operation of universities keen to see their analytical equipment applied to challenging material. The research continues today. There are still unanswered questions, but now there are answers too. For example, research undertaken for this publication shows that Blake used essentially the same range of colours in watercolours, colour printing and temperas, which implies that their appearance and tonal range was similar at first. Today this is not obvious. The gum mixture that Blake carefully selected for his temperas was virtually the same as the mixture he used in the (fewer) colour prints analysed here, and it has been discovered that the large colour prints all have water-based and not oil-based paint. The temperas include animal glue as well, which had not been realised before. As well as contributing to Blake scholarship and providing new insights into Blake the painter, the results presented here inform the decisions that have to be taken

by conservators about the regular display of these undoubtedly fragile works, about their cleaning, and about the best means of preserving them for future generations.

JOYCE H. TOWNSEND
Editor

1 J.H. Townsend, *Turner's Painting Techniques*, exh. cat., Tate Gallery, London 1993, reprinted 1996, 1999.
2 J.H. Townsend (ed.), *Turner's Painting Techniques in Context*, London 1995.

Acknowledgements

The research for this book has been supported throughout by the Conservation Department at Tate. Many colleagues from Art Handling, Conservation Science, Paintings Conservation, Paper Conservation, the Prints and Drawings Room, Tate Registrars and Tate Store have contributed over the years. Tate photographers have produced many images for this book, and in particular David Clarke and Joanna Fernandes produced digital images, Marcella Leith carried out infra-red false colour photography, Mark Richmond made X-radiographs, and Rod Tidnam photographed paper texture. Rosie Bass contributed to the editorial process. Anna Southall, formerly Senior Paintings Conservator, initiated the analysis of Blake's materials in the mid-1980s, and provided much useful initial information. Stephen Hackney, Head of Conservation Research, has made the greatest contribution, which included a critical reading of this manuscript.

The University of Northumbria at Newcastle (recently renamed as Northumbria University), School of Applied Sciences, has supported research and development into the analysis of Blake's gum and proteinaceous media, by securing and administering two doctoral studentships, and providing analytical facilities, for Dr Sarah Vallance (1995–1997) and Dr Bronwyn Ormsby (1999–2001). Bronwyn Ormsby would also like to thank the supervisors of her doctorate research, Drs Brian Singer and John Dean from Northumbria University, and Dr Joyce Townsend, Tate, as well as Ed Ludkin of Northumbria University for his technical advice. Thanks are due to Dr Katherine L. Brown of the Department of Chemistry, University College London, for conducting Raman spectroscopy during her doctoral research, and to her supervisor Dr Robin J.H. Clark for the use of portable analytical equipment. Noa Cahaner McManus would like to thank the Harold Hyam Wingate Foundation, which funded a year's work on the analysis of William Blake's pigments at Tate.

Robin Hamlyn acknowledges the published work of many Blake scholars, and is particularly indebted to Martin Butlin, formerly Keeper of the British Collection at Tate, for many discussions about Blake.

The authors are extremely grateful for the assistance of a number of people, many of whom made Blake temperas, large colour prints or watercolour palettes available: Anne Aldous of the Corporation of London Records Office; Ellen Baxter and William Real, Carnegie Museum of Art, Pittsburgh; Sally Bower, London; Katherine Coombs; Nicola Costaras, Mark Evans, Charles Newton and Pauline Webber from the Victoria and Albert Museum, London; Robert N. Essick, Los Angeles; Peter Hartley, Manchester City Art Gallery; Betsy Haude, Huntington Library, Art Collections and Botanical Gardens, Los Angeles; Tim Heath, who gave access to Blake's house; Jan Howard, Rhode Island School of Design, Providence; Peter Hughes, London; Charles E. Mather III, Philadelphia; Patrick McCaughey and Teresa Fairbanks, Yale Center for British Art, New Haven; Ian McClure, Hamilton Kerr Institute, University of Cambridge; Robert Payton and Alex Werner, Museum of London; Jason Revell, photography technician at Northumbria University; Polly Smith, Glasgow Museums; Christina Sitwell, National Trust, London; MaryAnne Stevens, Royal Academy of Arts, London; Mark Tucker, Philadelphia Museum of Art; Dr Fumio Yokoshima, Tokyo and the Foundation for Cultural Heritage, Japan, for his funding while he carried out research in the UK.

PART ONE

Introduction

William Blake at Work: 'Every thing which is in Harmony'[1]

ROBIN HAMLYN

Prologue

Before looking at the works of any artist in order to understand the techniques he or she used, it is always worth thinking about the sort of studio or painting room in which they were made. All the circumstances that dictated the nature of that work are relevant: the artist's temperament and training, the lessons learnt from dead as well as living artists, powers of invention, choice of materials and subject matter and the reasoning behind them, skill as a draughtsman and handler of paint, eye for colour, and the eyesight and the physique of the artist. Equally relevant are the artist's ambition and the income available to sustain it.

In the shaping of our overall view of Blake we must add to all this his writings. We know him best as a much published poet (though not in his own time) through works such as *Songs of Innocence* and *Songs of Experience*, which began life as illuminated books printed by himself in small numbers. However, he expressed his views on art forcibly, as did his famous Royal Academician contemporaries, Sir Joshua Reynolds, Benjamin West, Henry Fuseli, John Flaxman, James Barry, John Opie and J.M.W. Turner. The difference between them and Blake was that they did this in public lectures, which sometimes appeared in print shortly afterwards. By contrast, during his lifetime Blake's particular thoughts about art were expressed most fully in his private writings, with only fragments of his overall views appearing in conventionally printed form aimed at a wide audience. These can be found in his 1793 Prospectus *To the Public*;[2] the comments he passed on to his first biographer, Benjamin Heath Malkin, used in an introduction to *A Father's Memoirs of His Child* of 1806;[3] the *Descriptive Catalogue*,[4] along with its *Advertisement*[5] for his one-man exhibition of 1809; and the two Prospectuses of 1809 and 1810 for the engraving after the tempera *Sir Jeffery Chaucer and the Nine and Twenty Pilgrims on their Journey to Canterbury* (fig.103).[6] The audience for all this would have been at the most a few hundred people and certainly far smaller than the numbers of those who turned up for, or read, the Academicians' lectures. Those Academicians, apart from Barry, felt honour-bound by the convention that adverse criticism of other living artists was unacceptable in

a public forum. Blake did not feel so bound, and scornful references to 'the ignorant insults of Individuals'[7] and 'the Judgment of those narrow blinking eyes, that have too long governed art in dark corners' or 'the eyes of stupid cunning'[8] were directed at his contemporaries. He intended these individuals to be clearly identifiable.

In the end, though, with our prime sources consisting of his work and his private thoughts published long after he was dead, Blake tells us about himself and his art – what drove him as painter and poet, who and what he thought was good and bad in contemporary as well as past artistic practice – in a depth only comparable among his contemporaries to the thoughts of John Constable as expressed in his correspondence. In Blake's case, along with the comments made by those near to him which have come down to us, what we have is a vivid insight into his extraordinary, thoroughgoing honesty and integrity as a man and artist. Looking at Blake's pictures in a gallery requires getting close to them. It is an act akin to peering over the artist's shoulder. This book, in its own way, sets out to do something similar.

We can identify the influences that shaped the artist. He is recorded by Malkin as finding in the 'Gothic' monuments in Westminster Abbey, which he drew while an apprentice engraver with James Basire, that 'simple and plain road to the style of art at which he aimed, unentangled in the intricate windings of modern practice'.[9] These tombs dated mostly from the late thirteenth to the late fourteenth centuries, and, moreover, they were in a great building that dated largely from the mid-thirteenth to the end of the fifteenth centuries. It epitomised the Gothic and, initially at least, it seems easy to identify what Blake meant when he used the word in conversation with Malkin. More specifically, by comparison with what the idea of 'modern' meant to Blake and contemporary artists it is possible to arrive at a better sense of what Blake was driving at when he spoke of the 'Gothic' period. Joshua Reynolds was quite certain on the matter, as we can see when he invited his students to 'consider the barbarous state of the Arts' before the painter Masaccio (1401–28), 'one of the Great Fathers of modern Art', started working.[10] This definition of the 'modern', in other words the Renaissance, as commencing in the early 1400s was maintained by others: Barry referred to 'dryness and . . . [Gothic] imperfection . . . happily done away with about the year 1400',[11] and Flaxman spoke of a 'state of concealment and darkness of art' which lasted until 'the fifteenth century'.[12] A similar emphasis on the fifteenth century as marking the end of what was derogatorily summed up as a Dark Age is found in Fuseli's reference to 'the epoch of [art's] restoration in the fifteenth century'.[13]

However, Blake's inscription for his *Joseph of Arimathea ...* (fig.1), juxtaposing 'Gothic Artists' with 'what we call the Dark Ages' and the unequivocally 'modern' Renaissance 'Michael Angelo' actually betrays a careful detachment from such a view. A more detached view is his urging 'let them [that is, Reynolds's students] look at Gothic figures & Gothic Buildings & not talk of Dark Ages or of any Age! Ages are all Equal. But Genius is Always Above The Age.'[14] Gothic art was 'true',[15] possessing 'Living Form' and

thus 'Eternal Existence'.[16] For Blake this *could* be found in what was conventionally categorised as 'modern' art – for example in the work of Michelangelo and Raphael – but the fact that it could be found there rendered any such category by period irrelevant. He himself quite briefly adopted the neo-classical style early in his career, but for Blake it was, almost by definition, 'below' the age. What constituted departures from the 'true' in art, stigmatised by Blake as 'intricate windings' and so marking his reactions to them, are found in his comments on various acknowledged modern masters at work from the sixteenth century onwards: those of the Venetian and Flemish schools 'could not draw';[17] Rubens, Rembrandt and Titian 'did not Understand colouring',[18] while the 'unorganized Blots & Blurs' of the first and the last of these three were not 'Art';[19] and Rembrandt was a 'generalizer'.[20] In Blake's day Reynolds and Thomas Gainsborough 'blotted & Blurred one against the other'.[21] Such 'unappropriate Execution . . . is affectation & foppery',[22] in other words fashion or a response by the artists to their own age and not the products of a 'Genius' capable of rising above it. Pitting himself against all these men and allying himself with the 'true' in art Blake could claim 'I do Pretend to paint finer than Rubens or Rembt or Correggio or Titian' and 'I understand Drawing'.[23]

This was the 'Beginning' to which, as we shall see, Blake firmly related Michelangelo (1475–1564) and Raphael (1483–1520). He saw himself as their successor, his task being to return art to its first roots. The very acts of drawing in the Abbey in the mid-1770s and then engraving from the drawings were a crucial step towards Blake identifying this straight and 'unentangled' road, and reinforcing an already partly formed view of how best to find his way along it. It complemented exactly his earlier practice of making drawings after engravings by Old Masters: when aged about ten, he was buying prints by or after and copying from 'Raphael and Michael Angelo, Martin Heemskerk and Albert Durer, Julio Romano, and the rest of the historic class', a taste felt to be 'mechanical' by his companions.[24] The inclusion of Maerten van Heemskerck (1498–1574) and Albrecht Dürer (1471–1528) is the earliest indication of Blake's departure from an 'establishment' view of earlier art. Reynolds alerted Royal Academy students to the danger of a 'wrong direction' towards 'the meaner walks of painting' by saying that Dürer 'would, probably, have been one of the first painters of his age had he been initiated into those great principles of the art, which were so well understood and practised by his contemporaries in Italy',[25] namely a 'speaking to the heart' through the 'nobleness of conception' and 'intellectual grandeur' of the 'great stile' [style].[26] It had much to do with the matter of large scale, from conception to execution, which didn't allow for grandeur to exist on a small scale. Heemskerck, like Dürer, worked on a small scale and, as Reynolds pointed out, returned home from Italy, 'but like seeds falling on a soil not prepared or adapted to their nature, the manner of Michael Angelo thrived but little with them'.[27] Importantly, in such a by-passing of 'modern practice' Blake was not only going back to the real source of art, but actively mimicking the crucial processes – copying, though not at first, engraving – by which the art had been transmitted to him. Simultaneously, Blake was

identifying those figures he sought to emulate. The earliest and most complete surviving manifestation of this process is the small etching and line engraving, made when he was at Basire's in 1773 (fig.1). It was based on either (as Blake claimed) a drawing after Michelangelo or after an engraving of a figure in Michelangelo's fresco of *The Crucifixion of St Peter* in the Pauline Chapel in the Vatican.[28]

Blake's comments to Malkin about 'modern practice' certainly have a bearing on Blake's own later practice technically, aesthetically and in choice of subject matter. But they do date from around 1805–6. Some time after he had become a student at the Royal Academy in 1779, when he was looking at prints after Raphael and Michelangelo, the Keeper of the Academy, G.M. Moser, said he 'should not Study these old Hard Stiff & Dry Unfinishd Works of Art' and then went on to recommend, by showing him, 'finished' works as exemplified in prints after Charles Le Brun (1619–90) and Rubens (1577–1640). Blake 'spoke [his] Mind' saying, 'These things that you call Finishd are not Even Begun how can they then, be Finishd? The Man who does not know The Beginning, never can know the End of Art.'[29] Blake's telling of an encounter with Reynolds enlarges on this: 'Well Mr Blake,' said Reynolds, 'I hear you despise our art of oil painting.' 'No, Sir Joshua, I don't despise it; but I like Fresco better.'[30] Just as Moser's comments about Michelangelo's and Raphael's art – if they embraced their frescoes – were based on ignorance since he had never been to Italy, so Blake's admission, so definite, is equally curious: he could not have seen any actual fresco work of the kind he so admired, though he certainly knew their distant relations in wall paintings in the Abbey, notably that above King Sebert's monument (B12–14). We can be sure he knew about true frescoes through engravings, including the most famous, Michelangelo's in the Sistine Chapel and Raphael's *Bible* in the Vatican Loggia. He made copies of the former from prints[31] and perhaps copies from the latter.[32] Moreover, he could have come closer to the spirit of them if he saw the chalk drawings after Raphael that Basire made when he was in Rome in 1750.[33] He could also have seen drawings or oil copies (particularly important for their indication of colours and light and shade) after Michelangelo's and Raphael's works that artist friends such as Barry, George Romney,[34] Ozias Humphrey and Fuseli – all back in London from Rome by the end of the 1770s – made while they were there. Nevertheless, it would have been possible to get a clearer idea about fresco. For example, a small fragment of one attributed to Giotto[35] could be seen in London in the late 1770s, owned by the famous connoisseur Charles Townley whom Blake had met by 1799.[36]

He would have had first-hand experience of tempera both in easel paintings and during the 1770s working in the Abbey: he would have known the Westminster Retable

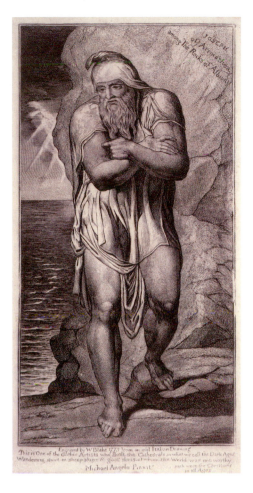

FIG.1 *Joseph of Arimathea among the Rocks of Albion* 1773/*c*.1810. Etching and engraving (22.8 x 11.9cm) printed in brown ink with some grey wash, framing lines. Fitzwilliam Museum, Cambridge

of 1270–80[37] and, slightly later on, probably the mural of scenes from the Book of Job in St Stephen's Chapel, which was uncovered in the 1790s.[38] Against this background we can identify the 'Beginning' that was so central to his seeing what the 'End' or purpose of art was. With Lebrun and Rubens in mind, both painters notable for their grandiose, vigorously handled oil paintings, 'finishd' art was 'not even begun'. 'Fresco' was preferable to 'oil painting' because it was the medium through which, as Blake would have learnt from Giorgio Vasari (1511–74), Cimabue (c.1240–?1302) and Giotto (1266/7–1337) 'resuscitated Painting as it were from the Dead'.[39] Its use was therefore integral to his mission, though Blake seems not to have ruled out oil completely until the end of the 1790s. Indeed, Blake would hardly have entered the Royal Academy Schools without some expectation of painting in oils. In 1809 he referred back to a time when he had 'painted in oil colours' and when 'his Pictures were shewn to certain painters and connoisseurs'.[40] Implicit in all this is that engraving, central to Blake's output, itself was equally important as a means of going back to 'The Beginning' simply because it had been through this medium that Blake himself found one path to it.

Blake and space

We begin to see the shaping of Blake's mind. We can also sense that gradual defining of the space in which it could happily and most productively operate. Like so many other young artists of his time he began by flourishing creatively in a domestic environment and this always remained the case. The exceptions were the larger spaces in which he drew as a student: aged ten to fourteen he drew in 'the Great Room' at Henry Pars's Drawing Academy in the Strand,[41] which was 65 × 30 × 24ft high (20 × 9 × 7.2m) – not far off the area of a tennis court – contained plaster casts of classical figures and in 1809 seemed to be able to accommodate about eighty pupils.[42] Again, drawing from casts such as that of the *Niobe* group (B178 verso; T2 verso)[43] and from the living model during 1779–80, he worked in the Royal Academy Antique and Living Model Schools at Somerset House in a space 40ft 8in × 25ft 3in × 16ft 11in high (12.4 × 7.7 × 4.9m) (fig.2).[44] These were work spaces in which art training took on aspects of public performance, as students vied with each other in demonstrating their genius and their skills. This perhaps contributed to the 'distaste' Blake felt about academic studies.[45] Obviously the largest of all the spaces in which he worked was Westminster Abbey.

By contrast, his parents' house in Broad Street

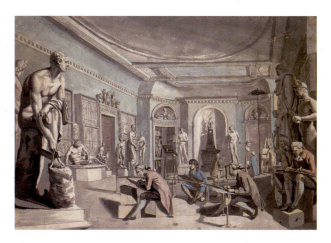

FIG.2 Edward Francis Burney, *View of the Antique Academy, New Somerset House c.*1780. Pen and ink and watercolour on paper 33.6 × 48.9cm. Royal Academy of Arts, London. The students in the foreground are drawing from a plaster cast of an antique figure of Cincinnatus. When Blake was an Academy student he made a careful pencil drawing from this cast: a fragment of the drawing has survived (B104A).

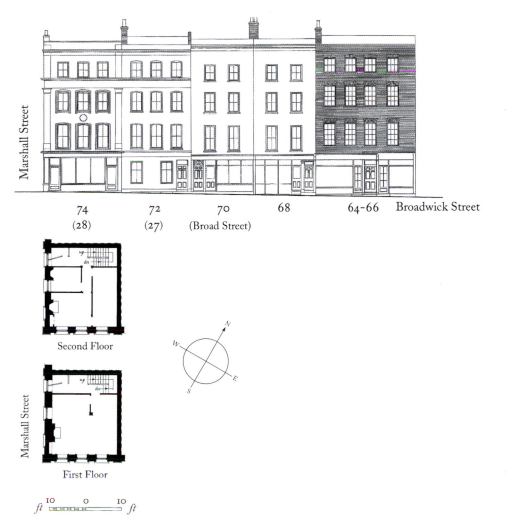

74
(28)

72
(27)

70
(Broad Street)

68

64-66 Broadwick Street

Marshall Street

Second Floor

First Floor

ft 10 — 0 — 10 ft

FIG.3a T. Biro, *Elevations of Houses on the North Side of Broadwick Street, formerly Broad Street, Golden Square, London c.1963.* Pen and ink on paper. National Monuments Record. Blake was born in 1757 at 28 Broad Street, over his father's hosier's shop (later 74 Broadwick Street, as shown here), on the corner with Marshall Street. During 1784–5 he was in a printselling partnership with James Parker next door at 27 Broad Street (here no.72).

FIG.3b F.A. Evans, *Plans of the First and Second Floors, 74 Broadwick Street, formerly 28 Broad Street, Golden Square, London c.1963.* Pen and ink on paper. National Monuments Record. These plans show two of the three upper floors of 28 Broad Street, but perhaps not with the spaces divided as in Blake's day. During 1809–10, Blake held his only public exhibition in these upper rooms.

(figs.3a, 3b), where he was born, was four storeys high with his father's hosiery shop on the ground floor over a basement, while each floor above with its principal rooms was contained within about 17ft by 18ft 6in (5.2 x 5.6m). In Blake's time the fourth floor might have been a roof garret.[46] In this house he learnt to draw from small plaster casts of classical figures.[47] As an apprentice engraver he worked in a three-storey seventeenth-century house in Great Queen Street.[48] Undoubtedly he must have produced his earliest writings in the same sorts of domestic spaces. With two exceptions to be discussed later (Lambeth 1790–1800 and Felpham 1800–3), this pattern of living and working in quite small spaces governed the greater part of Blake's life, and the nature of his output.

Between 1803 and 1821 Blake and his wife Catherine lived at 17 South Molton Street, just off Oxford Street. Uniquely among the Blakes' London homes the building has survived, with the structure intact. They occupied two rooms, the first floor front approximately 18 x 14ft (5.5 x 4.3m) and the other room approximately 12ft 6in square (3.8 x 3.8m) with the ceiling in each room about 9ft 6in (2.9m) high (fig.3c).[49] There was a small closet on a lower landing. Importantly, the door openings onto the staircase and down to the

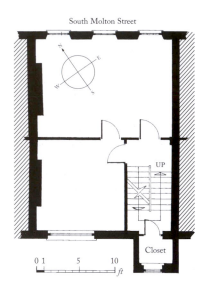

South Molton Street

0 1 5 10
ft

FIG.3C *Plan of
William and Catherine
Blake's Rooms on the
First Floor, 17 South
Molton Street, London.*
Measured and drawn
by Robin Hamlyn
2003. This plan has
been slightly revised to
show the back room as
the Blakes would have
known it 1803–21. Of
Blake's London homes,
this is the only building
that survives.

street are about 6ft x 3ft (under 2m x 1m), giving a diagonal opening of about 7ft (2.1m). The reported measurements of Blake's two largest but now lost temperas, *The Last Judgment* (84 x 60in / 213 x 152cm; B648) and *The Ancient Britons* ('about 14ft x 10ft' / 427 x 305cm, probably length x height; B657), suggest that while they would both have fitted into the front room, they would have had to be rolled to fit through the doors and be taken down to the street.[50] Given the amount of space at his disposal Blake's output during the South Molton Street years is remarkable. The rolling press accompanied them from Felpham, though it is difficult to imagine quite where the contents of the 'sixteen heavy boxes & portfolios full of prints' that went to Felpham[51] and presumably also returned with them were kept. For at least six months in 1804 he found room for two large cartoons and one smaller oil by George Romney.[52]

None of this seemed to act as a constraint on Blake, and South Molton Street stands out as the site of an intensely active and varied period of his career, including preparation for his one-man 1809 exhibition, the largest surviving work from which is the tempera *Sir Jeffery Chaucer* . . . painted on a canvas 18⅜ x 53¹⁵⁄₁₆ in (46.7 x 137cm). There was work on the 'experiment' pictures; the engraving of some eighty-five commercial copperplates; the production of a good number of the more than eighty biblical watercolours for Thomas Butts; a return to the large colour prints; fifty-seven watercolour illustrations to Milton; six for Shakespeare; twenty for Robert Blair's poem *The Grave*; at least nineteen of the first set of twenty-one watercolours illustrating *The Book of Job* (B550); the designing and relief etching of one hundred plates for the illuminated books *Jerusalem* and fifty for *Milton*; the printing of more than twenty copies of ten of the illuminated books (adding up to nearly a thousand separate pages); the reduced drawing from *Sir Jeffery Chaucer* and the engraving and publishing of a print from it; and writing the catalogue for the 1809 exhibition as well as the *Prospectus* for the Chaucer print. He had works accepted for the 1808 Royal Academy exhibition and the 1812 Associated Painters in Watercolours exhibition. Blake's steadfastness in the face of adversity can be found in the energetic meticulousness and well-ordered nature of his studio life in two small crowded rooms. What is more, if we are looking for one reason for Blake's invention of 'portable fresco' it must be that in such a confined space most things had to be portable.

From South Molton Street the Blakes moved in 1821 to their last home, once again two first floor rooms, at 3 Fountain Court near the Strand, and it is the home for which we have the most complete description. The front room was a 'rather dark reception room', which Blake used as a showroom for 'a good number' of his pictures. Although never mentioned by any visitor, his rolling press must have been in this room. A smaller back room served as a living room, bedroom and kitchen for William and Catherine as well as his work room, and it was the room in which he died (figs.3d, 4). It measured 12ft x 13ft 9in (3.65 x 4.2m). We know that *The Last Judgment* was at Fountain Court so we can

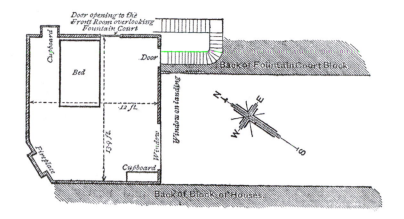

FIG.3d After Frederick J. Shields. *Plan of William Blake's Workroom and Death Room on the First Floor, 3 Fountain Court, Strand, London c.1880.* Reproduced from Alexander Gilchrist, *Life of William Blake*, 2nd ed., 1880, I, p.322. The Blakes' front room, not shown here but connected with the work-room through a door by the bed, overlooked Fountain Court and was a reception room in which Blake showed his frescoes, temperas and drawings. It was in the bed that Blake, propped up with an injured foot, started work on his designs for Dante's *Divine Comedy* in 1824.

assume that both rooms had door and ceiling heights similar to those at South Molton Street. Under the window in the back room was the long table at which Blake would sit drawing, painting and engraving. His tools to hand, he faced the light while he worked and, as Samuel Palmer remembered, when engraving by artificial light he used tissue paper around the lamp to reduce the glare from the shiny copperplates. Stacked on either side of the table were portfolios and drawings on his right and a pile of books on his left. Nearby on the wall hung Dürer's engraving *Melencolia I* (fig.9).[53]

Blake's later, self-confessed and overlapping roles of 'both Poet & Painter'[54] at least suggest that what for him was sufficient space for writing with pen and ink and pencil would be equally sufficient for his drawing and painting. The simplicity of the idea is perhaps best summed up in the beautifully designed and delicately finished illustration to the Introduction in *Songs of Innocence* (fig.7) with words that convey a rare sense of the piper (who is Blake) turned into writer and designer in action: 'Piper sit thee down and write / In a book that all may read − / . . . / And I pluck'd a hollow reed. / . . . / And I made a rural pen, / And I stain'd the water clear, / And I wrote my happy songs.'[55] Two seated figures writing on tablets or in books placed on their laps illustrated on plate ten of *The Marriage of Heaven and Hell* show the compact space in which writing can be

FIG.4 Frederick J. Shields, *William Blake's Workroom and Deathroom, 3 Fountain Court c.1880.* Watercolour on paper 21.6 x 31.1cm. Delaware Art Museum. Samuel and Mary R. Bancroft Memorial, 1935

done.[57] The burlesque *An Island in the Moon*, written from 1784 onwards, would have measured 12¼ x 14in (31 x 37cm) as an open book. The *Manuscript Notebook* in use between about 1787/8 and 1827, in which he made drawings and drafted and finished poems for *Songs of Innocence* and *Songs of Experience*, is about 8 x 12in (20 x 30cm) when open. To this we should add the *Blake-Varley Sketchbook* of 1819 (now dispersed), which opened to 6¼ x 16⅛in (15.5 x 41cm); the *Larger Blake-Varley Sketchbook*, also of 1819, which opened to 10¼ x 16½ in (26 x 41.9cm); and that for the *Divine Comedy* watercolours of 1824–7, when open

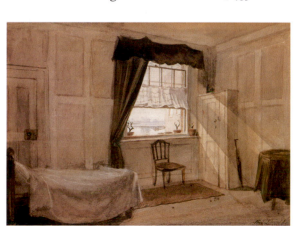

approximately 20¾ x 29 in (52.7 x 73.7cm), to be discussed later in the chapter on paper. He could, as he once admitted when referring to the latter, 'draw as well a Bed as Up & perhaps better', but, he added, 'I cannot Engrave'.[57]

From the outset, a similar scale of work can be found in his engravings. The earliest-known copperplate that Blake worked on was 10 x 5½in (25.6 x 14cm; fig.1). The largest of the engravings of this period that can be associated with him, after his drawings in the Abbey, for example the *Portrait of Queen Philippa from her Monument*, were on plates with an average size of 15³⁄₁₆ x 11¼ in (40.1 x 28.5cm).[58] In Basire's workshop he would have seen his master engraving on two of the largest copperplates ever used in Britain, 27 x 49in (68.6 x 121.9cm), impressions from which had required the making of the largest sheets of paper made for more than a century, 31 x 53in (78.7 x 134.6cm), a size known as Antiquarian. Blake was not tempted to work on anything approaching such a scale himself until his engraving *Chaucers Canterbury Pilgrims* was published in 1810. At 14⅛ x 38⅜in (35.8 x 97cm) it is the biggest of all his copperplates.[59] Otherwise, the sizes of the copperplates he used for his own engraved or etched designs ranged from 2¹⁄₁₆ x 1⁷⁄₁₆in (5.2 x 3.1cm)[60] to 18⅛ x 21¼in (460 x 540).[61] Among his commercial engravings, the largest copperplate he ever worked on (1788–90; E1991, XX) was for the print of Hogarth's *Beggar's Opera* at 17¹⁵⁄₁₆ x 22⅞in (45.7 x 58.cm).[62] Over his career drawings and finished watercolours ranged from about 18¾ x 26½in (47.5 x 67.5cm)[63] to 13¹⁵⁄₁₆ x 37¾in (35.4 x 95.8cm).[64] The smaller temperas are between 10⅛ x 14¹⁵⁄₁₆in (25.7 x 36.4cm) and 12⅝ x 19½in (32.7 x 49.cm) in size. The largest surviving tempera, *An Allegory of the Spiritual Condition of Man*, of 1811(?) is 59⅝ x 47¾ (151.6 x 121.3cm; B673).

Blake's painting practice: 'I know my Execution is not like Any Body Else I do not intend it should be so'[65]

We should, then, think about the scale on which, from the beginning, Blake worked as a writer, engraver and painter and combine this with the way in which he worked in practice. Temperamentally and physically his first and abiding instinct seems always to have been to draw and paint carefully, with all the implications this carries for working most successfully on a small scale. However, his ambitions led him to hope for a commission to paint frescoes with figures one hundred feet (30m) high.[66] An element in this carefulness must have been learnt from other artists, as is suggested by his practice of copying from meticulously executed woodcuts and engravings by Dürer and in his comment that 'the Greatest Artists' are 'the Most Minutely Discriminating & Determinate'; or his endorsement of Reynolds's advice 'that everything shall be carefully and distinctly expressed' as 'Excellent'.[67] It informed Blake's now unknown oil paintings, as can be seen in his own report of connoisseurs' views on them 'that they were very admirable Drawings on canvass; but not Pictures . . .'[68] What sounds like a 'liney' quality in these paintings could well have derived from what Blake found in engravings after

frescoes and his early emphasis on 'line' in drawing. Had Blake seen oil copies made from frescoes, as has been suggested, then his own handling of the medium might be attributable to any linear and dry treatment of colour, taken from the original frescoes, which such copies, if accurate, would have possessed.

We should first think about Blake's physique, to gauge his capacity for the sort of great physical energy that painting on a large scale would have required. Comments on this are few and far between. He was 'not quite five feet and a half . . . broad shouldered . . . well made . . . bore himself with dignity . . . the head and face . . . strongly stamped with the power and character of the man',[69] just as, in fact, we can see in Thomas Phillips's 1807 portrait of him (see the frontispiece). He had 'rapid & energetic' movements and, as one who in his youth possessed 'Vigour & activity' and in age 'unfading ardour & unabated energy',[70] Blake believed his constitution 'a good one'. Even so, a note of having to be careful about his health intruded. When he was 'young', as he admitted, the damp air in Hampstead and Highgate gave him stomach colds, which laid him up with 'excruciating' pain and would enfeeble him for up to about three days, and the same ailment afflicted him at the end of his life.[71] Also in his later years he suffered from piles, 'a most sore plague'.[72]

An image of youthful physicality is found in Blake's comment of 1804 about being 'really drunk with intellectual vision whenever I take a pencil or graver into my hand, even as I used to be in my youth . . .'[73] And in Westminster Abbey 'he drew [the monuments] in every point, frequently standing on [them] and viewing the figures from the top'.[74] Later on, in the absence of any descriptions, we have to imagine Blake standing and slowly and strongly turning the large star wheel of his rolling press as he printed the large colour prints or the pages of his illuminated books. It comes as a bit of a surprise to realise that for *The Last Judgment* (B648, untraced) and *The Ancient Britons* (B657, untraced) he would have had to stand up on a stool to reach some parts, as he must have done for the slightly smaller *Allegory of the Spiritual Condition of Man* (B673).

Certainly writers and engravers, given their tendency to work on a small scale and in small spaces, tended to work more privately than painters. Painters, often through necessity or image-making, brought an element of public performance into their studio behaviour, particularly those using oils or painting large pictures for public display. Portrait painters of course had a ready-made audience in their sitters. This would have been first learnt by many in the Academy Schools. Later this would be fruitfully deployed as part of the business of cutting a figure in public.

No oil painting by Blake has survived.[75] Descriptions of the oil painting methods of some of Blake's best-known contemporaries highlight how easily Blake might have been repelled by public virtuosity. They firmly suggest that a spacious studio was highly desirable: it provided an enhanced opportunity for display and what William Hazlitt so graphically characterised as 'swordplay' with the brush, with all its connotations not only of 'painterliness' but also of masculine combativeness aimed at rival artists.[76] Reynolds

'continually walked backward and forward' between sitter and canvas, then would 'rush up to the portrait and dash at it in a kind of fury'.[77] J.T. Smith, who often watched Gainsborough painting, 'was much surprised to see him sometimes paint portraits, with pencils [that is, brushes] on sticks full six feet in length, and his method of using them was this: he placed himself and his canvass at a right angle with the sitter, so that he stood still, and touched the features of his picture exactly at the same distance at which he viewed his sitter'.[78]

Fuseli, an artist much admired by Blake, 'invented and composed his pictures with great rapidity, and had [he] not a canvass of a convenient size, it was frequently his practice to rub in the new idea upon a finished picture'. And 'in painting his pictures, Fuseli used indiscriminately the right hand or the left'.[79] Turner was observed at Royal Academy varnishing days 'nodding like a mandarin at his picture, which he, with a pendulum motion, now touched with his brush, and now receded from . . . He went on shaping in some wonderful dream of colour; every touch meaning something, every pin's head of colour being a note in the chromatic scale.'[80] And he 'scratched' and 'scrabbled' paint on paper, out of which emerged an 'exquisite' finished watercolour.[81] Constable is recorded as 'pacing impatiently before a picture' while he decided on adding final effects – a decision made for him by Turner who 'seized a brush, and struck in a ripple of water in the foreground'.[82] With George Henry Harlow, who followed the dashing style of his teacher Thomas Lawrence, 'his pencil [that is, brush] was so rapid, and his eye for copying so quick, that when at Rome, he actually commenced and finished a copy of Raffaelle's *Transfiguration*, of the size of the original in only eighteen days'.[83] Such showing off was not confined to oil or watercolour painters: the painter and engraver J.K. Sherwin 'had . . . an extraordinary command over the use of both of his hands; and whenever he has been engaged on a very large plate that was difficult to turn, he would let the plate remain before him, throw the graver over from his right hand into his left, and accurately meet the sweeping line he had commenced with the former'.[84] In fact this is a quite rare insight into an engraver's 'virtuosity'.

What we see in Blake's execution, and what some of his contemporaries either liked or disliked, is his patient and meticulous hand. Around 1819, when drawing the *Visionary Heads* at John Varley's house, he would draw with the 'utmost alacrity and composure',[85] and much later in life he used a pencil with 'a few deft touches'.[86] Palmer left a lasting impression of Blake with his remark that he 'was always most careful not to depart [from] the first inventive lines'.[87] With this came application, 'a faculty so engendered in him that he took little bodily exercise to keep up his health: he had few evening walks and little rest from labour, for his mind was ever fixed upon his art, nor did he at any time indulge in a game of chess, draughts, or backgammon; such amusements, considered as relaxations by artists in general, being to him distractions'.[88] This application may well have derived from his early practice in copying from engravings, but equally because such precision attracted him.

The Westminster Abbey tomb drawings are precisely executed, this being an absolute

prerequisite for the engravings to be made from them for scrutinising antiquarians; we can see precise copying in pen and ink in the now identified subject of *St Christopher* (B178 recto, T2 recto, Tate),[89] which must surely have been taken from a fifteenth- or sixteenth-century print. The 'great care'[90] with which he drew from the antique figures in the Royal Academy Schools is obvious in the Tate's drawing of a head from a plaster of the Niobe Group. Palmer noted that he 'felt his way in drawing, notwithstanding his love of a "bold determinate outline", and did not get this at once'.[91] Such patience, tenderness even, became more thoroughly developed as he engraved and painted more and more. Blake knew this. Engraving, he rightly said in 1804, 'is of so slow Process . . . Endless Work is the true title of Engraving'.[92] Romney's large cartoons, he said, 'deserve to be Engraved by the hands of Angels & must not by any means be done in a careless or too hasty manner'.[93] So deeply rooted was this necessity that it inevitably governed his execution in all areas of his work: 'Nor can an Original Invention Exist without Execution Organized & minutely Delineated & Articulated Either by God or Man . . . Drawn with a firm and decided hand at once . . . like Fuseli & Michael Angelo Shakespear & Milton'.[94] It is epitomised in the care necessary to produce the relief-etched plates for the illuminated books, and, associated with that, in the application of ink and pigment with a dabber and stump brush to the copper before printing colour plates such as the *Frontispiece* to *Visions of the Daughters of Albion* (fig.5), later followed by carefully applied watercolour washes and strengthening of printed lines with pen and ink on those pages which had not printed well. The same but bolder use of pen and ink is visible in the large colour prints.

Reynolds's assertion that fresco painting 'excludes attention to minute elegancies' prompted the retort, 'This is False. Fresco is the Most Minute' and 'Fresco Painting is Like Miniature Painting; a Wall is a Large Ivory.'[95] The lost *Last Judgment* was notable for its 'exquisite finishing' with its 'upward of one thousand figures'.[96] Against this stands the inherent hopelessness of Blake's ambition to operate on this scale, underlined by what Flaxman (who probably first met Blake in 1779) once said of him: that by engraving and teaching drawing, as well as by 'making neat drawings of different kinds', he could make a good livelihood 'but if he places any dependence on painting large pictures, for which he is not qualified, either by habit or study, he will be miserably decieved [sic]'.[97] One further fact should also be considered here. Blake wore spectacles, though 'only occasionally',[98] and from an unknown age.

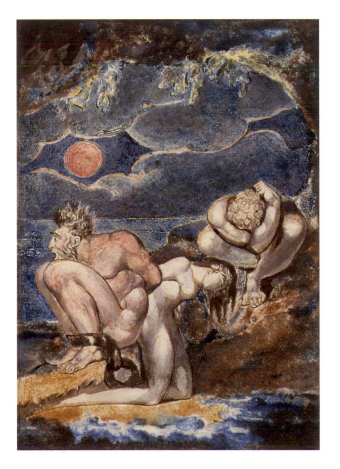

The pair that has survived shows that he was 'moderately' myopic,[99] in other words his near vision was much sharper than his distance vision, so close work would have come more naturally to him.

'Execution is only the result of Invention'[100]

At the end of his life Blake possessed a 'terrible fear' at the thought of moving from Fountain Court to John Linnell's house, a 'terror' created by the loss of 'Myself alone shut up in Myself or Reduced to Nothing'.[101] If we accept this as a consistently deep-rooted pressure within Blake with intellectual and physical implications, then a number of consequences for his art flowed naturally from it. One was his consistent reliance on imagination. It follows he did not need models nor want to copy objects from nature. An affirmation of this expressed in 1809 dealt with the importance of this 'Imaginative power', which he saw being destroyed by 'that infernal machine, called Chiaro Oscuro', which was in the hands of the Venetian and Flemish Old Masters or 'Demons'.[102]

The size and height of a single studio window is also very important to the way in which light and shade, or 'chiaroscuro', is distributed across the studio and the work in progress (any figure or object that is being painted), whether it be on an easel or a work table. The smaller the window is, the broader but more intense the shadows will be. Light entering at a high level will cast long shadows with the complementary effect of making the vertical distribution from light to shadow more pronounced. The quality of the light will affect the tone and hue of colours used by the painter. Good daylight is a requirement for any artist, and ideally it should come from one direction only, though which is a matter of personal preference. Most painters prefer north light, or even an east light, because it does not include direct sunlight, making it easier to maintain consistency of colour and tone in painting over long periods. Turner painted in a room that had 'a good north light'.[103] By contrast, light from the south – obviously more variable than north light because it includes sunlight – is also warmer and thus will tend to warm the colour tones used. When Palmer moved to a new home in London in 1851 he 'purposely' chose the drawing-room of the house for his studio 'on account of its direct *south* light' and to avoid 'the saddening influence upon an artist's colouring of a North light'.[104] Palmer's view is borne out by the brilliancy of palette (and handling) of Lawrence's portraits, whose painting room had south light.[105] Anthony Pasquin advised 'every Engraver to work by a North light, as it is more serene and equal than any other; but when the plate is finished, he should examine it by a South light, which administers a beam less flattering to the Artist, and more glaringly scrutinizing'.[106] The workroom window of the prolific and fashionable engraver William Woollett faced north.[107]

Personal preference inevitably played some part in an artist's or engraver's final choice of work space. In Blake's case it was made simpler by his rejecting, after his time in the Royal Academy Schools, the use of models for his figures. He professed 'drawing from

life always to have been hateful to him [speaking of it] as looking more like death, or smelling of mortality'.[108] As far as public reputation went, there was a danger in this: Reynolds, convinced that in 'error . . . Students never draw exactly from the living models which they have before them . . . and make a drawing rather of what they think the figure ought to be . . .',[109] was to criticise Blake's work (see fig.6) for just this when he told him 'to work with less extravagance and more simplicity, and to correct his drawing'.[110] During his working life Blake's studio or workroom light came from all points of the compass, so its quality or direction was not crucial to the rendering of light and shade or flesh tones of the human form. This is not to say, however, that he was totally unaffected by the effects of light on colour, as we can see when from 1800 to 1803 he lived in Felpham, Sussex, in a 'two story thatched cottage of six rooms' that faced almost directly north–south. Blake's first impressions conveyed just this: 'My first Vision of Light / On the yellow sands sitting / The Sun was Emitting / His Glorious beams . . .'[111] 'Often, in after years, he would speak with enthusiasm of the shifting lights on the sea he had watched from those [south-facing] windows.'[112] There seems little doubt Blake's time there actually influenced his handling of colour with the brilliant rainbow and its effects in *The Death of the Virgin* (B512, T49, Tate) showing his heightened response to this coastal light. He succeeded to the extent that 'he defies competition in colouring'.[113]

When we read Blake's description of *The Ancient Britons* (B657) in his 1809 catalogue, we see that his early rejection of drawing from life directly influenced his palette: having seen, as he later described it, that 'modern Man stripped from his load of cloathing . . . is

FIG.6 *Lear and Cordelia in Prison c.*1779. Watercolour and pen and ink on paper 12.3 x 17.5cm Tate N05189. Reynolds is reported to have criticised Blake's drawing technique for its 'extravagance' and suggested he work more correctly. Something of what prompted Reynolds's comments probably made around 1780 can be seen in this early drawing.

like a dead corpse', he looked instead for that 'flush of health' in the body 'accustomed to go naked' in the 'ancient happy period'.[114] It was not to be found in the living figure. So, when it came to his palette and use of colour in painting, what might be seen as conventional flesh tones in depicting the body – for Blake, those used by artists like 'Rubens, Titian, Correggio and all of that class', in whose paintings 'men are like leather' and 'women like chalk' – were not to be followed. 'Imagination only, can furnish us with colouring appropriate, such as is found in the Frescos of Rafael and Michael Angelo.' Thus in Blake's figures, as he claims, 'the blood is seen to circulate in their limbs', as for example in the male figure in *The Night of Enitharmon's Joy* (fig.47). Robert Hunt wrote in the *Examiner* (in a rare comment by a contemporary on Blake's colours) that the flesh colour of one of the Bards 'in the pangs of death' in *The Ancient Britons* was 'exactly like hung beef',[115] that is a dark reddish brown.[116] For Blake this would have been 'colouring appropriate'[117] and we can assume it would at least have been hinted at in the flesh tones of the principal figure in *The Bard, from Gray* (fig.132), since the bard's fate is the same. This is however no longer apparent, for reasons to be discussed in a later chapter. To Blake, colours were timeless because they were not dictated by the 'perishing mortal eye' but by the imagination, which is 'immortal'.[118] Invention for Blake knew no boundaries.

Nonetheless, while a clear connection between his particular type of art and a particular type of space becomes apparent, we can still see instances where Blake partially conformed to wider artistic imperatives of the day. Notably, in response to growing recognition and to achieve his aims fully, he obviously felt he had to move house. Such mobility among artists – and others – is quite common, but in Blake's day it can be linked to a prevailing patriotic optimism fuelled by the idea that in the British School, with its espousal of the Grand Style in emulation of Renaissance masters, big subjects had to be painted on large canvases in broadly handled oil paint. The history painter Benjamin Robert Haydon caught the mood of the day when, in the midst of the High Art struggle and working in a small painting room, he asked: 'Do you expect, really expect, to raise British Art by encouraging Pictures "three feet long & two feet wide?"'[119] It is discernible in Turner's move in late 1799 from his parents' house, 'small & ill calculated for a painter',[120] to new rooms, which resulted in his first historical subject and his largest oil painting to date exhibited at the Academy the following April; and in Constable's move in 1817 from bachelor lodgings to a house that gave him space to embark on the 'six footers' that were to make his reputation in exhibitions from 1819 onwards. Similarly with Blake: no doubt partly stimulated by his growing success as a commercial engraver and then in mid-1783 by a commission from a rich patron for 'a capital drawing',[121] he moved from his first lodging as a married man to a new address towards the end of 1784 when his short-lived print-publishing partnership with the engraver James Parker began (fig.3a). Here he must have embarked on his most ambitious work to date – the three watercolours showing scenes from the life of Joseph that were accepted for the 1785 Royal Academy exhibition (B155–7, Fitzwilliam Museum, Cambridge). Another larger finished

watercolour *Oberon, Titania and Puck with Fairies Dancing* (B161, T5, Tate) can be associated with the same move.

'The greatest of Duties to my country'[122]

So Blake, like many another artist in pursuit of those inextricably connected aims, fulfilling an artistic mission, sought greater public recognition, more patrons, more money and enduring fame, and having consolidated what he thought were the means to do it, once again looked for a more agreeable working space in order to meet these challenges. Thus, following his experiments with his newly invented relief-etching process in 1788 and the publication of his *Songs of Innocence* (fig.7) in 1789 which used this method, he and Catherine moved in autumn 1790 to 13 Hercules Buildings in Lambeth (fig.8). This house gave him more space in which to live and work than any of his previous homes: it was three storeys high with a semi-basement, with good light from a north-west, east-west direction and had room for the servant who initially accompanied William and Catherine.[123] The ground floor plan, ignoring the spaces on either side of the chimney breasts, shows clear working areas in two rooms of approximately 14 x 12ft (4.3 x 3.7m) and 11ft 6in x 9ft 6in (3.5 x 2.9m). One obvious result of his having more space was the production of his three largest intaglio engravings after his own designs to date, almost comparable in size with his Hogarth plate, though they were not published until 1793–4.[124] More significant, and the prime reason for the move, here he printed and published from his relief-etched copperplates six of his 'Illuminated Books', which were eventually announced for sale in his Prospectus *To The Public* of 1793 along with the intaglio engravings. Soon after, in 1795, he took his colour printing to its technical and aesthetic high point with the large colour prints. For ten years Blake, as he later put it, now 'had a whole House to range in'[125] and, with a servant, had someone to answer the door to any likely patron.

Some artists and writers have always searched for the 'new', and in Blake's time much of this centred on reviving aspects of the past in order that the present might equal or even exceed it. The process was always a mix of plagiarism and homage out of which truly great and original art would sometimes emerge. For Blake's generation the agenda for this was set by Reynolds, who concluded his *First Discourse* in 1769 with the hope that the Royal Academy would create such conditions that 'the present age may vie in Arts with that of [Pope] Leo the Tenth; and that *the dignity of the dying Art* may be revived under the Reign of GEORGE THE THIRD ...'[126] This was the driving force behind the intention to create a British School to rival great Renaissance masters such as Michelangelo and Raphael. With some artists such apparent conformity conceals a relationship with great work that goes far beyond the inanimate objects themselves and becomes an instinctive awareness of the presence of the hand – occasionally even an almost physical presence – of great masters whom they see as crucial to shaping their own work. It becomes a way of

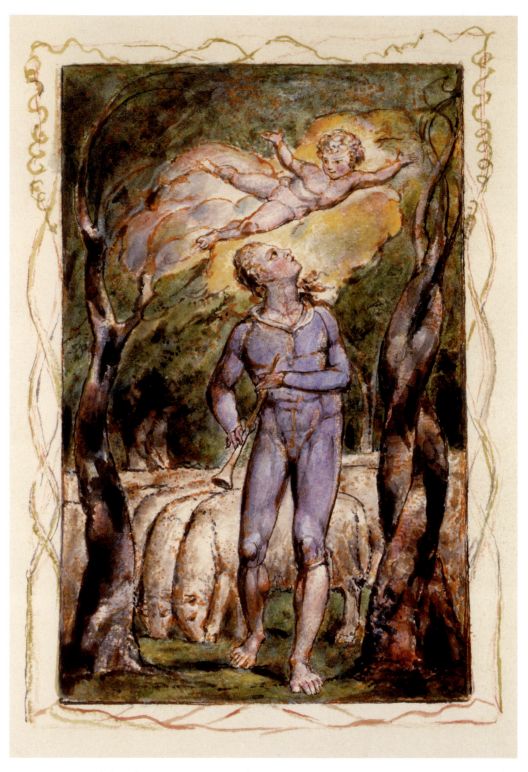

FIG.7 *Frontispiece* (plate 2) to *Songs of Innocence* from *Songs of Innocence and of Experience* 1794/1825. Relief etching printed in light red-brown ink finished with watercolour and pen and ink with some shell gold, approx. 11 x 7cm on paper 28.3 x 22.2cm. King's College, Cambridge. Blake's account of how his illuminated book *Songs of Innocence* came about is illustrated in this image which captures how important solitariness was to Blake for inspiration.

testing their own potential for greatness and then securing it alongside such masters for posterity. Generation after generation of painter, writer and composer has done this. We find Reynolds telling his students to 'possess' themselves with the 'spirit' of the great masters and then believe that their finished pictures were 'to be seen and criticised by them';[128] and Barry, as Professor of Painting at the Royal Academy telling his students to 'go home . . . light your lamps, and exercise yourselves in the creative power of your art, with Homer, with Livy, and all the great characters, ancient and modern, for your companions and counsellors'.[128] In painting of the same period we see it most stunningly exemplified in the work of J.M.W. Turner, who set himself the task of competing in subject matter and handling with other earlier artists – N. Poussin, Claude, Titian, Rembrandt, Cuyp – as a way of securing his place among such great figures. Among painters of our own time, we find Picasso experiencing the same when he said arrogantly: 'I have a feeling that Delacroix, Giotto, Tintoretto, El Greco and the rest, as well as all the modern painters, the good and the bad . . . are all standing behind me watching me at work.'[129]

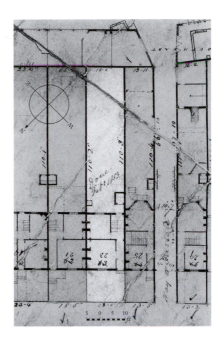

FIG.8 *Plan of the Ground Floor, Front and Back Gardens of William and Catherine Blake's house, 13 Hercules Buildings, Lambeth, Surrey, with adjacent houses 1853/68. Pen and ink and water-colour mounted on linen 53.1 x 62cm. Corporation of London Records Office. 13 Hercules Buildings was then no.23.*

In Blake's day it led quite a few British painters to copy the supposed painting techniques of such masters or, along with colourmen and also mountebanks, to research them in the hope that, by recovering the secrets of the grounds, colours and varnishes used by the Old Masters and then employing them, their own art would automatically rival these masters. The ways of doing this were sometimes quite drastic. Reynolds was 'indefatigable' in his research: he 'rubbed and scoured down to the very pannel on which [a picture] had been painted' and 'totally destroyed' several works by Venetian artists.[130] Opie, as Professor of Painting at the Royal Academy, signalled some delusory short cuts to this in his lectures of 1807 when he noted that 'still more wonderful recipes are announced for making Titians and Correggios by a chemical process'.[131] As we have seen, Blake was one such experimenter. As an engraver this was not altogether surprising. The notion of experimentation lay very much at the heart of the whole print-making process in which he had been trained: Blake's undertaking, in his indenture, to 'keep' his master's 'Secrets' recognised that experimentation and invention, whether with materials or with 'proof' impressions taken from a plate as a prelude to further work on an image cut in the metal, were part of the craft of engraving. But Blake need not have taken such a course; after all, very few printmakers of his time explored the medium in the way he did. However, it is a constant with Blake, underpinning his first work on the illuminated books and still discernible right at the end of his life in his and Edward Calvert's experimentation in 1826 with an etching ground that led to a chimney fire.[132] He made notes about methods of engraving or cutting on pewter,[133] and of course his 1821 illustrations to Robert Thornton's *Virgil*, as wood engravings, took him in an entirely new direction. We might even speculate that a reason for the tempera *The Agony in the Garden* being painted on a

piece of tinned iron (fig.86) was an abandoned interest in trying out etching methods on this metal as, for example, Lucas van Leyden and Dürer had done before they used copperplates.[134]

This naturally led Blake to enquire into types of paint media that matched his artistic aspirations. So far as we know, though, Blake the painter was not forensic like Reynolds, even if his own comments on his 'Experiment Pictures' – that they 'have been bruized and knocked about, without mercy, to try all experiments'[135] – might suggest an affinity with him. Nonetheless, his experiments with one medium in particular, which he called 'fresco', ought to be seen in relation to activity in the London art world at the time (1795) when he first attached that word to some of those works. These were the large colour prints, discussed in their own section (pp.82–99): *Lamech and his Two Wives* (fig.63), *Naomi Entreating Ruth and Orpah to Return to the Land of Moab* (fig.55) and *The Night of Enitharmon's Joy* (formerly *The Triple Hecate*, fig.48). Blake's use of the word at this moment takes on an almost polemical tone if we consider that he would undoubtedly have been aware of the 'true' frescoes painted by J.F. Rigaud in 1794 for the ceiling of the Common Council Room in the City of London's Guildhall. Rigaud believed that his scheme was 'the first work painted in Fresco in London', and it must be seen as a characteristically patriotic initiative by John Boydell who commissioned them, but also, as Rigaud noted, 'a new opportunity of introducing a kind of painting, which may in time afford employment to Historical Painters'. Rigaud advertised his achievement by showing his four oil sketches for them at the Royal Academy in 1795 as 'executed at Guildhall', though the frescoes themselves were later taken down because of faulty plastering.[136]

Among the 'wonderful recipes' alluded to by Opie was the 'Venetian Secret'. The 'secret' emerged in December 1795, with its discoverer Provis claiming that he had a recipe for painting in oil that Titian and other Venetian masters had used. Very much a by-product of the British School's preoccupation with Old Master colouring, the method, copied from an old document claimed by Provis to have been lost in a fire, was taken up by the then President of the Royal Academy, Benjamin West. Starting in early 1796, he painted a number of 'experiment pictures', to apply a term Blake would use later to define the testing of his own tempera and fresco recipes. Other Academicians followed suit, helped along by demonstrations from Provis's daughter, but by the end of 1797 the process was seen as a fraud and all those artists taken in by it were branded as dupes.

This background adds a further dimension to the way we should look at Blake's large colour prints as 'fresco'. They not only represent a culmination of his colour printing techniques but the description of 'fresco' on three of them seems to show Blake anticipating the entire group of twelve designs as a decorative cycle of precisely the type traditionally executed in 'true' fresco. In particular, as a cycle containing two works with chamfered corners (figs.55, 63), it invites a direct comparison with the hexagonal shapes of the four frescoes telling the story of the Creation in the first of the seven vaults of Raphael's *Bible* in the Vatican Loggia. It even anticipates Blake's 1809 use of the term

'portable fresco' where such an application is stated more directly.[137] For a sense of just how deeply attached Blake was to such a concept it is worth looking back to the beginning of his career, as one of the large colour prints, *God Judging Adam* (fig.53), whose first outlines were printed from a relief-etched copperplate, has a line of descent from Blake's first apprentice etching and engraving, *Joseph of Arimathea*, with its subject borrowed from a fresco by Michelangelo. Because of Blake's inscription on the first state this can be securely dated to 1773, and then in its second state (fig.1) tied specifically by Blake to Michelangelo. Interestingly, in 1773 a great scheme, involving six artists, to decorate St Paul's Cathedral with large oil paintings of biblical subjects was proposed but came to nothing.[138] It is not too far-fetched to see in Blake's imagery his youthful response to this plan, the first record of his interest in fresco, and his own ambition to see that medium and not oil used in St Paul's.

The large colour prints were conceivably, then, Blake's way of asserting the validity of his own re-discovery of true fresco, and as a continuing demonstration of how it might be used, a sense now further heightened by the apparent early technical failure of Rigaud's efforts. However, while we know that the colour prints were never exhibited – and with the 1795 date on them it is reasonable to expect that the ambitious Blake would have sought their display in a public exhibition of 1795 or 1796 – he might well have submitted one or more to a Royal Academy exhibition and been rejected: a comment made by John Hoppner tantalisingly suggests this possibility. Hoppner was not close to Blake and his circle and therefore would have known little or nothing about the artist's work, but he was on the selection and arrangement committee for the 1796 exhibition. He compared Blake's art to the 'conceits of a drunken fellow or a Madman', which even hints at the *Nebuchadnezzar* subject, dated 1795 (B303, Minneapolis Institute of Arts), madly staring at the viewer, as having been one print sent to the Academy.[139] The inscription 'fresco' could have been attached to some of the prints in anticipation of their being accepted for display and thus becoming an advertisement for his technique. The claim for their being 'fresco' would, of course, have been a public assertion by Blake of his belief in the primacy of this medium over that of contemporary oil painting and of his own superiority over those who were taken in by that supposed refinement to it, the Venetian Secret – particularly the Academicians.

As far as Blake was concerned, since he was naturally drawn at this stage towards small-scale work, largeness as such was never the sole yardstick by which the patriotic intentions behind a work of art were to be measured – even if later he nurtured ambitions to paint frescoes in which 'the figures were one hundred feet in height'.[140] For him the content and the modest dimensions of his illuminated prophetic books served the purpose equally as well as did works on a grand scale, as we know from his placing them in the context of John Milton's and William Shakespeare's works.[141] In fact, in the large colour prints Blake was challenging almost every aspect of the conventional treatment of historical subject matter. So, what we should also take into account when looking at

them is how the printing technique produced highly individual surface textures, as we can see in areas of *God Judging Adam* (fig.53), in *Pity* (fig.46) and particularly in the 'later' impression of *Newton* (fig.50), whose late date is discussed in the chapter on large colour prints. In their originality and effect they challenge the highly valued and fashionably swaggering brushwork that became a dominant characteristic of the British School of oil painting. If we look at the way in which so many history paintings reached a wide audience at home and abroad through large engravings – and so took on a patriotic dimension as products not only of the British School of painting but also of the native school of engravers – then we can find another side to the challenge: the dimensions of Blake's large colour prints (see Appendix 3) bear comparison with hugely successful prints such as Woollett's *Destruction of the Children of Niobe* of 1761 after Richard Wilson's oil painting; the same engraver's *Death of General Wolfe* of 1776 after West's oil; or James Heath's *The Death of Major Pierson* after J.S. Copley's oil of 1782–4, shown in an unfinished state at the Royal Academy in 1795.

Thus colour printing as 'fresco', and all the historical connotations that came with that word, in *facture* and in scale became a patriotic riposte to the accepted norm. In short they fit into that public articulation of a new and unexpected kind of patriotic art in which we now have to include the media that he used – an art first announced in his 1793 *To the Public*. Then Blake placed his intaglio prints along with the illuminated books as 'of equal magnitude and consequence with the productions of any age or country'.[142] In 1809 he expressed the wish, in his *Descriptive Catalogue*, to see four of his watercolours 'on an enlarged scale to ornament the altars of churches . . . to make England like Italy' for an exhibition which he advertised as 'the greatest of Duties to my Country'.[143]

It is also tempting to relate one other innovation of Blake's to the immediate post-1795 history of the large colour prints, and his continuing sense of their rightful place in contemporary print-making, for around 1804–5 Blake returned to them. His loyal patron Butts purchased eight in 1805 including two, *Nebuchadnezzar* (B301, T28, Tate) and *Newton* (fig.50), both dated 1795 but definitely datable to this time because they are printed on paper watermarked 1804. It coincided with Blake being 'again enlightened with the light I enjoyed in my youth, and which has for exactly twenty years been closed from me as by a door and by window-shutters'.[144] This was inspired by his 1804 visit to the Truchsessian Gallery of early or 'Gothic' Italian, Flemish and German pictures, and strongly suggests a direct, particular but somehow final contact with the same sorts of pictures from twenty years before that was being mourned by Blake. It is difficult to find a specific connection of this kind, though exactly twenty years earlier Blake was discovering the nature of this enlightenment and ambition in his own art. In this year he must have conceived and begun work on the four 1785 Academy exhibits already mentioned above. The central characters in these, a Bard and the Old Testament Joseph, are respectively a prophet and an interpreter of dreams – the 'light' of 'enlightenment' to which Blake referred twenty years later must surely mean his identification of these roles as ones

to be taken on by him. They immediately connect with the purpose that Blake, borrowing from John Milton's *Paradise Lost*, enunciated on the title-page of the illuminated book *Milton*, significantly also dated 1804: 'To Justify the Ways of God to Men'. He had found his own role as an interpreter or prophet once more and of course expressed it through a medium, that of the illuminated book, that had been revealed to him in a dream. The medium itself was that out of which 'real Art'[145] was formed and was thus for Blake intimately bound up with his prophetic acts as a painter. As such, his 1809 exhibition became the culminating public expression of that enlightenment which commenced in Felpham.

The period of enlightenment when Blake created the new impressions of the colour prints, their technique and Blake's aesthetic ambitions for them naturally invite a comparison with the arrival in Britain of an entirely new method of directly printing from drawn images. This was lithography, or 'Polyautography', invented by the Bavarian Aloys Senefelder around 1798. The method was simple: drawings were made in a greasy medium on an absorbent stone slab; the stone was dampened, the whole had printing ink rolled over it with the image alone retaining it, and an almost exact copy could be printed on paper. Following his arrival in England in late 1800, Senefelder persuaded a number of artists to work in the new method, including West, Fuseli and Thomas Stothard, who were contributors to the first issue of *Specimens of Polyautography*, published in 1803. A second series was put in hand and finally appeared in 1806–7. Just as we might read something polemical into Blake's use of the word 'fresco' for his prints in 1795, so we might see his interest in them in 1804–5 – an interest sufficient for him to direct Butts towards them – as something of a riposte to the new lithography.

'Myself alone'

Like engraving, painting in watercolour was a solitary occupation, with the marks of the paint on paper unforgiving of immediate correction and so, in any 'public' display, entailing a seeming fallibility of touch likely to dent the artist's reputation. Painting in oil, so often on a scale much larger than that of most watercolours and prints, involved the use of a medium whose malleable consistency allowed time for public display in its handling. We should take for granted, and in one case it was mentioned by Catherine, that Blake drew, engraved, painted and wrote with Catherine near or beside him. Otherwise there were few witnesses to his work: William Hayley was several times next to him as he was engraving, once with 'with great zeal';[146] Palmer saw him with a plate on which he had just stopped working;[147] Henry Crabb Robinson saw him at work on a plate;[148] Palmer and Linnell saw him in bed working on the *Divine Comedy* drawings;[149] and he pulled proofs at a printer with Linnell.[150] The silence in which Blake worked is conveyed in the matter-of-fact quietness of these reports by contemporaries. Among engravers who were Blake's contemporaries we read of Sherwin's brilliant powers of execution and that when Woollett finished engraving a plate he celebrated the fact by firing off a cannon

on the roof of his house,[151] but these seem to be rare instances of extroversion. Any of that tendency to solitariness that might have first led budding draughtsmen to become engravers was, in the case of British engravers, likely to be reinforced by the belief among many painters, from the Royal Academicians downwards, that engraving was inferior to painting because it was copying and not imaginative work. This attitude may even have been a catalyst for Blake's own inventiveness when it came to engraving.

Thus what we know of Blake's early life as an engraver and etcher and a desire to be 'Myself alone shut up in myself' makes a lot of sense as far as instinct, habits and needs for all his creative work were concerned. The rejection of the 'modern' fits into the pattern of solitariness identifiable from Gilchrist's and Malkin's accounts of Blake's early years, especially taking into account the reaction to the destruction of the 'harmony' of Basire's workshop that led to Blake's being sent out to Westminster Abbey, where he was 'shut up alone' to make drawings.[152] The time he spent 'in dream and imaginative reverie', his fondness for 'roving out into the country' on his own[153] – the essence of which is caught in the opening line of a *Song* he wrote before he was fourteen, 'How sweet I roam'd from field to field', and in the *Frontispiece* to *Songs of Innocence* (fig.7) – and even the description of him by the auctioneer from whom he bought his prints as 'his little connoisseur'[154] signal a uniqueness, almost eccentricity, that set him apart from others. Nor should we forget the solitariness of sleep itself, the unbroken sleep of three days and nights that followed the death of his brother Robert in 1787[155] and his visionary dreams: the deported Robert, who showed him the method of relief etching subsequently used for the illuminated books[156] and with whom William continued to converse 'daily and hourly';[157] 'Joseph, the sacred Carpenter', who revealed the secret of diluted carpenters' glue as a binder for pigments;[158] and then the metaphorical 'three years slumber' at Felpham. Blake was to invoke John Milton on this in 1799: 'The Muse visits his Slumbers & awakes & governs his Song when Morn purples The East.'[159] The great leaps forward in Blake's art and imagery were, according to his accounts, conceived in solitude to the point where it seems that his first interest in real fresco, maybe informed by second-hand knowledge, was stimulated by dreams. Several instances of 'Myself alone' occur in Blake's own practice: the single figure among the rocks in Blake's own early *Joseph of Arimathea* (fig.1), the depiction of Los's energy on plate 6 of *Jerusalem and Elisha in the Chamber on the Wall* (B756, T unnumbered p.251).[160] Close to his workbench hung Dürer's *Melencolia I* (fig.9). Solitude is necessary for the working of the imagination: it was crucial to Blake's development, as his comparison between the 'confusion' of London and the relative tranquillity of Felpham that allowed him to recollect 'all my scatterd thoughts on Art & resumed my primitive & original ways of Execution in both painting & Engraving' makes clear.[161]

At the age of four he had a frightening vision of God appearing at his window[162] and then, 'when quite a child', he saw 'a tree filled with angels, bright angelic wings bespangling every bough like stars'.[163] It seems highly unlikely that Blake at this time would have been familiar with just this sort of imagery, which can be found in prints by

some of those engravers whom he later came so much to admire and emulate, but the incidents do link him, in the first place distantly, with the visionary imagination of Dürer: the God at the window who made Blake scream suggests now the image of Christ's head crowned with thorns pressed against the picture plane of the *St Veronica between St Peter and St Paul* of 1510[164] or the *Sudarium Displayed by Two Angels* of 1513.[165] Lucas van Leyden engraved the same subject.[166] The angel-filled tree brings to mind those seen in Dürer's *Flight into Egypt*.[167]

When Blake was apprenticed as an engraver in 1772 he became associated through his indentures with a London guild, the Stationers' Company, whose origins as 'the Mistery of Scriveners, Limners and Stacioners' dated back to the early 1400s.[168] This placed Blake in a tradition of scribes and illuminators of books, comparable to the one to be described below linking him as a painter with Giotto via the contact with Cennino Cennini. In so far as Blake was very consciously 'recovering' another medieval prototype, through his use of fresco and tempera, perhaps his purest work as a scribe as well as illuminator is his unfinished illustrated manuscript of the Bible. It consists of two alternative title-pages and the first four chapters of the Book of Genesis with some variants introduced by Blake (B828). With its gothic lettering and the carefully ruled lines, necessary to control the page format but also visible in some of the finest medieval illuminated books, it immediately suggests some familiarity on Blake's part with them (fig.10). There is no direct evidence to support the idea. Working for Basire, engraver to the Society of Antiquaries, might have given him access to the Society's library, in which could be found, for example, *The Psalter of Robert de Lindesey* of the early 1200s, which was given to the society in 1768.[169] Working in Westminster Abbey would have brought him close to the magnificent *Litlyngton Missal* of 1383–4, though it seems unlikely that the Dean and Chapter would have made it accessible to a young apprentice engraver. Illuminated books also appeared in London auction sales, which we know Blake attended; a *Book of Hours* of *c*.1325–30, for example, was sold in 1789 and a *Psalter* of *c*.1325–35 in 1794. These were both subsequently owned by Francis Douce, who also later owned two of Blake's illuminated books.[170]

While these links are introduced somewhat tentatively here, one detail found in medieval illuminated manuscripts, for which a parallel can be found in Blake's books, is the addition of portraits or self-portraits. Images that might legitimately be interpreted in this way include the figure of a piper in the *Frontispiece* to *Songs of Innocence* (fig.7) and the tiny piper leaning against the 'I' of 'Innocence' in that book's title-page, which also recalls a usage sometimes seen in initial letters in medieval books.[171] There is an allegorical

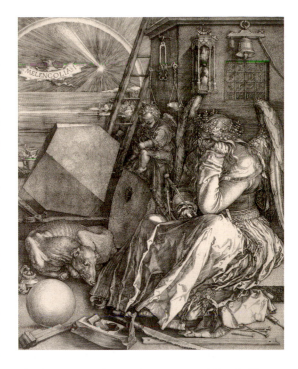

FIG.9 Albrecht Dürer, *Melencolia I* 1514. Second state, engraving, image size 24 x 18.8cm. The British Museum, London

FIG.10 *Adam and Eve in the Garden of Eden*, Leaf 6 (B828.6) from Illustrated Manuscript Copy of 'Genesis' *c.*1826–7.
Pencil and pen or brush and green ink on paper 38.2 x 28cm.
The Huntington Library, Art Collections, and Botanical Gardens, San Marino, California.
This example shows Blake using the same working techniques as his medieval predecessors.

self-portrait of Blake as Los in the *Frontispiece* to *Jerusalem*. The small spaces that he mostly worked in, the subject matter of his books and the use of the term 'illuminated' to describe them, especially with the *Genesis* manuscript in mind, invite comparisons between our own image of Blake and, for example, the portrait of the scribe Eadwine in the twelfth-century illuminated *Canterbury Psalter*,[172] the self-portrait of Simon Bening of 1558[173] and Andrea Pisano's relief of an artist painting a panel of *c.*1340,[174] none of them images that Blake would have known.

Blake's most important last work was his series of watercolour illustrations to Dante's *Divine Comedy*, and we might also cite that poet to reinforce the governing medieval prototypes we have already looked at. Blake wrote to Flaxman in 1800: 'And Now Begins a New life' (in Felpham).[175] This is a very distinct echo of the title given by Dante to his treatise on the writing of poetry, *La Vita Nuova*, written around 1295, which Flaxman would undoubtedly have recognised. The title can be translated in Blake's form from Dante's Latin 'Incipit Vita Nova' just as Blake's admirer D.G. Rossetti did in his translation of the work published in 1861: 'Here beginneth the new life.'[176] It signals a return to beginnings, in itself a fascinating insight into how Blake anticipated his years in Felpham being 'productive' and how we should view its outcome for him in eventual 'enlightenment'. In much the same way the new start that was the move to Lambeth in 1790 was rooted in Blake's looking ahead from the rewards that the newly invented illuminated books could bring him. This further link, rather like that forged by Cennini and Giotto, was one now perceived by Blake between himself as a poet and his medieval forbear Dante, the solitary visionary poet. As has been noted, this might be summed up in the words, 'To Justify the Ways of God to Men', but it is a path that inevitably took Blake back to another part of a beginning in art, since Dante knew Giotto and mentions him and his frescoes in the *Purgatory* of the *Divine Comedy*, and because Dante also painted. Dante wrote of 'the loneliness of mine own room' in which he had 'a marvellous vision',[177] and 'as I sat alone, I betook myself to draw the resemblance of an angel upon certain tablets'.[178] Blake, who wrote of 'trembling I sit day and night' at the beginning of *Jerusalem*,[179] can be compared too with Dante the poet who at the opening of the *Divine Comedy* writes of himself as a pilgrim with a fearful heart.

Blake was both an engraver and a painter. In his own time, though far more active in both fields than others, he was not unique: William Hogarth was a distinguished predecessor and Turner a distinguished contemporary. More to the point, Blake identified with earlier engraver-painters like Dürer, Lucas van Leyden and Heinrich Aldegrever.[180] The models they provided are fairly easily seen in his work and in what he said about them. Rather as he had once copied from Michelangelo, the figure of *Nebuchadnezzar*

(B301, T28, Tate) is derived from a detail in Dürer's engraving *The Penance of St John Chrysostom* of c.1496.[181] In the tempera *Sir Jeffery Chaucer . . .* of ?1808 (fig.103) the figure of the knight on horseback with his hound comes from Dürer's 1513 engraving *Knight, Death, and Devil*.[182]

As regards painting techniques, a pattern that fits in with other parts of Blake's chosen way can be discerned. By 1794–5 he might well have been aware through his friend George Cumberland of Cennino Cennini's (c.1370–c.1440) *Il Libro dell'Arte*, or *Book of Art*, written in c.1390.[183] Indeed, some of his techniques match Cennini's description, as will be discussed in the section on temperas. With Cennini tracing his artistic lineage straight back to Giotto,[184] Blake by the mid-1790s would have found confirmation of his place in the lineage that he had already allotted himself in the 1770s. If he was not aware of it in 1794–5, then we can detect the same sensation on his noting, on being given an 1821 Italian edition of Cennini by Linnell, that he 'was gratified to find that he had been using the same materials and methods in painting as Cennini describes'.[185] In 1808 Blake's resolve 'to print an account of my various Inventions in Art'[186] somewhat echoed Cennini's efforts. Blake's 'account' was never published though parts of what he had to say about them were undoubtedly included in his *Descriptive Catalogue* for his 1809 exhibition. This made great claims for how he had 'recovered' fresco painting and thus the 'Art'.[187] In March 1825, acting (so to speak) as a Giotto for the young artist George Richmond, he copied out chapter 6 from an 1821 Italian edition of Cennini's book: 'How you begin drawing on a little panel; and the system for it' (fig.11). Written in Richmond's sketchbook, not always accurately and with one instruction omitted, this may have been their first meeting. Richmond then working on his first tempera, *Abel the Shepherd* (fig.121) that was painted on wood. It was also to Richmond, who had come to Blake for advice on how to regain his powers of invention, that the advice to pray was given – as done by William and Catherine in the same circumstances[188] – inevitably recalling, for example, the prayers of dedication and praise to the Almighty, the Virgin Mary and several saints (including St Luke, the patron saint of painters) that open and close Cennini's book.

FIG.11 Blake's extract from *Il Libro dell'Arte*. Pencil on paper, from a leatherbound sketchbook of 1824–?6, 46.2 x 28.6cm. B828. Rosenbach Museum and Library, Philadelphia.

In the company of immortals?

When John Richardson referred to the presence of other masters standing behind him, he singled out the thought as an aspect of how the artist 'vainly pursued immortality by painting himself into the company of immortals'.[189] So completely did Blake identify with other masters that the possibility of a similarly vain pursuit on his part comes to mind: vain because, as it comes down to us, he seemed confident about his immortality. As early as 1784 he was encouraged to think in such terms by at least one artist who knew what he

was talking about: 'Mr Romney thinks his historical drawings rank with those of [Michael] Angelo.'[190] And for himself he said: '[I] am Convincd that either my understanding is incapable of comprehending the beauties of Colouring or the Pictures which I painted for You Are equal in Every part of the Art & superior in One [that is, colour] to anything that has been done since the age of Rafael.'[191] He could, with reference to himself as 'excluded', state: 'There cannot be more than two or three great Painters or Poets in any Age or Country.'[192] And R.H. Cromek for some time believed Blake's self-confidence and self-promotion, and 'so often' told him that 'his works were equal, nay superior, to a Raphael or to a Michael Angelo!'[193] Surprisingly though, Blake seems not to have done what Raphael himself did, as reported by Vasari, when as far as one aspect of his art was concerned he realised 'he should be forc't to come short of *Michael Angelo*'.[194]

What is consistently surprising about Blake's career, beliefs and ambitions is how the more we look, the more they seem rooted in a very distant past – the 'Beginning' to which he related his art. When Blake wrote, in response to Reynolds's doubts about the value of copying from art, 'What is Laying up materials but Copying',[195] the original notion was subtly re-worked to give it a dimension that embraces an enduring way of living. In fact, it becomes a copy of words and spirit – Paul's First Epistle to Timothy when he is charged with telling the 'rich in this world' about 'Laying up in store for themselves a good foundation against the time to come, that they may lay hold on eternal life'.[196] The *Genesis* manuscript shows Blake locating himself even further back in a biblical context, just as he does when he compares himself with the Old Testament seer Balaam, who was unable to 'go beyond the word of the LORD, to do either good or bad'.[197] It is a striking instance of Blake's allegiance to the power of the spoken and written word. When Blake was young, Ezra the scribe and Isaiah the prophet came to him,[198] and in *The Marriage of Heaven and Hell* he wrote of dining and talking with Isaiah and another prophet, Ezekiel.[199] He was, Palmer tells us, 'fond of' the works of the mystic and writer St Teresa (1515–82) and of other similar writers on the spiritual life,[200] while he stated that Fra Angelico (c.1400–55), a Dominican friar, preacher, painter and illuminator, was 'an inspired inventor and . . . a saint'.[201] It is tempting to see in all these allusions, compounded by his working in spaces that were suggestively cell-like or monastic, an element of self-conscious myth-making on Blake's part, comparable with the public performances turned in by some of his painter contemporaries: a 'copying' of the Gothic artist's acts – in writing and in art – seated alone in his room poring over the work that was central to his rejection of 'the windings of modern practice'. Such images would have been known to him through prints by Dürer – the *Jerome in his Study* or the *Erasmus*.[202] Blake's crouching or lying down next to one of the tomb effigies in Westminster Abbey in order to draw its vaulted canopy (B5) suggests in his own experience an early prototype for what was to follow in his later practice, and was caught in a truly Gothic perception of the saint and scribe at work in the small oil painting on panel, *St Jerome in his Study* by Antonello da Messina (active 1456–79; fig.12); Blake's words, 'Prayer is the Study of

Art / Praise is the Practise of Art / fasting &c. all relate to Art', suddenly come to life.[203]

So distinctive is Blake's unconventionality among artists of his own or any time that this view of him, which has played a significant part in ensuring his 'immortality', will probably prompt many readers and viewers to ask the same question about him that his biographer Alexander Gilchrist used as the title to one of his closing chapters – 'Mad or not Mad?'[204] A few during the artist's lifetime thought that his 'visions', the seeming incoherence of his writings and his eccentric behaviour were clear manifestations of madness. Following Blake's death in 1827, the idea gained a wider currency after an article published in 1833 claimed that he had been sent to Bedlam,[205] the London hospital for the insane. Hints about it started quite early, in 1785 with the allusions to extravagance in his pictures[206] and in 1796 when Joseph Farington talked with Blake's friend Henry Fuseli, noting that Blake's 'whole . . . aim is to produce singular odd shapes and combinations'

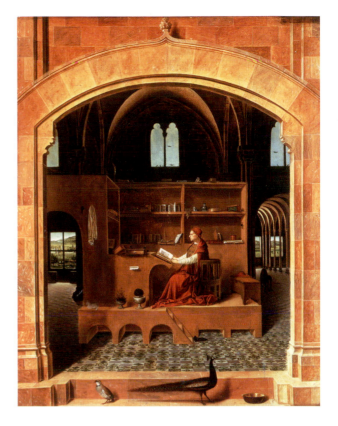

FIG. 12 Antonello da Messina, *Saint Jerome in his Study* c.1460–5. Oil on lime 45.7 × 36.2cm. National Gallery, London. St Jerome, a fourth-century saint, is frequently depicted in art as a bible scholar at work in his study. One of the fathers of the Church, he is shown here as a cardinal. The peacock in the foreground is a Christian symbol for immortality.

and that he 'has something of madness abt. him'.[207] Blake himself heard by 1809 that people had been told 'that my Works are but an unscientific and irregular Eccentricity, a Madman's scrawls'.[208] His sole public reviewer then, Robert Hunt, described him as an 'unfortunate lunatic', while Henry Crabb Robinson saw him as 'the insane poet painter & engraver',[209] and by 1811 the now almost completely forgotten poet Robert Southey 'held him for a decided madman', with *Jerusalem* a 'perfectly mad poem'.[210] Gilchrist, with the help of those who knew Blake well, successfully refuted the charge of madness, but in its context one central aspect of his work – his meticulousness – stands out. This careful approach must owe much to what his patron William Hayley identified in 1802 as a 'too apprehensive Spirit' with 'little Touches of *nervous Infirmity*';[211] Hayley also described Blake as an 'anxious, enthusiastic Engraver'.[212] Blake's response, 'you'll do', to Palmer's admission that he worked 'in fear and trembling'[213] was an admission of mutual feeling on Blake's part that is supported by an apprehensiveness discernible in his 1807 portrait by Phillips (see the frontispiece). At the same time it provides us with another more telling insight into these acknowledged fears: that quite simply this was rooted in the belief that the exercise of great care in his art was one sure way of pre-empting adverse criticism of art and mind.[214] Thus, 'he hated the bold, abrupt, off-hand style of drawing'[215] and so in his great enterprises painting on canvas and engraving on copper become 'Drawing' and 'nothing else'.[216] The certainty of that act eliminated the possibility of mistake, as he sought approbation in his own time and hoped for immortality thereafter.

The State of Knowledge on William Blake the Painter

BRONWYN ORMSBY AND JOYCE H. TOWNSEND
WITH BRIAN SINGER AND JOHN DEAN

Accounts of Blake's printing and painting techniques first appeared with J.T. Smith's book *Nollekens and his Times*, published in 1828.[1] Alexander Gilchrist's comprehensive biography of Blake's life was the first to include an elaboration of Blake's techniques, beyond the repetition of Smith's accounts.[2] Gilchrist included Frederick Tatham's accounts of Blake's methods, written as though from Tatham's observation. Tatham, however, was born in 1805[3] and was writing either from his own experience as an artist or from conversations with Blake and his widow Catherine.[4] Since then there has been a proliferation of biographies as well as an increasingly wide and varied range of scholarship on almost every aspect of Blake's life, art, spirituality and politics.[5]

To date, a number of publications by both Essick and Viscomi and others have been devoted to Blake's printing techniques,[6] which therefore were not included in this research. Only Lister has included information on Blake's tempera and watercolour techniques.[7]

Few scientific analyses of Blake's materials have been reported. Maheux analysed pigments from a number of watercolours, and reported that Prussian blue, gamboge, vermilion, madder lake, red lakes, red ochre mixed with the other reds, blue verditer and charcoal black had been used, but not bone black.[8] Vallance analysed gums[9] and proteins[10] in a preliminary study of Blake temperas at Tate, and a single analysis of the medium in *Lamech and his Two Wives* (B298, Robert Essick) has been published,[11] as summarised by Essick.[12] Karaya gum *Sterculia urens* or *Astragalus verus* gum (substituted for gum tragacanth and perhaps sold as such), but not gum arabic or tragacanth, was suggested as the most likely identification. According to Donnan's recent analyses, Blake used bone black, Prussian blue, natural ultramarine, vermilion, madder lake, yellow ochre and gamboge in his early illuminated books, while Prussian blue and gamboge were suggested for Blake's green mixture, and vermilion and gamboge for his orange mixture.[13] Earlier remarks, such as Lister's on his use in the colour prints of gold leaf, shell gold (gold leaf mixed with honey and ox gall and sold in mussel shells) and gold powder, mixed with honey before use, were based on practical experience.[14] This experience is of course

invaluable for the study of any artist's technique, as it shows which methods and materials could have worked in skilled hands, and eliminates some ideas which fail entirely in practice. It need not reveal all the methods an artist used, however.

Gilchrist wrote that Blake painted his temperas 'with a camel's-hair brush, not with a sable, which he disliked'.[15] Cohn quotes Lister's statement that his brushes were camel hair, a brush type more suited to single strokes than to broad washes, and points out that 'camel' brushes are in fact made from the tail hairs of Russian squirrel (*kolinski*), secured in a quill, which gives a round brush.[16] Maheux made the same suggestion, from practical experience.[17] This is virtually the only aspect of Blake's technique where all commentators are in agreement.

Smith described Blake at work on a tempera:

> Blake's modes of preparing his ground, and laying them over his panels for painting, mixing his colours, and manner of working, were those which he considered to have been practised by the earliest fresco-painters . . . His ground was a mixture of whiting and carpenter's glue, which he passed over several times in thin coatings: his colours he ground himself, and also united them with the same sort of glue, but in a much weaker state. He would, in the course of painting a picture, pass a very thin transparent wash of glue-water over the whole of the parts he had worked upon, and then proceed with his finishing.[18]

Carpenter's glue is animal glue, possibly in its purer form, gelatine. Tatham's account was similar:

> Blake painted on Panel or canvass covered with 3 or 4 layers of whitening & carpenters Glue [perhaps made from rabbit skin]; as he said the nature of Gum was to crack, for as he used several layers of colour to produce his depths, the Coats necessarily in the deepest parts became so thick, that they were likely to peel off.[19]

Gilchrist also described Blake's tempera technique and preferred palette:

> He ground and mixed his water-colours himself on a piece of statuary marble, after a method of his own, with common carpenter's glue diluted, which he had found out, as the early Italians had done before him, to be a good binder. Joseph, the sacred carpenter, had appeared in a vision and revealed *that* secret to him. The colours he used were few and simple: indigo, cobalt, gamboge, vermilion, Frankfort-black freely, ultramarine rarely, chrome not at all.[20]

Blake's patrons and followers John Linnell and Samuel Palmer described Blake's methods and aims in his late tempera painting from observation. Linnell wrote: 'The first copy of Cennino Cennini's book seen in England was the one I obtained from Italy, and gave to Blake, who soon made it out, and was gratified to find that he had been using the same materials and methods in painting as Cennini describes, particularly the carpenter's glue.'[21] There is a contrary view that Blake could have read a manuscript copy of Cennini's *Il Libro dell'Arte*, or *The Book of Art* [22] in the late 1790s,[23] just when he began to experiment with his 'frescoes', as discussed in the previous chapter.

Linnell wrote of the temperas, 'water-colour on a plaster ground (literally glue and whiting); but he always called it either fresco, gesso, or plaster . . . white was laid on and mixed with the colours which were tempered with common carpenter's glue.'[24] Palmer discussed 'Blake's white', made by mixing whiting with animal glue and used by implication only for temperas. He recreated it, and recorded that there was a trick in getting the glue proportion and strength right.[25] Palmer also described Blake's 'first inventive lines – from which he was always most careful not to depart' and wrote: 'At times Blake worked up and finished his drawing in either pencil or Indian ink, and left it at that, without proceeding to water-colour. But whether the preliminary drawing was left in its original form, or worked up into something more elaborately finished, Lister describes this decisiveness being evident time and time again and with very few exceptions – the first lines enduring, with little modification, through to the finished work.'[26]

It is also relevant that the development of commercial watercolour paints was beginning to expand when Blake was painting the bulk of his temperas. Lister described the commercial paints available to Blake: 'In those days it was more usual for water-colour painters to buy colours in powder form than in soluble cakes, although these had been invented by the firm of Reeves as long ago as about 1780, an invention that earned them a premium from the Society of Arts. By 1801 Ackermann was also marketing such cakes, and other firms followed.' Lister continued:

> Blake preferred to continue as he had begun, that is to grind his own colours from the powder. He probably found the soluble cakes too hard, for the invention of moist colours in pans did not occur until about 1832, when they were listed by Winsor and Newton. Before that it was often difficult to remove the colour from the cakes, and brushes were worked hard, and eventually worn, by the friction necessary for this. Another method of removing colour from a cake was to agitate it in a saucer of water; this was fine for producing tints, but generally unsuitable for rich colouring.[27]

Smith provided some insight when describing his experience of the (now lost) tempera, *The Last Judgment* (B648): 'The lights of this extraordinary performance, have the appearance of silver and gold; but upon Mrs. Blake's assuring me that there was no silver used, I found, upon a closer examination, that a blue wash had been passed over those parts of the gilding which receded, and the lights of the forward objects, which were also of gold, were heightened with a warm colour, to give the appearance of two metals.'[28]

However, the accounts of Blake at work state in every case that he created his paints from raw materials,[29] that he ground his pigments on a marble slab and that the binder was always either 'watercolour' or 'carpenter's glue'. Blake's colours appear to the eye of a conservator to be too transparent for a casein-based medium, and the presence of casein has not been confirmed by scientific analysis in the studies mentioned earlier. Interestingly, Blake referred to his frescoes as having been painted in 'watercolours', which is also stated in Linnell's description. This leads to confusion, as the use of the word 'watercolour' also refers to paints bound with plant gums, most commonly gum arabic.

Hence, it is not impossible that the multiple references to Blake's use of 'watercolours' may also include the use of gum, even though Tatham's account specifically mentions that Blake did not use gum because of its tendency to crack.

It is clear from the observations of numerous conservators that Blake also layered a material resembling animal glue between his colours and as a finishing layer prior to the application of a final varnish.[30] This seems to mirror Bindman's description of Blake's paint as having density, achieved by 'the use of a medium which holds several layers of colour separately in suspension'.[31] Smith further stated that 'Blake preferred mixing his colours with carpenter's glue, to gum, on account of the latter cracking in the sun, and becoming humid in moist weather.'[32]

Tatham concluded his account of Blake's tempera technique by observing that by washing 'his Picture over with glue in the manner of a Varnish, he fixed the Colours, and at last varnished with a white hard varnish of his own making'.[33] Here Blake was using a technique commonly practised by watercolourists in order to seal the paper, prior to the application of a spirit varnish. A lengthy version of this technique was described in a seventeenth-century treatise, as part of a process for mounting and varnishing a print, which involved applying six to eight coatings of spirit varnish, three times over, with a few days between each session for drying.[34] Smith also describes a similar method of finishing where Blake passed 'a very thin transparent wash of glue-water over the whole of the parts he had worked upon'[35] prior to the application of a spirit varnish.

While accounts of Blake varnishing his own works do not exist, evidence for Blake's use of spirit varnishes comes from letters written by his wife Catherine two years after his death. The letters both refer to the tempera of c.1825, *The Characters in Spenser's 'Faerie Queene'* (B811; Petworth House, National Trust, fig.112). In one she wrote: 'The Picture of Spenser's Fairy Queen has upon it 2 Coats of *white hard varnish*, it would be better for one more, but the weather being so chilly & damp it would not be safe to apply it now.'[36] In the other she commented: 'Any Artist or person accustomed to Pictures can apply a coat of white hard Varnish supposing the Weather be settled & Warm. Oil or any other varnish will inevitably turn the Picture yellow . . . But as the Picture having already had 2 Coats may not require another for 2 or 3 years.'[37]

There are fewer accounts of Blake's colour printing methods. D.G. Rossetti wrote of 'this perplexing quality of execution' and confessed that he could not understand how *Newton* had been produced: '[It] consists in great part of a rock covered with fossil substance or lichen of some kind, the treatment of which is as endlessly varied and intricate as a photograph from a piece of seaweed would be . . . I can conceive no mechanical process short of photography which is really capable of explaining it.'[38] He quoted Tatham, who was *not* quoting from observation:

> Blake, when he wanted to make his prints in oil, took a common thick millboard, and drew in some strong ink or colour his design upon it strong and thick. He then painted upon that in such oil colours and in such a state of fusion that they would blur well.

He painted roughly and quickly, so that no colour would have time to dry. He then took a print of that on paper, and this impression he coloured up in water-colours, re-painting his outline on the millboard when he wanted to take another print . . . he could vary slightly each impression; and each having a sort of accidental look, he could branch out so as to make each one different.[39]

Tatham added that the printing was done 'in a loose press from an outline sketched on paste-board; the oil colour was blotted on, which gave the sort of impression you will get by taking the impression of anything *wet*. There was a look of accident about this mode which he afterwards availed of, and tinted so as to bring out and favour what was there rather blurred.'[40]

Most other commentators such as Butlin imply or state that Blake used the large rolling press in his studio for the colour prints.[41] Practising printmakers have also tended to assume that the paper that was printed had to be made damp first in order to take the paint, regardless of the medium used.

Lister, himself a printmaker, illustrated a trestle table with slots which would have been convenient for such printing, but came down in favour of a metal plate, even a zinc one, on the grounds that millboard is too absorbent for the purpose. He also quotes a more complicated method used by Camille Pissarro as applicable to Blake studies; this involved painting a print, putting glass on top, re-creating it on the glass, transferring this to millboard or metal and then printing off it. Lister's trestle table suggestion rather implies that hand pressure or rubbing was sufficient to transfer paint to paper.[42] Bentley assumed that a copperplate was used for the colour prints:

> About 1794 Blake tried adding colours to the copperplates themselves, so that all the colours could be printed at once. The process was technically intricate, for the ink had to dry so slowly that the first colour applied was still wet when the last one was added, and the last one must not be so wet that it spread more than the first colour . . . The thick, sticky ink actually rose a little when the plate and paper were separated, leaving a granular surface rather like lichen, a surface which is brilliantly successful in conveying the texture of rock or moss.[43]

Essick supports the view that a millboard was much more practical for these large works.[44]

Lister noted that oil, as well as yellowing, sinking and being greatly disliked by Blake, does not give a 'bounding line', and hence would be an unlikely choice of medium. Gilchrist thought that a glue medium (only) would give the reticulated effect that Blake so obviously sought in his prints, according to Lister. He observed, too, that most of Blake's watercolours had a preliminary drawing, and were then either worked in pen and ink and left at this stage, or then coloured, the initial sketch being carried through to the completed work, after which he added highlights and retouches over the dried watercolour wash.[45] There is no mention of Blake varnishing his colour prints.

In short, Blake's paint medium for temperas and colour prints has not been investigated with great success. His medium for watercolours has not been investigated at all.

Analytical Methods

JOYCE H. TOWNSEND

An understanding of the materials and techniques used to create a tempera or watercolour can be achieved by a combination of simple but thorough observation, reinforced where necessary by more sophisticated analysis.[1] A *binocular microscope*, typically in the range of x 7–40 magnification, is used to assist visual examination in daylight or equivalent light. The angle of illumination through fibre-optic guides can be adjusted to create raking or diffuse lighting. At the lower magnification features barely evident to the naked eye become easier to observe: for instance, the texture of the support, pen-strokes where the ink ran out and the pen was re-dipped, cracks and their accumulated contents, and thick transparent layers that cause the colours on top to have an appearance of 'floating'. A delicately painted image that remains convincing in its depiction of detail even under closer inspection begins to unfold under the microscope. Most of the macro-photographs in this book were taken at x 7 or x 10. The application of light or heavy (during printing) pressure to flatten paper, the impression of a pen or a tool on paper, a graphite pencil mark running on top of the paper, slight unsteadiness of hand, the overlay of one colour on another and the handling and flow (known as rheological) properties of the wet paint become apparent as the magnification is zoomed up. At x 40 a few coarsely ground pigments can be distinguished from others that are always finely ground, but the sequence of paint application can no longer be grasped.

Technical photography is a useful non-destructive tool, and is brought into play next. Very strongly *raking light* creates intense shadows and exaggerates surface conformation. Many artists' materials exhibit *ultraviolet (UV) fluorescence*: that is, they emit visible light when illuminated with ultraviolet light. This can be photographed on conventional colour or black and white film. Paint media based on proteins fluoresce quite strongly and appear bluish white, whereas many oleoresinous media, such as oil paint and the mastic resin varnishes often used in the early nineteenth century, fluoresce far more strongly, and appear yellowish white or even greenish yellow. A few artists' pigments fluoresce so strongly under UV that they cannot be missed, hence simple UV examination can confirm

their absence: examples are madder and Indian yellow. If there is so little paint medium present that it can only fluoresce weakly, cobalt blue and lead white may sometimes be recognised by their fluorescence, and all earth colours by their very dark and dull appearance in UV. Illumination with a light source which provides infra-red light – and most do, causing the paint surface to be heated very slightly – can make it easier to see and photograph drawing in graphite pencil or ink, based on carbon black beneath the paint. This technique is called *infra-red reflectography*. Even in its more sophisticated forms, which involve a digital infrared camera, it cannot 'see through' paint which includes carbon black overlying drawing in a similar material; hence it cannot reveal whether Blake reinforced ink underdrawing for his temperas with black paint, for example.

X-radiography is used to reveal material that is opaque to X-rays. In the medical field X-rays are absorbed by bones and transmitted by most other body tissues. For painted artworks heavy metal pigments, by far the most abundant one being lead white, are X-ray absorbent and appear light on the X-radiograph regardless of the paint medium. Chalk is a low-density material that does not show at all on an X-radiograph. Gold can be seen if it has been applied as gold leaf, often less than one micrometre thick, over chalk. Gold applied over lead white would show too little contrast to 'read' on an X-radiograph.

Infra-red false colour photography (*IRFC*) requires a special photographic film sensitive to electromagnetic radiation both in the visible range (blue, green and red) and in the infra-red region.[2] The dyes developed in the film[3] and the colours reproduced do not correspond to the surface colour of the object. The basic principle of IRFC has been known since the early 1960s but older film presented difficulties in processing and reliability due to its much higher sensitivity to heat.[4] The IRFC image can emphasise differences in the infra-red reflectance of pigments, with many materials exhibiting a specific infra-red signature. The film enables us to distinguish clearly between certain pigments that may appear similar in normal light or when mixed with another colour. Identification of unknown pigments can be accomplished to a certain degree by using a chart of known authentic colours as a reference (figs.13, 14).[5] Identification is easier for historic pigments, because fewer were available for the artist to select. After Blake's era many more pigments became available to artists, and the technique is of limited use.

Prussian blue produces a very dark colour, copper blues and smalt appear a lighter blue and indigo and ultramarine have a characteristic deep red colour in IRFC. Prussian blue and indigo were both used widely in eighteenth- and nineteenth-century watercolours and often produce a similar colour in normal light, but are very clearly distinguished by this method. Vermilion appears a bright yellow in IRFC, red ochre a greyish yellow, while madder, carmine and alizarin are also yellow, and the red lake brazilwood (and possibly other pigments from similar sources) appears a darker orange-red colour. Yellows generally appear white, except for yellow ochre, which appears a dull grey. Blacks appear a darker colour than in normal light and all white pigments become transparent. Different types of watercolour medium do not seem to have an effect on the IRFC image. Similar

FIG.13 Almost the complete range of watercolour pigments available within Blake's lifetime, except for white ones, painted out in gum Arabic and photographed in visible light.

FIG.14 The same range of pigments photographed with IRFC (white pigments do not show up in IRFC).

colour results were obtained from the watercolours and the large colour prints. The ability to recognise Prussian blue and indigo, and therefore the blue in the mixed greens, was significant for the study of Blake's works.

The limitations of IRFC in pigment identification are many. There are many contributing factors to the exact colour in an IRFC image, such as the chosen developing process, the camera settings, the type of lighting and the filters used on the camera. It is necessary to be consistent with these factors when taking the photographs of the artworks and the pigment chart. In addition to this, it is difficult to obtain the complete range of pigments, especially historic, organic ones. This research was very restrained in drawing conclusions from the IRFC results alone. For the white and black pigments the technique was not at all useful, and for the other pigments it was found useful only to a limited extent. When many works were examined, however, it did reveal a great deal of information concerning the two blue pigments used repeatedly and often adjacently by Blake in his watercolours.

If this technique were used in conjunction with a *portable spectrophotometer*, which measures the reflectance of pigments throughout the visible spectrum, it would be possible to identify a wider range of blue pigments from Blake's era, for example ultramarine and indigo, and possibly some greens and yellows in addition. Such an instrument was not available when the IRFC studies were carried out, but it has considerable potential for examining watercolour paint non-destructively.

Raman spectroscopy is a technique whereby the sample is illuminated by a monochromatic beam of light, usually from a laser.[6] A small percentage of the incident light is inelastically scattered through interactions with vibrations of the sample molecules, and gains or loses a small amount of energy, when it is said to be Raman-shifted. It can be displayed as a spectrum, in effect a fingerprint for each pigment, allowing rapid identification through comparison with reference spectra.[7] The technique is non-destructive and is conducted *in situ*, with no need for sample preparation.[8] It provides excellent results on inorganic, mineral pigments but is not sensitive to plant-derived organic pigments like gamboge, and materials that have been used only sparingly.

The two methods of IRFC and Raman spectroscopy were most useful when employed in conjunction with each other.[9] In *The Penance of Jane Shore in St Paul's Church* (fig.15)

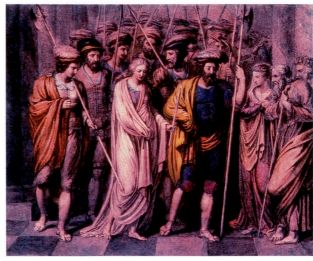

two types of blue are clearly visible in IRFC (fig.16) but not in normal light. The central male character in a blue garment and a red cloak was first painted in indigo and then had a layer of Prussian blue applied on top, apart from the areas over both knees. The IRFC image clearly displays the different pigments applied one on top of the other in the figure's deep blue clothes. The blue used in the almost white collars of the figures is also revealed as Prussian blue. The red outer garments in different shades are more clearly shown to be painted with different pigments in the IRFC image. An example of the presence of both types of blue in a late work is in *Dante and Virgil Approaching the Angel Who Guards the Entrance of Purgatory* (fig.31). Here IRFC (fig.17) reveals the use of two types of blue pigment adjacently in a single composition. The image also reveals the order of application, and gives a strong indication of the types of pigments used (Prussian blue and indigo), which was then confirmed by Raman spectroscopy, used also to identify a small area of red as vermilion.[10] In areas of flesh colour Raman spectroscopy implied that both vermilion and lead white were used (fig.18).

To obtain further information small samples can be taken for analysis, if the painting is in some way damaged. The maximum size of a sample is limited by the need for its removal to be invisible under all normal viewing conditions, and its minimum size depends on the use to which it is to be put. *Cross-sections* also provide sampling problems because a sample must be taken through more than one layer and remain coherent, though they do give the best overall view of how the work was constructed. The sample, varying in size from a pin-point to a pin-head, is placed on a block of transparent synthetic resin in a mould, and further resin is added to embed the sample. This is ground down carefully at right angles to the paint surface, until the sample is exposed edge-on. It is then polished, avoiding contact with water if it is feared that any layer might be water-sensitive, and viewed in reflected light under an *optical microscope* at x 100–500. Layers of varnish, paint and ground can be examined, and the interface between layers

indicates whether they were applied wet-in-wet or after a period of drying, according to its fuzzy or sharp appearance. *UV fluorescence microscopy* allows observation of the fluorescence of each layer. This helps to examine the distribution of organic components such as the medium and organic pigments. It adds further information but does not provide a definitive analysis. *Staining of the cross-section* with stains specific for proteins or oils further helps to distinguish the different layers. This technique is very useful for Blake temperas, but is inappropriate for Blake watercolours, which have no distinguishable layer structure.

Inorganic pigment analysis can be carried out with optical microscopy. A small sample is dispersed on a microscope slide in a liquid or resin of known refractive index, and is viewed in transmitted, plane-polarised light. Examining the *optical properties* of the inorganic pigments present allows a skilled and experienced microscopist to identify most of the commonly used pigments, even in quite complex mixtures. Virtually all historic pigments can be identified, because they were ground by hand and tend to have large particles with distinctive properties. The identity of pigments in a tiny fleck of paint, or in a layer within a cross-section, can be confirmed by analysing the elements that are present, and subsequently deducing which combination of pigments gave rise to the range of elements detected. Most *scanning electron microscopes* (*SEMs*) are equipped to carry out such analysis, which is known as *EDX, EDS* or *EDAX, energy-dispersive X-ray analysis*.

The *identification of paint media* can still provide a considerable challenge. Some of these components alter chemically on ageing, and some can interact with other materials found in traditional paint. As a consequence, the analysis of historic paint media may involve the recognition of compounds that were not even present in the freshly dried paint. Two approaches have been used for this problem: broad characterisation of chemical class, and initial separation of all the components so that the more abundant or more characteristic ones can be identified separately.

The technique known as *FTIR* (*Fourier transform infra-red spectroscopy*) is used for broad characterisation of chemical class. It works on the principle that particular chemical bonds absorb infra-red radiation of characteristic energy: the amount of infra-red energy transmitted at each wavelength then indicates whether and how strongly a bond has absorbed energy. This information can be used to work out the structure of a compound, or more usually, to compare its infra-red spectrum with that from known materials. The method can, for example, indicate that a drying oil, a protein-based material, a wax or a resin is present in paint, but not which ones.

Chromatographic methods of analysis work by separating and identifying the components of a usually complex mixture of polymeric organic materials, such as paint-binding media.

FIG.17 *Dante and Virgil Approaching the Angel who Guards the Entrance of Purgatory* 1824–7.
From *Illustrations to Dante's Divine Comedy.* Pencil, pen, ink and watercolour on paper 52.7 × 37.3cm. B812.78 Tate N03367. Photographed with IRFC

FIG.18 Raman spectrum of a modern sample of vermilion red. Recorded by Dr Katherine Brown.

There is a range of chromatographic techniques available where aspects of the sample preparation procedure, analytical conditions and instrumentation can be altered for the analysis of specific compounds. Some chromatographic techniques have been in use to analyse paints for about fifty years. In recent years a reduction in the required sample size for chromatographic techniques and an improvement in the sensitivity of the instrumentation have led to investigations into new techniques and fine tuning of sample preparation procedures for historic paints. All chromatographic techniques still require careful planning with regard to sample taking and analytical procedures, as well as sample and instrument preparation, since the potential for contamination with other materials is high. Even fingerprints left by someone who handled the painting, or poorly washed sample bottles, could lead to false results.

It remains almost impossible to analyse tiny amounts of additives to paint, however, except when very large samples are available – which is not possible in practice, except in rare cases, for example when studio materials survive. Their detection would give useful information, because the addition of just one per cent by weight of water, glue or egg can affect the way oil-based paint handles in practice, and whether it runs out to form a thin film or holds the brush-stroke to form thick impasto. Animal glue, egg and ox gall were often recommended as additives to watercolour paints in Blake's era (a point to be discussed when his use of materials for temperas is set in context), and their presence as minor constituents would go unnoticed in almost all analyses.

The two analytical techniques used for the identification of Blake's paint media include a combined technique called *gas-chromatography-mass spectrometry* (*GC-MS*), for the analysis of drying oils and plant gums such as Arabic, tragacanth, karaya and cherry, and

reverse-phase high performance liquid chromatography (RP-HPLC), for proteinaceous paint media such as egg, casein and animal glues. With each method the polymeric paint sample is first broken down chemically into its monomer units in a reaction called hydrolysis, and these are then reacted with another reagent that facilitates the retention of each monomer on the chromatographic column. For this study all the possible gum types available to Blake were prepared as reference samples, and a wide range of these gums from different sources was analysed,[11] in order to discover how much these materials vary naturally. The more common gums were mixed with individual pigments used by Blake, artificially aged with heat and light, and then re-analysed. This clarified the interpretation of Blake's 200-year-old paints.

For the GC-MS technique used for the analysis of plant gums,[12] the monomer mixture is made up of several monosaccharides (commonly known as sugars) such as arabinose and glucose. As the mixture enters the column, the monomers are carried along by the gas flowing through the column (mobile phase) and become separated over a distance of 30 metres by a series of interactions with the prepared inner surface of the column (stationary phase) and a slow, steady rise in temperature. The monomers eventually leave the column at different times, with the lowest molecular weight monomers passing through first, when they are detected and assigned a 'retention time'. The monomers are then passed through an electron beam that breaks them into even smaller components. Each plant gum in question will produce a unique fingerprint known as a mass spectrum, which can then be used to identify unknown gum samples by comparison. Candy sugar and then honey in the early nineteenth century[13] were often added to gum medium to reduce the drying out of watercolour blocks, as well as to reduce the cracking of the paint film; both can be analysed by the same means. This has already been done for some watercolour palettes contemporary to Blake's materials as part of the present study.[14] Glycerine is used today for the same purpose, but was not sought through analysis, since it was only introduced to commercial watercolours after Blake's death.[15]

Sample preparation for the RP-HPLC technique used for the analysis of proteins[16] similarly involves breaking down the polymeric protein sample into a range of constituent amino acids such as glycine and alanine. They are then reacted with a compound which renders the amino acids fluorescent in ultraviolet light for easier detection. Once inside the HPLC column, the monomers are eventually separated. Again, the identification of any unknown sample of protein is made by comparison with known standards.

The methods used to identify each pigment are summarised in Appendices 2, 4 and 6 and not noted repeatedly in the text. Noa Cahaner McManus worked with IRFC and interpreted the results of Raman spectroscopy carried out by Katherine Brown, while Joyce Townsend carried out the other pigment identifications. Gum analyses quoted in the text were made by GC-MS, and protein analyses by RP-HPLC, both by Bronwyn Ormsby. Any other analyses are described in the notes to each chapter.

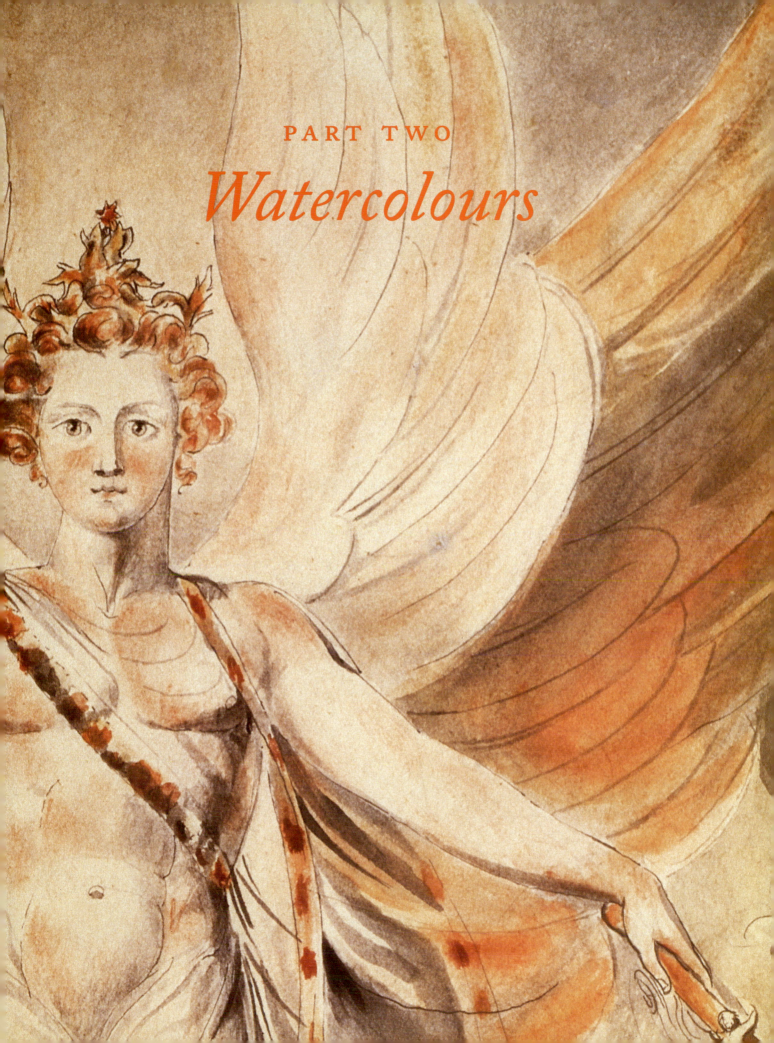

PART TWO

Watercolours

The Vivid Surface:
Blake's Use of Paper and Board

PETER BOWER

Several authors[1] have recorded information on Blake's paper usage, usually in the form of simple lists of watermarks, without discriminating between different papers that might have similar marks, and sometimes in quite idiosyncratic ways. Although there have been occasional misreadings of individual marks, these notes were of great use for this research.

Blake, unlike many of his contemporaries, travelled little, and certainly never left Britain, so the range of papers available to him was necessarily limited. Of the twenty-nine papermakers so far identified among Blake's *oeuvre* all of them, with one exception, regularly supplied the London stationery and colourmen's market. Nineteen operated mills in Kent, two in Hertfordshire, two in Hampshire, two in Surrey, one in Northamptonshire, and two papers carry London paper merchants' marks rather than papermakers' marks. The exception is the Dutch paper mill of Hattem, Guelderland, operated by the descendants of the French papermaker, Jean Villedary (watermarked IHS / VILLEDARY). Villedary paper, designed for printing engravings, was available in small amounts in London during the 1790s and was used by J.M.W. Turner and Thomas Girtin.[2]

Besides these watermarks there are several part marks and initials, including those made by Ann Blackwell at Nash Mills, Hertfordshire (watermarked A BLACKWELL / 1798) and those from the stationer and bookbinder in the Strand, William Dickie (watermarked W DICKIE / 1804), on papers that were used only for Blake's correspondence.

Some of Blake's papers can be identified as having come from the same batches of paper as sheets used by other British artists, such as John Constable, John Sell Cotman, Girtin and Turner. It is fascinating to see how different ways of working and different aspirations have led to such different results, even with the same media on the same paper.[3]

There were occasions when the paper Blake used was provided by his clients: Richard Edwards provided him with 900 sheets of paper, watermarked 1794 / J WHATMAN, for his illustrations to Edward Young's *Night Thoughts* (B330). The excess sheets were later used by Blake for his *Vala* or *The Four Zoas* (B337), and his designs for Thomas Gray's *Poems*. The biggest group of papers found in Blake's works in all media are the various

'Whatman' papers, but despite their watermarks these are not all from one source. For example, there are some forty different papers, several of which were used by Blake, watermarked 1794 / J WHATMAN, more if we consider variations in actual making between batches of papers, nominally of the same type. The type and size of the mould, the furnish used (that is, the combination of fibres) and its beating finish, pressing, the felts used (woven woollen blankets used to separate the newly formed sheets during wet pressing), sizing, weight and bulk vary considerably. Each change in any one of these parts of the process imparts a subtle difference to the character and behaviour of the sheet in use. Until 1794 Turkey Mill, outside Maidstone, Kent, was operated by James Whatman the younger. Upon his retirement in 1794 the mill passed to a partnership between his *protégé* William Balston and the Hollingworth Brothers, dissolved in 1805. Balston then moved to his newly built mill, Springfield, on the other side of Maidstone, and the Hollingworths continued to operate Turkey Mill. Both mills had the right to use the Whatman name in their watermarks. It is not yet possible to say with any certainty which of the two mills produced specific J WHATMAN papers between 1805 and 1808. After some confusion between the two companies the Hollingworths adopted the additional words TURKEY MILL or MILLS in their watermarks.

The physical evidence shows Blake using writing papers for his drawing and printing as well as for his correspondence The papers produced for writing were made by John Taylor and watermarked I TAYLOR. Writing papers and drawing cartridge papers came from Robert Edmeads and John Pine, watermarked with variants of E&P, EDMEADS & PINE / 1802 and IVY MILL / 1806; from James Whatman the younger, watermarked J WHATMAN; and from Whatman's successors, Balston and Hollingsworth, watermarked 1794 / J WHATMAN. *Songs of Innocence* copies P and Q include the watermark EDMEADS & PINE 1802, while the IVY watermark can be seen in *America a Prophecy*, copies C–E and G–K and R.[4] For Copy D of *Milton* (Library of Congress, Washington DC) Blake used an 1815 paper by Ruse and Turner,[5] while Whatman paper made by the Hollingworths is found in only plate 29 (one of three plates at Harvard University) of the *Songs Of Innocence and Of Experience*.[6]

Examination of the paper might solve a major question regarding the date of printing of the large colour prints. It may well be possible through further analysis of all the sheets used for these prints to determine whether they came from one batch of paper or from different ones. As yet this work has not been tackled, and all that can be said is that they appear to come from at least two and possibly three different batches of paper, one of which, *Newton* (fig.50), is watermarked 1804.

Blake's use of Kent papermakers is not surprising, since all these makers supplied the London market, but they were not the only papermakers to do so. The intense but generally friendly rivalry among the Kentish papermakers had a distinct effect in raising the quality of paper they produced, as well as contributing to some similarities in papers of the same types. The papermakers obtained their linen and cotton rags and animal

gelatine from many of the same sources, the beatermen and vat crews who produced each sheet of paper were trained in the same local traditions and methods of working, and produced a distinctive range of both plate (printmaking), watercolour and writing papers.

One must also distinguish between papers that, despite the similarity of their watermarks, were both designed and used by Blake for distinctly different purposes. Many artists leave little record of their thoughts on the papers they used. The only surviving evidence is the type and quality, or otherwise, of the sheets they chose to work on. Blake was particular in the choice of papers he worked on. In his Prospectus of 1793 he stated that he proposed to use only 'the most beautiful wove paper that could be procured'.[7] The watermarks found in this period suggest that he meant papers produced by Edmeads and Pine and James Whatman the second, at that date considered the foremost papermaker in England. Blake had long been familiar with the high quality of the paper made by Whatman at Turkey Mill: in the 1770s he had used their *Royal* (20 x 25in / 50 x 76cm) and *Writing Royal* (19 x 24in /48.3 x 61cm) laid writing papers, watermarked J WHATMAN + Fleur de Lys / Strasbourg Bend / GR, for the drawings he executed in Westminster Abbey (see pp.21–23). These were engraved and published under the name of James Basire,[8] for Gough's *Sepulchral Monuments of Great Britain* (1786) and Ayloffe's *Some Ancient Monuments in Westeminster* (1780).[9] Whatman produced several different sized *Royals* for different purposes during the 1770s, all around the 19–20 x 24–25in (50 x 76cm) size range. Understanding the nature and type of papers that Blake used is fundamental to an accurate understanding of his working practices.

As might be expected with Blake, his use of paper and board was not confined to the conventional. Tatham's (unreliable) account of Blake's colour printing, quoted earlier on p.43, mentions 'millboard', but in a later account Tatham wrote 'paste-board'.[10] These are two distinctly different materials, with different surfaces and strengths, and it may be that Tatham was using the word 'millboard' generically, as it is often used, covering a wide range of pasteless boards, pasteboards, scaleboards and other laminated cards and boards, as well as genuine millboards. 'Millboard' has a very specific meaning. A millboard is not a pasteboard, despite assertions by various researchers:[11] even when several plies of thick board are laminated together, no paste is used in the manufacture of true millboard. Most paste and laminated boards were made up by stationers and boardmakers, who bought in papers and stuck them together, but millboard was a product of the paper industry itself.

The name millboard comes from the method of manufacture, when the thick solid sheets are given a very hard surface by being 'milled' between heavy iron rollers. They were often made from fibre refuse, waste papers, leftover pulp in the vats, etc. By the beginning of the nineteenth century the better grades of millboard were produced from hemp and flax fibres only, derived from the same materials used for making strong brown wrapping papers, namely tarred ropes, old sacking and sailcloth. By using a deep deckle to retain the pulp on the papermaking mould and compressing the newly formed sheet with another mould prior to couching (transferring the wet sheet from the mould onto a woven woollen

blanket before pressing), thick, dense, rigid sheets could be made without using glue. Millboard was generally made unsized, but examples exist from the late eighteenth century onwards of boards that have had a light coating of animal gelatine (glue size) applied. Some of these examples have telltale marks of the brush showing that the size was applied by simply brushing the hot solution onto the surface. Other boards appear to have been sized by the more traditional method of submerging the board in a vat of size.

Pasteboards were simply made by pasting sheets of papers together to the required thickness and rigidity. By the end of the eighteenth century the pasteboards used by artists retailed under different trade names such as Bristol, London and Superfine Drawing boards, and were produced by many different makers. In the nineteenth century the choice was extended: one new product was Turnbull's Crayon Board, which will be discussed later (p.168) in the context of the display of Blake's watercolours. These boards were distinguished by the impression of blind-embossed marks in the corner, identifying the type and/or the maker of the board. They were made up using two, three, four, five, six, even eight sheets of the finest hot-pressed drawing paper, laminated together and then given varying degrees of glaze by being placed between two very smooth metal plates and passed through a set of glazing rolls. The finished board was then trimmed. Cheaper versions of these pasteboards were made from layers of coloured wrappings and were usually sold untrimmed and unstamped.

Millboards are perfectly capable of being used in the manner Tatham described. Their dense compacted surface was admirably suited to such activity: after all, primed or un-primed, they were the ground of choice for much late eighteenth-century and nineteenth-century *plein air* oil sketching. Pasteboards, however, would have been more problematic. Their effectiveness, after the first pull of a print, would depend to a great extent on firstly the nature of the glues used in their lamination, some of which could have delaminated relatively easily, and secondly the actual strength of their surfaces, since many such boards could not take a high degree of working without the surface beginning to break up.

Essick has described 'letters, or at least uncolored surfaces of the paper that look like fragments of letters printed in blind', visible towards the bottom right of *God Judging Adam* (B295, Metropolitan Museum of Art).[12] This is likely to be, as he suggests, a platemaker's mark, showing that the image had been printed from copper. The suggestion has also been made that these letters are part of a blind embossed stamp of the type used by paper merchants, and some mills, to identify their products. There are two main objections to this theory. While such stamps were becoming common in writing papers from the early 1790s onwards, their appearance in boards is very rare in English papermaking practice before *c*.1805 and is confined to pasteboards. Millboards were never stamped in this way. The other main objection lies in the structural difference between blind-embossed papermakers' or paper merchants' stamps and those used by platemakers. In the blind impressions made in paper or board the background is impressed, leaving any letters or devices raised, unlike the marks in copperplates where the letters are struck into the

FIG.19 *The Simoniac Pope* 1824–7. From *Illustrations to Dante's 'Divine Comedy'*. Pen and ink and watercolour on paper 52.7 x 36.8cm. B812.35 Tate N03357. A sheet from the Elgar Imperial folio where Blake has worked on the feltside.

metal. If a board stamp was inked the letters would show as printed ink, not the uncoloured surface seen in this work.

Late in his life Blake returned to 1790s Kent paper, bound into a large album, for his illustrations to Dante's *Divine Comedy* of 1824–7 (figs.19, 20). This was a hot-pressed, white, single-faced laid paper, watermarked W ELGAR / 1796 and an ornamented Fleur-de-lys / WE monogram, and made by William Elgar. Elgar was a banker from Maidstone who among his other interests operated Chafford Mill on the Medway, just outside the village of Fordcombe, near

Tonbridge, between *c*.1785 and 1802. The mill specialised in the production of fine writing papers although, as is evident from Blake's Dante illustrations and works by other artists including Turner at the same period,[13] the paper was very suitable for both drawing and watercolour. Much of Elgar's output came to London paper merchants and through them to those stationers and colourmen who liked his products. Bound notebooks, ledgers and larger 'albums' filled with his paper are commonly found.

The design of the fleur-de-lys watermark shows that the folio sheets were originally *Imperial* (nominally 22 x 30in / 56 x 75cm) and each full sheet contained both the fleur-de-lys watermark, centred in one half of the sheet, and the Elgar countermark centred in the other half of the sheet. The large folio book would have been bound in signatures of groups of sheets folded in half, giving runs of the watermark followed by a run of the countermark. These would not necessarily have been coherent as, even if each signature contained the same number of sheets, they would not necessarily have been folded together with the watermarks and countermarks aligned in the same direction. All that can accurately be said is that each full sheet would have one work (one page) worked on the wireside of the sheet and, because of the fold, the other half of the sheet (another page) worked on the feltside, if Blake had turned the page for each new watercolour. The illustrations for the *Divine Comedy* today measure 14½ by 20¾in (37 x 53cm) on average, so a narrow strip has been lost on all four sides of the whole sheet.

This paper was nearly thirty years old when Blake began working on John Linnell's commission to illustrate the *Divine Comedy*. Samuel Palmer described how Linnell and he called on Blake in 1824 and found him: 'Lame in bed, of a scalded foot (or leg). There, not unactive, though sixty-seven years old, but hard-working on a bed covered with books sat he up like one of the Antique patriarchs, or a dying Michael Angelo. Thus and there was he making in the leaves of a great book (folio) the sublimest designs from his (not superior) Dante.'[14] One of the characteristics of big heavy volumes, as this must have been, is that, once bound up and unused, the sheets are subjected to a slow and steady pressure over time, lessening the differences between the wire and feltside surfaces. This allowed Blake to work either side of the sheet with equal ease and at speed. All the Tate's *Divine Comedy* illustrations have a paint-free margin on the edge closest to the spine of the book,

FIG.21 (*left*) Fleur-de-lys / WE monogram watermark found in *The Simoniac Pope* (fig.19). Each full sheet of paper contains both a watermark and a countermark (see fig.22), each centred in one half of the sheet.

FIG.22 (*right*) The W ELGAR / 1796 countermark found in *The Pit of Disease: The Falsifiers* (fig.20). This countermark is centred in the other half of the sheet to the watermark (see fig.21).

or only a few dribbles of liquid paint, as further corroboration of the volume's thickness.

Where and how the mark meets the surface is an intimate realm where Blake was completely at home. His understanding was based both on his vision – in the two senses of the word (his eyesight, literally, was very good for close work as discussed earlier, p.24) – and on years of practical tactile experience of drawing, painting and printing. His vision was after all grounded in the practicalities of painting.

FIG.23 Closeup (inverted) of the felt-side of the sheet used for *The Simoniac Pope* (fig.19). Although the laid texture of the surface is visible it is not as crisp as the texture seen in the other side of the paper (fig.24). No wire impression of the letters in the counter-mark can be seen in this detail.

FIG.24 Closeup of the wireside of the sheet used for *The Pit of Disease: The Falsifiers* (fig.20). The laid wires are clearly visible as are the impressions of the wire used to form the watermark.

Watercolour Methods, and Materials Use in Context

NOA CAHANER McMANUS AND JOYCE H. TOWNSEND

Within the context of the 'great age' of British watercolour drawing, which is taken to begin around 1750,[1] Blake's watercolours are extraordinary in many aspects. Besides subject matter, the departure from his contemporaries is strongly displayed in his technique, which relates rather little to contemporary artists' manuals and prevailing approaches.

Watercolour wash technique was developed out of the tradition of tinted drawing as demonstrated by the works of seventeenth- and eighteenth-century artists including Alexander Cozens and Thomas Girtin. In tinted drawings a sketch was usually executed in a range of grey tones over a graphite or ink preliminary line drawing and then allowed to dry before pale washes of watercolour were applied locally. It was later to become more common to apply washes of pure colour directly onto the paper, to increase the contrast and create more dramatic colour transitions, a trend led by artists such as J.M.W. Turner, David Cox and others.

Artists' manuals were significant in the development of the watercolour technique but Blake was not a great follower of guidelines and trends. He developed his distinctive style and working methods, turning away from prevailing formulas. Adopting an individual approach, Blake increasingly worked more freely in colour washes, with strong line drawing. He is often considered to be more like a medieval than a post-Renaissance artist. His use of elementary colours, flat compositions, strong bounding contours, abstract structures and rejection of the representation of natural phenomena assert his conceptual world, as discussed in the Introduction (pp.12–16).[2] Furthermore, his subjects were rarely landscapes and he claimed to depend on visions for the imagery of his works.

Transformation is clearly evident in Blake's watercolour technique with the passing of the years, while certain features remain fairly consistent. By training and profession Blake was originally an engraver, and his printed work continued to play a significant part in his artistic output. His range of work expanded far beyond printing but the most obvious trace of it is the importance of line in the composition. His link with the

printing world continued, as many of the watercolours he executed over the years were originally commissioned to be reproduced as engravings.

It is possible to establish a general sequence for the execution of Blake's watercolours, consisting of preliminary drawing, basic tonal wash, colour application and outlines. In the following text the watercolours are categorised as 'early' works, referring to works executed between 1779 and 1793; 'mid-period' or 'later' works, executed before 1820; or 'late' works, for the watercolours produced between 1820 and 1827 and mainly referring to the illustrations to Dante's *Divine Comedy*.

Preliminary drawings appear to be the foundation for all the watercolours. Gilchrist referred to the importance Blake saw in preliminary lines and quotes him: 'First thoughts are best in art, second thoughts in other matters.'[3] The lines are usually done in graphite pencil, but occasionally in diluted ink or even light chalk lines, according to Lister,[4] who examined a range of the *Divine Comedy* watercolours among others. In some earlier Tate watercolours the preliminary outlines, usually in graphite pencil and occasionally black chalk and/or charcoal, remain clearly visible through the coloured washes, but heavier colouring and black ink outlines often fully or partially conceal them. In the *Divine Comedy* series of watercolours the preliminary drawing in both graphite pencil and charcoal, used at the same time rather than successively, remains particularly apparent because of the free nature of the lines, the less rigid relationship between outline and tonal areas and the often light watercolour application. Charcoal had a bad reputation for absorbing the colour from watercolour washes that touched it, especially if they included rose madder,[5] which may account for the fact that Blake used it mostly for lines and for shaded areas, but rarely painted over it, as can be seen in *Cerberus* (fig.25).

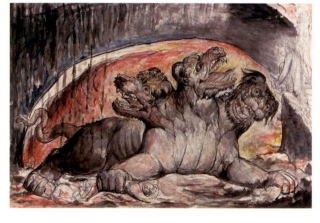

FIG.25 *Cerberus* 1824–7. From *Illustrations to Dante's Divine Comedy*. Pencil, pen and ink and watercolour on paper 37.2 x 52.8cm. B812.12, T134; Tate N03354

Establishing the composition by means of a monochrome base of grey tones applied prior to the other colours is common in many of Blake's watercolours, especially the early ones. Following the preliminary drawing with a monochrome base was a common practice at that time. Blake adopted the procedure but used it in a distinctive fashion, often adding only minimal colour over the grey tones or working in grey monochrome only, a technique that is termed 'tinted drawing'. Between about 1785 and 1789 Blake produced a set of twelve monochromatic illustrations to accompany his early poem *Tiriel* (B198), using black ink and grey washes only. Blake returned to the 'tinted drawing' technique much later in a sub-group within the large series of biblical watercolours (painted for Thomas Butts between 1800 and 1805), which share a near-monochromatic grey colouring. In another series of watercolours from this period yellow and orange pigments were added locally alongside the grey washes, for example to *David Delivered Out of Many Waters: 'He Rode upon the Cherubim'* (fig.26).

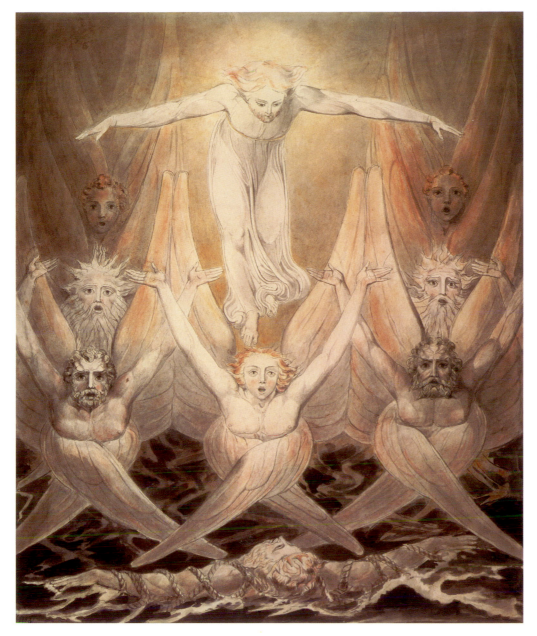

FIG.26 *David Delivered Out of Many Waters: 'He Rode upon the Cherubim'* c.1805. Pen and ink and watercolour on paper 41.5 x 34.8cm. B462, T41 Tate N02230

While many artists of the late eighteenth century changed to using 'neutral tint' for the grey base tones of their watercolour drawings, Blake generally remained faithful to ink diluted to varying grey tones, as noted by others.[6] In several cases the monochrome base was achieved with earth colours, as can be seen in *An Allegory of the Bible* (fig.27). The visible effect of this method is reduced intensity of colour of the brighter pigments applied over the monochrome base colour: they appear duller than when brushed over bare paper. 'Neutral tint' is an optical grey made by mixing blue, red and sometimes other pigments, popular mixtures in Blake's era being Smith's grey (lake, yellow ochre and Prussian blue) and Payne's grey (lake, raw sienna and indigo),[7] and these colours were widely used both

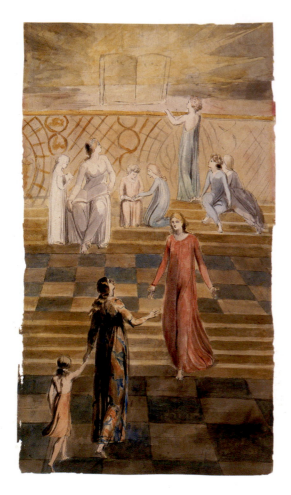

FIG.27 *An Allegory of the Bible c.*1780–5. Pencil, pen and ink and watercolour on paper 61.5 x 34.9cm. B127, T3 Tate T01128

self-prepared and ready-made.[8] The pink colour that some of Blake's greys have in IRFC may well indicate indigo as a component, even when it is too badly faded to appear very blue today. In the late works Blake seems to have abandoned to a large extent the practice of creating a grey base, and he applied pure colour directly onto the paper support.

Blake worked his watercolour surfaces with different applications that range between thin broad washes and small visible brushstrokes, employing both opacity and transparency. In the early works local colouring of heavier watercolour, which would often produce fairly opaque surfaces, generally followed the initial broad washes except for small areas reserved to depict light-coloured areas such as flesh. In these works the brushstrokes are fairly subtle, with limited superimposing of colours, creating surfaces that are generally uniform or otherwise carefully graduated, with clearly defined transitions between colour areas. As well as having particularly visible brushwork, in his later watercolours Blake seems to have been less restricting of colour to form, freer with overlying pigment washes and to have a greater preference for leaving exposed paper. His working process and sequence is largely revealed in these works, since the preliminary drawing is particularly visible through the thin washes, and the superimposed brushstrokes are perceptible. The brushwork is a combination of broad wet washes and 'dry brush' work.

The juxtaposition or overlaying of pure (bound) pigments directly onto the paper support in preference to mixing them on the palette is characteristic throughout Blake's work. Mixing of different pigments by overlaying paint using a brush had to be carried out in a calculated manner to create a new tone without re-dissolving the paint beneath. One option was to wait between applications so that the bottom colour dried before the next was brushed on, and another was to use a very dry application over the top. Both types of applications are mostly evident in the late works, particularly in the *Divine Comedy* series of 1824–7 where in order to darken areas of the sky, for example, one type of blue has been brushed over another, and black was then brushed over both, as in *Homer and the Ancient Poets* (fig.28). In a similar technique grey tones superimposed over a colour wash were employed for shading or modelling of figures, as for example in *Dante and Virgil Penetrating the Forest* (fig.34) and *The Inscription over the Gate* (fig.29). Optical greens were often achieved in a similar way by bringing together blue and yellow pigments directly onto the sheet of paper rather than mixing them on the palette. This practice is not unusual and is particularly discernible under magnification by the uneven colour of the surface.

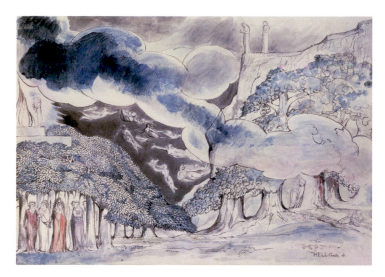

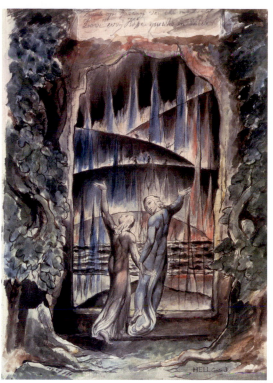

FIG.28 *Homer and the Ancient Poets* 1824–7. From *Illustrations to Dante's 'Divine Comedy'*. Pencil, pen and ink and watercolour on paper 37.1 × 52.8cm. B812.8, T133 Tate N03353

FIG.29 *The Inscription over the Gate* 1824–7, From *Illustrations to Dante's 'Divine Comedy'*. Chalk, pencil, pen and ink and watercolour on paper 52.7 × 37.4cm. B812.4, T132 Tate N03352

Blake strongly disliked *chiaroscuro* and expressed his rejection of light-and-shadow contrast: 'All the dawbed black & yellow shadows that are found in most fine ay & the finest pictures. I altogether reject as ruinous to Effect tho Connoisseurs may think otherwise.'[9] He did, however, give attention to modelling throughout the years to varying degrees. Figures were often modelled either by modifying the strength and level of dilution of the preliminary grey tonal washes, or by superimposing grey brushstrokes over colour areas. In several more elaborately worked watercolours from the *Divine Comedy* series Blake produced figures with truly sculptural quality by using small brushstrokes of red, blue and black. This was carried out with great care not to mix but rather to lay the pigments side-by-side in small brushstrokes, creating a speckled surface that continues to incorporate the paper tone, as can be seen in *The Serpent Attacking Buoso Donati* (fig.30). Rough modelling or no attempt to achieve any sculpting of figures is observed in the more sketchy watercolours such as *Dante and Virgil Approaching the Angel Who Guards the Entrance of Purgatory* (fig.31).

Blake utilised the paper support as a colour in itself more noticeably in his later works. In the early works he was more inclined to use broad washes that cover the entire support, whereas later larger areas were either thinly washed or left bare. In the *Divine Comedy* series Blake was leaving greater gaps than before between washes and opaque brushstrokes: in the most extreme cases this is due to the work being in an unfinished state.

Exploiting the paper tone in the colour composition is an artistic device that was developed by watercolour artists and played a significant role in their technique. The

FIG.30 *The Serpent Attacking Buoso Donati* 1824–7. From *Illustrations to Dante's 'Divine Comedy'.* Pen and ink and watercolour on paper 37.2. x 52.7cm. B812.53, T141 Tate N03361

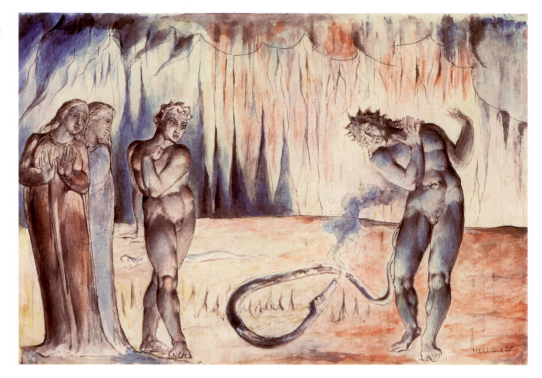

transparency of the watercolour allows special colour effects to be achieved that were often employed for naturalistic appearance. Avoiding naturalistic depiction, Blake utilised the opaque and transparent qualities of watercolours on paper in a manner different from his contemporaries. Another way of revealing the colour of the support is by scratching or rubbing off watercolour washes to create highlights. Turner, for example, used engraving needles for single scratches and engraving rockers to make parallel scratches; he blotted off washes or partly lifted them off again with water; he left fingerprints as he manipulated the paint with his fingers; and he rubbed out paint with stale bread of varying degrees of age and hardness, as well as using the unmodified support as a white and adding the occasional highlight in chalk.[10] Blake avoided all these methods, which might have seemed to him to be evidence of indecision or second thoughts.

Being a significant element in most of Blake's compositions, the preliminary lines were usually reinforced and reworked with black ink subsequent to colour application. Apart from providing the outline for basic forms, ink lines were also drawn through coloured areas, following the direction of the brushstroke or emphasising the folds of drapery and so on. This type of line drawing is most evident in some of the late works, for example in *Dante and Virgil Penetrating the Forest* (fig.34). The work sequence is evident in the order of application of the black ink lines, the strongest lines generally having been applied over the colours as a final stage of the drawing.

Blake often omitted the ink line altogether in his last series of watercolours, in the works considered 'unfinished' but possibly purposefully left this way. In other works of the series

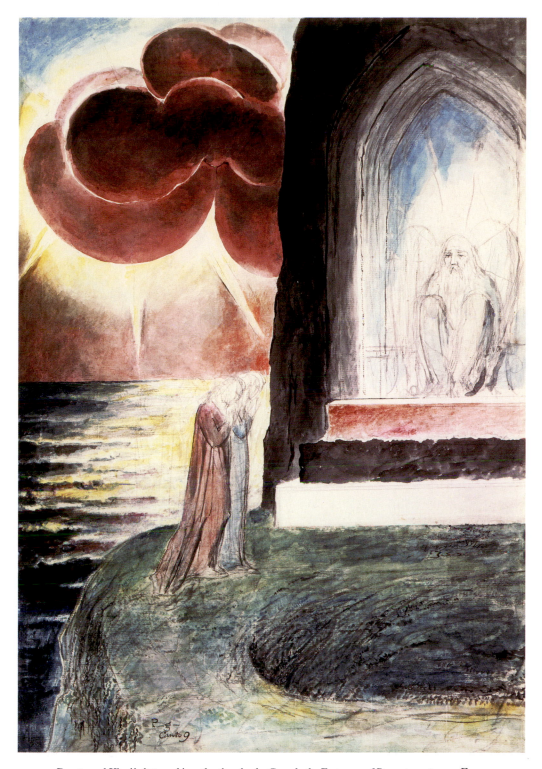

FIG.31 *Dante and Virgil Approaching the Angel who Guards the Entrance of Purgatory* 1824–7. From *Illustrations to Dante's 'Divine Comedy'*. Pencil, pen and ink and watercolour on paper 52.7 × 37.3cm. B812.78, T146 Tate N03367

the black lines are prominent, irregular in their width, thicker and darker than previously. The *Divine Comedy* illustrations were originally commissioned to be published as engravings, although only seven images reached the stage of being engraved for printing. In their shape and boldness the lines on some of the watercolours in this series could be seen to resemble the printed lines of relief etching, but the freedom of line and variation in thickness and intensity are also clearly characteristic of Blake's brushwork. The printed and directly applied colour and line are continuously linked together in Blake's graphic work, parting and meeting as he moved between the two artistic techniques interchangeably. Gilchrist quoted Blake as asserting 'all really great works were in watercolour'.[11]

The pigments found in a number of Tate watercolours produced at various periods of Blake's life were: carbon black (both in ink and watercolour washes); Prussian blue; blue indigo used both alone and in optical greens; vermilion red, alone and lightened with either chalk or lead white for flesh tones; browner red brazilwood; yellow gamboge used both alone and mixed with blue for optical greens; and yellow, brown and occasionally red ochres. Less frequently, a pigment resembling blue verditer was seen in the earlier works, where sap green may also have been used, and chrome yellow and a second red lake (neither brazilwood nor madder) were seen in the *Divine Comedy* series. These pigments will now be described in more detail, with a focus on their appearance in Blake's works, their properties, permanence and the likelihood of their use in his time.

Blue is a prominent colour in Blake's watercolours along with black and grey tints. Prussian blue and indigo were used simultaneously, in most cases unmixed and occasionally overlaid with black-grey washes. Both pigments were applied in broad background areas as well as more defined elements such as garments and foliage. In some late works such as *The Serpent Attacking Buoso Donati* blue appeared alongside red and grey for flesh tones. Both Prussian blue and indigo are mentioned in pigment lists compiled by Blake's contemporaries: John Varley in 1816,[12] who also used cobalt blue, and Girtin,[13] who also used ultramarine. These pigments were also employed by Turner, one of the few watercolourists whose materials have been analysed in detail.[14] Prussian blue was the dominant blue pigment in Blake's watercolours from the start. It has been suggested that Blake referred to this pigment in a phrase that appears on Plate 65 of *Jerusalem*, where he wrote: 'They staind him with poisonous blue, they inwove him in cruel roots . . .'[15] Initially it was suspected he was referring to woad, but the mention of the word 'poisonous' turned the interpretation towards Prussian blue.[16] It was used in thin (transparent) washes producing a uniform light blue colour or in heavier brush applications yielding a variety of hues. Prussian blue was already popular in the second half of the eighteenth century and widely distributed as powder pigment or dry cakes.[17]

Indigo was also easily available at that period, imported in large amounts from India and Bengal, and was particularly recommended for use in watercolours.[18] It had a bad reputation for fading inconsistently, though its resistance to fading is pretty good for an organic pigment.[19] Indigo appears quite extensively in Blake's watercolours and it seems that he

was using the two pigments interchangeably, especially for achieving dark blue areas. Indigo was possibly employed in fewer instances but seems to have been preferred for optical greens. Indigo generally has a lower covering power than Prussian blue and their working properties also differ, Prussian blue being very difficult to grind and mix with a water-based binder.[20] Both, however, can produce a deep dark tone when applied thickly.

Cobalt blue occurs in Gilchrist's list of Blake's pigments but has not been identified here. It was discovered in 1802 and was used by Turner in 1805–10,[21] but it was costly and therefore if used by Blake it was probably only in rare cases. Another pigment from that list which has not been discovered in the watercolours is ultramarine, which became available in its relatively inexpensive artificial form only after 1827–8, after Blake's lifetime. Natural ultramarine could have been purchased in London throughout his lifetime, but was very costly. He seems to have reserved it for the temperas, to be discussed later. In Maheux's earlier research blue verditer, an artificial copper blue pigment, was identified in a mixture with yellow.[22] In Blake's period blue verditer was considered an inexpensive substitute for ultramarine, but its blue colour was rarely satisfying on its own, whereas it gave an acceptable optical green.

The Pit of Disease: The Falsifiers (fig.20) employs Blake's entire palette with superimposed pigment washes. Examination reveals the sequence of colour application, especially in the dark sky area where it becomes clear that indigo was applied first and was then followed with black and almost opaque Prussian blue, except for a narrow strip along the top, and a small amount of red. Both blues were used elsewhere in the composition: indigo for Virgil's costume and Prussian blue in the landscape. In other watercolours in the *Divine Comedy* series, *Dante and Virgil Penetrating the Forest* for example, Virgil's costume was painted in Prussian blue.

Two types of red pigment have been identified: vermilion and a red lake. They were used together (beside each other but not mixed) in many of the watercolours. In the early *Penance of Jane Shore in St Paul's Church* (fig.15) vermilion was used for the central figure's garment and red lake for the far left figure's garment. As with the other colours in this work and the other early watercolours, each pigment is confined within distinct outlines. In natural light the visible difference between the two reds is not always great when they are applied as a thin wash, but IRFC clearly distinguishes between the two types of pigment in *The Pit of Disease: The Falsifiers*. In the *Divine Comedy* series either one or both pigments were used in most works, alongside each other or superimposed but not mixed on the palette. For Dante's costume, always depicted in red, Blake alternated between red lake and vermilion. In *The Pit of Disease: The Falsifiers* both red pigments were used together to depict the red flames of hell in the centre of the composition. Dante's costume was painted with red lake and the landscape includes thin washes of vermilion. Vermilion produces a solid bright red colour whereas the red lake is more transparent and tends towards a dark/deep-pink tone. In some works only one type of red was used and in others both pigments were used, usually for different parts of the composition and only

occasionally applied adjacently (in late works). Red lakes have very different working properties to vermilion, and the two types were rarely combined in watercolour painting.[23] Vermilion was applied as a very thin wash for flesh tones in a number of watercolours and more frequently in a thicker (opaque) layer over small areas such as garments and decorative patterns, as in *Age Teaching Youth* (fig.32), and in landscape/background as the flames of hell in the *Divine Comedy* illustrations. Being commercially available

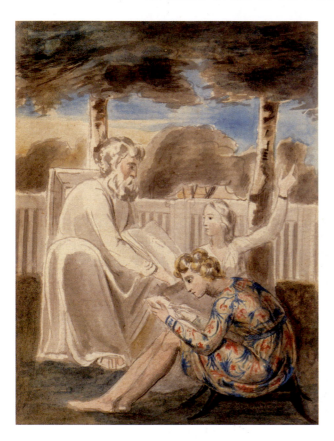

as well as having good properties for the watercolour artist – that is excellent body and hiding power and good dispersion properties – vermilion was a common and likely choice for a bright red colour. The pigment was being produced in England but was increasingly imported (Dutch or Chinese vermilion) during the eighteenth century due to the reportedly poor quality of the English vermilion.[24]

Blake's second type of red was a red lake. Those used in England around Blake's time were Indian lake made from lac, carmine/cochineal manufactured locally, madder, brazilwood and safflower. The source of all these pigments was an organic material, either plant- or animal-based, in contrast to inorganic pigments made from mined or industrially made minerals. The reds produced from insects, such as cochineal and Indian lake, were generally much more expensive than the plant-based dyes such as madder or brazilwood.[25] Cochineal would have been a likely option for Blake, apart from its high price, stemming from the laborious harvesting of the insect. Brazilwood is a natural red dye

FIG.32 *Age Teaching Youth* c.1785–90. Pen and ink and watercolour on paper 10.8 x 8cm. B91, T8 Tate N05183

extracted from *Caesalpinia echinata*, a type of wood from the *Leguminosea* family, its main origin being Ceylon, Jamaica or Brazil. (In fact, the last country was so named for this major export, by its European discoverers.) The artist (or his colourman) would soak the powder and boil it with water often mixed with vinegar, then usually add alum and gum. The dye was used to make many red colours from rose to crimson.[26] The inferior quality and hence unpopularity of brazilwood-containing lakes has been suggested by its general absence in European paintings of the fifteenth to seventeenth centuries.[27] It has poor permanence and was not considered a high quality artists' pigment, belonging instead to the economy range.[28] Brazilwood does not appear in the artists' manuals of Blake's era, and there is no mention of its use in recommended pigment lists of the eighteenth and nineteenth centuries. However, it would have been a reasonable choice for Blake considering its low price and availability. It is the red used everywhere except the centre of *Dante and Virgil Approaching . . .* (fig.31). Its preparation with gum could account for its

rather medium-rich appearance. Safflower came into use only in the nineteenth century and produced a dull colour that does not correspond to the colours Blake used. Madder does not appear to be present in any of the watercolours examined in ultraviolet light (its fluorescence is unmistakable), nor cochineal in any examined with IRFC photography, which indicates that brazilwood is the best identification from this group for Blake's more commonly used red lake. The other one remains mysterious.

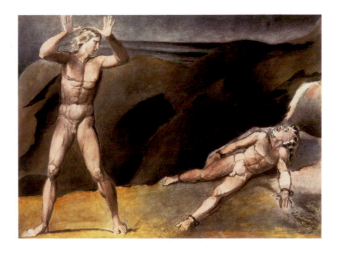

A third type of red pigment, strongly suspected to be red ochre, was found in only a few places – for example in the flesh tones in *Age Teaching Youth* (fig.32) and *Los and Orc* (fig.33). Ochre pigments were used in numerous works by Blake, yellow ochre in particular. Red ochre at that period would most likely have been prepared by calcining yellow ochre rather than by mining it directly from the earth.[29]

FIG.33 *Los and Orc* c.1792–3. Pen and ink and watercolour on paper 21.7 x 29.5cm. B255, T13 Tate T00547

It seems that two types of yellow were used in Blake's watercolours: yellow ochre and the organic pigment gamboge. Yellow ochre was found in *An Allegory of the Bible* (fig.27) and is present in other watercolours. It appears in Varley's and Girtin's recommended pigment list. Native ochres were regarded as reliable pigments and were easily obtained, but their usefulness for watercolours was debated among manual writers of Blake's period.[30] Other ochre pigments employed in Blake's watercolours are red (discussed above), brown and orange, all equally available to Blake and similarly useful and stable pigments. Brown ochre was produced in a wide range of tints, some appearing almost orange. *An Allegory of the Bible* has both yellow and brown ochre thinly brushed over broad areas, and in heavier lines in the top section of the image. Gamboge is mentioned in Gilchrist's list of Blake's pigments. It appeared on most pigment lists in artists' manuals and treatises even beyond 1850, and was easy to obtain and prepare for use: it is a natural gum resin imported from South-East Asia and was used widely, especially by watercolourists, in the eighteenth and nineteenth centuries, though its lightfastness is not high and by then it was known to fade on exposure to light.[31] When it is mixed with gum water, it can have a very glossy appearance and can form thick warm yellow layers as well as thin, pale ones. The former can be seen in the foreground of *Los and Orc*.

Blake's selection of colours included green but to a clearly limited extent, and mainly in the late *Divine Comedy* series. Like his contemporaries, Blake seems to have preferred an optical green, combining blue and yellow pigments either mixed on the palette or applied separately onto the support. This form of mixing is revealed by the irregularity of the green colour as well as by the blue or yellow edges that extend beyond the green areas, often visible only under magnification. IRFC photography suggests that indigo was used in most cases in mixed greens, along with a yellow component that was identified as

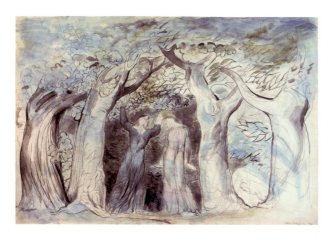

FIG.34 *Dante and Virgil Penetrating the Forest* 1824–7. From *Illustrations to Dante's 'Divine Comedy'* Pencil, pen and ink and watercolour on paper 37.1 x 52.7cm. B812.2, T131 Tate NO3351

gamboge in several watercolours. Maheux found the same mixture in the Blake watercolours she studied, and indigo is present in *Sir Jeffery Chaucer and the nine and twenty Pilgrims on their journey to Canterbury* (fig.103).[32] *Dante and Virgil Penetrating the Forest* (fig.34) provides an example of the extensive use of Prussian blue in the foliage, with indigo present only in the small areas of green foliage. The greens in these areas appear to have been mixed on the palette and applied as a thin wash in what seem to be arbitrary places within the 'forest'. Blake may have deliberately chosen to depict the forest in blue. Another explanation could be that a second blue-yellow mix consisting of Prussian blue and (another) non-lightfast yellow pigment was used and has faded, to such an extent that no traces of yellow can be seen under microscopical examination, but resulting in the general blue appearance of a large number of therefore faded watercolours in the series. In *Homer and the Ancient Poets* no green can be seen at all, but rather two types of blue pigment with no trace of yellow mixed with either one. Indigo was used in the cloud shape (applied thickly over Prussian blue) and the blue of the foliage was painted with Prussian blue. The leaves were coloured with tonal variation, while some were left with an outline only, which argues for this work being unfinished. Blake was working on the series during his last illness, sitting up in bed, and it is not known which of them, if any, constitutes his 'last work'.[33] It is possible that he had intended to apply yellow paint here.

An unidentified green in the garments of two of the back figures in *An Allegory of the Bible* is light and uniform and has a different appearance from the mixed greens of later works. It is not unlikely that it is a thin wash of an organic green pigment, which has not been observed in other watercolours. The small number of pure green pigments available for watercolourists of the eighteenth and early nineteenth centuries all presented great difficulties in use on account of their sensitivity to light and/or great transparency, for example organic sap green, whose popularity appears to have increased in the eighteenth century but declined again in the nineteenth.[34] Scheele's green and various other copper-based green pigments did not go unmentioned in artists' manuals, but each had disadvantages and limitations, being poisonous, detrimental to the paper support or just not having favourable handling properties. Therefore most ready-made greens were not favoured by watercolourists. Common mixtures in Blake's time were Prussian blue and gamboge (known as Hooker's green), or indigo and gamboge.[35]

Blake used black extensively and in a variety of forms in different stages of the production of each watercolour: in preparatory drawing and base tint (as discussed earlier), for shading and purely as a watercolour, as well as for final outlines. It seems that a carbon-based black watercolour pigment or ink, diluted to a varying tonal range, was used

for all these applications. Most of the black pigments available from 1750 to 1850 were composed of pure carbon, differing mainly in its source. The source of soot for making Blake's black pigment was probably burning wood or a similar substance. The 'Frankfort black' mentioned in Gilchrist's list is a black pigment used mainly for printer's ink and made by 'charring the lees of wine [grape stalks and husks] in close vessels'.[36] The alternative, optical greys, were described earlier.

The term 'Indian ink' refers to carbon black ink, which was prepared by mixing soot with a water-based medium such as gum or glue. The mixture was dried in stick form, then rubbed with water on a slab for use.[37] Gum water keeps the fine black particles in suspension and makes a more flowing ink than could water alone. In the present-day language of paint technology, the gum medium forms a 'protective colloid'. Shellac dissolved in borax (hydrated sodium borate)[38] was added to nineteenth-century Indian inks to reduce the water solubility of the dried ink. This reduced solubility would have allowed Blake to apply colour washes over the ink lines, or ink over water-based paint, if he so wished. Blake would have bought this type of ink ready-made. He would have chosen it because it is a more intense and non-fading black (see fig.68) than the ordinary iron gall writing ink of his era, which turns brown with age, and makes the paper so fragile that the inked portions may crumble to dust.

FIG.35 *Epitome of James Hervey's 'Meditations among the Tombs'* c.1820–5. Pen and ink and watercolour on paper 43.1 × 29.2cm. B770, T71 Tate N02231

Lead white was generally found in mixture with coloured pigments. There is also no evidence to suggest the widespread adulteration of Blake's pigments with chalk or the use of whiting as a preparation over the support. Most commercially prepared watercolour blocks analysed in this study (see p.141–4) did contain chalk and other materials to extend them. The general absence of chalk in Blake's watercolour paints is good evidence that he did indeed grind his own pigments, rather than purchase blocks of colour. Chalk is likely to be present in his flesh paint though, where it is obvious from ultraviolet examination that white lead was not the pigment mixed with vermilion for this purpose. Chalk was in fact identified in the flesh tones in *Los and Orc* (B225, T13, Tate).

Gold powder paint was found in only one of the watercolours studied, in the *Epitome of James Hervey's 'Meditations among the Tombs'*, c.1820–5 (fig.35). The gold was employed for Blake's signature, as well as in writing the name of all the figures, and in other features such as haloes and radiating rays, which are all thin streaks of gold. Gold was traditionally used for adding brilliance to the image in a number of manners, mainly in leaf

form. Powdered gold leaf mixed with honey and gums (or even egg) forms a paint that Blake would have applied with a fine brush, not a pen. The practice among manuscript illuminators and later watercolourists of using (oyster) shells as small, disposable palettes and containers gave the material its name, 'shell gold'.[39]

The binding medium in watercolour paints almost always consists of the sticky exudate from the bark of wounded shrubs or trees, such as *Acacia* species for gum Arabic, *Astralagus* species for gum tragacanth and *Prunus* species for cherry gum. These gums literally hold the pigment particles in suspension, forming the protective colloid mentioned above, while the paint film is drying via the evaporation of water, after which the resulting paint film essentially consists of uniformly dispersed pigments within the dried gum polymer. Within western watercolour painting practice, gum Arabic traditionally has the most suitable properties for a watercolour binder, because of its superior water-solubility and availability. Additives such as honey or candy sugar, and even animal glues, were also incorporated to alter the physical properties of the paints, such as flexibility and flow. Although there has not previously been any analytical evidence (but see below) to suggest that Blake used anything other than gum Arabic as a binder for his watercolours, there is a widely held belief that he employed a different substance for this purpose, perhaps the 'carpenter's glue' mentioned by Gilchrist. Previous research supports the idea that warm animal glue was used in the more elaborate watercolour paintings, as part of Blake's technique of overlaying colours.[40]

This recent analysis has consistently revealed in Blake's tempera paints, as well as in two of his large colour prints, the presence of both animal glue and a mixture of gums Arabic or karaya and tragacanth, with the addition of candy sugar or honey as a plasticiser and humectant.[41] In the temperas, or 'frescoes', the animal glue appears to have been used both as a paint medium, particularly for the priming layer and final glazes, and as an intermediate layer between applications of paint in order to 'seal' or protect the underlying colours from 'wetting up' or dissolving upon the next application of paint, as well as for a final coating in preparation for the application of a spirit varnish. The gum mixture, consistently used throughout the 1799–1826 period, was primarily employed as a binder for the pigmented paints, and possibly for the priming of these works. Blake appears to have deliberately mixed these gums in varying proportions to alter the properties of his paints. For example, the inclusion of gum tragacanth would add greater body and adhesion, as well as decrease water-solubility, and the occasional addition of cherry gum possibly increased the clarity and hardness of his paint layers, helping to create the 'enamel-like' effect he was striving to achieve. It is therefore probable that Blake used the same combination of gums and animal glue in his watercolour paintings, the materials being to hand, which would account for the increased body of some of Blake's watercolour paints, notably the yellows.

The range of colours that Blake applied to paper was in fact wide, and in comparison to those of his contemporaries, the works would have seemed bold and assertive. The

fortunately well-preserved *Beatrice Addressing Dante from the Car* (fig.36) still does, to an audience well used to intense colours. It includes the greatest number of pigments of any *Divine Comedy* sheets examined during this research, and there is no evidence for fading.

There is all too obvious evidence for faded indigo in the *Divine Comedy* sheets, *The Devils, with Dante and Virgil by the Side of the Pool* (B812.40, T138, Tate) and *The Hypocrites with Caiaphas* (fig.37), when the edges that have been protected by a mount are examined. The red lake, probably brazilwood, in the former work has also lost colour, and the (unidentified) yellow looks too green-toned for the gamboge used in the other sheets. Faded red lakes were noted in *Homer and the Ancient Poets* (fig.28, B812.8, T133, Tate), *The Ascent of the Mountain of Purgatory* (B812.74, T145, Tate) and *The Laborious Passage along the Rocks* (B812.46, T140, Tate), and all have the colour now that one associates with brazilwood. (This pigment was difficult to identify even when it was unchanged. Analysis of a discoloured and chemically altered material is even less certain without a genuine piece that can be painted out and sacrificed for experimental purposes.) Gamboge does not show obvious fading in the *Divine Comedy* series – mostly because it does not always extend to the edge of the support where a comparison with unfaded material would be possible. There is no rational basis at present for deciding whether Blake applied a thin wash of gamboge that has survived or a more intense one that has lost colour.

Nor have the other watercolours survived unaltered. The *Epitome of James Hervey's 'Meditations Among the Tombs'* (fig.35) has lost some of the blue indigo component from optical greens, but some or all of the (unidentified) yellow has survived. The earlier works have on occasion faded too: *An Allegory of the Bible*, c.1780–5 (fig.27), has lost red lake from the background to the arched screen in the middle portion and its appearance is now dramatically changed, with the unaltered pattern of the foreground dominating. Blue is probably gone from *The Four and Twenty Elders Casting their Crowns*, c.1803–5 (B515, T51, Tate), certainly gone from *The Crucifixion: 'Behold thy Mother'* (fig.38) and *David Delivered Out of Many Waters*, c.1805 (fig.26), and its disappearance from *Satan in his Original Glory* of 1805 (fig.39) is complete, as previously noted by Butlin.[42] All four works

FIG.36 *Beatrice Addressing Dante from the Car* 1824–7. From *Illustrations to Dante's 'Divine Comedy'* Pen and ink and watercolour on paper 37.2 × 52.7cm. B812.88, T148 Tate N03369

FIG.37 *The Hypocrites with Caiaphas* 1824–7. From *Illustrations to Dante's 'Divine Comedy'* Pencil, pen and ink and watercolour on paper 37.3 × 52.7cm. B812.44, T139 Tate N03359

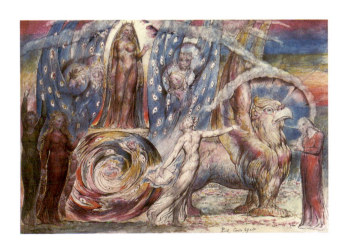

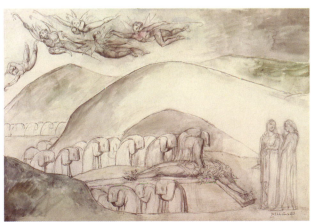

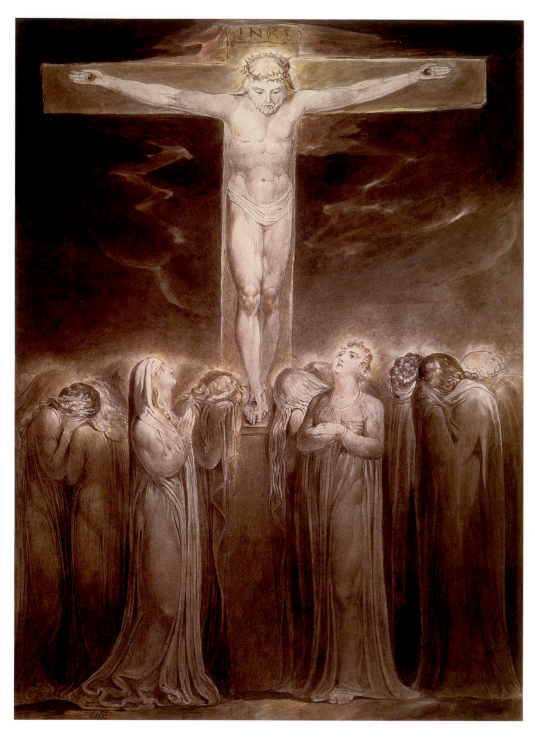

FIG.38 *The Crucifixion: 'Behold Thy Mother' c.*1805. Pen and ink and watercolour on paper 41.3 x 30cm. B497, T47 Tate N05895

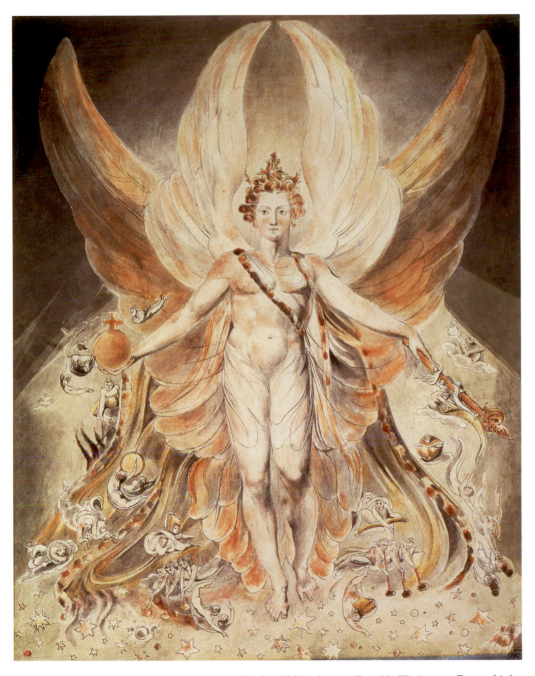

FIG.39 *Satan in his Original Glory: 'Thou wast Perfect till Iniquity was Found in Thee' c.*1805. Pen and ink and watercolour on paper 42.9 x 33.9cm. B469, T44. Tate N05892. The original blue can be seen clearly (in this reproduction) only at the lower right edge.

now have a seriously compromised tonal range. *Satan in his Original Glory* appears today to be a muted red-and-white image with touches of yellow on a very off-white background (but see below). At three of the edges a thin strip of intense blue can be seen, modulated in tone by Blake, and faded to different degrees where it was protected by at least two different mounts, in one of which the watercolour slipped down at a corner. In Blake's conception Satan strode through a deep-blue firmament illuminated with bright and warm-toned stars. The firmament might have been cloudy, or hazy with starlight, but the details are gone beyond recall.

A peculiar colour effect can be seen in *The River of Life* (fig.40): a blue band along the base, previously interpreted,[43] as in the examples discussed above, as an unfaded strip of blue pigment which once covered a larger area – the river itself. Analysis indicates, however, that the blue strip was painted with Prussian blue, a pigment of pretty good lightfastness, rarely seen to have faded in the other watercolours examined here. Also, there are only a few small surviving blue brushstrokes throughout the entire 'river' and no obvious traces of a different blue pigment, which would have completed the depiction of water. This strongly suggests that this area was not coloured at all. This watercolour has obviously suffered from over-exposure to light. A speculative solution to the puzzle could be that a restorer 'improved' the river with a less light-resistant Prussian blue paint, distinct from Blake's, and less lightfast, perhaps in the conviction that Blake's indigo pigment had faded by that time. Then the restorer's blue paint itself faded, along with any evidence that he might have seen of Blake's earlier blue paint surviving at the edges.

Over-exposure to daylight causes the paper support to yellow. This is noticeable in *The River of Life, The Crucifixion: 'Behold thy Mother'* (fig.38) and, by far the worst of all, *Satan in his Original Glory* (fig.39). To a less disturbing extent it is also noticeable in *Virgil Girding Dante's Brow with a Rush* (B812.70, T144, Tate) and *The Wood of the Self-Murderers* (B812.24, T136, Tate), neither of which shows loss of colour, and in *The Devils, with Dante and Virgil by the Side of the Pool* (B812.40, T138, Tate), whose indigo has faded. The yellowed papers tend to make each typical Blakean colour appear as a dull shade of the expected one.

Paper discolours more readily in ultraviolet light, so that exposure in a very sunny room rather than a north-facing room with no direct sunlight can damage it quickly as well as irreversibly. Blake's papers were of good quality, as discussed earlier, and the early ones, which came from different sources, would be expected to withstand light exposure well, though to differing degrees. All the sheets from the *Divine Comedy* series share a common paper, and a common early history, to the time when the heavy volume was disbound and they were separated for exhibition in 1893,[44] or possibly 1862.[45] Discoloured paper was sometimes treated with strong bleach in the past, to effect a temporary improvement in its appearance that would eventually be followed by even greater darkening. Such treatments are rarely documented or identifiable with certainty.

Most pigments that are notorious for fading – and this includes indigo, brazilwood and gamboge – will lose colour in visible light as well as ultraviolet light, so that exposure to

north light, to nineteenth-century candle and gas lighting and twentieth-century electric lighting all take their toll of colour, though the paper will turn yellow more slowly in these circumstances. Different degrees of fading and different shifts in colour balance tell us something about the way these works were stored in the dark, displayed in various lights, perhaps exposed to pollution in cities, and even washed or bleached by conservators through a period of two hundred years, if we could but 'hear' them. Properly studied, they can tell us how best to protect their still-pristine fellows – which was one reason among many for undertaking this study. Blake used a moderate selection of colours so regularly over the years that we can recognise colour change more readily, through comparison, than we can in watercolours by artists who were always trying out new techniques and materials.

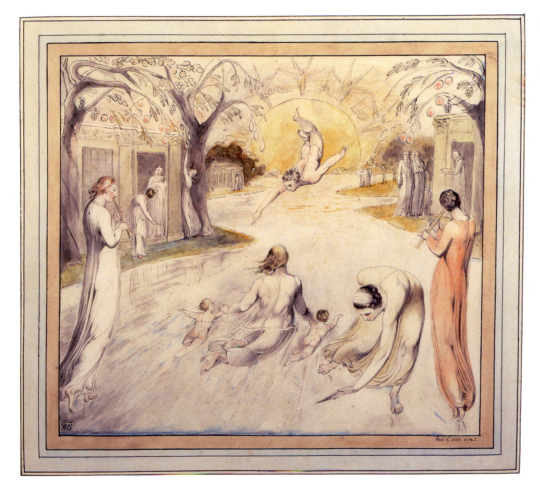

FIG.40 *The River of Life* c.1805. Pen and ink and watercolour on paper 30.5 x 33.6cm. B525, T52 Tate N05887

PART THREE

Large Colour Prints

The Large Colour Prints:
Methods and Materials

NOA CAHANER McMANUS AND JOYCE H. TOWNSEND

The making of the large colour prints

Blake signed a number of the large colour prints on the image itself (see Appendix 4).
He generally wrote in Indian-type ink, though for *Satan Exulting over Eve* (fig.71) the
signature was scratched into the paint. 'Fresco' is additionally written in Indian-type ink
on several of the colour prints (figs.41, 42). Some of the trimmed large colour prints have
no inscription.[1] The term 'fresco' and the meanings Blake attached to it have already
been discussed in the first chapter (p.20–27, 30–33).

FIG.41 Detail of lower
left corner of *Naomi
Entreating . . .* (fig.55)
showing 'Fresco'
painted in Blake's
hand, and his
signature.

FIG.42 Closeup detail
of *Naomi Entreating
. . .* (fig.55), showing
the letter 'F' of
'Fresco'.

 Authenticity has never been seriously questioned for either the unsigned colour prints
or those that bear Blake's name. Their dating, however, is far less clear-cut, notwith-
standing the inscriptions in Blake's own hand. All the large colour prints are thought
to have been executed between 1795 and 1805.[2] The earliest possible date of production *is*
clear-cut for a few colour prints: 1794 for *The Night of Enitharmon's Joy* (formerly *Hecate*,
fig.47) and 1804 for *Newton* (fig.50), as shown by Butlin from the watermarks on their
paper;[3] and also 1804 for *Nebuchadnezzar* (B301, T28, Tate N05059) for the same reason.
The late date for *Newton* has been argued independently on two grounds: that Blake
drew rock pools he must have first encountered in Felpham in 1800–3 and that he first
used stippled brushmarks at Felpham.[4]

Not all cut-down paper bears a watermark, and some prints are too dense for any watermark to be visible even in a strong light, so no more physical evidence is likely to be found on dates. As Butlin reasonably noted, papermakers just might have started using a dated watermark the previous year, but earlier use would not be likely. And a dated watermark might have remained in use for a few years before the mould was re-made.[5] The obvious point that watermarked paper need not be used in the year of its marked date is not always appreciated in discussion. Dates of production for all the colour prints prior to 1809 do seem inescapable nonetheless, through documentary evidence. The seeming failure of logic in still dating the whole group to 1795 was resolved by Butlin, who defined 1795 as the date of conception of the designs, and supported this idea with Blake's known habit of dating the later states of some engravings with the same date as the first state.[6] Technical examination might suggest a sequence of production as Blake acquired greater dexterity and confidence with his medium and introduced more complex and detailed finishing to the colour printing.

Many colour prints are on untrimmed paper, and some bear hand-written inscriptions that have rarely been given any consideration, nor reproduced for study. One inscription is regarded as contemporary with Blake's lifetime, but almost certainly not his,

namely the title on the lower margin of *Lamech and his Two Wives* (fig.43).[7] Other titles or even inventory numbers on Tate colour prints, which have been rather obviously added for identification purposes by nineteenth- or earlier twentieth-century owners or more likely print room curators, are written in small and cramped characters and are placed where any frame would cover them.

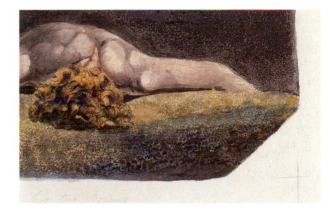

FIG.43 Detail of lower-right corner of *Lamech and his Two Wives* (fig.63) showing the very smooth texture of the wove paper, part of an inscription in graphite pencil, and registration marks for framing, in graphite pencil.

By the early 1790s Blake was already colour-printing his relief-etched illuminated books. More than one aspect of the colour-printing technique of the illumi-nated books remains uncertain and there is strong disagreement among Blake scholars regarding one element in particular. The dispute is whether Blake did one or two 'pulls' for each print. ('Two pulls' would mean that the text was printed separately from the coloured design, more than one sequence of events then being possible,[8] while 'one pull' means that both text and design were printed at the same time[9]). The process or processes used by Blake for the large colour prints have not been given nearly as much attention.

The untrimmed colour prints give insight into some of Blake's production methods. Most are printed in a rectangular, landscape format – very slightly skewed and somewhat above the centre of the sheet – on paper that was neatly torn to size, leaving roughly 10–20cm of margin at each edge. The paper was not prepared with any priming, but would have been wetted to make it more receptive to printing. The Tate versions of *Elohim Creating Adam* (B289, T25), *Nebuchadnezzar* (B301, T28), *Pity* (fig.46), *The House of*

Death (B320, T32), *The Night of Enitharmon's Joy* (fig.47) and *The Good and Evil Angels* (B323, T33) are in this group, along with the British Museum version of *Pity* (B313). A skilled printer like Blake could easily have given these prints symmetric margins, had this been important to him. Instead he followed the standard practice of centring the print sufficiently well for minimal trimming when it was mounted or even bound into a book. He did the same for the relief etchings, too.[10]

Lamech and his Two Wives (fig.63) and *Naomi Entreating . . .* (fig.55) were printed in a similar manner, with untrimmed margins, but the images have a mildly irregular octagonal format. Blake's reasons for using this format were examined in the introductory chapter (pp.30). These colour prints are still in landscape format, with the corners cut off the 'plate' before printing was done. It is impossible to take exact measurements of the printed areas, because Blake's finishing extends thickly over some corners, obscuring the original outline. It looks as if the two 'plates' had slightly different irregular shapes originally. There is no known precedent for millboards, copperplates or any other likely materials for printing having been produced in an octagonal format. The corner cutting was presumably done by Blake himself. The other version of *Lamech* (B298, Robert Essick) has been trimmed to just the extent that a similar octagonal format would have been reduced to a rectangle,[11] and the rectangular format of the other version of *Naomi Entreating . . .* (B300, Fitzwilliam Museum, Cambridge) has suffered the same fate.[12] Ruth lost the tip of her thumb, some of her head-dress and a third of her halo in the process, all of which argue strongly against Blake having done the deed.

Most of the untrimmed prints, *Lamech* (B298) and *Naomi Entreating . . .* (fig.55) included, have fine crosses marked in hard graphite pencil outside the image area in each corner and arranged symmetrically. For none of these prints has it ever been suggested during technical examination that they were printed with heavy pressure from a metal plate, a process that would leave marks in relief, so-called 'plate marks', even if the paper were subsequently flattened during conservation treatment. *Lamech* (B298) and *Naomi Entreating . . .* (fig.55), both examined in particular detail, certainly were not. Only *God Judging Adam* (fig.53) exhibits lines in relief, strengthened by lines drawn in ink. Part of this image was relief-etched into a copperplate, most noticeable in the figure of God in his chariot, where there is just discernible embossing. Close examination of it suggests that the colour printing was done in more than one pull, the black outlines first, followed by red and yellow, but the latter paint almost obscures the evidence. The pencil crosses are similar to those on the other untrimmed prints. It is more likely that the pencil marks were made by Blake for framing purposes, than during colour printing.

Early ideas on Blake's techniques were provided by Tatham, as noted in full on p.43–4. Essick has suggested that the terms 'colour-printing and drawing' or 'surface printing' may be more descriptive, and he also refers to the printing process as 'monotype', which is one of the large class of 'offset' printing processes.[13] Many were invented during

Blake's lifetime, as noted earlier (p.33). Degas's and Gauguin's colour-printing methods are also classified as 'monotype'. According to Tatham, Blake 'took a common thick millboard . . . then took a print of that on paper . . . re-painting his outline on the millboard when he wanted to take another print'.

A study of Butlin's 1981 catalogue and its illustrations shows that each colour print has distinct dimensions, yet the versions of each subject match in size to a few millimetres, or trimming that is obvious in relation to the main figures accounts for the discrepancy.[14] A batch of papers made in the same mill, and also a batch of millboard, would end up with a comparable range of dimensions, after the sheets had been dried, wetted for printing and then stored in different temperature and relative humidity conditions for about two hundred years.

A small majority of the untrimmed prints measure close to 17 by 21in (43.2 x 53.3cm), and several more measure 17 by 24in (43.2 x 61cm), while most of the others are 17in on one side, and between 21 and 24in on the other. This reasonable match in size would have made framing and presentation easier for the purchaser, and matched formats were typical of print series at this period. The matched formats provide an argument for some subjects having been grouped together by Blake, or produced at the same time, though this is speculative. This simple study of dimensions suggests that millboard was the more likely 'plate' than copper, which would have been available in only a few sizes. It was noted in an earlier chapter (p.37) that the desired ink absorbency is very easy to achieve on millboard. Millboard is, of course, considerably cheaper than copper and much easier to trim to size.

Tatham's suggestion that Blake repainted his millboard between printing seems untenable. Simply maintaining paint – regardless of its medium – sufficiently wet in the finished parts while the rest of the millboard was painted would not be easy, and pulling the 'plate' off the paper would leave both plate and papers tacky and somewhat reticulated, hence difficult to repaint. There are two versions of some of the colour prints, three of others, but never more: the paint would begin to dry before the next pull, a self-limiting process, as Essick has pointed out.[15] Repainting the plate later, when it was dried and lumpy, would give a very different outline to the printed areas, and a very different later print. The two versions of *Satan Exulting over Eve*, one in the Getty Museum and the other in the Tate collection (figs.69, 71, discussed later), have been compared for the present study: their design elements match at most points. Clearly they were pulled from the same painted 'plate', the Tate version being probably a late pull which transferred to paper what little paint still remained on the 'plate'. Even a comparison of photographs of the same subject always suggests a very close correspondence between different pulls. Tatham's method should have led to the existence of many more versions of at least some subjects.

It is generally – and logically – assumed that the darkest print was pulled first, the lightest last, for example by Essick, who describes the second and later pulls from the 'plate'

FIG.44 *Naomi Entreating . . .* (fig.55): closeup detail of the paint used for printing the garment of the wife with red hair.

as 'maculatures'.[16] However, Zeger's practical printing experiments following the methods of Gauguin, which involved laying a paper on painted glass and rubbing it over with a spoon, showed that the method can give up to four impressions and that the use of wetter paper and/or more pressure can give a later impression that is darker than the previous one.[17] As illustrated by Zeger, the fourth pull would be suitable for working up, but could be so fuzzy that the finished prints might greatly differ in appearance from the first pull. Essick and Viscomi have already pointed out that the later pulls are necessarily each 'one-pull' impressions.[18]

The reticulated surface of the colour prints was clearly intended by Blake (fig.44). He may have experimented with different paint recipes, and with different ways of separating 'plate' and paper, to achieve it. Oil, glue and gum have been suggested as the paint medium for his colour printing,[19] the most practical suggestion in this context being that Blake would not have cared what type of medium he used, as long as it proved useful for the colour effects he was aiming to create. Lightweight millboard, which flexes somewhat, would have been an easier material to use than a rigid metal plate. Water-based paint would also be easier to use over the time needed to print several impressions, and could be 'revived' to a degree by contact with the next wet sheet of paper. Essick and Viscomi have assumed that water-based paint was used.[20] Little runs of paint on *Satan Exulting over Eve* (fig.71; discussed p.100) indicate that the paint was runny. Oil-based paints form a skin as they dry, and different colours dry at different rates unless a great deal of care is taken in adding driers to level out this tendency.[21]

FIG.45 *Naomi Entreating . . .* (fig.55): closeup detail of the paint in the foreground.

Only one colour print examined in this study seems to have been made with oil-based paint: Plate 4 of *Visions of the Daughters of Albion* (B265, T22, Tate N03374), which has dark staining on the reverse corresponding to the heavy blue and black printed area. This is in fact a colour-printed relief etching that may have been printed two years before the first large colour print, and it could be expected to include distinct materials. Oil on paper causes the paper to degrade, and show dark yellow 'oil stains' within a few decades of application, unless there is a size or priming layer present to reduce this effect. And there is no unusual sizing of Blake's watercolours: it would have affected the way watercolour wash 'took' to the surface, and it would have been obvious today. A typical detail from *Naomi Entreating . . .* (fig.45) shows no staining round the lightly printed blue paint.

It would be reasonable to suppose that Blake first drew his design on the 'plate' before he applied paint. Drawing would be more practical and more decisive on a piece of millboard than on copper. Even had he used Indian ink, it could have dried while he brushed on the paint just prior to printing, and would not have printed onto the paper even if it outlined the paint. Graphite pencil or charcoal would not have printed, either – and they would have prevented the paint wetting out the 'plate' and given a fuzziness of outline that would have been anathema to Blake. Two of the prints examined here, *Naomi Entreating . . .* and *Satan Exulting over Eve*, may show evidence that Blake painted an outline of the 'plate' before he coloured it. For both, the X-radiograph (fig.70) shows the figures broadly outlined in a paint that must have been lead-rich – possibly one of the paints he would use for the colour printing. In the other prints he might have used lead-free paint for outlining, hence nothing would show of this on the X-radiograph.

In this study, in one sample from *Pity* (fig.46) and two from *The Night of Enitharmon's Joy* (fig.47), gums Arabic and tragacanth were identified, and either sugar or honey was found to be present as a plasticiser or humectant. At this date they would have been used 'raw'. This is the same gum-and-sugar mixture found in Blake's tempera paintings. Gum of unspecified type, but no oil medium, was found also in *Naomi Entreating . . .* (fig.55). The one previous analysis (see p.40) of the medium in *Lamech* (B298, Robert Essick) pointed to *Astralagus verus* gum, similar to gum tragacanth. Gum tragacanth is

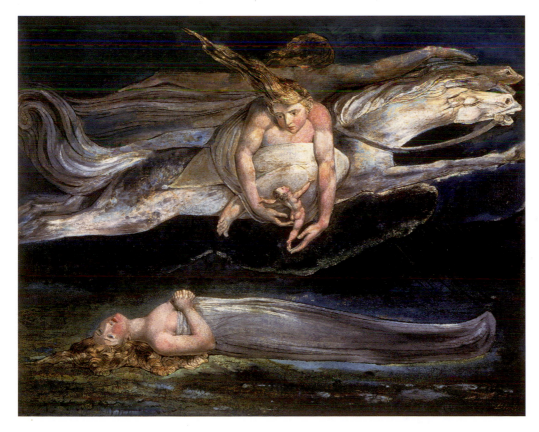

FIG.46 *Pity c.*1795.
Colour print
(42.5 x 53.9cm)
finished in ink and
watercolour on paper
B310, T30 Tate N05062

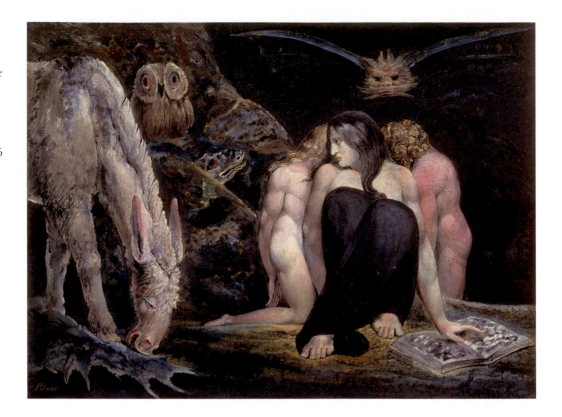

FIG.47 *The Night of Enitharmon's Joy* (formerly called *Hecate*) c.1795. Colour print (43.9 x 58.1cm) finished in pen and ink and watercolour on paper
B316, T31 Tate N05056

FIG.48 *The Night of Enitharmon's Joy* (formerly *The Triple Hecate*) c.1795. Colour print (43 x 57.5cm) on paper. B317 National Gallery of Scotland

a more suitable gum to use for printing than gum Arabic alone, and the addition of honey is also practical and sensible. It would have improved the handling qualities of the paint, and it was an additive used by many and easy to obtain. It is also significant that Blake was using numerous watercolour washes, which is to say gum-based materials, over the printing and that they would 'wet out' the already applied paint much more successfully over existing gum than over any other medium he could have used for printing (though it could be argued that gum washes would also wet glue-based paints successfully – and did in the case of the temperas). It may have been the case that Blake added small amounts of whole egg, egg white or ox-gall to the mixture. All of these can improve the working properties of paint to an astonishing degree when only an undetectable 1 per cent or so by weight is added (p.50).

From examination of the works it can be seen that an ordered sequence was followed for all of them. The printed image was hand-coloured when it was dry, as there seems to be no smudging of the reticulated patterns, while applying hand-colouring directly after the printing stage would have altered the character of the printed surfaces. The difference in style between the different impressions of a single design also indicates that they could have been hand-coloured at different times. Knowledge of the circumstances and dates of the sale of several large colour prints to Butts, as well as the common style seen in this particular group, further suggest that the hand finishing was carried out only when a buyer was found.[22]

Even a brief examination shows that Blake expended far more time finishing the pulls that had printed more successfully, and used a greater variety of materials and colours, than he did on the inferior pulls of the same design. He applied stronger, more opaque colouring and more complex layering to the better pulls, to complement the dense printing. The 'least successful' pull can show aspects of his technique hidden beneath the more paint-rich versions: *The Night of Enitharmon's Joy* (formerly *The Triple Hecate*; fig.48)

FIG.49 *God Judging Adam* (fig.53): closeup detail of flames above God's head (fig.54).

includes drawing in both graphite pencil and charcoal, and an instance of two colours applied successively to the 'plate' before one-pull printing was carried out. The blue-printed area shows reticulations, while the yellow that printed beneath appears flat, though it has the typical reticulated texture where it was the only colour on the 'plate'. This version has more drawing, as well as washing in grey, to compensate for the printing of rather little paint, but fewer watercolour washes. It is obvious that most of the black lines in the landscape were painted with a brush, while others (on the witch's face) were applied with a pen. Indian ink was scarcely used at all in this version, since it might have dominated the pale printed colours and the localised

transparent washes of watercolour. *God Judging Adam* is unusual in that it includes exposed paper and thin transparent washes of paint in an otherwise highly finished work (fig.49). The intricate brushwork in *Newton* (fig.50), *Pity* (fig.46) and *The Night of Enitharmon's Joy* (fig.47) is most obvious in the modelling of the figures, where a stippled effect was achieved in the juxtaposition of small brush-strokes of opaque watercolour.

Blake's choice of pigments was narrow. He was using generally the same limited palette as for the watercolours, and extending it with Naples yellow, red lead and ultramarine for temperas (see later) as well as colour prints. The frequent addition of lead white at the colour-printing stage suggests that he sought to make highly opaque paint that could be contrasted with thin opaque washes of watercolour as well as the more conventional transparent watercolour washes. Not surprisingly, the same palette was used by Blake for both the colour printing and hand colouring.

The pigments identified (see Appendix 4) conclusively include Prussian blue in every case, mixed with carbon black for the printing of dark areas; blue ultramarine; vermilion in almost every print, used for bright reds and mixed with lead white for both printed and painted flesh tones; red lake less often; red lead in one instance; yellow gamboge, probably used frequently though it has not always survived (fig.51); Naples yellow on occasion; yellow, brown and red ochres; lead white in some of the printed colours; chalk and china clay in others, when the pigments served to give an opaque paint; chalk as the

FIG.50 *Newton* 1795/ *c.*1805. Colour print finished in ink and watercolour on paper 46 x 60cm. B306, T29 Tate N05058

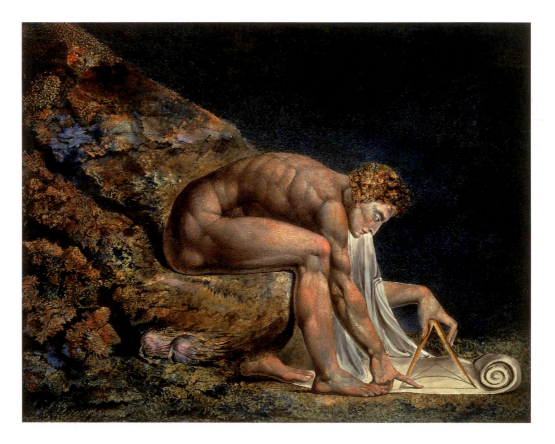

only white pigment used for hand finishing; bone black in watercolour washes; and lamp black in the Indian ink. Blake seldom used so much chalk that it lightened the colour of the paint, an exception being its mixture with Prussian blue round the prone figure in *Pity*. This pigment has such a high tinting strength that it is generally lightened with white. Lead white was extensively used along with yellow in the upper background of *God Judging Adam* (which is a colour-printed relief etching of the same date as the early colour prints), and it was mixed with Prussian blue in the same work and with carbon black in small areas on the horse. Lead white also seems to have been employed for mixtures with different pigments on the large rock in *Newton*.

One peculiar occurrence in all the large colour prints is the pigment used for the figures' hair or at least part of their hair and/or beards, both printed (in *Nebuchadnezzar* – B301, T28, Tate) and hand-painted (in *Lamech and his Two Wives*, fig.52 and see fig.43). In normal light it has a reddish brown and resinous or gummy appearance, and it leaves a stain on the reverse of the paper, as Indian ink does. It may be dragon's blood, the deep golden/brown gum from rare trees in South-East Asia, available in Blake's era but probably never very popular with watercolourists.[23] The only passing references to its use are as varnishes for furniture and musical instruments.

A drying oil was found in a sample of black ink from *Pity*. Boiled linseed oil has been the traditional medium for printers' ink, which usually also included a resin,[24] not found in the inks studied here. A brown halo surrounds the black graphic lines, which further suggests that only the black ink contains oil. Blake's Indian ink probably varied in composition.

As well as white pigment, Blake employed the paper tone in the composition, as for example in the sheet of paper next to the feet of *Newton*. In *God Judging Adam* (fig.53) the white in the figure of God and the horses is the paper support (fig.54).

FIG.51 Closeup detail of the sun in plate 4 of *Visions of the Daughters of Albion* (B265, Tate) showing yellow gamboge.

FIG.52 Closeup detail of the murdered man's hair in *Lamech and his Two Wives* (fig.63)

FIG.53 *God Judging Adam* 1795. Colour-printed relief etching with ink and watercolour on paper 43.2 × 53.5cm. B294, T26 Tate N05063

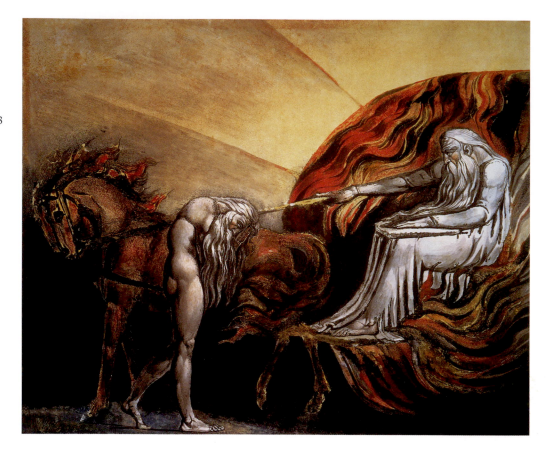

FIG.54 Detail of the flames about God's head in *God Judging Adam* (fig.53, see also fig.49). The lightest parts of the flames are in fact blank paper. Uniquely among the large colour prints the first outline of this design was printed from a relief etched copper plate. The light grey reticulated lines defining God's arm and his hair seen in this detail and also visible elsewhere in the print are the result of ink being tranferred from the plate onto the paper. Blake later strengthened these lines with ink.

A high-quality pull: Naomi Entreating Ruth and Oprah to Return to the Land of Moab

Examination of *Naomi Entreating . . .* (fig.55) at low magnification and in raking light suggests that colour printing was done in one pull and without much pressure applied. All the colours – slate blue, bright blue, mixed green, yellow grey/black – were applied to the 'plate' without overlap (fig.56), leaving uncoloured areas for the figures of Ruth and Orpah and for Naomi's head and hands. The bright blue and the slate blue paint were made from a rather finely ground (and hence lower quality and cheaper) ultramarine and coarsely ground, opaque, lead white. The slate blue and the black paints both include a fine-grained black pigment, probably lamp black, and Prussian blue, mixed with lead white. The green was mixed from a fine-grained, very dark blue pigment (probably the same as that used for the blue paint) and a coarser, opaque yellow one. The shading in the green is caused both by uneven mixing of yellow ochre and Prussian blue, which must have been accidental, and uneven thickness of the paint when printed. The yellow printed area in the foreground was mixed from yellow ochre, chalk and china clay, and was used without any blue toning. Yellow ochre is sufficiently opaque that lead white was unnecessary in the formulation of the green and yellow paints, and so these areas do not register on the X-radiograph (fig.57). These paints all have a gum medium.

Local applications (which Essick has called 'colour blotting'[25]) of the bright blue,

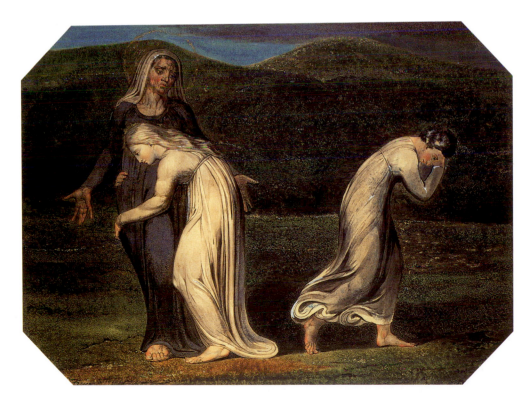

FIG.55 *Naomi Entreating Ruth and Orpah to Return to the Land of Moab* 1795–1805. Colour print on paper 42.6 x 60cm B299 The Victoria and Albert Museum

FIG.56 Closeup detail of *Naomi Entreating* . . . (fig.55), which shows that the areas of green and blue paint do not overlap.

FIG.57 X-radiograph of *Naomi Entreating* . . . (fig.55)

lead white-based paint used for the colour printing may have been made to the figures with a small rag, giving areas with reticulations on a smaller scale, obviously not applied with a paint brush. The X-radiograph makes the two types of reticulated surface easy to distinguish. These localised, blue areas (fig.58) seem too well placed in the costumes to have been done at the printing stage, unless the 'plate' had bounding lines and considerable drawn detail on it, easily visible through the paint. It has printed so opaquely that this seems unlikely. The fine reticulations look too painterly to have been capitalised on after they occurred accidentally during printing. A little gold leaf was applied to the still-wet paint soon after printing (see fig.56). All the gold is a pale shade. In fact the shell gold (powdered gold leaf in a medium of gum/glue, ox-gall and honey[26] applied with a brush) that Blake used more extensively in this print contains a gold-silver alloy, which accounts for its pale colour. This would not have been as expensive as pure gold.

Before the print was dry, Blake rubbed down paint that had printed too far into the reserve for the figures, leaving smooth smudges, at Orpah's ankles for example (fig.59). He applied some watercolour paint at this stage, and also at a later one. It is smooth, non-glossy, was applied thinly and dried evenly without forming a dark ring of concentrated pigment at the perimeter. It wetted the printed paint very successfully, and was easily wetted by Indian ink as well. All these points suggest a well-gummed wash, carefully formulated for the task. Then the bounding lines of the figures were applied by pen in glossy Indian ink, to add detail to the fuzzy outline of the reserve (fig.60), along with lines of Indian ink in the landscape. All the lines are controlled and evenly applied, with little sign of tailing-off or thickening where the pen was recharged with ink, as it was after a few centimetres of each line (fig.61).

FIG.58 Closeup detail of Orpah's garment in *Naomi Entreating* . . . (fig.55), with localised printing in light blue.

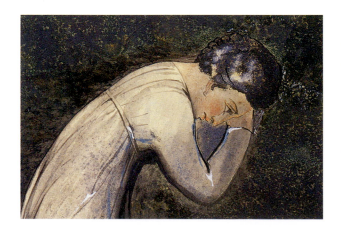

Washes of watercolour were applied next, followed by translucent highlights in chalk, applied with a brush

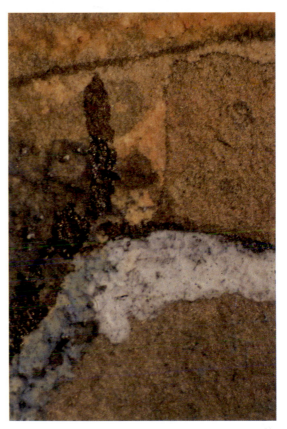

FIG.59 Closeup detail of Orpah's ankle in *Naomi Entreating* . . . (fig.55), where Blake rubbed down paint that had printed too far into the reserve for the figures, leaving smooth smudges.

FIG.60 Closeup detail of Orpah's ankle in *Naomi Entreating* . . . (fig.55) showing where the printing extended sufficiently far that the black bounding line was not needed at this point.

FIG.61 Closeup detail of Ruth's hair, with ink lines just tailing off before the next dip of the pen, in *Naomi Entreating* . . . (fig.55)

FIG.62 Detail of a highlight painted in chalk in *Naomi Entreating* . . . (fig.55)

(fig.62). They were not well gummed, which ensured that they would retain an opaque appearance, and as a result the thickest parts now have fine cracks. Details in localised gold were applied next, as shell gold. Then Blake washed some watercolour over the shell gold, to modulate its colour and also perhaps to act as a fixative. This colour print also has a transparent coating applied with a broad brush to many of the Indian ink lines, and round most of the perimeter of the figures. It is made from animal glue, the only occurrence of this material on the print, and it is much less assured than Blake's paint. Because it runs over tiny losses in the gold, it cannot in fact be his.

A highly accomplished colour print: Lamech and his Two Wives (fig.63)

Virtually the whole image has been printed (fig.64), with no reserves of paper left for finishing in watercolour. Prussian blue was used in the dark background paint, mixed with lead white and a black pigment, and in the foreground green mixed with yellow ochre, as was seen in *Naomi Entreating* . . . The green is not a uniform colour but a mottled surface appearing more yellow in some areas. It also appears that some of the printed colour overlies printed yellow, i.e. that two colours were applied successively to the 'plate'. There was a light application of brown (possibly of ochre, burnt sienna or dragon's blood) over the green foreground and for Lamech's beard. After this layering of colour, Blake blended the paint on the 'plate' in a very painterly fashion (figs.65, 66). Lamech's and his wives' faces were worked up well by blending pink and white paint for the flesh, and adding dark paint for the dark eyes (fig.67), as well as an overall paint colour for the hair of the two wives (one colour for each woman). The body of the murdered man, but not his face, was worked up in similar detail on the 'plate'. The costumes were fully printed, with a lilac/grey colour for most of each costume, of a different tone for each person and shaded a little with grey on the 'plate'.

This seems to be a considerably more developed form of the technique used in *Naomi Entreating* . . . , which argues that this print was made late in the series. In terms of paint transfer, this print is intermediate between *Satan Exulting over Eve* (B292, fig.71), where very little colour was transferred, and *Naomi Entreating* . . . , which had a great deal

FIG.63 *Lamech and his Two Wives* 1795. Colour print (43.1 x 60.8cm) finished in pen and ink and watercolour on paper. B297, T27 Tate N05061

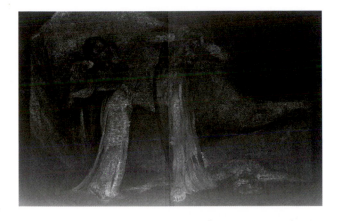

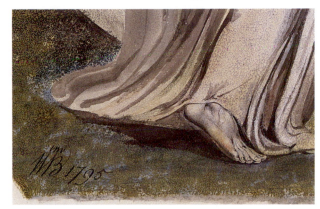

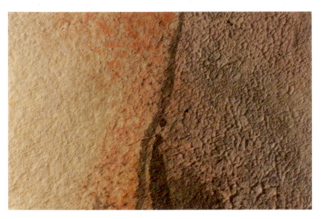

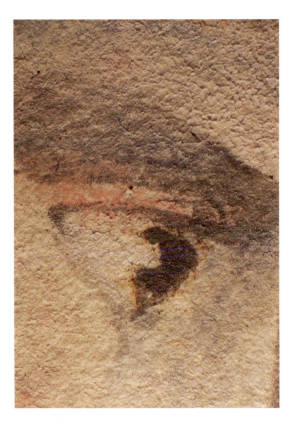

FIG.64 X-radiograph of *Lamech and his Two Wives* (fig.63).

FIG.65 Detail of the left corner of *Lamech and his Two Wives* (fig.63), showing that the paint on the plate was blended before printing, and that almost the entire surface was printed.

FIG.66 Detail taken in raking light (to reveal the texture of the paint), shoulder of the red-haired wife in *Lamech and his Two Wives* (fig.63). Again, the paint was blended to give modelling.

FIG.67 Closeup detail of the right eye of the red-haired wife, in *Lamech and his Two Wives* (fig.63).

of paint transferred, yet also very clean reserved areas. The level of finish of *Lamech* is intermediate too, i.e. it matches the quality and extent of the printing.

The black bounding lines for the figures were applied in watercolour with a brush. The careful, pen-applied graphic lines of *Naomi Entreating . . .* have given way here to freer and more expressive ones. Some black lines were applied to dry paper: they have dried with the pigment concentrated at the edge of the stroke. For example, Lamech's toes were outlined over the same paint used to print his robe, then flesh tones and a lilac/grey wash (an optical mixture which matches the printing colour, but was applied as watercolour) were added to give modelling (fig.68). There is more sense in this work than in many of the others

that Blake exploited 'accidents' of printing. For example, the murdered man's head and flesh printed quite thickly, and brushstrokes of Indian ink were used to increase the hair texture, before thin watercolour washes of two earth colours, possible dragon's blood and black, were added to give a highly finished effect. The flesh tones are probably painted with vermilion and certainly include lead white to give opacity.

The outer edges have all been neatened with grey watercolour, to give a very straight-edged outline to the print. They have not, however, corrected the poor symmetry of the corners. This paint need not have been Blake's.

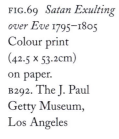

FIG.68 Detail of Lamech's toes in *Lamech and his Two Wives* (fig.63).

Satan Exulting over Eve: *a brief comparison of two versions*

The conservation of the Tate version (fig.71), described in the next chapter, gave new information about Blake's working process for *Satan Exulting* . . . The materials he used are discussed in the context of their recognition during the treatment.

Blake painted on top of this inferior pull extensively. He was still 'playing with' the composition. To compare the two versions, a monochrome transparency was made of

FIG.69 *Satan Exulting over Eve* 1795–1805 Colour print (42.5 x 53.2cm) on paper. B292. The J. Paul Getty Museum, Los Angeles

each, to the same scale, and they were overlaid on a lightbox. This confirmed that the figures were exactly registered, while making the variations easier to spot. In fact the more one studies the two, the more the differences appear. All that remain constant are the basic blocks of two figures, serpent and flames. Everything else was added later, when the coloured paint was dry: water-insoluble ink (presumably with a pen), watercolour washes and then more of the ink. Tate's *Satan Exulting . . .* has a much longer

spear. Flames cover the bottom half of Satan's shield in the Tate version. In the Getty version (fig.69) Satan and Eve both have two legs, while they have one apiece in the Tate version, and seem to be depicted more in profile. The X-radiograph of the Tate version (fig.70) shows that the figures were drawn in outline (on the 'plate') with a lead-based paint, just as they were for *Naomi Entreating . . .* (fig.55) giving Satan one leg as in a sketch of the subject in Blake's *Notebook*.[27] The other version has not yet been X-rayed. This suggests that the extra legs in the Getty version are Blake's afterthought, and actually the second legs look rather awkwardly drawn. There was little paint left at the second printing, because little transferred to the paper, so the strengthening may have been necessary, and a third pull out of the question. The run-marks of paint visible on the X-radiograph show that the paint was liquid and slumped a little while the paper was propped or hung up to dry.

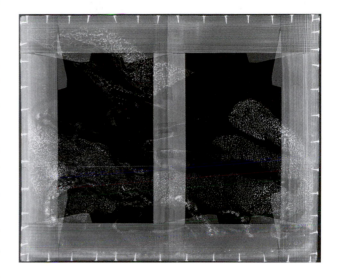

FIG.70 X-radiograph of *Satan Exulting over Eve* (fig.71) Tate B292.

Undoubtedly the Tate version has suffered damage and local losses of paint, but it is obvious from examination that the Getty version was finished to a much higher degree, because the quality of the printing justified it. The lower level of detail in the Tate's version makes the single leg apiece for Satan and Eve acceptable, since they seem to be in profile, while disguising the real similarities in production for the two prints.

The Conservation of a Large Colour Print: Satan Exulting over Eve

PIERS TOWNSHEND AND JOYCE H. TOWNSEND

Conservation and restoration of this colour print gave crucial new insights into Blake's method of creating it, and revealed how its appearance has changed in the course of its eventful life. We see first how examination led to a proposal for a safe conservation treatment, then what came to light during cleaning.

This colour print (fig.71) has always had 'Satan' included in its titles. Although it apparently featured in Thomas Butts's sale in 1853 as *Satan traversing the Realms of Space,*

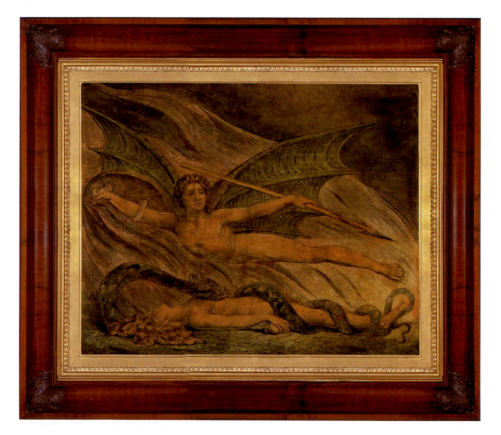

FIG.71 *Satan Exulting over Eve c.*1795. Colour print (43.9 x 53.5cm), pen and ink and watercolour on paper. B292 Tate T07213 Shown after conservation, in the frame designed for its display in the *William Blake* exhibition at Tate Britain, 2000–1.

it has the title *Satan Triumphing over Eve* on its stretcher from this time or later (fig.72) and was catalogued as *Satan Exulting over Eve* by Gilchrist.[1]

Satan Exulting over Eve began life as a colour print that could only be described as a poor-quality, single pull. It was printed on good-quality white wove paper, with the appearance of Blake's Whatman paper, though this sheet lacks a watermark. It seems to be a linen paper, tub sized with glue size in alum during manufacture,[2] which is typical of a paper at the end of the eighteenth century.[3] *Satan Exulting . . .* suffered the indignity of being lined to canvas (a glue and flour paste was applied,[4] and the paper and canvas were ironed together), then stretched tight over a wooden stretcher. The double border in ink was added, then the surface was varnished. It is as though the collector wanted to turn it into an oil painting (p.163), not an uncommon proceeding in the eighteenth and nineteenth centuries.[5] It was put into a gilded frame – leaving displaced fragments of gilding visible at the edges when it arrived at the Tate in 1997. At first the print might have looked attractive, its colours saturated by the varnish. But after a few years the varnish would have begun to discolour, and start the sad decline. By 1997 the thick varnish layers had discoloured to a dull brown, cracked and lost gloss, because of long exposure to light. The surface was very uneven, and the viewer needed a bright light to be able to make sense of the composition. The frame had disappeared into oblivion. We know that the lining canvas had never been removed from the stretcher, since its metal-tacked edges survived and had no extra tack-holes to indicate re-stretching. This proves that the image always measured 42.9 x 53.5cm, though lining and stretching can alter these measurements a little. There would once have been wider margins, trimmed off during lining.

FIG.72 *Satan Exulting over Eve* (fig.71): the stretcher bears an earlier title on its reverse side, legible in raking light.

Blake did not varnish the other colour prints owned by Butts or line and stretch them like canvas paintings. The idea of viewing them through a brown treacly glow would have been horrific to him. However, *Satan Exulting . . .* changed hands in 1853, 1863, 1904, 1909, 1914, 1941 and 1942[6] and might have been treated for sale or sent off for treatment by a new owner. It is hard to pinpoint when this treatment may have been performed, but an excise mark on the back of the canvas suggests an early date from this group. Because excise duties on foreign and British linens and stuffs were repealed from 1 March 1831, the lining is unlikely to have been done much after that date.

The excise mark itself seems to be early nineteenth century (fig.73). NEWBURGH is a town in Fife, to the north of Edinburgh. The crown above a thistle is a Scottish emblem, and below it is the legend A LIVINGSTONE STAMPMASTER. Enquiries yielded a wealth of detail on the subject of taxation stamps, but no firm dates.[7] A. Livingstone was given

FIG.73 *Satan Exulting over Eve* (fig.71), showing the canvas stamp on the non-original canvas support that was removed during conservation. 'LIVINGSTONE' is legible on the right side.

his commission as a 'stamper and lapper of the linen & hempen manufacture, Newburgh' on 1 June 1791, A. Livingstone was registered as a stampmaster at Newburgh in May 1808, and there is a sample copy on linen of his stamp that matches the one found on the Blake. In an earlier register the stamp for Newburgh is for a J. Livingstone, registered on 7 September 1775, which hints that A. Livingstone may have been a second generation stampmaster. There is no entry for his name in the Cupar Sheriff Court Register of Deeds, however, which suggests that he may have died without leaving a will, and it is difficult to know when he died because the General Register Office for Scotland has no records of burial for the parish of Newburgh. His period of active working life therefore has to be guessed at, as does the length of time that the cloth in question sat waiting to be used after someone purchased it.

The set of numbers and letters to the left of the crown and thistle are the so-called frame mark, adjusted at irregular intervals to deter counterfeiters, which would have enabled a customs officer to know the type of cloth, its length and breadth, and the date of stamping. Stampmasters kept careful accounts recording this information. Here, L is the identity of the stamp, B is the division in the Excise List for the type of material, 1141 is the progressive number (the number of pieces stamped so far), 35 is the length in yards, and that is as far as we can go. Normally the width was recorded in hundredths of a yard, but in our stamp the space is blank. Written at right angles in iron gall ink we have 4. This is hard to interpret, as are the other fragmentary printed signs after it, and the clearly inked 384. The canvas was cut from a larger piece. We know this because the selvedge, the naturally neatened border formed during weaving, is not present – hence a large piece of canvas was cut into. The stretcher was not distinctive: from the early nineteenth century to the present, many were made from five pieces of batten, using a vertical cross-bar and keys at the corners, just like this one. Inscriptions can always be added to the stretcher, like the title *Satan Triumphing over Eve*, and the price of £65. This last must date from a mid-twentieth-century sale, since Blake himself sold the colour prints for one guinea apiece (£1.05), and even lower pre-twentieth-century prices have already been documented.[8]

There was much discussion as to what remedial treatment might be possible. The Getty version (fig.69) showed what a never-varnished version could look like, and previous Tate experience of cleaning *The Night of Enitharmon's Joy* (formerly *Hecate*, B318, Huntington Library and Art Gallery) demonstrated that varnish removal could be performed successfully.[9] In any case, the drum-like tension of paper and canvas made it unsafe to leave the picture on its stretcher. The weak material might easily split. Radical treatment was indicated: varnish removal, canvas and glue removal, washing of the

paper, and final adjustment of the paint losses. Curatorial opinions were sought, cleaning tests made, alternatives pondered. All indications were positive, and the picture was acquired on the understanding that its condition could be improved.

Treatment began with surface cleaning: dirt came off readily from the varnish using saliva-dampened cotton wool swabs. These swabs smelled of smoke, and could be seen to hold a grey sooty component and also a more soluble brown ingredient. Then the varnish could be analysed,[10] and its history pieced together: counting out from Blake's paint, the varnish layers include glue (which might be Blake's medium or varnish, but see later), an unidentified layer, shellac with a drying oil (which would have made a very insoluble varnish), a mastic-type resin, and a hard wax coating with a high melting point. The shellac varnish ran over the tape, which was attached after lining and before framing, so it and the varnishes on top were definitely not Blake's, and their

removal was justified. Shellac-based varnishes are a pale gold colour at best, and a dark honey colour at worst, and were commonly used on nineteenth-century printed paper, for example to protect maps. Mastic was a typical picture varnish throughout the nineteenth century, and both of these darken with years of light exposure. Wax coatings imbibe and hold dirt, so this combination of layers was guaranteed to make the colour print look yellow and glossy at first, and brown, dirty and rather matt at last (fig.74).

Initial varnish-cleaning tests were done with mixtures of alcohols and White Spirit, because it is prudent to approach varnish removal cautiously, to ensure that the artist's paint beneath cannot be harmed. The White Spirit removed the wax and its load of dirt. However, slowing the rate of evaporation of the alcohol with White Spirit increased the possibility of blanching of the cleaned surface, so pure propan-2-ol was to be preferred. A drawback to the use of solvents is the risk of damage to the yellow pigment gamboge, which could have been lurking unrecognised beneath the brown/yellow varnish. It was quite out of the question, for example, to immerse the picture in solvent, which might otherwise have been a possibility, and would not be an unusual treatment for a water-colour on paper. The mastic varnish was removed gradually and carefully with a swab treatment, when it became apparent that after a previous partial cleaning the picture had been unevenly coated with the shellac/oil varnish. This largely resisted removal with propan-2-ol, even with ethanol added.

Varnish removal had been performed with the canvas still on the stretcher. Then the tacks were pulled out and the stretcher lifted off. In order to separate canvas from paper, a poultice with water and Laponite[11] was applied to the back, which softened the adhesive enough after half an hour to allow the canvas to be peeled away. The thick layer of glue and flour paste that remained was scraped at gently and swabbed away, revealing

a fairly evenly discoloured paper. What it did not reveal was a patchy yellow halo round the areas of Blake's colour printing: it if had, we would have known that Blake had used an oil-based paint for the colour printing. The paper was floated paint-side-up on water for a few minutes, and then more of the paste could be swabbed off the back. Water-based paint media, like gums, gradually form a chemical bond with paper as they age over decades, so it is not as surprising as it sounds that an initially water-based paint should be water-resistant after about two hundred years. Blake's typical gum formulation, which includes gum tragacanth, may well make a contribution to the water-resistance.

Immersion of the paper in water washed out a great deal of discoloration, and a second immersion in very weak magnesium hydrogen carbonate in water washed out more, as well as reducing its acidity. All papers grow yellow/brown and turn acidic eventually, especially after exposure to ultraviolet light, and acidic paper carries the seeds of its own destruction, so a washing treatment to make the paper less acidic (more neutral) is an effective way to increase its lifetime. A further 'deacidification' treatment to leave the paper alkaline would increase the lifetime further. This treatment has no effect on nineteenth-century pigments except possibly on gamboge, which can change to a darker yellow if it is made alkaline rather than neutral, so the treatment had to be minimal. After

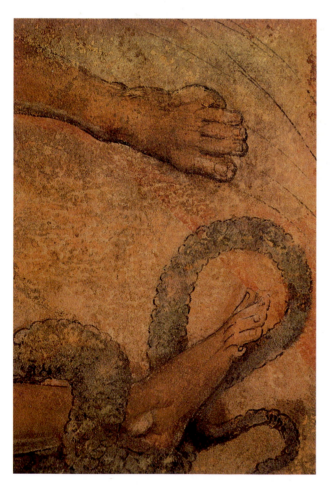

FIG.75 Closeup detail, showing a shellac-free area at Eve's toes, in *Satan Exulting over Eve* (fig.71)

drying, the paper was also more flexible than before, but still very discoloured for its age. Local tests with a weak aqueous solution of the mild bleaching agent hydrogen peroxide proved safe on the paints, so the back of the paper was sprayed with it. Another water wash to remove the by-products made it a paler brown. Further bleaching was not felt to be a good idea, because if the paper became too pale (even if this were closer to its colour when Blake used it), then the small losses in the paint would become more obvious.

After drying, the disfiguring shellac varnish could be seen in ultraviolet light. It was possible to remove much of it mechanically in small flakes, with no damage to the surface below (fig.75). Only near the tip of Satan's spear was the shiny shellac still such a coherent film that it had to be left alone. The overpaint on Satan's hand, brow, shield and leg, whose presence as blobs with no relation to Blake's image had been obvious in the X-radiograph made before treatment, was now seen to lie on top of this varnish. The overpaint on Satan's face had in fact altered his appearance considerably. When the overpaint was picked off, it revealed shiny varnish. The overpaint was made from

lead white in oil paint, and had been matched to the varnish surface, so it did not correspond at all to Blake's colours, which could now be appreciated at last.

Blake's paint, and a few spots of other paint on top, were then examined at moderate magnification with a microscope and under ultraviolet light, and the X-radiograph was studied carefully again. Tiny samples the size of a pin-point were taken from the edges for pigment identification. It turned out that the 'foreign'-looking paint spots included modern pigments, interlopers from the mid-twentieth century that arrived after the print and the frame parted company. The borders had been drawn using water-based ink with bone black and brown ochre on top of the tape, just like the varnishes. Everything else was applied by Blake, and has the typical appearance of water-based paint. There were substantial traces of a proteinaceous coating like glue, which Blake probably applied as a protective varnish, as he did to his temperas. A similar layer had been found over the watercolour *The Penance of Jane Shore* (fig.15) during the removal of a non-original varnish in recent decades. In many places watercolour paint had been lost because the varnish had cracked and fallen away, taking tiny pieces with it. Because of this the coloured surface remains vulnerable to rubbing, as for example in Satan's wings and

FIG.76 *Satan Exulting over Eve* (fig.71): detail of Satan's arm, wing and spear during the removal of shellac varnish.

particularly the area of dark background above him, where the paper surface was easily visible. The glossy, black, waterproof ink that Blake used for painting in the strong graphic lines of Satan's wings (fig.76), Eve's curling tresses, her toes and other details has survived very well. Since it does not extend to a damaged edge, it defied sampling and analysis, but is probably Indian ink, since Blake used this on other colour prints and in watercolours.

Blake added the 'bounding lines' once the colour printing was well dried, and also watercolour paint where it was deficient, then sharpened some details with more ink, just as he had done for *Naomi Entreating . . .* (fig.55). The serpent's scales and his wicked-looking eye were probably delineated again over the colour. Finally, Blake scratched his name into the paint, in the lower left corner.

The paint used for printing included vermilion mixed with lead white for Eve's flesh, and red lead mixed with lead white for the flames, with pure red lead highlights surviving in places. Additional red lead paint was applied over Blake's first application of Indian ink. Red lead and vermilion are both very opaque pigments, but red lead is more orange – flame-coloured, in fact. Eve seems to have very little flesh-coloured paint. This is because rather little transferred from the plate, so little indeed that Blake's glue varnish, now yellowed with age, has impregnated the paper, and provides most of the flesh colour. The same is true of Satan. Had more paint come off the plate, Satan might have had a darker skin than Eve: the skin tones vary considerably in the three versions

of *Hecate*, for example (fig.48; B318, Huntington Art Collections; and fig.47). Blake had definite views on the correct depiction of flesh colour, as noted earlier (p.26).

The greenish blue watercolour areas of Satan's wings include the 'early' type of Prussian blue used by some artists till the 1840s,[12] bone black, and gamboge, which would have made a slightly transparent green to contrast with their glossy ribs. The same green mixture was intensified with Naples yellow, a bright and very opaque pigment, for some of the serpent's coils and with lighter yellow ochre and vermilion for others. The serpent's scales had localised glazes of a deep transparent red lake and highlights of yellow ochre, which was the most dazzling part of the image (figs.77, 78). The gamboge must have faded by this time, and paint losses revealing the paler paper have sadly reduced its impact now. Most of the flames lack modulation and the visual interest one would expect from Blake, which may well be attributable as well to loss of gamboge toning.

In order to flatten the paper, it was humidified, i.e. made damp but not wet (as it happens, just as it might have been when Blake printed it), and pressed between felts. Now the effects of the treatment so far could be properly evaluated, and Blake's image could be studied at last. There was unsightly pale blanching of the dark shadows round Satan's head. This could have been eliminated with the help of a coat of varnish, but that would have been inappropriate, as it would have saturated the paint and given it a glossy appearance. Instead, a poultice made from a little hydroxy propyl cellulose in propan-2-ol corrected the blanched appearance without giving a shine. Paint losses inevitably became more noticeable once the obscuring dirt and varnish were gone: it was because of them that the colour print had originally been metamorphosed into a little 'oil painting' in the first place, so everyone expected to see a damaged colour print at this point. A mix of paper extract[13] and watercolour was used to compensate for the losses. Paper extract, apart from helping to give a dull and unobtrusive colour to retouchings on somewhat discoloured paper, is useful in that it remains water soluble, and means that watercolour in-painting on top of it is more easily reversible. (In-painting or retouching is always applied in such a way that future conservators can remove it without endangering any

FIG.77 Closeup detail of the serpent's scales in *Satan Exulting over Eve* (fig.71).

FIG.78 Closeup detail from another area of the scales, not far from that shown in fig.77.

original paint.) The retouchings are necessary so that the viewer's eye does not home in on the losses and miss Blake's image altogether, and the skill in retouching lies in stopping at the point where the damaged image has been re-integrated just enough for its meaning to be appreciated. Further retouching would have involved applying paint over Blake's own paint, which would contravene present-day conservation ethics.

For exhibition the print was reversibly attached with paper hinges to a backing of cream-coloured, non-acidic museum board, then framed. This simple statement about the framing understates a great deal of effort and discussion, because the choice of appropriate frame was not easy. The presentation of Blake's 'paintings' is the subject of the epilogue.

PART FOUR

Temperas

The Painting of the Temperas

BRONWYN ORMSBY WITH BRIAN SINGER AND JOHN DEAN

Blake's 'fresco' method

William Blake painted more than one hundred tempera paintings during the period from 1799 to 1827, and approximately seventy are now housed in both public and private collections.[1] He did not publish his intended account of his tempera technique, but his most famous claim with respect to his tempera paintings was that he had rediscovered the lost art of fresco: 'Fresco Painting is Properly Miniature, or Enamel Painting; every thing in Fresco is as high finished as Miniature or Enamel, although in Works larger than Life. The Art has been lost: I have recovered it. How this was done, will be told, together with the whole Process, in a Work on Art, now in the Press.'[2]

Blake's choice of the fresco technique appears to have arisen from many factors, discussed earlier. It is clear that Blake saw fresco as one of the highest and most pure forms of art, as he described in the *Descriptive Catalogue* regarding his desire for four of his watercolours: 'The above four drawings the Artist wishes were in Fresco, on an enlarged scale to ornament the altars of churches, and to make England like Italy respected by respectable men of other countries on account of Art.'[3]

However, Blake's choice of painting techniques also arose from his training as an engraver as well as his love of Gothic art, which instilled in him a deep belief in the superiority of line, as he continued: 'The great and golden rule of art, as well as of life, is this: That the more distinct, sharp, and wiry the bounding line, the more perfect the work of art; and the less keen and sharp, the greater is the evidence of weak imitation, plagiarism, and bungling.'[4] To Blake, a loss of outline equalled a loss of character, which was also exemplified through his arguments against the use of oil paints. His disciple Tatham recalled that Blake's early rejection of oil was the result of his inability to achieve his desired linear effects and by its loss of brilliancy:

> Oil painting was recommended to him, as the only medium through which breadth, force, & sufficient rapidity could be obtained; he made several attempts, & found himself quite unequal to the management of it; his great objections were, that the picture after it was painted, sunk so much that it ceased to retain the brilliancy & luxury that he

intended, & also that no definite line, no positive end to the form could even with the greatest of his Ingenuity be obtained, all his lines dwindled & his clearness melted, from these circumstances it harassed him, he grew impatient & rebellious, & flung it aside tired with ill success & tormented with doubts. He then attacked it with all the Indignation he could collect, & finally relinquished it to men, if not of less minds of less ambition.[5]

The use of water-based paints, on the other hand, such as those used for fresco or tempera, enabled Blake to paint transparent, pure colour and to achieve greater precision of line. He could also create brilliance by the layering of transparent colour over his white priming layers and was able to achieve his 'firm and determinate lineaments unbroken by shadows', which allowed him to 'display and not to hide form'.[6]

Writing of *Sir Jeffery Chaucer and the nine and twenty Pilgrims on their journey to Canterbury* (fig.103), Gilchrist quoted Blake on technique and his sense of aesthetics, as opposed to those represented by Rubens and Rembrandt: 'The character and expression in this picture could never have been produced with Ruben's light and shadow, or with Rembrandt's, or any thing else Venetian or Flemish. The Venetian and Flemish practice is broken lines, broken masses, and broken colours. Mr. B.'s practice is unbroken lines, unbroken masses, and unbroken colours. Their art is to lose form, his art is to find form, and to keep it. His arts are opposite to theirs in all things.'[7]

Although Blake himself used both terms 'fresco' and 'tempera' when referring to his paintings, his technique has been misinterpreted from shortly after his death in 1827. By 1863 Gilchrist and William Michael Rossetti had more correctly defined the paintings as temperas.[8] However, confusion remained, since in the many exhibitions including Blake's temperas held over the past one hundred and fifty years, the paintings have been described as glue or egg temperas, watercolours and even oils, despite Blake's vehement dislike of oil paint.

The confusion is not surprising, as the terms 'fresco' and 'tempera' encompass a variety of painting techniques, ranging from *buon fresco* to *fresco mezzo* and including several types of tempera painting, which are vaguely defined through a combination of the painting support and the binding medium, and can encompass paints made with gum, egg, glue, casein, wax, resin or other combinations of water-soluble or even oil-based binders.

As Blake's paints are clearly 'tempered', or mixed with a binding medium, his 'fresco' technique lies closer to *fresco secco*, where the paint is tempered with egg or glue and painted onto a dry wall, or to *fresco mezzo*, where the design is commenced on wet plaster and then finished with water-based colours once the wall dried. Interestingly, however, Blake constructed his own definition of the 'fresco' technique by saying that it merely required the presence of a 'plaster ground and the absence of an oily vehicle'. He also considered that 'the peculiarity from which it takes its name – that of being executed on a wet surface – as a comparatively trivial one',[9] and thus, by his own definition, he was, of course, painting in fresco. However, technically speaking, Blake's choice

of paint medium and painting supports leads to the conclusion that he was producing tempera paintings. This process was correctly described by one of his friends, collaborators and followers, John Linnell, when he wrote that Blake's paintings were 'nearer to *tempera* in process than to anything else, inasmuch as white was laid on and mixed with the colours, which were tempered with common carpenter's glue'.[10]

The Bible Series (1799–1800) illustrated by The Body of Christ Borne to the Tomb, *a very well-preserved tempera*

The first group of temperas Blake painted formed part of a series of over 150 illustrations to the Bible commissioned by Thomas Butts. They were begun in 1799 and completed during Blake's period in Felpham, which ended in 1803. In a letter to George Cumberland, dated 26 August 1799, Blake wrote: 'I am Painting small Pictures from the Bible . . . My Work pleases my employer & I have an order for Fifty small Pictures at One Guinea each.'[11] Of the fifty original pictures, approximately thirty have survived, and fifteen were recently examined.[12]

The majority of the examined temperas in this group are of similar dimensions at approximately 10½ x 15in (28 x 38cm),[13] with the exception of two slightly larger works, *The Miracle of the Loaves and Fishes* (B416, private collection) and *The Baptism of Christ* (B415, Rhode Island School of Design). Most are painted on canvas, although three are on copper and one on tinned steel, which Blake appeared to abandon as a support after this series. The temperas from this series are quite delicately painted, highly coloured and show varying levels of complexity with respect to paint application.

The Body of Christ Borne to the Tomb (fig.79) is one of Blake's best-preserved temperas from the 1799–1800 Bible series and has been painted on his typically light, fine-weave linen canvas, which was almost certainly prepared by Blake himself. The edges of the painting have been trimmed by at least a few millimetres, as have most of the temperas on canvas, and the canvas has been lined onto cardboard, the original stretcher having been discarded. It is signed 'WBinu' in monogram at the lower left, in what is probably Indian ink over the green foreground (fig.80). This is characteristic of the signatures on this series.

As is the case for most of Blake's temperas, this painting has a restoration history that very probably dates to the second half of the nineteenth century and has ensured that most of the original evidence for Blake's canvas preparation has either been removed or blocked by a succession of treatments. However, evidence of Blake's canvas preparation methods has been gleaned from the small tempera painted in *c*.1800 by Catherine Blake, *Agnes* (BNO.C1, Fitzwilliam Museum, Cambridge).[14] This tempera is one of the few remaining unlined paintings by either of the Blakes, and the rough workmanship of the stretcher does not suggest it was made by a professional. *Agnes* also provides a clue as to how Blake prepared his canvas, as there is evidence that the canvas was roughened

FIG.79 *The Body of Christ Borne to the Tomb c.*1799–1800. Tempera on canvas, mounted on cardboard 26.7 x 37.8cm. B426, T39 Tate N01164

prior to the application of an animal glue size.

Once the canvas was fully prepared, Blake always applied a white priming layer with a tool such as a palette knife or large brush. This served the same purpose as the paper in watercolour painting, that is to reflect light back through the transparent paint layers in order to intensify colour, to create a contrast for the black line-work and to serve as the white areas of the composition.

Blake's priming layers were identified as containing a relatively wide range of white materials, which may reflect something of Blake's poverty and his intermittent purchasing of small amounts of materials and/or a lack of concern about the exact nature of his whites. Natural chalk (whiting, calcium carbonate) was the most commonly identified pigment, or occasionally the similar-looking white pigment gypsum (hydrated calcium sulphate). Some of these pigments also included extenders such as kaolin and barytes (barium sulphate), which were added by the manufacturer to decrease costs. Analysis of several samples identified the priming medium as pure animal glue, with the addition of a little unrefined sugar or raw honey, which would have been added to prevent cracking. However, the additional presence of Blake's standard plant gum mixture (analysed in the few colour prints that could be sampled) of Arabic or karaya and tragacanth was also confirmed in many of the priming samples, which suggests that Blake may have deliberately included the gums in the medium, although it is also possible the gums

FIG.80 Closeup detail of the 'nv' of 'inv[enit]' in Blake's monogram on *The Body of Christ* . . . (fig.79).

may have soaked into the ground layer from the paint layers above.

Smith recorded that Blake applied his priming in several thin coatings,[15] but no layers could be discerned within any of the paint cross-sections from *The Body of Christ* . . . , suggesting that he applied the mixture in a relatively fluid state. However, two other temperas from the same time period, *Christ Giving Sight to Bartimaeus*, 1799–1800 (B420, Yale Center for British Art, New Haven), and *Cicero*, 1800–3 (B343.3, Manchester City Art Gallery), show evidence of Blake's priming application by the presence of vertical striations. This indicates that Blake may have applied each successive priming layer in opposing directions, as practised by early Renaissance panel painters.[16] What is clear is that he would have applied the warmed chalk mixture onto the painting while it lay flat, to allow the layers to settle between applications. In addition, his priming layers appear grainy, with numerous tiny air bubbles, which are known to be caused by the overheating of the priming mixture[17] and/or hurried brushing.

Blake then began his under-drawing, which for the majority of the temperas appears to have been carried out with either dilute ink or dilute paint. He preferred to sketch outlines and suggest prominent features of the composition, most of which were still visible in the finished work, rather than create elaborately finished drawings, which offers insight into his belief in his initial concept. This was related by one of his followers, Samuel Palmer, who stated that Blake was 'always most careful not to depart from his "first inventive lines"'.[18]

Blake then sealed both his priming and under-drawing with a layer of animal glue, probably made from rabbit skin or glove clippings, containing a portion of sugar or honey. By applying the glue layer, he protected the layers from saturation with subsequent applications of paint and resin varnish. This sealing layer may also have served as the lower layer of an animal glue 'sandwich', within which Blake intended to 'seal' his colours, because he believed that glue 'stands the sun, and change of atmosphere has no effect on it'.[19]

After this glue layer was dry, Blake began to apply his colours, which tended to follow a general sequence of alternating pigmented layers and unpigmented layers of animal glue. Smith described this in his account of Blake at work on a tempera: '[He] would, in the course of painting a picture, pass a very thin transparent wash of glue-water over the whole of the parts he had worked upon, and then proceed with his finishing.'[20] Blake probably applied the glue sealing layers as an attempt to prevent the pigmented layers from cracking and to 'seal' the recently applied colours, protecting them from dissolving, bleeding or blending with the next layers. The visual effect of the glue layering is

particularly noticeable in finishing glazes, as shown in fig.81, which has resulted in Christ's vermilion wound appearing as if it were 'floating' over the background.

Interestingly, medium analysis carried out on Blake's pigmented layers consistently revealed the presence of plant gums, which directly contradicts Frederick Tatham's account of Blake's rejection of plant gums because of their 'tendency to crack'.[21] Several samples from *The Body of Christ Borne to the Tomb* were identified as containing the mixture of gums, Arabic or karaya and tragacanth, with the addition of sugar or honey, that appears to have been used in every tempera. In Blake's era sugar would not have been refined and honey would have been used 'raw'.

FIG.81 Closeup detail of Christ's wound in *The Body of Christ . . .* (fig.79).

Gum Arabic is an expected component of watercolour paints because of its dominant use in watercolour painting and superior water-solubility, and the addition of gum tragacanth, the second most commonly used but relatively expensive gum, would impart greater body, adhesion, film strength and 'water fastness' to a gum Arabic-based paint.[22] Blake probably encountered gum tragacanth during his engraving apprenticeship and through his introduction to miniature painting, where gum tragacanth was often preferred because it 'allow[ed] tints to be repeatedly laid without moving or washing up'.[23] Hence, a mixture of gums Arabic and tragacanth would render Blake's paints better able to withstand his multiple applications of warm, water-based, animal glue.

The presence of karaya gum as a deliberate component of Blake's tempera paints was initially dismissed because it does not appear to have been imported into Britain on a regular basis until the mid- to late nineteenth century. However, it was retained in the interpretation of the analytical results for two reasons: firstly, because of the possibility of the early use of karaya gum, also known as 'Indian tragacanth',[24] as an adulterant in gum tragacanth, and secondly, because the analytical technique of GC-MS could not distinguish it from gum Arabic, when in a mixture with gum tragacanth.[25]

The analytical results suggest that Blake probably used the gum mixture as the primary medium for his colours and simply sealed his paint layers with layers of unpigmented animal glue. However, the examination of several cross-sections clearly revealed that some of the pigmented layers, usually the upper glazes, also contained animal glue, which Blake may have added to achieve a well-bodied, smoother finish and/or as an attempt to prevent the cracking and flaking associated with gum-based paints. The practice of adding glue to his paints is reflected in Smith's account, that Blake 'ground his colours himself, and also united them with the same sort of glue [as he used for the sealing layers], but in a much weaker state'.[26]

As a result of the merging and thinness of Blake's paint layers, it was not possible to determine the exact method by which he mixed his gum and glue paint media, although

there are a number of viable possibilities. Blake may have ground his pigments into the mixed gum mucilage and added the warmed glue on the palette to dilute the colours when required. Alternatively, he may have prepared gum-based colours and added them to warmed pots of animal glue, or he may have prepared his paints in the animal glue medium, which he then kept warmed in separate pots for each colour, and mixed them into the dry or liquid gum mixture, on the palette. Lastly, Blake may have prepared a gum/glue mucilage as the primary binder and then added animal glue and/or gum to dilute or add body to the colours only when desired. Indeed, in 1835 George Field the colourman listed a plant gum/animal glue medium for watercolour painting prepared by adding as much gum (Senegal/Arabic) to liquid glue 'as it will conveniently take up'.[27] However, as mentioned above, if Blake did use this kind of glue-gum mucilage, the advantages of adding gums Arabic, tragacanth and even cherry gum into a solution where the resulting physical properties would be dominated by the animal glue are less certain. What is clear is that Blake would have worked with the supports laid flat in order to prevent the flow of the congealing paints and to promote the smooth, enamel-like quality he was striving to achieve, and that warmed pots of animal glue must have been at hand.

Blake's palette contained over twenty pigments, which were used fairly consistently throughout his life, as he appears to have shied away from any newly developed ones. Although not an exhaustive list, those identified in *The Body of Christ Borne to the Tomb* include some of Blake's more commonly used colours such as Prussian blue, yellow gamboge and opaque red vermilion. Additional pigments identified over the range of temperas include ultramarine blue, an organic blue (possibly indigo); red lead, madder, Mars red, a red lake; yellow ochre, possibly Indian yellow, possibly deep yellow orpiment; an organic green (probably sap green), mixed greens made with Prussian blue and gamboge; Mars browns, umber, a resinous brown earth (probably Van Dyck); chalk or whiting, bone black; shell gold, gold and silver leaf (both used on their own), and a silver-gold alloy leaf.

Blake generally preferred not to mix his pigments, probably to avoid the muddying of tone that can result.[28] In this, Blake followed the watercolour-painting rule (which can be derived from experience as well as from theoretical knowledge) that 'a much purer compound hue may be produced by passing one tint of different chemical character over another, than by applying them mixed together'.[29] Therefore, Blake preferred to create changes in colour, tone and form by a number of methods including increasing the pigment content of the paints, diluting his colours, applying contrasting passages in primary colours, mixing chalk or bone black with pure colours, and stippling, glazing, scumbling and hatching over areas with other, pure colours (fig.82).

The Body of Christ Borne to the Tomb, as for most of the temperas, was begun by the blocking in of colour with light washes, with very little overlap from one passage to the next, followed by the application of delicate glazes. The lack of turbidity and wet-in-wet paint passages was also achieved by leaving the paint layers to dry fully between

applications, a practice that was confirmed by the presence of thin layers of dirt between layers, found in several of the cross-sections examined.

As was the practice in eighteenth-century water-colour painting, Blake created his greens by layering glazes of gamboge over Prussian blue. This can be clearly seen in the foreground area, where the passage varies from the deep blue-green at the two lower corners to the bright yellow green in the centre, which has been additionally modelled with small strokes of

FIG.82 Detail of the vase carried by Joseph of Arimathea (the figure with the long white beard) in *The Body of Christ* . . . (fig.79).

red. In the same way Blake created the background foliage, by applying gamboge and Prussian blue over the earth browns and umbers of the tree trunks.

The figures and fabrics in Blake's temperas are mostly lightly glazed, with a reliance on the priming for the light colours. The two rightmost figures in *The Body of Christ* appear to be painted with the same Prussian blue pigment as used in the sky and the leftmost figure is probably painted with red ochre. Blake's skin tones in tempera are usually, although not always, lightly pigmented and generally consist of yellow ochre and/or gamboge with vermilion, red lead and Mars red glazes, as well as very light touches of Prussian blue or ultramarine for the shadows, as seen in this work (fig.83).

After the bulk of the colour had been applied, with most of the temperas Blake then used a black ink, which in one case was identified as a printers' ink by the presence of drying oils, to reinforce the lines of his under-drawing. This was often applied in conjunction with the impasto, chalk-based white paint, which Blake also regularly used in the final stages of painting to highlight faces, hands, feet, hair, fabric folds, decorative elements, architectural features and landscape backgrounds, as shown in fig.84. The X-radiograph of *The Body of Christ* . . . , fig.85, shows the thicker areas created with the impasted white, such as the outlines of the figures and foliage, as well as the two gourds carried by the bier-bearer holding the staff and the central figure.

These highlights were consistently identified as chalk bound in animal glue (and

FIG.83 Detail of the toes of Joseph of Arimathea in *The Body of Christ* . . . (fig.79).

FIG.84 Detail of Christ's crown of thorns in *The Body of Christ* . . . (fig.79).

possibly the gum mixture), which strongly resembles the recipe for 'Blake's white', discussed earlier (p.42) and recorded by Samuel Palmer in a letter dated in 1866:

Blake's White.
Get the best whitening – powder it.
Mix thoroughly with water to the consistency of cream.
Strain through double muslin. Spread it out upon backs of plates, white tiles are better, kept warm over basins of water until it is pretty stiff.
Have ready the best carpenters' or cabinet makers' glues made in a very clean glue pot, and mix it warm with the colour:- the art lies in adding just the right portion of glue. The TEST is, that when dry upon the thumb nail or on an earthenware palette it should have so much *and no more* glue as will defend it from being scratched off with the fingernail.
This, and the cleanliness of the materials are the only difficulties.[30]

Palmer also remarked that he had 'tried Russian isinglass which has less color, but does not work so pleasantly as the glue',[31] and also recommended 'Mrs Blake's white' to George Richmond in 1828, when he stated that it 'is brighter, and sticks faster than chalk; and it seems such a quick way of getting a showy, but really good effect'.[32]

FIG.85 X-radiograph of *The Body of Christ* . . . (fig.79). These figures must have been outlined with an ink that absorbed x-rays, as discussed on p.87 for large colour prints.

At the final stages of painting, these white highlights were often followed by additional reinforcement of the line-work in black ink, and then occasionally the addition of more white highlights and delicate glazes, until the painting was complete. After this, Blake appears to have applied a final coating of animal glue, as recorded (and noted earlier, p.43) by Tatham. He applied this final layer in order to seal or 'fix' his colours, and to protect the paint layers and priming from saturation with spirit varnishes, as commonly used by watercolour artists of the day.[33]

Catherine Blake's correspondence, noted in an earlier chapter (p.43), provides the only evidence that Blake may have varnished at least some of his temperas with resin, though none of the extant varnishes examined in this study is original. The 'white, hard varnish' she mentioned was probably a spirit varnish, a natural resin dissolved in solvent, as opposed to an oil varnish. Major artists' colourmen throughout the nineteenth century did sell products known as 'white spirit varnishes' or 'white hard varnishes'.[34] Most of these products were alcohol-based, and were said to contain sandarac and mastic resins, with the best ones including copal, benzoin or amine resins, and plasticising materials such as gum Elemi and Venice turpentine.[35] They may have originally been intended for varnishing paper objects.

A second painting from the 1799–1800 Bible series, *The Agony in the Garden* (fig.86), is of similar dimensions, and is again signed 'WBinv' in monogram, at the lower right in white, although the signature is damaged. The materials and technique used for this

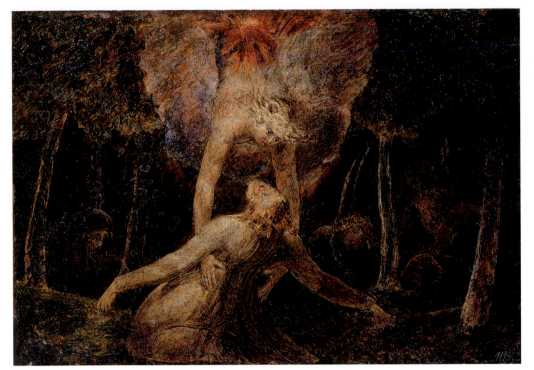

FIG.86 *The Agony in the Garden* c.1799–1800. Tempera on tinned iron with chamfered corners. 27 x 38cm. B425, T38 Tate N05894

tempera are similar to the others, though this painting has some unique features associated with the painting support. The first is Blake's use of tinned iron,[36] which is unique to this painting, and the second is the layer of red lead applied directly onto the metal support, as shown in fig.87. Blake's metal supports that we examined were 'sealed' with a layer of red paint bound with the standard gum mixture and animal glue, which was probably intended as a corrosion inhibitor and as a better adhesive surface for the priming layer. However, ironically, Blake's sealing layers appear to have offered little protection against corrosion and did not provide adequate adhesion for the overlying paint layers, which has led to widespread paint delamination, as will be discussed later.

FIG.87 *The Agony in the Garden* (fig.86): closeup detail of the red layer applied over the support.

However, since they obviated glue linings, these temperas on metallic supports facilitated the analysis of his original animal glue, which was confirmed in several paint samples and cross-sections from *The Agony in the Garden*, such as fig.88. This clearly shows a thin layer of glue just above the priming that has the characteristic white fluorescence of animal glue, with a thick, glue-bound, partially dislodged layer at the top of the sample.

Another unusual feature in *The Agony in the Garden* is the additional presence of cherry gum in Blake's gum mixture, identified in two of the eight samples analysed. Cherry gum and other *Prunus* gums are most

FIG.88 *The Agony in the Garden* (fig.86): cross-section photographed in ultraviolet light at x 250, showing Blake's use of glue layers over the priming and as thick interlayers between pigmented layers.

FIG.89 Detail of the trees in *Abraham and Isaac c.*1799–1800. Tempera on canvas 26 x 37.5cm. B382 Yale Center for British Art, New Haven

closely associated with medieval manuscript illumination. For example, cherry and almond gums are mentioned in the *Strasbourg Manuscript*, where the former is described as producing a 'stronger, clearer paint' than gum Arabic, to give an 'enamel effect'.[37] Doerner also recommended mixing cherry gum with gum tragacanth and isinglass 'for a good tempera paint',[38] indicating that cherry gum was used in tempera paint formulations well into the nineteenth century and that therefore Blake's use of it may not have been unusual.

The foreground of *The Agony in the Garden* also shows Blake's characteristic application of the chalk priming mixture onto the priming layer in order to build form and texture into specific areas of the composition, such as foliage. This is best illustrated in *Abraham and Isaac* (B382, Yale Center for British Art, New Haven), a detail of which in fig.89 shows Blake's build-up of chalk beneath the blue and yellow glazes.

Another of the Bible series on metal is *Eve Tempted by the Serpent* (fig.90), which is

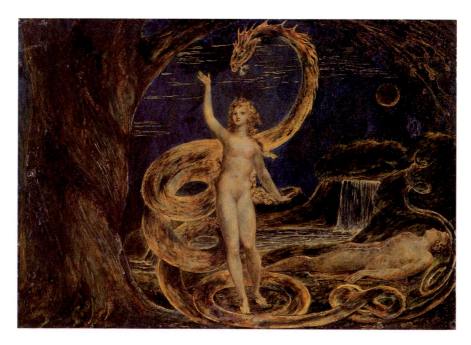

FIG.90 *Eve Tempted by the Serpent c.*1799–1800. Tempera on copper 27.3 x 38.5cm. B379 The Victoria and Albert Museum

painted on a copperplate of comparable dimensions to the other temperas. It is signed at the lower left in black ink with 'WBinv' in monogram with no accompanying date. Blake's materials for this painting are similar to those used in most of the other temperas, though the impasted white appears to be more dominant. This painting is the only one in this series where Blake used shell gold. The paint layers also appear to be very dense, which is the result of what appears to be a larger number of paint layers. For example, the cross-section in fig.91 shows approximately seven thin layers of paint above the priming and also, clearly, Blake's application of glue between paint layers.

FIG.91 Cross-section in ultraviolet light from *Eve Tempted by the Serpent* (fig.90), photographed at x 200, showing Blake's application of several thin layers of paint and animal glue (illumination uneven).

The 'Heads of Poets' series: c.1800–3

The second group of temperas consists of eighteen portraits known as the 'Heads of Poets', which were painted between 1800 to 1803 while Blake was living in Felpham as a guest of the poet, biographer and patron of artists, William Hayley. Butlin lists these pictures as forming a part of the 'uncongenial projects found him by the well-meaning but uncomprehending Hayley' and apparently destined for the library at Hayley's house, The Turret.[39]

In a letter to Hayley dated 26 November 1800 Blake wrote that he was 'absorbed by the poets Milton, Homer, Camoens, Ercilla, Ariosto and Spenser, whose physiognomies have been my delightful study'.[40] The pictures are all painted on canvas, unsigned and of various sizes, presumably to fit the decorative scheme of the library. The final scheme included nine English poets and nine from other countries, and may have been created as a memorial to Hayley's son Thomas Alphonso, who died in 1800. Butlin suggests that the tempera *Thomas Alphonso* (B343.18) probably formed the centrepiece, over the fireplace on a short wall, with *Homer* (B343.1) and *Milton* (B343.11), *Demosthenes* (B343.2) and *Cicero* (B343.3), and *Camoens* (fig.92) and *Chaucer* (B343.5) as pendants, and the other heads hung in pairs.[41]

Gilchrist reported that by 1830 some of the group were in bad condition.[42] Nonetheless, they were acquired by Manchester City Art Gallery in 1885 after being heavily restored. This had involved glue lining and overpainting in oils, which had been done so completely that they were listed as oil paintings in an 1884 sales catalogue.[43] In most cases the analysis of materials and particularly the identification of original protein have been restricted by these multiple glue linings and oil retouching. However, Blake's style, materials and technique appear to be particularly consistent throughout this series.

The portrait of the Portugese poet Luis Vaz de Camoëns shown in fig.92 is one of

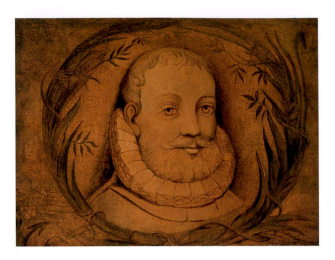

FIG.92 *Luiz vas de Camoens* c.1800–3. Tempera and pen and ink on canvas 41.5 x 56.5cm. B343.6 Manchester City Art Galleries

the pictures mentioned by Blake in his letter of 26 November 1800. This tempera has vertical striations in the priming as well as a highly visible ink under-drawing, which is particular to this series. Blake's paint medium was again identified as a mixture of gums Arabic or karaya and tragacanth. However, the occasional sample also contained a higher proportion of gum tragacanth, which indicates that Blake may have adjusted the medium according to the paint passage or pigments used. Animal glue was also identified in the paint medium, as it was between pigmented layers.

The paint application in this series appears looser than in the more delicately painted Bible series temperas, which reflects both the commission and larger dimensions of these pictures. Most have the appearance of monochrome ink drawings, where the poets' faces are painted as tonal studies in grey and brown washes, with the wreaths and accompanying poetical scenes often coloured with intense daubs of vermilion, organic red, Prussian blue and gamboge glazes, alongside ultramarine and possibly indigo background washes. Chalk-based white highlights and black ink definition are used to finish the designs, but gold does not appear to have been used in any of the temperas in this series.

Blake's paint layering involves thicker priming layers and fewer paint layers than seen in the Bible series, although the use of the chalk priming mixture to build form and texture is a common feature. In addition, the structure of temperas such as *Camoens* and *Chaucer* has been made more complex by the presence of what is possibly an abandoned image underneath the final design, as represented by a cross-section from *Camoens* (fig.93), where the first priming and blue paint layers were completely covered over by the second chalk priming. An underlying image is even more evident in the tempera *Chaucer*, where the previous ink drawing can be seen in areas of loss to the overlying paint layers.

FIG.93 Schematic of cross-section from a background leaf decoration in *Camoens* (fig.92), showing the presence of a blue layer underneath the current painting and the addition of a second ground layer. This suggests that Blake may have covered an earlier image to proceed with the current one, i.e. that he re-used this canvas.

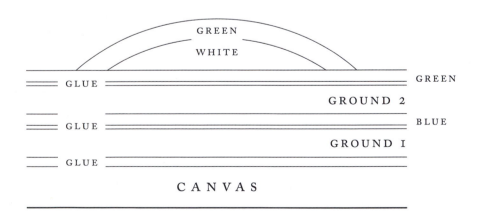

TEMPERAS

The 1809 exhibition: 1805–9

Blake exhibited nine temperas, mostly painted between *c*.1805–9, in his one-man exhibition at 28 Broad Street, Golden Square (figs.3a and 3b) , held in 1809. These were the first of the temperas not to be painted on commission, and represent Blake's most determined attempt to establish himself as a painter. Blake summed up the scope of the exhibition in the full title of his accompanying publication, *A Descriptive Catalogue of Pictures, Poetical and Historical Inventions, Painted by William Blake, in Water Colours, Being the Ancient Method of Fresco Painting Restored: and Drawings, For Public Inspection, and for Sale by Private Contract.*[44] Hence, these paintings were exhibited to illustrate Blake's artistic, religious and political beliefs, with the aim of widening his audience, gaining a reputation as a painter and securing sales.

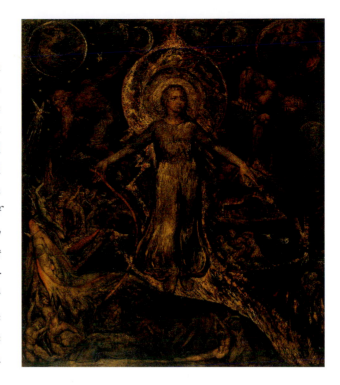

FIG.94 *The Spiritual Form of Pitt Guiding Behemoth* (?)1805. Tempera heightened with gold on canvas 74 x 62.7cm. B651, T59 Tate N01110

Most are signed 'W. Blake' in black or brown and are accompanied by a date, although as a result of damage some dates are now partiallyillegible. Despite the marked discoloration of some of the group, Blake's intricate compositions are still visible through dramatic use of reds and blues and extensive use of gold leaf.

Blake described his intention in using fresco for the pair of *Spiritual Form* pictures, *Pitt Guiding Behemoth* (fig.94) and *Nelson Guiding Leviathan* (fig.137), in the *Descriptive Catalogue*, which also indicates that he had general concerns about the longevity of painting materials: 'The Artist wishes it was now the fashion to make such monuments, and then he should not doubt of having a national commission to execute these two Pictures on a scale that is suitable to the grandeur of the nation, who is the parent of his heroes, in high finished fresco, where the colours would be as pure and as permanent as precious stones though the figures were one hundred feet in height.'[45] With these paintings, Blake used the same materials as he had earlier; but his use of gold leaf increased markedly, which undoubtedly reflects their importance as exhibition pieces. The gold leaf (fig.95) was used as an intermediate paint layer to increase the intensity of colour by reflecting light back through the overlying glazes, and as a final decorative layer in conjunction with shell gold, which was also applied to many areas, including flesh passages. Figs.96 and 97 illustrate and describe the layer structure of the

FIG.95 Closeup detail showing gold leaf and a red glaze used in *The Spiritual Form of Pitt . . .* (fig.94).

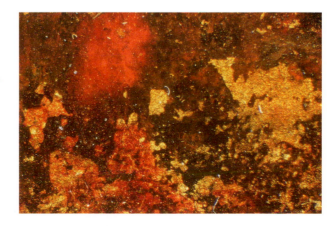

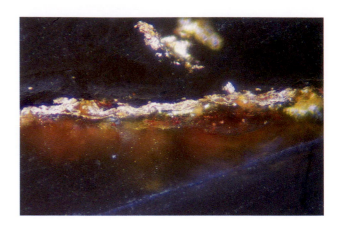

FIG.96 *Pitt Guiding Behemoth* (fig.94): cross-section from a gold leaf area, photographed at x 320, showing a thick layer of gold leaf, applied onto an oil size and worked into the surface, probably with a brush.

FIG.97 Layer structure of a cross-section containing gold leaf, from *Pitt Guiding Behemoth* (fig.94).

transparent layer	resinous varnish
dirt	
thick gold leaf (mixed together by surface burnishing)	burnished or otherwise disrupted, or might be 2–3 leaves of gold stuck together
thin yellow size layer	oil size with yellow ochre
glue	ultraviolet fluorescence
thin red paint	vermilion
glue	ultraviolet fluorescence
under-drawing	small, round particles
white priming?	well soaked with glue from the medium and/or from the lining, which makes it look very insubstantial

cross-section containing gold leaf. In this case the leaf appears to have been applied to an oil size and worked into the surface, probably with a brush.

Blake's use of gold is also often associated with the pigment vermilion as an under-layer, which had been recommended in watercolour painting manuals as a dark base tone for 'shady parts of the picture' prior to the application of shell gold.[46] However, in some cases Blake's chalk-based white was also used as both a preparatory and texturing layer prior to the application of both gold leaf and shell gold. Blake's occasional practice of inscribing/scraping to reveal the white priming beneath can be seen in *The Spiritual Form of Pitt Guiding Behemoth* as shown in fig.98, where the upper paint layers were broken to form the lighter centre of a small flower in the background.

As mentioned, most of the temperas in this group are markedly discoloured, which is primarily the result of Blake's use of thicker glue layers and medium-rich paint, to be discussed in the next chapter. A cross-section removed from *The Bard, from Gray*, 1809? (fig.132), shown in fig.99 and described in fig.100,[47] illustrates the main cause of this discoloration: the presence of several layers of glue and the accumulation of surface dirt.

This clearly illustrates Blake's practice of layering animal glue over recently painted passages, and the dirt layers also confirm that significant periods of time must have passed between paint applications, which is not surprising, as Blake is reported to have returned to his works for periods of years after they were commenced.[48]

The identification of a gold-silver alloy leaf in two of the temperas from this group, including *The Bard, from Gray* and *Satan calling Up His Legions – An experiment Picture, ?c.1795–1800* (figs.102 and 131), renders Smith's rejection of Blake's use of silver leaf in the (now lost) tempera, *The Last Judgment* (B648), a little less certain.[49] However, Smith's accompanying description of Blake's use of coloured glazes to alter the tone of the leaf appears to be accurate, and is particularly visible in this group of temperas.

The Bard, from Gray also clearly shows Blake's over-layering of two pigments of the same colour to create his intense, enamel-like effects. For example, fig.101 shows how

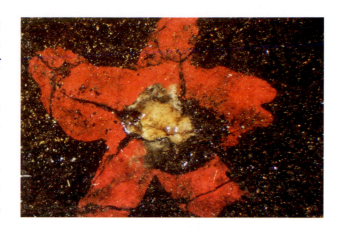

FIG.98 Detail of a flower from *The Spiritual Form of Pitt Guiding* (fig.94).

FIG.99 A, B Cross-section from blue paint at right edge in *The Bard, From Gray* ?1809 (fig.132), tempera on canvas, photographed at x 320 visible light (fig.99A) and in ultraviolet light (fig.99B), showing several layers of glue in the upper portion separated by layers of dirt. This suggests that Blake left decent time intervals before reworking some of his images.

glue	ultraviolet fluorescence
yellowed, thick coating	fluorescence suggests a natural resin
dirt	
glue	ultraviolet fluorescence
dirt?	
glue	ultraviolet fluorescence
blue paint	Prussian blue in chalk or other material, possibly glue, as seen (sunk?) into the layer beneath
glue	ultraviolet fluorescence
priming? paint?	glue and chalk, with a few patches of vermilion
dirt	

FIG.100 Layer structure of a cross-section of blue paint from *The Bard, from Gray*.

Blake depicted blood by layering a thick transparent organic crimson glaze over an opaque vermilion passage, a method described by Cennini for painting wounds,[50] and used by many artists since then.

Blake referred to three of his 'frescoes' included in the 1809 exhibition as 'Experiment Pictures'. They were begun as experiments in painting technique and were intended to be 'painted at intervals, for experiment on colours, without any oil vehicle'.[51] However, Blake describes the outcome in the following passage from the *Descriptive Catalogue*:

FIG.101 Closeup detail of two blood-red areas from the river of blood, *The Bard, From Gray* (fig.132).

'These Pictures, among numerous others painted for experiment, were the result of temptations and perturbations, labouring to destroy Imaginative power, by means of that infernal machine, called Chiaro Oscuro, in the hands of Venetian and Flemish Demons ... They cause that the execution shall be all blocked up with brown shadows. They put the original Artist in fear and doubt of his own original conception.'[52] From this it appears that Blake did not intentionally set out to lose 'lineaments' and block-up all light with these experiments,[53] although his purpose in including these pictures in the exhibition was clearly instructive as has been discussed earlier (p.24). By showing the audience the results of becoming influenced by 'Venetian and Flemish demons' and without changing any materials, he was able to demonstrate the resulting loss of lineament and the muddying of intention, which served to reinforce his accompanying artistic theory. However, Eaves ascribed a more political motivation to their inclusion in the exhibition, suggesting that Blake created the experiment pictures to mock Reynolds's emulation of the old masters and to follow in his own way the Royal Academy's 'scientific' approach to the creation of 'good art' (see p.29–30).[54]

According to Essick it was only later, as the paintings started to get worse and worse with more labour, that Blake realised that he had been heading in a wrong direction.[55] Indeed, Blake wrote of his tempera, *Satan calling Up His Legions – An experiment Picture* (fig.102): 'it may be worthy of attention, not only on account of its composition, but of the great labour which has been bestowed on it, that is, three or four times as much as would have finished a more perfect Picture; the labour has destroyed the lineaments, it was with difficulty brought back again to a certain effect, which it had at first, when all the lineaments were perfect.'[56] A comparison of the experiment picture with the more finished version of the same image painted, possibly some years later, for the Countess of Egremont, *Satan Calling up his Legions*, *c.*1800–1805 (B662, The National Trust, Petworth House), shows that the latter painting clearly has stronger lineaments, which have been achieved by Blake's use of thinner paint layers, a more restrained use of gold and far fewer layers of animal glue between paint applications.

The 1809 exhibition also included *Sir Jeffery Chaucer* . . . ?*c.*1808 (fig.103). This tempera was clearly intended as a showpiece and is one of Blake's greatest achievements with respect to paint application, design and technical skill, including examples of his intricate use of shell gold, chalk white highlighting and ink definition. In a famously bitter episode from his life Blake claimed that, after seeing his design, Cromek commissioned Thomas Stothard to paint a version, and speculation still exists as to which of the three men, Blake, Stothard and Cromek, had the original idea, with each having their own story about the alleged deceptions that followed.

This painting has an unusual appearance for the 1809 group, as it is much less laboured, more intricate, less discoloured and in a different format from the other temperas in the exhibition. Even more unusually, the canvas has escaped being lined, which is almost certainly because Blake appears to have glued the reverse of the canvas to the stretcher bars. This was proably caused by the application of animal glue during Blake's canvas preparation process, although it is difficult to discern whether the adhesion was intentional.

The absence of lining also presented an opportunity to analyse the paint for the presence of original animal glue, which was positively identified in several paint samples as well as in the final layer, where small pools of glue had remained on the surface. Blake's characteristic gum mixture was also identified, as were the organic pigments gamboge, a red lake and probably indigo. More unusually, Blake appears to have used silver instead of gold for his impressive powdered metallic highlights, which have been very delicately applied to the lettering on the Tabarde Inn, the horses' eyes, hair, facial features and many other decorative elements throughout the composition.

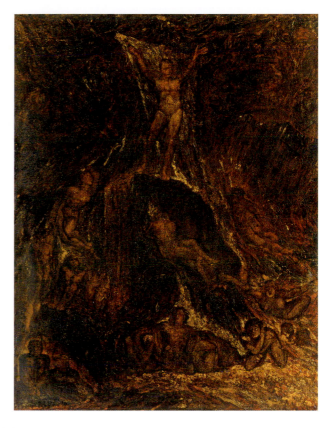

FIG.102 *Satan calling Up His Legions – An experiment Picture c.*1795–1800. Tempera on canvas 52.1 x 41.9cm. B661 The Victoria and Albert Museum

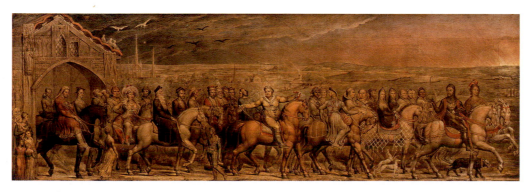

FIG.103 *Sir Jeffery Chaucer and the nine and twenty Pilgrims on their journey to Canterbury* ?*c.*1808. Tempera on canvas 46.4 x 135.6cm. B653 Glasgow Museums: The Stirling Maxwell Collection, Pollok House

Five temperas of 1810–11

Blake produced this group of five paintings between 1810 and 1811. The four temperas painted in 1810 were probably commissioned by Thomas Butts, and the fifth, Blake's largest surviving tempera, *An Allegory of the Spiritual Condition of Man* (B673, Fitzwilliam Museum, Cambridge), was painted in ?1811.

Adam Naming the Beasts (fig.104) was painted as a companion piece to *Eve Naming the Birds* (B668, Glasgow Museums) and, at 75 x 62.2cm, it has dimensions similar to all four of the 1810 paintings. It is signed 'Fresco by Will^m Blake 1810' in brown paint in the

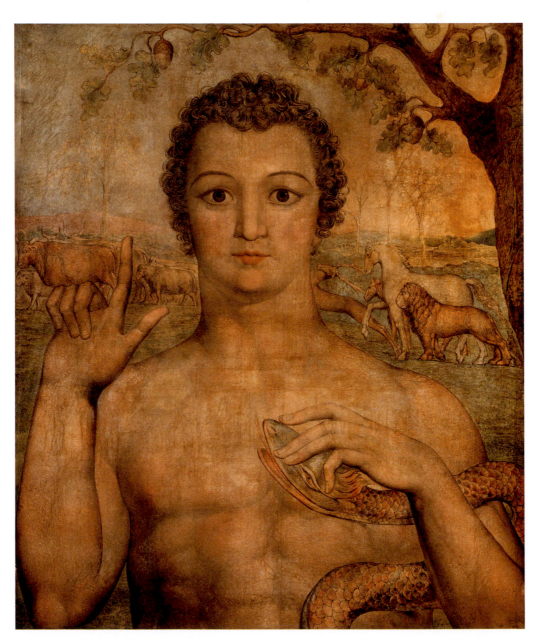

FIG.104 *Adam Naming the Beasts* 1810. Tempera on canvas 74.9 x 61.1cm. B667 Glasgow Museums: The Stirling Maxwell Collection, Pollok House

tree-trunk at the side of the composition, which is also the case for *The Virgin and Child in Egypt* (B669, Victoria and Albert Museum, London). However, the first part of Blake's signature on *An Allegory of the Spiritual Condition of Man* has been slightly abbreviated, to 'Wᵐ Blake 1811'.

All five pictures are lightly coloured when compared the majority of the temperas in the 1809 exhibition, with thin, fine watercolour washes, light glazes, monodirectional hatching and clearly dominant line-work,

FIG.105 Detail of *The Virgin and Child in Egypt* 1810 (tempera on canvas (76.2 x 63.5cm); B669, Victoria and Albert Museum, London), showing ink lines in the hair.

which produce the overall effect of a coloured drawing on canvas. The paint medium in *Adam Naming the Beasts* as well as *An Allegory of the Spiritual Condition of Man* was again identified as a combination of the usual gum mixture and animal glue, and the pigments appear to belong to Blake's standard palette, although perhaps with less use of Prussian blue. Blake also appears to have decreased his use of gold and chalk-based white highlights, and correspondingly increased his reliance on the use of ink, as is clearly shown in another tempera from the group, *The Virgin and Child in Egypt* (fig.105).

Late temperas c.1818–26

This last group, dated from *c.*1818 to 1826, includes two small temperas on a mahogany-type tropical hardwood panel, which are the first of Blake's temperas to be painted on wooden panel supports. *The Ghost of a Flea* (fig.106) was produced during Blake's collaboration with the watercolourist and astrologer John Varley from *c.*1819 to 1825 to create the 'Visionary Heads'. This is one of Blake's smallest temperas at 21.4 x 16.2cm and is signed 'W Blake Fresco' in shell gold at the lower right (fig.107). It is minutely drawn, with the real flea sitting between the ghost's lower legs (fig.108), which clearly reflects Blake's technical skill during this later period. However, the style and colouring, as well as the condition and appearance of this painting, closely resemble the temperas from the 1809 exhibition, rather than either the group painted in 1810–11 or the temperas painted from 1821 onwards. With *The Ghost of a Flea*, Blake returned to the use of a silver-gold alloy leaf, first identified in two of the temperas in the 1809 exhibition, as an under-layer for the curtains and flesh tones, as well as the stars and comets in the background (fig.109). In parts Blake also left the priming layer unpainted to create white areas such as one of the background stars, and glazed the metal leaf with both warm and cool paints in order to alter their tone.

Apart from Blake's usual gum mixture and animal glue, the medium analysis also revealed the presence of small amounts of cherry gum in every sample removed from this painting. As this was only previously identified in two samples removed from *The Agony in the Garden* (B425, T38, Tate),[57] it is possible that Blake added cherry gum specifically to

FIG.106 *The Ghost of a Flea* c.1819–20 Tempera heightened with gold on mahogany 21.4 x 16.2cm. B750, T64 Tate N05889

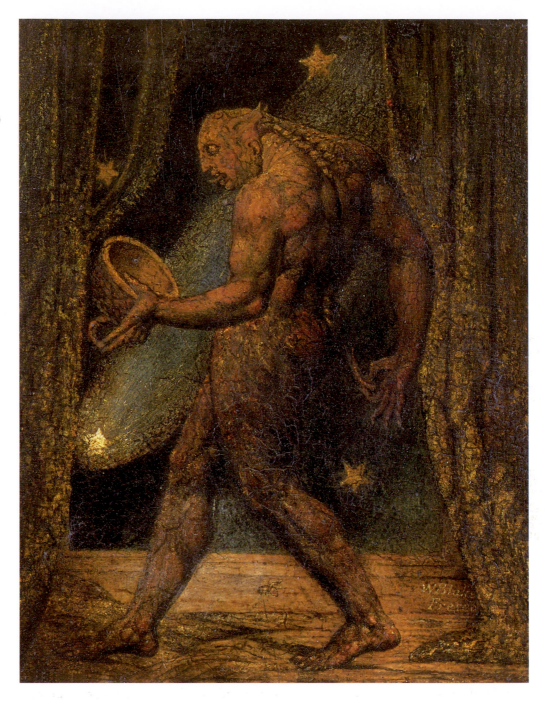

this painting, in order to increase the hardness and gloss of his paints, or, perhaps more simply, he had depleted his supply of gum tragacanth. In addition, he was working closely with Varley during this period and it may have had some influence on Blake's materials. By this stage Blake had adapted his painting supports, possibly the result of having witnessed the deterioration of some of his earlier temperas on canvas, and hence by adding cherry gum to the mixture, he may also have been aiming to improve the physical characteristics of his paint.

FIG.107 Blake's signature on *The Ghost of a Flea* (fig.106).

FIG.108 Detail showing the flea itself in *The Ghost of a Flea* (fig.106).

FIG.109 Closeup detail of part of a star in *The Ghost of a Flea* (fig.106).

Another late tempera on a tropical hardwood panel is *The Virgin and Child* (B674, Yale Center for British Art, New Haven), also known as *The Black Madonna*. Although it bears the later date of *c*.1825, it appears to be contemporary with *The Ghost of a Flea* with respect to style, dimensions, support, appearance and technique. The date of this work has been previously questioned by Butlin because of stylistic differences with the rest of the later temperas and the obvious spelling mistake in the restored shell gold signature, which reads 'Freso 1825 Blake'.[58]

In raking light the *Virgin and Child* (fig.110) shows the clearest example of Blake's priming build-up and use of incision to define elements of the design, and again Blake used the priming for white areas, such as the stars in the background. This painting also provides the only surviving evidence for Blake's use of a specific colourman, revealed by a branding on the reverse, which reads 'R. Davy / 16 Wardour St', as shown in fig.111.

The temperas dating from 1821–6 include seven painted on panel and one on paper, *The Sea of Time and Space*, 1821 (B803, The National Trust, Arlington Court). *Satan Smiting Job with Sore Boils*, *c*.1826 (B807, T70, Tate), *Count Ugolino and his Sons in Prison*, *c*.1826 (B805, Fitzwilliam Museum, Cambridge) and *The Body of Abel Found by Adam and Eve*, *c*.1826 (B806, T69, Tate), are painted on mahogany-type tropical hardwood, while the three temperas commissioned by the Reverend John Johnson, *Winter* (B808, T68,

FIG.110 *The Virgin and Child*, also known as *The Black Madonna* ?1825 (30.5 x 23.9cm, B674, Yale Center for British Art, New Haven), tempera and gold on panel, shown in raking light.

Tate), *Evening* (B809, private collection) and the untraced *Olney Bridge* (B810), were all painted on pine and dated by Butlin as *c*.1820–5.[59] This later group displays an improved confidence and skill in the handling of paint, and the combination of the use of panel supports and thinner priming and paint layers also implies that Blake may have adjusted his materials to increase the longevity of his temperas.

Correspondence between Blake and John Linnell mentioning *Count Ugolino and his Sons in Prison* offers some insight into Catherine Blake's association with the temperas towards the end of Blake's life. In his letter dated 25 April 1827, Blake wrote, 'as to Ugolino &c I never supposed that I should sell them my Wife alone is answerable for their having Existed in any finishd state – I am too much attachd to Dante to think much of any thing else.'[60] While it is unlikely that Catherine literally finished painting some of Blake's temperas, it is clear that she was solely responsible for encouraging Blake to finish them. What is also clear from Catherine's tempera painting *Agnes* (BC1, Fitzwilliam Museum, Cambridge) is that she had intimate knowledge of Blake's tempera painting materials.

The Characters in Spenser's 'Faerie Queene' (fig.112), apparently a late work of *c*.1825 and sold by Catherine Blake to Lord Egremont in 1829, represents Blake's return to the lighter, more watercolour-like style seen in some of the temperas of the 1808–11 period. It bears a strong resemblance, and may well have been intended as a pendant to, *Sir Jeffery Chaucer …* (fig.103), with a similar format and dimensions of 45.7 x 135.8cm. With this painting Blake also appears to have returned to an earlier signature style, using the small 'WB' common to the temperas in the 1799–1800 Bible series, although this is now very obscured and may have been damaged. *The Characters in Spenser's 'Faerie Queene'* was painted on a very fine canvas or muslin, which has been marouflaged to panel (a similar process to lining canvas to canvas) and appears to have no priming layer, although it is possible that a thin priming may have been saturated with glue or varnish and is therefore no longer visible. This lack of priming may also account for the use of graphite pencil in this painting, which is unusual, as Blake preferred to use dilute ink or paint when there was a priming to prevent these materials smearing out.

Gold was not used in this painting, and, like the group from the 1810–11 period, white highlights are almost non-existent. The subtle colouring, although masked by a film of discoloration, also appears similar to the paintings from 1810–11. Areas of light modelling

and possible washes of ultramarine are contrasted with dense passages of vermilion as in *Sir Jeffery Chaucer*...

From this it appears that Butlin's explanation of Blake's change of technique during this later phase of painting to consist of 'a much thinner paint film, akin to watercolour, on a gesso ground laid on paper or panel' is correct, as is his additional note that these temperas have subsequently 'survived in a much better condition'.[61] Indeed, Blake's brushwork in the later paintings appears finer, with the use of smaller brushstrokes and an increased reliance on stippling, also described by Keynes, who stated that by *c*.1821 Blake's technique had 'developed to a fine point of skill'.[62]

Interestingly, the analysis and identification of the constituents of Blake's paints consistently revealed that he used the same pigments, media and layering techniques throughout the years of tempera production. This therefore suggests that the wide variations in style, appearance and condition across the temperas result from a combination of factors including the commissions and subject matter, as well as subtle changes in paint application and other materials such as painting supports, to be discussed further in the next chapter.

FIG.III Stamp of Davy the colourman on the panel support of *The Virgin and Child*.

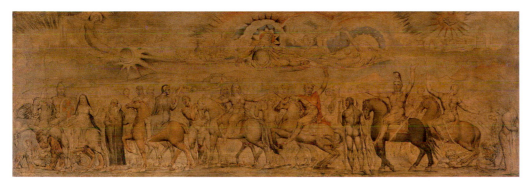

FIG.II2 *The Characters in Spenser's 'Faerie Queene'* c.1825. Tempera on canvas or muslin attached to panel 45.7 x 135.8cm. B811 The National Trust, Petworth House, Petworth

Blake's Use of Tempera in Context

BRONWYN ORMSBY WITH JOYCE H. TOWNSEND, BRIAN SINGER
AND JOHN DEAN

Suppliers of artists' materials in London (colourmen)

Although artists in eighteenth-century London were able to purchase materials from a few colourmen as well as herbalists and apothecaries, the manufacture of watercolour materials essentially began in 1776, when a well-known engraver, Matthew Darly, advertised 'Transparent colours for staining drawings'.[1] Until that point watercolour artists were seemingly restricted to purchasing raw materials, and it was therefore commonplace for watercolour artists to prepare their own colours by grinding the pigment and mixing it with the required portion of gum Arabic.[2]

However, by the late eighteenth century the number of established colourmen had grown. By the 1780s Reeves had invented the first soluble watercolour cakes. By 1801 Ackermann was also producing watercolours in boxes accompanied by detailed instructions and best practice manuals. By this stage many other colourmen were also established, including: Sherborn,[3] Rowney, Middleton, George Blackman, Kebby, John Skidmore of Holborn, Charles Schofield, John Scott of the Strand, James Newman and, a little later, Messrs Roberson, who were experimenting 'with pigments ground in honey instead of being bound into a hard cake'.[4]

Blake would have known of these shops and suppliers through his tuition at Henry Pars' Drawing School as well as his engraving apprenticeship and study at the Royal Academy. Hence, Blake would have been tutored in the preparation of his own paints during the 1760s, and problems with the prototype watercolour cakes may have influenced him to continue preparing his own colours, as his disciples and followers stated he did.

Of the historical accounts, only one record by Gilchrist refers to Blake's purchase of art materials:

> On his rising in the morning, Mrs. Blake went out with half-a-crown, all the money they had in the world, and of that laid out 1s. 10d.[5] on the simple materials necessary for setting in practice the new revelation. Upon that investment of 1s. 10d. he started what was to prove a principal means of support through his future life, – the series of poems

and writings illustrated by coloured plates, often highly finished afterwards by hand, – which became the most efficient and durable means of revealing Blake's genius to the world.[6]

However, there are no surviving records as to where she intended to purchase them.

The examination of Blake's tempera paintings provided little information on the source of his materials, because most of the temperas on canvas have been lined during restoration, which would conceal any canvas stamps, and the original stretchers have been discarded. The canvases themselves have the typical plain weave (one warp thread crossing one weft thread) and medium weight favoured by most oil painters of this time – at least those represented in the Tate's collection. Twill-weave canvases (which have a range of weaves, always with more than one thread crossing any number of other threads) with more distinctive textures were also available, but they cost significantly more. Unprimed canvases would have been cheaper than primed ones prepared by the colourman, and primed ones had a poor reputation for durability at that time. This was probably justified – many other commercially prepared artists' materials were criticised when they first became available, as products with poor quality control.[7] Those who lived through the earlier decades of the industrial revolution must often have found that the first products available were the least durable. From Blake's viewpoint the typical pre-primed canvas with several layers of lead white and chalk ground in linseed oil would have introduced the oil medium he so disliked into his temperas. Alternatives to oil grounds were also available commercially, based on combinations of chalk, gypsum, bone-ash, wheat starch paste or size (animal glue).[8] Quite apart from considerations of cost, the artists who primed their own supports could control the absorbency as well as the texture of the priming, and also its colour and 'freshness'. In smoky and smut-rich London, making a pure white ground only when it was needed had advantages. The severe urban pollution of Blake's era also caused primings of lead white and oil to turn brown distressingly quickly, as the pigment reacted with hydrogen sulphide.[9] Absorbent grounds influenced the drying time of a painting and its tendency to flake and peel (or not) once dry. There was a great vogue for them in the last years of the eighteenth century and the start of the next one, and many artists experimented with recipes for primings.[10]

The reverse of the panel on which *The Virgin and Child*, dated 1825 (B674, Yale Center for British Art, New Haven), is painted has a Davy branded stamp (fig.111), which shows that Blake was purchasing at least some of his painting supports from this London-based manufacturer, first established in 1795.[11] This stamp shows the address that Davy moved from in 1822, but this does not prove that Blake had purchased the panel earlier, as the company may have had old labelled stock on its shelves after the move. Many other artists purchased panels from Davy, yet bought their colours from a range of other colourmen, Turner for example.[12] The panels are obviously of good quality, and all have survived in good condition, proving to be a far more durable support than canvas. Davy panels were often sold with a priming applied by the colourman, but this label does not imply it.

The greatest variation in Blake's materials occurs with the painting supports, and the priming he used on them. The first group, painted from 1799 to 1800, are all on either canvas or metal, which was then followed by the sole use of canvas from 1800 to *c*.1811, with the exception of a miniature painting on copper.[13] The majority of the temperas from *c*.1818 onwards are painted on mahogany-type tropical hardwood or pine panels, on dual supports of canvas and panel or on paper and canvas. Interestingly, with the exception of his continued work on the vast lost tempera *The Last Judgment*, the later temperas from 1818 to 1826 show a return to the smaller formats of the 1799–1800 period, which may have been motivated by the poor condition of some of his larger works, and particularly those painted on canvas. Equally, Blake appears to have abandoned the use of metal supports quite early, which could be the result of his having witnessed the deterioration of some of his earlier temperas on metal. Copper was an obvious support for a commercial engraver to try out. His possible reasons for using an iron supports occasionally have been discussed in the introduction, p.30.

Pigments used in Blake's temperas

Within the group of over twenty colours that Blake used in the temperas (see Appendix 6) the most frequently used pigments include Prussian blue, ultramarine blue, vermilion red, one or two red lakes, yellow gamboge, yellow ochre, Mars browns (brown ochres that were manufactured, not ground down from naturally occurring coloured earths as yellow ochre was), white chalk and black ink. He used red lead and red ochre less often, indigo in a few cases and possibly Naples yellow and/or a yellow lake once or twice.

It is probably significant, though typical of his era, that he chose a selection of red, blue and yellow pigments without greens, and added black and white to this range. This accords with Newtonian colour theory, as Gage has discussed.[14] Vermilion, Prussian blue and either gamboge (before it fades) or Naples yellow give a good approximation to primary colours, and could be used to mix almost all other colours, if white were added. Blake chose not to, however, except when he was obliged to produce an optical green from an optical mixture. Brown pigments were reserved for naturalistic colouring, in hair and tree trunks, and were never toned with other pigments to produce a harmonious colour scheme: Blake seems to have scorned such adulteration. The same remarks apply to the large colour prints, though they have less application to the late *Divine Comedy* watercolours, where Blake significantly widened his colour range beyond the three primaries.

With this exception, Blake's choice of pigments was remarkably consistent in all media, and he used a similar number of pigments to most other artists of his era. His habit of using the same pigment range in several different media is not unusual. Very few artists used the full range available. Turner was an exception, as an extensive study of his materials has shown,[15] though even he dropped some early favourites entirely as he moved

on to newly invented materials. Most British artists did try at least some of the pigments that were invented from the later eighteenth onwards,[16] or mentioned them in their correspondence or diaries. Blake's completely consistent choice over many decades is unusual – or else it was the pragmatic and practical choice of a busy printer as well as artist. Blake's selection speaks of satisfaction with his choice, and fitness of these pigments for his purposes. If the pigments had a symbolic or alchemical resonance for him, then it was an unchanging one.

Blake did have a number of lifelong friends who were also artists, so he must have been aware of the new materials becoming available and what others thought of them, yet he resisted the lure of the new and untried. He could have used,[17] but did not use: patent yellow, an attractive pale yellow first described *c.*1775; Indian yellow, a deeper golden yellow comparable in colour to gamboge, mentioned by 1786; expensive chrome yellow from about 1814, though the early shades were hardly better than patent yellow if cost mattered to him; Scheele's green from 1778, a purer green than the bluish verditer he did occasionally use; opaque oxide of chromium, a green sold by Field the colourman from 1815; emerald green from its discovery in 1814; very expensive cobalt blue from the early 1800s, an attractive and transparent deep blue; the developing range of madder lakes sold by Field, in shades from bluish to brown red, or manufactured red or orange shades of iron oxide. Many of these would have extended his colour range to provide a different shade of the intense colours he used. Most, though, would have cost more than the pigments he bought. The exception is ultramarine, which Blake probably only used for commissioned work, since even a tiny amount of ultramarine would have cost more than the materials, including the supports, for several temperas.

Two features that most of his pigments have in common are cheapness and constant availability. The same could be said of his priming materials. Blake's limited financial resources, and the relatively small working spaces he had, made these into important considerations, when he was colouring different versions of prints on demand, over a period of years. Essick and Viscomi have discussed elsewhere Blake's careful use of materials and avoidance of waste.[18] Another common feature is reliability: none had been newly invented, so the bad as well as the good properties of these pigments must have been well known to him or else were easy to find out from his colourman.

Gold can be first detected as shell gold in one of the Bible series temperas, *Eve Tempted by the Serpent* of *c.*1799–1800 (fig.90). He also used it in some of the large colour prints discussed earlier, dated between 1795 and 1805, and it is impossible to say in which medium he first used it. The 'Heads of Poets' temperas do not include any gold, although gold leaf is a prominent feature in the temperas exhibited in Blake's 1809 exhibition. Pure silver leaf first appears in *Sir Jeffery Chaucer and the nine and twenty Pilgrims on their journey to Canterbury* (fig.103) and a silver-gold alloy leaf was first identified on two of the 1809 exhibition temperas, *The Bard, from Gray* (fig.132) and *Satan calling Up His Legions – An experiment Picture* (fig.131). During the period 1810 to 1819 Blake abandoned the use

of metal leaf until its re-emergence in *The Ghost of a Flea, c.*1819–20 (fig.106), where it was identified as a silver-gold alloy leaf, and his extensive employment of shell gold in *The Virgin and Child, c.*1825 (fig.110, B198 674, Yale Center for British Art).

The 1805–9 period includes Blake's only surviving, unlined work, *Sir Jeffery Chaucer . . . ?c.*1808, which displays his intricate use of shell gold, silver, impasto white highlighting and fine ink work. This group also incorporates Blake's more political temperas such as *The Spiritual Form of Nelson Guiding Leviathan, ?c.*1805 (fig.137), *The Spiritual Form of Pitt Guiding Behemoth, ?c.*1805 (fig.94), and *The Bard, from Gray*, as well as the three 'Experiment Pictures' (B659, 660 and 661 – two of which are untraced). These temperas show a powerful use of red paint and line-work, as well as the most prominent use of gold-silver alloy leaf seen throughout the range of temperas.

Blake's use of plant gums and animal glue

Most of the historical accounts of Blake's tempera technique recorded that he employed carpenter's glue (animal glue) for his tempera paints, and the analysis and examination of forty-five of his temperas confirmed the presence of animal glue across the whole range. Blake consistently used animal glue as the binder for the priming, the seal for the under-drawing, an isolating layer between paint applications and a final sealing/isolating varnish, as well as the binder or co-binder for some of his colours.

However, contrary to the historical accounts which stated that Blake rejected gum as a binder because of its tendency to crack and to peel off when applied in several layers,[19] the analysis of Blake's tempera paints also revealed the consistent presence of a mixture of gums Arabic (or karaya) and tragacanth with the additions of sugar or honey, and occasionally cherry gum. This suggests that Blake's chroniclers might not have witnessed the entire paint preparation process and/or that the full details were never revealed, which must make Blake's use of plant gums one of his best-kept technical secrets. It may also explain why Blake referred to his 'frescoes' as being painted in watercolours and not 'distemper',[20] which means a water-based medium that generally includes glue.

In order to understand whether Blake's use of gum mixtures was commonplace in watercolour and tempera painting, an investigation into the historical uses and availability of plant gums was carried out. The gums listed in several sixteenth- to nineteenth-century watercolour manuals and treatises included: gums Arabic, tragacanth, cherry, ammoniac, guaiacum, hedera and sarcocolla. Not surprisingly, gum Arabic was clearly the dominant gum because of its superior water-solubility, and was recommended for most purposes, as well as for use as a component of ink and as a temporary varnish for darker colours.[21] The other gums appeared more frequently in manuals dated prior to the nineteenth century, and seem to have been used occasionally as alternatives to Arabic, or combined with gum Arabic to amend its physical and aesthetic properties. They were not used on their own.

Gum tragacanth, the second major component of Blake's tempera paints, was also the second most commonly mentioned gum in artists' manuals. Tragacanth is mentioned through the sixteenth to the nineteenth centuries, for example in the *Strasbourg Manuscript*[22] and by Peacham,[23] James[24] and De Massoul,[25] who commented that it produced a less supple paint film than gum Arabic. In 1835 George Field the colourman wrote that tragacanth with the addition of borax (hydrated sodium borate) was the best medium for miniature painting because 'tragacanth allows repeatedly tints to be laid without moving or washing up'.[26] This means that it was possible to add another layer of paint in this medium, without the earlier layer dissolving and running into the new one. This property was important if the artist sought for 'enamel-like', pure colours, not mixed ones, as Blake did. Blake also chose gum tragacanth to increase the body of his paints, so that he could apply thick layers when needed. The animal glue in his medium added further body.

The presence of karaya gum as a deliberate component of Blake's tempera paints was dismissed primarily because it does not appear to have been regularly imported into the United Kingdom until the mid- to late nineteenth century.[27] However, because of the relative lack of trade regulations at that time, it is not possible to exclude the early though unintentional use of karaya, marketed as 'Indian tragacanth', as an adulterant in or replacement for the relatively expensive gum tragacanth.[28] These facts were not known during the early stages of this research into Blake's materials or to earlier researchers, when its identification was reported in temperas[29] and a large colour print.[30]

Cherry gum, which, like other *Prunus* species such as apricot, almond, peach and plum, was also occasionally found in Blake's temperas, is most closely associated with medieval manuscript illumination, and was mentioned by Theophilus for tempera recipes.[31] In the *Strasbourg Manuscript* cherry gum is described as producing a 'stronger, clearer paint' than gum Arabic, giving an 'enamel effect'.[32] Interestingly, Doerner recommended mixing cherry gum with gum tragacanth and isinglass 'for a good tempera paint',[33] which indicates that cherry gum was used in tempera paint formulations well into the nineteenth century.

There are few mentions of gum sarcocolla. Eastlake mentioned that sarcocolla has sometimes been mistaken for gum tragacanth,[34] as they have similar physical properties and are both members of the *Astralagus* species. In the late nineteenth century Vibert wrote that sarcocolla produces rich, intense colours, which, like gum tragacanth, allow the subsequent layering of colour without any unintended mixing of the new and old layers, and also 'takes' to the existing paint very successfully.[35] This is interesting with respect to Blake's technique, as Blake's use of multiple layers of water-based colour and his desire to have his colours appear as if they were 'precious stones' reflect two of the distinct advantages of the use of gums sarcocolla and tragacanth. However, the analysis of Blake's paints consistently confirmed the presence of gum tragacanth.[36]

Gum hedera was described by Peacham in 1607 as originating from the ivy plant,[37] whose species carries the same name. Gum hedera was used as a diluent for animal glue

size and as one of the ingredients in an egg white varnish known as 'Gumme Lake'. It appears again in the 1634 edition of the same manual, but no other references were found. In all cases gum ammoniac, from the *Dorema ammoniacum* species,[38] is associated with gilding, having been first blended with gum Arabic and garlic. In the nineteenth century Field suggested its additional use as a varnish to protect fugitive colours and for glazing, as he regarded it as a very 'tenacious' vehicle with properties somewhere between oil and water.[39]

The treatises and manuals also contained the occasional recommendation and recipe for gum mixtures, for example the Roberson recipe for 'Water-colour McGuelp',[40] dated 1862, which called for equal proportions of gums Arabic and tragacanth. A mixture of gums tragacanth, cherry and isinglass was also suggested as a good tempera paint recipe in Doerner's treatise of 1867,[41] which presumably increased the hardness and water-resistance of the tempera paint film. Many different additives were also used to alter the properties of the paints, such as animal glue, isinglass, egg, glair, linseed oil, ox-gall,[42] honey, candy sugar, alum,[43] borax,[44] alcohol, ammonia and rice starch.[45] Preservatives, such as the essential oils lavender and rosemary, and coloquintida[46] were also added, though this was less common in the nineteenth century.[47]

Animal glue, usually made from sheep, kid, buck or doe skin glove clippings,[48] and isinglass were mentioned for size recipes[49] and grounds,[50] as well as for paint media,[51] where both animal and fish glues were suggested as an alternative medium to gums to achieve a matte paint. Field stated that animal glues were added to gum paints to prevent the flow of colours, and he also recommended a blend of gum and isinglass as a mucilage for watercolours, described as being created by adding as much gum Senegal/Arabic to liquid glue 'as it will conveniently take up'.[52] This blending of gum and glue was also found in some Roberson watercolour cake recipes, such as those for blue, flake white and carmine.[53]

An anonymous treatise dated to 1770 mentioned the use of animal glue as a medium for watercolours and as a temporary or final varnish for watercolour paintings.[54] In 1804 Tingry also listed isinglass as a sealing varnish for works of art on paper applied prior to a resin varnish,[55] which would otherwise sink into the paper. In 1758 Dossie also mentioned the use of isinglass as a varnish for paintings, with the addition of a small amount of sugar/honey, although he also warned that the glue-based varnish was 'apt to turn very yellow with time' and that it is not lasting.[56]

Egg was also occasionally mentioned as a medium to which gums could be added in a 1730 treatise by Smith,[57] and it has also been associated with gilding, where it is mixed with honey and used with vermilion for texturing bole, the coloured substrate beneath the gold leaf, and as a tempering medium for silver leaf.[58] However, most commonly, egg was used as a temporary final varnish in the form of glair, or egg white.[59]

Although Blake's tempera materials and technique were essentially consistent during the period from 1799 to 1826, there are some observable differences between the

tempera groups. These differences were partially dictated by the commission, but also show that Blake was achieving different aesthetic effects and styles with the same raw materials, which is particularly noticeable in the temperas produced during the 1805–9 period.

The fact that many of the early watercolours contain evidence of the minimal use of gum tragacanth or cherry gum in addition to gum Arabic proves that Blake's use of a blend of gums Arabic and tragacanth is not particularly unusual. Nor was the addition of honey or sugar innovative. However, it is clear from the variations in both the content and proportions of each gum in the samples removed from Blake's temperas that he was preparing his own paints from raw materials and was not relying upon commercially produced watercolour cakes. His painting techniques dictated that he would have to use a mixture of gums such as these in order to paint as he did.

The analysis of watercolour paints

As mentioned earlier, the late eighteenth and early nineteenth centuries saw the rise and proliferation of artists' colourmen, who were responsible for the introduction of commercially prepared watercolour cakes. The prototypes, allegedly first developed by Reeves, were apparently very hard and required agitation in water for some time prior to use.[60] These difficulties ultimately led to the development of 'soft' watercolour paints, which were easier both to use and manage because of their higher sugar/honey content, which was later replaced by glycerine. Although it is generally assumed that gum Arabic, candy sugar, honey and ox-gall were the most common ingredients of watercolour paints, the examination of watercolour treatises and manuals suggests that watercolour practices until the mid-nineteenth century involved more complex uses of materials. However, it appears that by the mid- to late nineteenth century watercolour paints were made almost exclusively with gum Arabic. The analysis of watercolour cakes from Blake's era helps to place his choice of gums in context.

Twenty-two watercolour cakes from an Ackermann watercolour box were analysed.[61] They were mostly dated prior to 1837,[62] although four had 'Winsor and Newton' stamps (figs.113, 114), which additionally dates them to 1835 at the earliest, and one other was a 'Newman' cake, which means it was made after 1799.[63] The entire gum content of every cake was identified as Arabic, with the addition of varying levels of sugar/honey. Several of the cakes that were legibly labelled as 'Honey Colours' (fig.115) included honey as

FIG.113 Four unused Winsor and Newton watercolour blocks, roughly contemporary with the end of Blake's lifetime. Samples and photographs made available by Dr Fumio Yokoshima, Japan.

FIG.114 The other side of the four unused watercolour blocks: labelled PRUSSIAN BLUE, [YELLOW] OCHRE, BURNT SIENNA and NEUTRAL TINT.

FIG.115 (Originally blue) Ackermann watercolour block, labelled COULEUR SANS DANGER / BEST HONEY COLOUR, roughly contemporary with the end of Blake's lifetime. Sample and original photographs made available by Dr Fumio Yokoshima, Japan. Image processing by David Clarke.

the major component of the binder, with only small amounts of gum Arabic or no detectable gum at all. All the pristine blocks are stamped with a pigment name, though not all the contents are genuine: that marked 'dragon's [blood]' (fig.116) proved to contain chalk, china clay, additional extenders and a red lake.

Several boxes containing watercolour cakes manufactured by Reeves, and dated between *c*.1783 and some time shortly after 1837 from the form of the label stamped on the front or back of the blocks (fig.117), were also studied, a few blocks from each box being analysed (fig.118).[64] The results were similar to the Ackermann colours in that all samples were identified as containing gum Arabic as the major component, with the sugar/honey content varying from negligible to a significant proportion of the binding medium. However, a small portion of the blocks also contained trace amounts of gums tragacanth,

FIG.116 Watercolour block, labelled DRAGON'S [BLOOD], roughly contemporary with the end of Blake's lifetime. Sample and photograph made available by Dr Fumio Yokoshima, Japan.

cherry or sarcocolla. In addition, a sample of liquid paint medium included as a separate bottle in a box dated between *c*.1781 and 1788 was identified as containing a blend of Blake's preferred mixture of gums Arabic and tragacanth. The amount of tragacanth in the mixture was minimal. However, the presence of the mixture suggests that the blending of gums Arabic and tragacanth may have been a more common practice than previously thought, and that Blake's use of these two gums may therefore not have been uniquely innovative.

Several watercolour cakes from the Roberson Archive dated 1853–90 were also analysed.[65] The results again identify the dominant gum as Arabic with the inclusion this time of honey/sugar. However, as was the case with some of the Reeves colours, some of the cakes also included the possible addition of small amounts of cherry, tragacanth or sarcocolla gums. Lastly, three watercolour boxes,[66] one by Reeves and two by Rowney dated to the early twentieth century, were found to contain gum Arabic alone, with the

FIG.117 Closeup of a Reeves watercolour block, roughly contemporary with the end of Blake's lifetime. Sample and photographs made available by Dr Fumio Yokoshima, Japan.

addition of sometimes large amounts of sugar. This return to the sole use of gum Arabic perhaps indicates that the experimentation with other gums seen in nineteenth-century watercolours was no longer occurring.

Blake's contemporaries

To broaden the context for Blake's use of plant gums even further, and in the absence of any surviving watercolour type materials from Blake's workshop,[67] the medium and pigments from three watercolour palettes and boxes owned and used by Blake's younger contemporary Turner were analysed (fig.119).[68] (No other watercolour materials closely linked to a known artist of Blake's era have survived to our knowledge.) The palettes date from post-1814 and include a travelling watercolour palette of an unknown date. They may in fact date to after Blake's death in 1827, since an artist's surviving materials are inherently more likely to have been retained from the end of his life, when he was well known, than from the beginning.

The results showed that Turner's watercolours consistently contained gum Arabic as

FIG.118A Detail of the colourman's stamp from a LIGHT RED Reeves watercolour block, roughly contemporary with the end of Blake's lifetime. Museum of London

FIG.118B Other side of the LIGHT RED Reeves watercolour block.

FIG.119 Travelling
watercolour palette
used by J.M.W.
Turner. Royal
Academy of Arts,
London

the major component, but again with the possible addition of trace amounts of gums cherry, tragacanth or sarcocolla. To supplement this, two watercolour paintings by Turner, *Venice from Fusina* of 1828 (D32162, Tate) and the sketch *Funeral of Sir Thomas Lawrence* of 1830 (fig.120), were also analysed, and interestingly the same Arabic and tragacanth gum mixture as used by Blake was identified in each painting. Comparing these results suggests that Turner may have added gum tragacanth to his paints when the work required it, although none of the palettes analysed showed strong evidence of this. This is interesting because examination of numerous watercolours shows that Turner often added extra gum to his watercolour paint.

Blake's followers

Two members of the group of Blake's followers known as the 'Ancients', Samuel Palmer (1805–81) and George Richmond (1809–96), were introduced to Blake through John Linnell, and Palmer occasionally worked 'under Blake's eye'.[69] After Blake's death Richmond was responsible for an early restoration of *Pitt Guiding Behemoth*,[70] and Palmer

provided valuable accounts of Blake's tempera materials and techniques, for example 'Blake's white' (see pp.42, 118),[71] which apparently so impressed him that he recommended it to George Richmond in 1828.[72]

Blake and the members of this group are known to have borrowed from and influenced each other with respect to philosophy, art theory, design and colour.[73] In addition, the extent of Blake's influence on their tempera techniques has recently been explored through the technical examination of four Tate temperas and analysis of all but the first:[74] Richmond's *Abel the Shepherd*, 1825 (fig.121); Richmond's *Creation of Light*, 1826 (fig.122), which was certainly 'painted under the influence of William Blake' (p.37);[75] Richmond's *Christ and the Woman of Samaria*, 1828 (figs.123–5); and Palmer's *Coming from Evening Church*, 1830 (figs.126–9) – all painted within a few years of Blake's death.

All four temperas are painted with similar materials, including supports. Richmond obtained his panel for *The Creation of Light* from the colourman Davy: it bears a Davy label on which the colourman claims to be 'The only Manufactory for Genuine Flemish Grounds on panel & Millboard . . .', which does not suggest that Richmond actually used such an absorbent ground.[76] They are of similar sizes and have similar supports

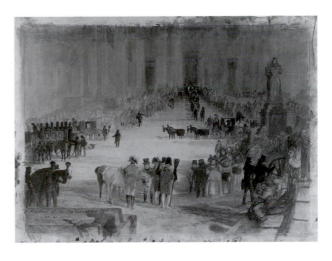

FIG.120 *Funeral of Sir Thomas Lawrence: A Sketch from Memory* exh.1830. Watercolour and bodycolour on paper 56.1 x 76.9cm. Tate D25467. With Turner's paint on the untrimmed margins of the paper.

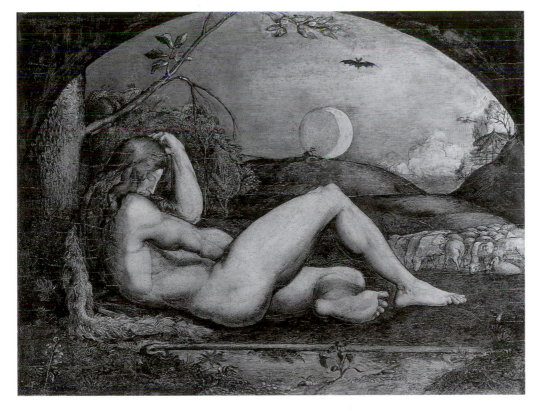

FIG.121 George Richmond, *Abel the Shepherd* 1825. Tempera on oak 22.9 x 30.5cm. Tate N05858

FIG.122 George
Richmond, *The
Creation of Light* 1826.
Tempera, gold and
silver on wood
48 x 41.7cm. Tate
T04164

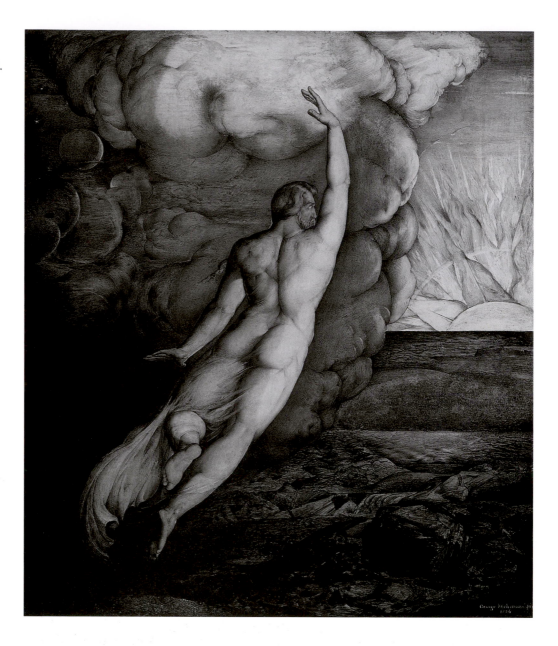

to Blake's temperas produced from *c.*1818 onwards, which coincides with the period of closest contact between the three artists. Similarly, all four paintings contain chalk-based grounds. However, the examination of each painting with infra-red reflectography revealed that, unlike Blake, both Palmer and Richmond preferred to use graphite pencil for under-drawing. Richmond's drawings in particular were both finer and more detailed than Blake's. Unsurprisingly, these younger artists drew with less assurance than Blake did, and therefore drew in much more detail than he.

Another feature common to all three artists is their use of animal glue, which was confirmed by the examination of cross-sections from all of the paintings except *Abel the Shepherd*, and also by the HPLC analysis of paint from Richmond's *Christ and the Woman*

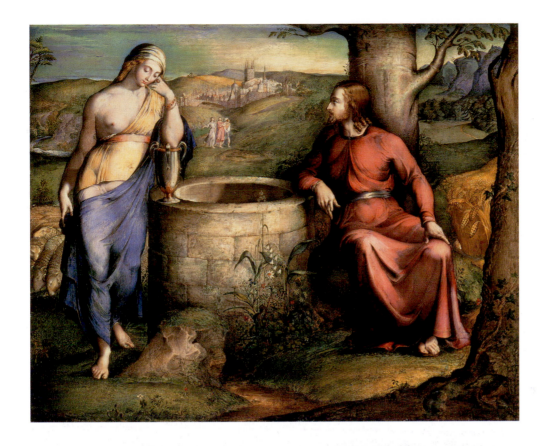

FIG.123 George
Richmond, *Christ and
the Woman of Samaria*
1828. Tempera and
gold on wood
41 x 49.8cm.
Tate NO1492

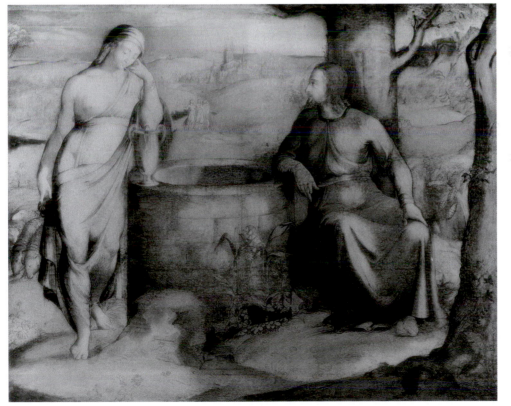

FIG.124 The infra-red
photograph of *Christ
and the Woman of
Samaria* (fig.123)
reveals the delicate
yet decisive drawing
used for the distant
landscape and
buildings.

of Samaria. It appears that both Richmond and Palmer used animal glue in a similar manner to Blake, with glue layers applied to seal the ground and directly beneath the resin varnish, as well as glue being a possible component of the paint in Richmond's case, and the major component in Palmer's case.

More interestingly, both artists also appear to have used plant gum mixtures in their tempera paints, a finding that renders Palmer's recollections of Blake's purely 'glue-based' technique less reliable, as their use of specific gum blends strongly implies that both artists must have known of Blake's practice. There is, however, one slight difference in that Palmer's *Coming from Evening Church* contains a blend of gum Arabic and a small amount of cherry gum rather than gum tragacanth, whereas in *Christ and the Woman of Samaria* Richmond used the same blend of gums Arabic and tragacanth as Blake.

Palmer's and Richmond's palettes also contain several of the pigments used by Blake, including shell gold, Prussian blue, ultramarine, sienna, vermilion or red lead, madder, bone black, and earth colours such as yellow ochre. However, both artists also appear to have used lead white, and Richmond extended his palette to include yellows such as Naples or Indian yellow and a pure, possibly copper-based green. Both artists used shell gold and an impasted chalk-based white for highlights, although Richmond's application is particularly delicate and some of the bodied highlights are also pigmented. This is in effect 'Blake's white' whose use by Blake himself was discussed on pp.42, 118.

With respect to paint application, both Palmer and Richmond employed similar techniques to Blake such as the use of short, delicate brush strokes, as well as stippling and washes, although Palmer painted *Coming from Evening Church* in a less detailed and more suggestive manner than that seen on the Richmond temperas. Blake's influence on Palmer further extended to his use of black ink and the application of thick glue layers, which has also resulted in the darkening of the paint layers and the obscuring of subtle details. Richmond's paint application varies from both Blake's and Palmer's in that it is consistently finer, more ordered and very delicate. In addition, the paint layers tend to be thinner and less reliant upon inter-layers of animal glue, and as a result the paintings have generally remained brightly coloured.

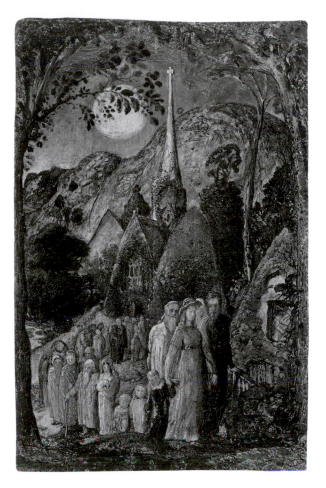

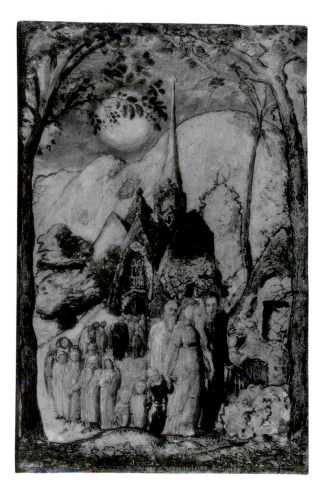

FIG.126 Samuel Palmer, *Coming from Evening Church* 1830. Mixed media on gesso on paper 30.2 x 20cm. Tate N03697

FIG.127 The infrared photograph of *Coming from Evening Church* (fig.126) reveals Palmer's thicker drawing beneath the paint.

FIG.128 Closeup detail of the branch lying across the moon, showing glazes that appear to 'float' on the surface of *Coming from Evening Church* (fig.126).

FIG.129 Closeup detail of transparent glazes from the foreground, in *Coming from Evening Church* (fig.126).

The Appearance of the Temperas Today

BRONWYN ORMSBY WITH BRIAN SINGER AND JOHN DEAN

From his public criticisms of oil painting it is clear that Blake cared about the longevity of his works of art. Blake used his 'fresco' painting technique for many reasons, one of which was to avoid the pitfalls he perceived as inherent in oil painting: 'Oil will not drink or absorb colour enough to stand the test of very little time and of the air. It deadens every colour it is mixed with, at its first mixture, and in a little time becomes a yellow mask over all that it touches.'[1] And 'oil being a body itself, will drink or absorb very little colour, and changing yellow, and at length brown, destroys every colour it is mixed with, especially every delicate colour. It turns every permanent white to a yellow and brown putty, and has compelled the use of that destroyer of colour, white lead; which, when its protecting oil is evaporated, will become lead again.'[2]

In defence of 'fresco' Blake stated: 'All Frescoes are as high finished as miniatures or enamels, and they are known to be unchangeable.'[3] And he clearly intended that his colours should remain 'as pure and as permanent as precious stones'.[4] However, it is now very apparent that Blake made some incorrect assumptions about the nature of animal glue, which he believed could withstand sunlight, and that 'change of atmosphere has no effect upon it'.[5]

Despite his noble intentions, changes to the appearance and condition of some of Blake's tempera paintings were noted within his own lifetime.[6] By 1863 Gilchrist and William Michael Rossetti had recorded that some of the surviving temperas were now 'darkened'[7] or, in one case, 'half-ruined'.[8] Butlin also includes comments that a portion of the temperas were once 'probably more coloured',[9] which suggests the wholesale fading of colour. Similar remarks have been made by various restorers, curators and historians throughout the twentieth century, including the 'colour is drying',[10] the painting is 'darkened', the colour is 'largely gone'[11] and that 'much of the colour had gone forever'.[12] This 'darkening' is caused by many factors, not the least of which was Blake's habit of 'reworking' his paintings until the surfaces had considerably darkened, as proved by his experiment pictures.

Blake himself commented on the effects of his practice of 'over-labouring', on the sadly lost or destroyed tempera, *The Last Judgment* (B648), as Gilchrist reported: 'Blake, on looking up one day at this *fresco* as it hung in his front room, candidly exclaimed, as one who was present tells me, "I spoiled that – made it darker; it was much finer, but a Frenchwoman here (a fellow-lodger) didn't like it. Ill advised indeed, to alter *colour* at a fellow-lodger and Frenchwoman's suggestion!" Blake's alterations were seldom improvements.'[13] This suggests that Blake worked on *The Last Judgment* for a period of over seventeen years,[14] till it was 'blackened with overpainting'. Interestingly, this is similar to criticisms of *fresco secco* and *fresco mezzo* painting, where the colours are said to 'turn black' after retouching with gum/glue colours.[15]

However, Blake's habit of over-labouring does not account for all of the discoloration seen in the temperas. The greatest contribution originates from the production of brown compounds from the combined effects of the degradation of Blake's animal glue, gum and sugar/honey medium, and a chemical reaction known to take place between proteins (animal glue) and carbohydrates (plant gums, sugar, honey), called the Maillard reaction. This results in the severe browning of the paint layers, the extent of which is shown at a paint loss site from *The Ghost of a Flea* (fig.130) and in the severely darkened glaze layers from *Satan calling Up His Legions – An experiment Picture* (fig.131).

This discoloration results in an imbalance in the tonal relationships within the composition by reducing the brilliance of the colours, by 'yellowing' the lighter tones, by 'greying' the white priming and by masking Blake's more subtle, transparent glazes. In addition, the degradation of the glue-gum paint medium and natural resin varnishes produces a slight increase in opacity, which also reduces the contrast between dark and light passages, and further obscures the image. As a result, the discoloured paintings become dominated by the opaque and darker passages, as seen in Blake's elaborately designed temperas, *Sir Jeffery Chaucer and the nine and twenty Pilgrims on their journey to Canterbury*, ?c.1808 (fig.103), *An Allegory of the Spiritual Condition of Man*, c.1811 (B673, Fitzwilliam Museum, Cambridge), and *The Characters in Spenser's 'Faerie Queene'* (fig.112).

This also explains why many of Blake's temperas exhibited in the 1809 exhibition, such

FIG.130 Detail of an old loss in the varnish(es) of *The Ghost of a Flea* (fig.106), tempera on panel, showing bright blue paint beneath.

FIG.131 *Satan calling Up His Legions – An experiment Picture* (fig.102), showing discolouration of glazes that would have been yellow and transparent.

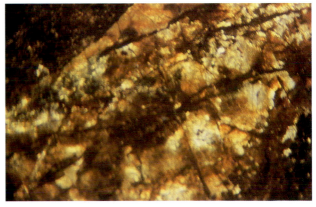

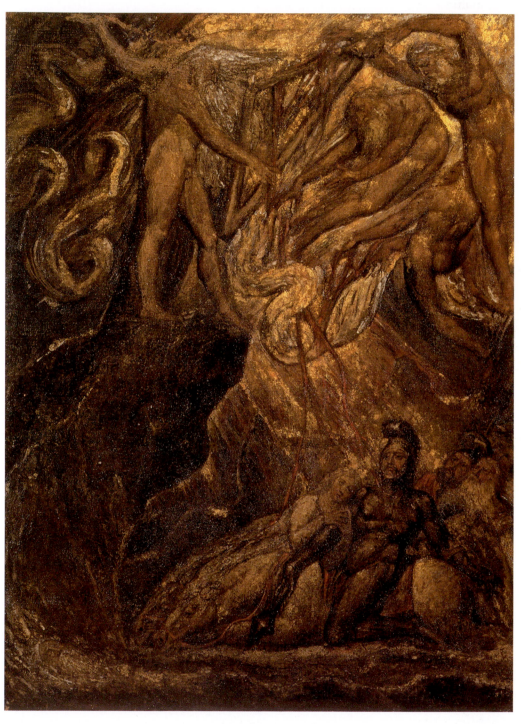

FIG.132 *The Bard, from Gray*, ?1809. Tempera heightened with gold on canvas 60 x 44.1cm.
B655, T60 Tate N03551

as *The Bard, from Gray* (fig.132), appear to be the most severely darkened. Here Blake used multiple, thick paint layers as well as many inter-layers of animal glue, all of which naturally lead to a marked discoloration. Similarly, some of Blake's better preserved temperas from the 1799–1800 Bible series, such as *The Body of Christ Borne to the Tomb* (fig.79) and *Charity* (fig.133), as well as the four biblical temperas from 1810, contain fewer paint layers and thinner animal glue inter-layers.

Blake's severely darkened, 'over-laboured' experiment pictures have also suffered possible additional contributions from Blake's 'experiments', where he allegedly bruised and knocked them about, 'without mercy, to try all experiments'.[16] The microscopic examination of *Satan calling Up His Legions – An experiment Picture*, probably 1800–5 (fig.102, B662, Victoria and Albert Museum), revealed that the lower paint layers had erupted upwards into the upper layers, which suggests the application of heat either during the experimentation, i.e. by Blake himself, or more likely as a consequence of lining. Heat is also known to promote the degradation of animal glue and the formation of coloured compounds.[17]

In almost every case these processes of degradation have been augmented by layers of surface dirt that have accumulated during the periods between Blake's paint applications (see figs.99 and 100) and retained by the hygroscopic (water-absorbing) nature of Blake's paints. This discoloration can be seen on Blake's temperas on canvas, for example in the central area of *Sir Jeffery Chaucer . . .* , where the areas of canvas lying over the stretcher bars are clearly lighter in tone as a result of the decreased air flow and subsequent dirt deposition onto those areas.

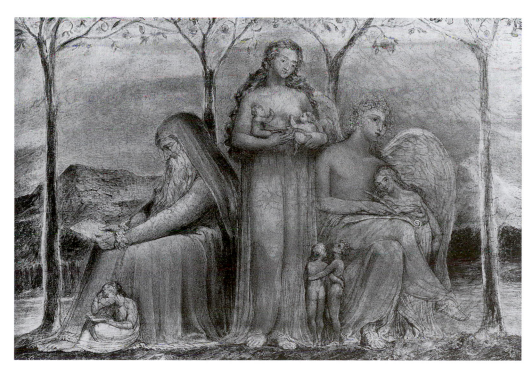

FIG.133 *Charity* 1799. Tempera on paper attached to canvas 27 x 37.8cm. B428 Carnegie Museum of Art, Pittsburgh. Bequest of Charles J. Rosenbloom

Aspects of the physical deterioration of the temperas also contribute to changes in appearance. The continued expansion, contraction and flexing of each layer in the painting structure, including the support, priming, multiple paint layers and varnish, produce a build-up of stress that initially causes tension cracking (figs.134–6) and slowly weakens the adhesive bond between layers, ultimately leading to flaking paint and paint loss. Glue responds rapidly to changes in relative humidity, which can themselves be caused by variations in room temperature as well as seasonal variations, and these rapid changes stretch layers of other materials beyond their breaking-point. These changes to the surface create discontinuity and reduce contrast, while the scattering of light on the surface impairs our ability to 'read' the image. In 1863 Gilchrist described some of Blake's 'Heads of Poets' temperas as being 'like most of Blake's "temperas" and "frescoes", they are blistered and cracked, and have not been improved by varnish and exposure to dust and gas'.[18]

Another aspect of Blake's tempera technique contributing to paint delamination is the contracting force exerted by the animal glue-based layers upon initial drying. This contributes to stress at the paint layer interfaces. The application of a layer of animal glue at too cool a temperature can also prevent adequate adhesion and thus create an inherent weakness in the painting structure. In addition, the sheer bulk and weight of Blake's

FIG.134 Closeup detail of cracks in the surface of *Moses Indignant at the Golden Calf* c.1799–1800, tempera on canvas (B387, Tate).

FIG.135 Closeup detail of cracks in the surface of *The Spiritual Form of Nelson Guiding Leviathan* c.1805–9 (B649, Tate), tempera on canvas. The tempera itself is shown in fig.137.

FIG.136 A paint loss from *The Agony in the Garden* (fig.86), tempera on tinned iron, reveals the red paint Blake applied over the metal. Scratched metal can be seen beneath the red paint.

sometimes numerous paint layers can promote paint loss, as described by Tatham: '[he used] several layers of colour to produce his depths, the Coats necessarily in the deepest parts became so thick, that they were likely to peel off.'[19]

Bindman suggested correctly that Blake's choice of painting support played a significant role in the deterioration of the temperas and concluded that Blake's 'use of glue made the surface extremely sensitive to the atmosphere. As a consequence some have survived in good condition where atmospheric conditions have been ideal, but others began to flake badly from an early date, especially those on copper.'[20] Interestingly, Blake himself showed an awareness of the potentially damaging effects of humidity on works of art in his use of a piece of seaweed as a barometer, stating that it 'gets wet & dry as the weather gets so'.[21]

Blake's temperas on copper and other metallic supports have not survived well, primarily because of the difference in expansion and contraction rates of the metal, compared with those of the organic paint layers, with temperature. When combined with the inherently weaker adhesive bond between the paint and the metal, this can cause paint adhesion failure, as William Bell Scott warned in 1865 in an inscription on the reverse of *The Nativity*, c.1799–1800 (Philadelphia Museum of Art), which reads: 'Don't place this picture in the sun or near the fire, or it will crack off the Copper.'[22] In addition, Blake's only tempera painted on tinned iron, *The Agony in the Garden* (figs.86 and 136), has been affected by an accumulation of iron corrosion products between the metal surface and the priming, which continues literally to push the paint away from the metal surface. Tinning is a process designed to prevent iron corroding, but if Blake had previously scratched the surface when trying it out for engraving, as suggested in the introduction, p.30, its corrosion would have been assured.

Some time after Blake's death, John Linnell offered an explanation for the cause of the 'lamentable decay into which some of Blake's "frescoes" and temperas have already fallen' by claiming that Blake

> evidently founded his claim to the name *fresco* on the material he used, which was watercolour on a plaster ground (literally glue and whiting); but he always called it either fresco, gesso, or plaster. And he certainly laid this ground on too much like plaster on a wall. When so laid on to canvas or linen, it was sure to crack and, in some cases, for want of care and protection from damp, would go to ruin. Some of his pictures in this material on board have been preserved in good condition, and so have a few even on cloth.[23]

Here Linnell correctly suggests that the thickness and stiffness of Blake's ground layers, as well as his choice of painting support, are major factors in the physical deterioration of the temperas, which is also reflected in the better condition of the temperas on wood panel. Blake's priming or grounds are prone to cracking from the shrinkage of the animal glue (and possibly gum) binder. Similarly, the temperas with thinner ground layers have survived in better condition, such as *Charity*, 1799 (fig.133) and *The Characters in Spenser's 'Faerie Queene'*, c.1825 (fig.112).

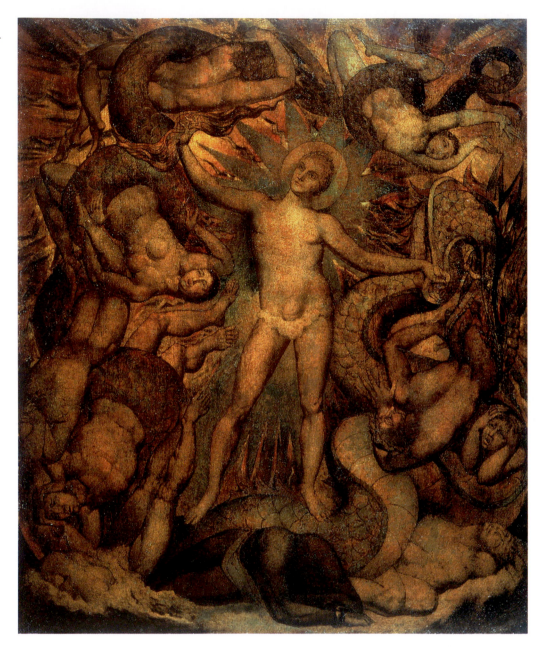

Lastly, the appearance of Blake's temperas cannot be divorced from the consequences of sometimes numerous old restoration treatments, which, while primarily intended to stabilise physical condition, have also often had a marked effect on appearance. Some of the 'darkening' can also be attributed to the saturation of the priming and paint layers during lining, consolidation and varnishing processes, where the white chalk priming is rendered transparent by impregnation with adhesives and varnishes, which results in an overall darkening of the image. Traditional 'lining' of a canvas involved brushing an adhesive in liquid form onto the back of the artist's canvas while it was face down, placing a new canvas on top and heat-sealing them together by ironing the new canvas

with a hand-iron that had been heated (this also makes the glue discolour, as noted on p.151). The lining adhesive would melt and soak into the absorbent priming from the canvas side. 'Consolidation' is the process of feeding liquid adhesive beneath a loose flake of paint, then allowing it to set, or heating it locally with a special tool to achieve a very localised lining effect. Localised absorption of the glue into a ground like Blake's would then be likely, and varnishing a canvas painting which had already lost flakes of paint could lead to the varnish soaking into the canvas or the ground from these losses. So universal were these treatments from the nineteenth century until they were reassessed by the conservation profession from the 1970s onwards,[24] that the only one of Blake's temperas on canvas that has never been lined is *Sir Jeffery Chaucer . . .* (fig.103).

In the majority of cases the retouching campaigns were restricted to disguising losses, covering abrasion and minimising the distracting effects of cracked paint. However, others include areas of overpaint aimed at reinforcing Blake's 'lost colour', which are fortunately often rendered distinguishable by the use of anachronistic pigments. For example, the bright greens in the foreground of *The Agony in the Garden* and similar bright optical greens in the foreground and upper foliage in *Christ Blessing the Little Children* (fig.138) cannot have been used before the production of their yellow component in 1850 or so. The application of completely different paint media, such as the heavy, opaque oil paint used in *The Miracle of the Loaves and Fishes*, 1799–1800 (B416, Robert Essick), and in the colour print *Satan Exulting over Eve* (fig.71), described in the chapter on its conservation, pp.100–7, offer further examples.

Rossetti's records revealed that some of the temperas noted as being in bad condition in 1863 had been restored or 'repaired' prior to 1880, and current conservation records repeatedly document the restoration of Blake's temperas by three particular artists/ restorers, including an occasional reference to Blake's follower George Richmond, who restored *The Spiritual Form of Pitt Guiding Behemoth*, (?)1805 (fig.94), in Samuel Palmer's studio some time prior to Palmer's death in 1881.[25] (Their care of the temperas extended to framing, a point that will be discussed in the epilogue.) Many were also restored by Stanley William Littlejohn from the British Museum before his death in action in the First World War.[26] In the 1940s and 1950s many others, including some previously restored by Littlejohn, were restored by Dr Johann Hell,[27] who generally espoused moderation and harmony in the cleaning of paintings, or the 'metaphysical approach', as opposed to the 'total cleaning' theory favoured by his colleague, Helmut Ruhemann.[28]

Thirty per cent of Blake's temperas have been lost through neglect and poor condition, and although restoration treatments have preserved the majority of them for future generations, some of the more unsympathetic treatments have also resulted in severe changes to original appearance. These include the excessive trimming of tacking edges for lining, disfiguring overpainting, patchy varnish removal, paint abrasion and the removal of delicate glazes. The most radical example involved the almost complete repainting prior to 1885 of each of the eighteen 'Heads of Poets' (Manchester City Art Gallery) in

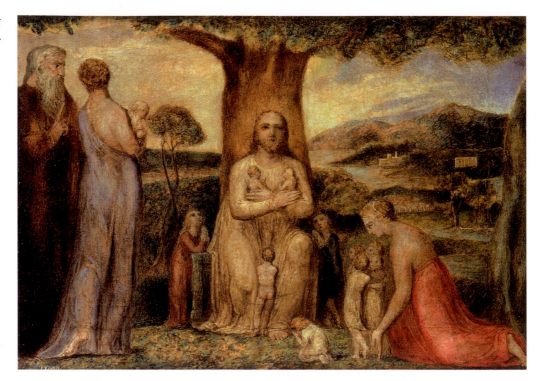

oil paint (now removed) and included many alterations to Blake's actual designs, such as the addition of a second eyeball to the portrait of *Camoens* (fig.92).[29]

Another restoration procedure that contributes to the overall darkening of the temperas, as well as some of the varnished coloured prints and watercolours, is the yellowing and fracturing of natural resin varnishes with time. This is particularly relevant, as some of the later applied varnishes were identified as containing drying oils, which are known to yellow to a greater extent than the spirit varnishes allegedly preferred by Blake. This may account for the fractured, orange surface on *The Spiritual Form of Nelson Guiding Leviathan*, c.1805 (figs.135 and 137), which appears to be a combination of a degraded varnish and Blake's final 'sealing' glue layer. In addition, each new application of varnish adds weight to the paint layers and also exerts a contracting force upon drying, which can also promote paint flaking.

One of the reports written by Dr Hell in 1954 during his cleaning of *The Virgin and Child*, c.1825? (fig.110) stated that 'beneath the layers of dirt and glue the picture was in perfect condition, the colours as fresh and lovely as they were one hundred and twenty nine years before'.[30] As pigment analysis revealed Blake's general use of a range of non-light-fugitive pigments in the temperas, this could provide insight into the early reports of a 'loss of colour' by indicating that the upper glue and varnish layers were responsible for most of the darkening. If this is the case, then Gilchrist, Rossetti and others may have been referring to the effective masking and 'loss' of colour caused by the cumulative discoloration and ongoing degradation of Blake's paint media, as well as

the accumulation of surface dirt and/or the literal loss of 'colour' caused by the extensive amounts of paint loss, rather than the wholesale fading of pigments.

There appears to be little evidence of the wholesale fading of pigments on Blake's temperas, and no remaining evidence of the blackening of the lead-based pigments reported by D.G. Rossetti in his supplementary chapter to Gilchrist's 1863 biography.[31] Recent practical experiments in paint-making have also shown that indigo manifests the least fading in gum and in proteinaceous media,[32] and indeed there is only one obvious example of faded indigo among the temperas in the sky of *Sir Jeffery Chaucer . . .*, where the frame protected a small strip of indigo-based paint from the light. In watercolours, as noted earlier (pp.75–9), indigo *has* faded, but gamboge faded less often. Some fading of gamboge is possible in the temperas. On the one hand, a browned sealing layer of glue medium on top may have protected areas of gamboge from the harmful effects of light; on the other hand, such a layer also conceals the colour of the gamboge. It is even more likely that some gamboge glazes were accidentally removed during cleaning, because of their solubility in ethanol. Blake did not use the fugitive brazilwood in his temperas, though he did in his watercolours (see Appendix 2), and the madder that he used in the temperas when he required a red lake would have been less prone to fading.

What is clear is that the changes in appearance seen in all of Blake's tempera paintings are the result of a number of complex and sometimes interdependent factors, including Blake's choice and use of paint media; the accumulation of surface dirt; the yellowing of natural resin varnishes; the deterioration of the physical condition of the paint film; the fading of pigments; the possible removal of glazes; and the effects of restoration procedures such as lining, cleaning, paint consolidation and retouching. All of these have sadly resulted in the at least partial, and sometimes severe, disguising of Blake's intention.

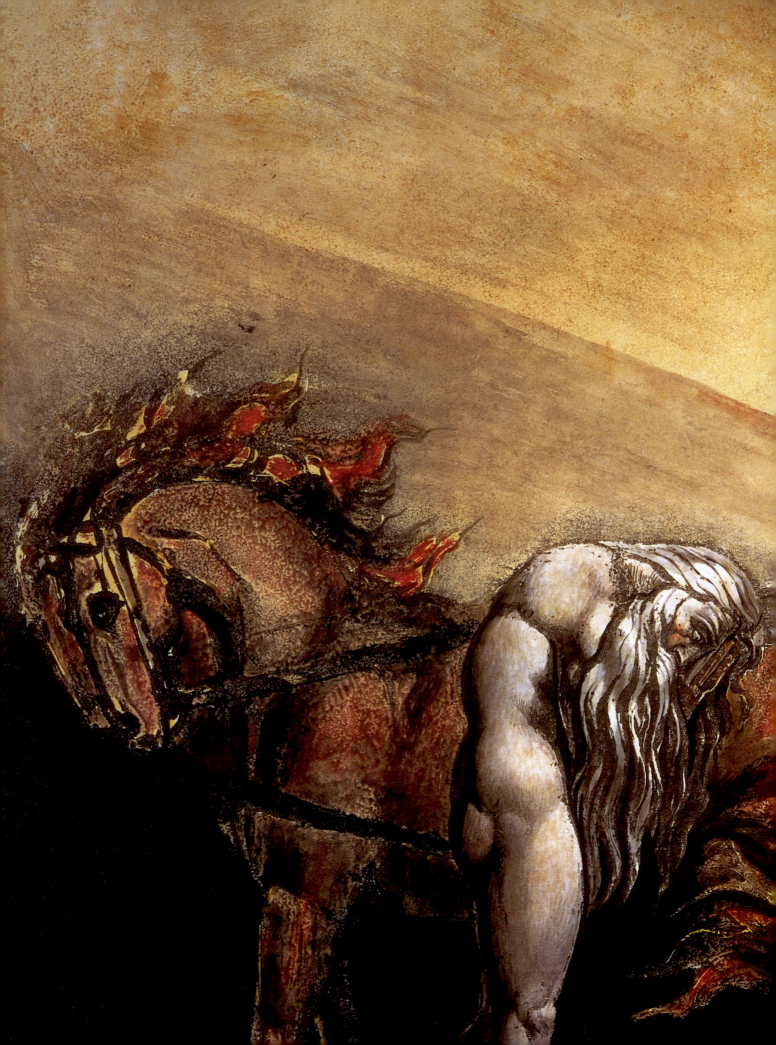

PART FIVE

Epilogue

The Presentation of Blake's Paintings

JOYCE H. TOWNSEND, ROBIN HAMLYN AND JOHN ANDERSON

Past framing and display practices

It is only in very recent years that the framing and presentation of paintings and prints have been studied critically in an historical context. Books that illustrate original frames and discuss past framing practices have only been published in quantity since the 1990s.[1] The consequence is that paintings and prints in numerous collections are displayed in frames that date from a later period than the work itself, without any explanation that this is the case. Now, whenever an individual work receives conservation treatment or a new display is planned, a decision has to be taken: should the previous frame be reused or replaced? Was it historically justified? Do we even know what type of framing might have been used historically? Is the viewing public going to assume that every frame on display must have been chosen carefully by the artist? Is framing instead the province of the room designer? Does it then reflect the fashion of the time? It often did in the past and still does.

Prints and even oil paintings were regarded in the seventeenth century as 'furniture', part of the interior decoration of a room,[2] and in inventories the quality of the frame was at least as likely to be mentioned as the artist's name. The frame would generally have been selected by the current owner, not by the original artist, who would have sold the work on its own, unless the buyer had specified otherwise or paid more for a frame. Watercolours continued to have low status in the eighteenth century, and prints were held in even lower regard and framed accordingly. It has been noted that 'This business requires little genius, and neither much learning', and that frame-making for prints was 'a specialist branch of the furniture trade' by the time of Blake's birth,[3] and hence during his early years as a commercial engraver. Most prints were seen as ephemeral, perhaps valued as much or as little as a present-day exhibition poster, which might be displayed for only a few years by its purchaser. When prints were displayed, their destruction through fading due to light exposure, damp, insect attack, unsuitable framing materials, dust and urban pollution was almost assured. This means that the evidence for historic framing practice is rare indeed.

Highly prized prints were generally kept in portfolios, and whole collections might be arranged by subject and formed and re-formed into albums at the owner's behest.[4] This work was neither highly regarded nor well paid in relation to the worth of old master prints. Some individuals in contrast lavished enormous care and expense on the display and storage of their collection of prints, or caused their employees and students to expend much time on it. The architect Sir John Soane was such a one, collecting throughout the exact period when Blake produced colour prints, watercolours and temperas, though Soane possessed only bound copies of Blake's illustrated editions of Edward Young's poem, *Night Thoughts* (copy F, hand-coloured though not necessarily by Blake himself),[5] and Robert Blair's *The Grave*, neither purchased directly from the artist. Sir John Soane's museum is unchanged today and can be visited in London.[6] It has also been illustrated and discussed in detail.[7] He represented any artist's dream of a prosperous and generous patron, one moreover deeply interested in British art. Blake was equally fortunate in having one wealthy and stalwart patron, Thomas Butts, though unlike Soane he was not a public figure.

Watercolours had low status when the Royal Academy of Arts was founded in 1768. One of its statutes declared that 'There shall be an Annual Exhibition of Paintings, Sculpture and Designs',[8] and oil paintings were displayed until 1836 in the impressive and well-lit Great Room on the top floor of Somerset House, Strand, London (which is today one of the display spaces in the Courtauld Institute Gallery). So too were miniatures, mounted in groups in small gilt frames with '[no] more than one Inch of Framing', prescribed by statute in 1791,[9] and crammed in round the fireplace where larger oils could not have fitted. The display of oil paintings was strictly regulated, since the walls were literally covered with them. Reynolds himself had been in the habit of sending one of his own gilt frames year after year to the annual exhibition, with different paintings each time.[10] Prints, watercolours and sculptures were relegated at first to a smaller, ill-lit room on the ground floor. In 1793 the prints ascended one floor.[11] Watercolours were probably displayed in frames that the artist might have used year after year for this purpose, though no illustrations of this have survived.[12]

Glass for frames was expensive historically. Blown glass could easily be made into flat sheets of small to moderate size, while larger sizes were difficult to produce and cost much more. In Blake's time the cost of glass large enough for his colour prints was not insignificant relative to the guinea[13] he originally charged Butts for each print in 1805,[14] and to the five guineas per large print he suggested to Dawson Turner in 1818 for the whole set.[15] For example, the 'framing and glazing' of a print after *Sir Jeffery Chaucer . . .*, of plate size 35.8 x 95cm (i.e. less than twice the area of a large colour print), cost two guineas.[16] The framing on its own would not have cost nearly as much. The expense of glass has been suggested as the main reason for 'close framing' in the eighteenth and earlier nineteenth centuries.[17] A 'close frame' reveals only the print, and on occasion its title, description of the scene, name of the engraver, etc., not the paper border or any decorative

wash or mount. It nearly always had gilding on the inner portion of the frame, next to the image. Close-framing conferred on a print more of the status of a finished picture.

Blake's presentation?

Blake's illuminated books were scarcely 'presented' at all: he or his wife Catherine stitched the pages between plain paper wrappers so that the purchaser could have them bound to his taste. In one case a copy of *Songs of Innocence* was 'stitched into an account book cover by Blake'.[18] A set of the *Job* prints was bound (too tightly) in 1826 for its new owner,[19] while in the same year another set of *Job* prints was presented in 'flatts', which might be read as 'matts', made by the frame-maker James Linnell (the father of Blake's patron) for John Varley.[20] The *Large Book of Designs* (*c*.1796) had been bound into the back of a copy of *Europe* by 1827.[21] The early illuminated plates had no borders and were washed lightly, while the text was uncoloured: Viscomi has pointed out that this emphasises the text and makes the whole plate appear less like a contemporary print, though some plates did incorporate design elements that wrapped round the text like a border.[22]

Blake certainly knew how borders framing his images could strengthen presentation. We can see it in its simplest form in his *Joseph of Arimathea* (Essick 1983 I; see fig.1). With the second copy (copy B) of the *Small Book of Designs* printed in 1796 as part of a reworking from about 1818,[23] Blake ruled ink framing lines around each relief-etched colour-printed plate, as in *Teach these Souls to Fly* (B261.5, T23, Tate), which includes the title inscribed in ink in his hand just below the lower line. When Linnell bought a copy (copy O) of the illuminated book *America* in 1821 from him, Blake ruled a single framing line around the designs with an orange-red ink, which complements the ink used in the printing. In the 1825 copy W of *Songs Of Innocence and Of Experience*, which stayed with Blake until his death, the watercolour margins became delicate, decorative frames, enhancing the words and designs that they surround. All these, however, are devices intended for works that were thought of essentially for private contemplation.

For the public display of his watercolours and temperas, it needs to be remembered that over his entire career Blake had only fifteen works accepted for London exhibitions, twelve of them shown at the Royal Academy: in 1780 in the 'Ante-room', which led into the Great Room; in 1784 and 1785 in the ground floor 'Exhibition-Room of Sculpture and Drawings'; in 1799 a small tempera in the Great Room; in 1800 the tempera *Loaves and Fishes*, which was, however, relegated to the Antique Academy on the first floor; and in 1808 two watercolours were elevated to the more prestigious Council Room on the first floor.[24] It seems inconceivable that he did not submit some of the large colour prints, too, but if he did they were rejected, one assumes partly on the grounds that their technique was too unconventional:[25] in 1809 he stated that 'my Designs, being all in water-colours, (that is in Fresco) are regularly refused to be exhibited by the *Royal Academy*'.[26] This would have reinforced his antipathy to the Academy and its first president Reynolds, by

then dead. If we consider now equally famous contemporaries such as Constable, who over his career had more than 130 exhibition entries, and Turner, who had more than 600, we realise that framing for public display played but a small part in Blake's studio routine.

He also showed sixteen paintings in his own exhibition of 1809–10, held in the living quarters of his brother James's home and shop in 28 Broad Street, Golden Square, London (figs.3a, 3b). The arrangement of this exhibition, with visitors entering through the ground-floor shop, has recently been reconstructed to scale by Patenaude, based on the order of the works in Blake's *Descriptive Catalogue*.[27] Patenaude argues that the pairing of some works was very deliberate, and that the relatively similar sizes of some works made the scheme more workable. There were no options for the placing of the larger works, such as *The Ancient Britons* and *Sir Jeffery Chaucer* . . . The first-floor rooms could only just accommodate them: their ceiling heights and overall dimensions were comparable to all Blake's other living spaces, as discussed earlier (pp.16–20). Patenaude was not able to find any evidence for Blake's framing practice.

Gilchrist wrote in 1863, 'The three *Joseph* drawings turned up within the last ten years in their original close rosewood frames (a far from advantageous setting) at a broker's in Wardour Street, who had purchased them at a furniture-sale in the neighbourhood,'[28] which refers to the 1785 exhibition. Whether the frames *were* indeed original is highly debatable, given that the Royal Academy had always specified gilt frames at this time, and that rosewood frames were more common for prints from about the 1820s. The tempera in the Great Room in 1799 would certainly have had a close gilt frame as though it had been an oil painting.[29]

Watercolourists regularly saw their exhibited works badly hung and eclipsed by larger and inherently brighter oils at the Royal Academy. In 1805 some of them founded the Society of Painters in Water-Colours, which existed until 1812 with good attendance and sales at its exhibitions,[30] and whose displays greatly resembled those at the Royal Academy at the same date. Blake was not a founder member and seems never to have exhibited there. In any case, membership of the Royal Academy precluded membership and therefore exhibition with any comparable society, until well after Blake's lifetime.[31] He did become a member of the Associated Artists in Watercolours, which existed from 1808 to 1812, in its final year, when he showed the temperas *Sir Jeffery Chaucer* . . . (fig.103), *The Spiritual Form of Pitt Guiding Behemoth* (fig.94) and *The Spiritual Form of Nelson Guiding Leviathan* (fig.137), all of which had been left on his hands since the 1809 exhibition. Blake also showed 'Detached specimens of an original illuminated Poem'. Essick has pointed out that the *Jerusalem* plates in question are now trimmed of text, and are likely to have been trimmed by Blake himself for that exhibition.[32]

The rival watercolour societies drove one another to extinction. In the 1823 exhibition of the survivor, the Society of Painters in Watercolours, the works were displayed like oils in 'gorgeous frames' with 'glittering gold' and needed to be strongly coloured to stand up against this dazzling surround.[33] They were still competing for the status – and prices –

long afforded to oils and denied to two-dimensional art in all other media, and Blake's paintings have to be seen in this context. Blake's *Divine Comedy* series, and many of his earlier watercolours, had the requisite tonal range for such presentation and some were finished to exhibition standard, even though they were never exhibited in his lifetime. All the unaltered and surviving temperas we see today had a comparable tonal range. In fact the wider range of pigments that he employed for the *Divine Comedy* series, comparable to the range he had used for the temperas, could well have been influenced by changes in display practice, as well as the development of the exhibition watercolour by Girtin and his much longer-lived rival Turner, during Blake's lifetime. It has to be admitted, though, that Blake's contemporaries developed watercolour techniques far more than Blake himself did.[34]

Blake's watercolours provide the best evidence of how his work was displayed. Washline borders, not drawn by Blake himself, frame the illustrations to Young's *Night Thoughts* (B330).[35] One group of watercolours that was shown in public, but not by Blake himself, was his twenty 1805 illustrations for Blair's poem *The Grave*, commissioned by R.H. Cromek. Apart from the title page, they measured 9½ x 5½in to 10¾ x 8¾in (23.5 x 13.2cm to 24 x 22.7cm) and were pasted on cream card, 13⅛ x 10½in (33.3 x 26.7cm), probably not long after Blake handed them over, since one mount has an 1806 watermark. Each watercolour is framed simply by three ruled ink lines about 3mm wide on the card, with the outer two forming a narrow washline border in grey.[36] Cromek's purpose in doing this was to make the works presentable to potential subscribers for the expensive volume that Blake's engraved watercolours were to illustrate – this involved showing them in various towns outside London in 1806–7.

The little other evidence of how Blake's works were shown in his lifetime is found among the eighty-five surviving watercolours of biblical subjects for Butts, painted 1800–5. Even so, this relates to display in a private, domestic setting, rather than the public one now so familiar to us in museums, galleries or study rooms. Where the edges have not been trimmed, it is clear that some of these were finished by Blake with framing washline borders of several ruled ink lines with watercolour washes between, all on the same sheet of paper as the image, as can be seen in *The River of Life*, c.1805 (fig.40).[37] As watercolourists often did, Blake chose a colour for one of the principal bands that complemented one in the picture – the orange in the drapery of the right-hand figure. Similarly complementary is Blake's reference to book, chapter and verses, which he inscribed in ink beneath the lower right corner of the image, within the orange band. (The title inscribed in pencil beneath the border is not in Blake's hand.) Other biblical watercolours with similar borders are *Sealing the Stone and Setting the Watch* (B449, Fogg Art Museum, Harvard, Cambridge, Mass.), *The Ascension* (B505, Fitzwilliam Museum, Cambridge) and *Mercy and Truth are Met Together* (B463, Victoria and Albert Museum, London). This presentation was quite typical, and evidence, including evidence against framing, survives on works by other artists too.[38] Varnishing the result all over would not

have been uncommon and would certainly have reduced the chances of long-term survival. The practice is sometimes illustrated in paintings or watercolours of interiors.[39] The worst fate for a watercolour or print was to be pasted to a wall, as even some well-known collectors such as Thomas Munro (1759–1833) did.[40] At Fountain Court Blake's showroom at the front of the house had 'panelled walls hung with frescoes, temperas, and drawings'.[41] It is quite likely that these were unframed, as in South Molton Street, where the reduced pencil drawing for the engraving after the tempera *Sir Jeffery Chaucer . . .* was probably placed over the sitting-room door, where it was 'long exposed to air and dust'.[42]

An alternative was drum-mounting, where a window slightly smaller than the image was cut into the mount, and then the watercolour was pasted on the back by its outer edges. The mounts could be kept in a portfolio, pinned to a wall or even propped up against one, without money having to be spent on framing. It is possible that Blake originally used and inscribed such mounts for the biblical watercolours of *c.*1805 purchased by Butts (the possible replacements for such mounts are discussed below, p.168). Butts had a home in rural Dalston, east London, from 1786 and another in Great Marlborough Street near Oxford Street (and near Blake's home) from 1789, moving from both these to a new address in Grafton Street near Fitzroy Square in 1808, where he died in 1845. We know from his great-granddaughter Mary Butts (1890–1937) that the house where she grew up had a specially built 'Blake Room'[43] housing what remained of the family's original Blake collection. This suggests a family tradition of 'Blake Rooms'. *The Entombment* and *The River of Life* were undoubtedly among those that Mary Butts looked at closely, following her parents' injunction to 'make good use of her eyes', so acquiring 'the kind of seeing that there was in William Blake'.[44] Blake only ever referred to his works being 'preserv'd in [Butts's] Green House',[45] an image that succinctly conveys the artist's gratification at having a patron who allowed his art to flourish and grow.

Blake seems to have been aiming at the high-value end of the print market when he produced the large colour prints: in their technique and medium they represented a hybrid between a print and an oil painting, and were emphatically intended for display, though they never were shown in his lifetime. Alexander illustrates and discusses such framing in the eighteenth century, and notes that prints produced as a series were generally the same size, 14 by 10in (35.6 x 25.4cm) being common.[46] Blake's colour prints, as noted earlier, were larger and therefore more imposing works than this, with a minimum image size (where they survive untrimmed) of 17 by 21in (43.2 x 53.3cm). The temperas would certainly have been intended for display, not storage in albums, and many are of comparable size to the large colour prints. Blake's *Descriptive Catalogue* of 1809 typically does not mention frames, nor does the single review of the exhibition.[47] Since his working space in South Molton Street was limited at this time, he could not have made his own frames for the exhibition: only in the early years at Lambeth could he have found the additional space for this activity.

The only frame that may be Blake's own choice can still be seen with the tempera *The*

Body of Christ Borne to the Tomb (see fig.79). The chain of evidence that does not prevent it being linked to Blake, but does not make it certain either that this was his preference for framing, is presented below.

Nineteenth-century posthumous display of Blake's paintings

The other documented manner in which Blake's biblical watercolours were 'presented' post-dates Blake's lifetime. More practical than decorative, it can be identified in whole or in part from about thirty-five of them, trimmed to the image and then drum-mounted on thin card blind-stamped 'Turnbull's Crayon Board'.[48] The boards measure about 21⅛ x 17½in (55.5 x 44.5cm), which is 'Royal' size, and they are 'natural' paper colour. Viscomi has noted good candidates in London for the firm that made the boards,[49] but the earliest known date of production of such board, similar to 'Bristol Board', is 1846.[50] Five of the nine Butts Bible watercolours at Tate once had such mounts, which had titles and relevant texts written on them in a copperplate hand, namely *The Blasphemer* (B446, T40), *Satan in his Original Glory* (B469, T44), *The Crucifixion* (B499, T47) and *The Four and Twenty Elders* (B515, T51). *The Death of the Virgin*, 1803 (B512, T49), was recorded by W.M. Rossetti in 1863 as 'inscribed', presumably on a matt.[51] A sixth, *The Entombment* of *c*.1805 (B498, T48, Tate), remains drum-mounted on Turnbull's Crayon Board with the title *Joseph Burying Jesus* inscribed in faint graphite pencil in copperplate above the watercolour, and 'Luke ch: 23rd: v. 53rd' inscribed bottom right, again in faint graphite pencil in copperplate. The inlaying of Blake's paper to the crayon board was carried out with great care, the necessary overlap between card and paper having been chamfered smooth. This watercolour offers some evidence – suggestive but not compelling – for a method of presentation known as *verre eglomisé*.

Verre eglomisé was an expensive procedure, carried out by a gilder rather than a framer, which conferred a very clean-cut, neat appearance, and also protected the work behind glass. The evidence consists of substantial spots of a glossy, opaque black paint on all four sides of the crayon board, running over the pencil inscription in more than one place. It includes bone black, bitumen (a very glossy material) and some drying oil.[52] Opaque, oil-based paint known as 'black japan' was made with linseed oil and driers. *Verre eglomisé* involved applying neat lines of gilding to the underside of a glass sheet that matched the size of the mounted watercolour, so the gilding would outline the image. Then the gilding and the non-image areas of the glass were neatly painted with black japan, also on the underside, and the work was framed. From the front, the result was a glossy black surround with gilded mount lines. The method came into use in the later eighteenth century, and though it became less popular after the middle of the nineteenth century, it never fell out of use.

Apart from the first biblical watercolour, all were in Butts's collection until sold in 1906. The exception is *The Blasphemer*, sold along with others in 1852. Thus, the mounting with

inscriptions must have been completed between 1846 and 1852, which rules out any possible association with Blake himself, and even with Butts who died in April 1845. But it is close to the era of popularity for *verre eglomisé*. The original mounts – if they existed at all, they would have been soiled after forty years – might have been replaced by the family once Butts was no longer alive to defend any samples of Blake's own handwriting. More interesting from a museological point of view is the fact that the inscriptions on the Turnbull mounts do anticipate a didactic approach to public display, which, through the widespread use of wall captions, became part of museum and gallery presentation in the twentieth century.

In 1878 the National Gallery in London acquired its first two Blake watercolours, *David Delivered Out of Many Waters: 'He Rode upon the Cherubim'* (fig.26) and *Epitome of James Hervey's 'Meditations among the Tombs'* (fig.35), but they were not displayed, nor do we know how they were framed.[53] The next Blake acquisition in 1882, *The Spiritual Form of Pitt Guiding Behemoth* (fig.94), was glazed immediately, which was by then the gallery's policy, and put on display.[54] In 1884 the small tempera *The Body of Christ Borne to the Tomb* was presented to the Trustees and displayed in the same year:[55] it was 'hung under glass' though not noted as having been glazed by the gallery, so it is reasonable to assume it arrived in a frame with glass. Indeed, the frame in which it is still displayed at Tate Britain may be this one, the first ever made for it – but unfortunately not associated firmly with Blake himself. From its construction it is a late eighteenth- or early nineteenth-century frame, and while it has obviously been taken apart and re-gilded at some stage, the 'compo' leaves in the corners are intact, which means that the frame dimensions are unchanged, so it would always have been suitable for *The Body of Christ* (The description 'compo' implies that the leaves were made in a pre-carved mould, then applied to the wood, rather than being carved. This last process has been used since the mid-eighteenth century and employs a mixture of whiting (calcium carbonate) and animal glue, often with the individual frame-maker's preferred additives, which usually include drying oil or a resin. The process put more traditional frame carvers out of work in a generation or two.)[56]

The case of *The Spiritual Form of Pitt* . . . is more interesting. Palmer probably acquired it some time after 1849[57] and he would certainly have looked after the picture. It was first offered to the National Gallery in 1870 when it was said by George Richmond that 'there is hardly to be found another picture in such good preservation',[58] though it had been exhibited regularly: in Blake's 1809 show, at the 1812 exhibition of the Associated Painters in Water-Colours, at the Royal Academy 1870–1, and at the Blake exhibition at the Burlington Fine Arts Club in 1876. It was offered for sale at Christie's in March 1882 but the National Gallery finally purchased it from Palmer's executors, and it is probably safe to assume that it had a frame without glass at least soon after Palmer acquired it. Palmer had a connection at mid-century with the picture-framer James Henry Chance (1810–after 1875?).[59] He was a nephew of Blake's patron Linnell, while his brother, the surgeon Edward J. Chance (1807–95), had been involved in aspects of Blake's affairs, and

later his widow's, too.[60] As a dealer in the 1850s and 1860s a number of Blake's works passed through his hands including the three *Joseph* watercolours (B155–7),[61] and W.M. Rossetti visited him while recording Blake's paintings and drawings for the appendix to Gilchrist's biography. Chance was also close enough to Richmond and Palmer to act for them in taking *The Spiritual Form of Pitt . . .* to the National Gallery in 1870 and then returning it,[62] and therefore sufficiently intent on preserving Blake's legacy to have influenced the framing. The tempera came to Tate in 1909,[63] and it was probably then re-framed. It still has this non-original frame, whose quality and gilding colour are typical for the early twentieth century. The stamp of a framer who worked for the National Gallery in the inter-war period is on a tablet (used to display the title and/or artist) fixed to its little-worn surface, which gives further evidence that this could not be the frame exhibited so frequently in the nineteenth century, and presumably worn out. We cannot tell whether the original frame style was copied. Once again, the evidence for a genuine Blake frame has been lost for good.

Tate presentation of Blake's paintings

There have been regular displays of the watercolours and large colour prints throughout the twentieth century, generally in one of three 'Blake rooms'.[64] Photographs of these displays exist from 1940 onwards showing mounts in frames. Fig.139 features a display on the main floor in 'gallery 2' (as it is known today) with the Boris Anrep mosaic pavement,

FIG.139 1960s Tate Gallery display of large colour prints and watercolours from Dante's *Divine Comedy* series in gallery 2. Tate Archive.

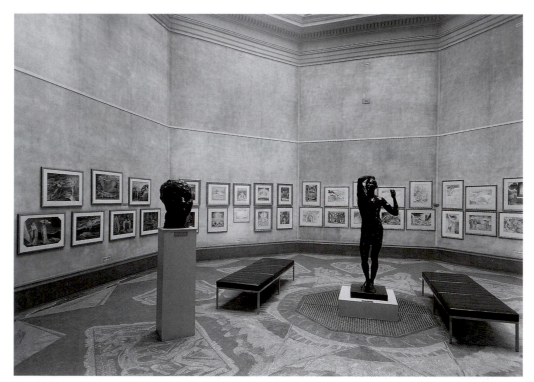

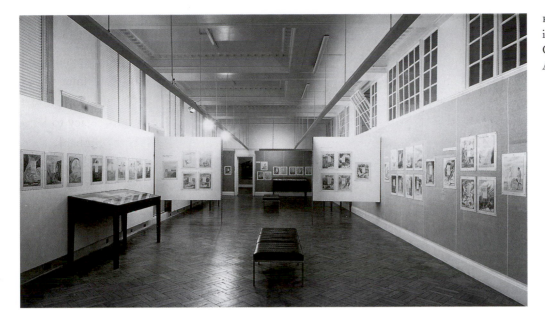

which, installed in 1923 and still *in situ*, illustrates proverbs from Blake's *The Marriage of Heaven and Hell*. Later displays were sited downstairs (fig. 140) while exhibitions devoted to Blake were held on the main floor (figs.141, 142) and then from 1978 to 1989 on the main floor in a specially designed, air-conditioned gallery without daylight, to minimise light damage to the paper and fading of pigments. That design (fig.143) was inspired by the contemporary display at the British Museum, and the centre of the room was kept dark in order to make the deliberately low illuminance in the cases appear bright and appealing.[65] In 1990 they moved to a different room, to permit a chronological arrangement of British art in one half of the building (with modern art in the other). Today Blake's paintings can be seen together on the main floor, in a gallery that was refurbished and fully air-conditioned as part of Tate Britain's centenary development. It is not appropriate to display works on paper continuously: in fact the display is changed on an annual basis, taking account of any works that are to be loaned to other galleries, so that the most sensitive works on paper are displayed for 50 per cent of the time at most, over a four-year period.

The end of the 1970s and the next decade saw the display of groups of works on paper throughout galleries in Britain in custom-made 'print cases' with internal, fluorescent lighting. The idea behind such cases (similar to those used in the 1978–89 display) was that the individual works appeared to have no glazing; hence there were no annoying reflections to distract the viewer, and they were secured against theft or damage. But it proved very difficult to light such displays evenly while meeting the conservation requirement of low illuminance, even at the edge nearest to the lights. There was always one work that straddled the seam where two sheets of glass joined or overlapped with a large lock on view, or one work too large to be illuminated evenly (see figs.142 and 143). The photograph belies the idea that such 'fish tanks' cut out all the distracting reflections.

All the Tate display photographs show that the practice of close framing for prints and watercolours was out of fashion by the early to mid-twentieth century – and remains so to this day in the vast majority of British galleries. Pale cream-coloured window mounts (made from conservation-quality board), free of any decorative lines or text, and narrow, undecorated hardwood frames with a 'natural' and 'unobtrusive' finish can be seen in the 1971 Tate display of Dante's *Divine Comedy* (fig.140), and the same frames were used for the large colour prints, displayed in mounts that covered any surviving margin of paper on each print. (In fact they are still in use at the time of writing – see fig.145.) There is an undoubted advantage to a gallery in using mounts of a standard size: each artwork has a window to fit the image size, while the outer dimensions of the mount match those of standard frames. When an artwork is not on display, the mounted works can be stored in boxes of standard size, in cabinets designed to accommodate them efficiently. The short-lived fashion of cutting the mount narrower at the top can be seen in a few cases in the 1978 Tate Blake exhibition (fig.142).

The temperas have always been close-framed like paintings, as far as we can infer from conservation records and tell from later, twentieth-century photographs. Another view of the 1978 *William Blake* exhibition shows a close-framed tempera in a very characteristic 1970s grouping of many works, complete with contemporary lettering and a white-painted panel that concealed the architecture of the south Duveen gallery (fig.141).

The acquisition of *Satan Exulting over Eve* meant that impressions of eleven out of the twelve large colour prints were now held by Tate, the twelfth being at the Victoria and Albert Museum. Its loan for the 2000–1 *William Blake* exhibition at Tate Britain prompted a serious re-consideration of how the whole set might best be re-framed. The frames were designed and created in the Conservation Department at Tate.[66] The style represented a return to historical framing practices, and can be described as British neo-classical, based on existing patterns dating from around 1790–1810.[67] It is a close frame with a plain, dark wood, scotia surround, with a gilded inner flat, relieved with gilded leaves made from 'compo' in each corner. 'Scotia' means the concave curvature more commonly used for frames than a convex one, which would reflect light away from the image (fig.71). The surround for the new frames was made from pearwood, stained and polished.

It is common practice at Tate and other galleries to glaze delicate works on paper, such as the large colour prints. The frames were built to accommodate glass. Specially coated 'low-reflecting' glass is used, and this is almost invisible to the viewer. It certainly reduces the complaints that viewers have justifiably made about plain glass since the later nineteenth century, when it came into general use in many galleries.

Many of the large colour prints have broad margins of blank paper extending beyond Blake's image: we carefully preserve such evidence of production today. Now that the paper is degraded and brittle it is not safe to fold, so the frames needed to be made sufficiently spacious to accommodate these margins without being too visually massive,

FIG.141 Display associated with the *William Blake* exhibition in the South Duveen at the Tate Gallery 1978. Tate Archive.

FIG.142 Another view of the 1978 exhibition (main floor). Tate Archive.

FIG.143 The Tate Gallery's new Blake Room (gallery 7) when it opened in 1979. Tate Archive.

FIG.144 Part of
Blake's divine comedy
series shown in the
2000–1 Tate Britain
exhibition *William
Blake*. Tate Education
Department

yet still giving the impression of a close frame. The plain wood margin allowed the gold leaf inners to be toned slightly to suit the individual prints, without the frames looking discordantly different from each other when hung together (figs.144, 145). For example, *Satan Exulting* needed restrained gilding because of its dulled colours, whereas *God Judging Adam* (fig.53), being bright, could bear brighter gold.

This return to tradition, which began in the last two decades of the twentieth century and makes use of recent rediscoveries about historic framing practices, itself forms part of a 'new tradition' in the sympathetic display of British art within the architecturally significant spaces of most public galleries including Tate Britain.[68]

FIG.145 Blake's large colour prints shown in the 2000–1 Tate Britain exhibition *William Blake*. Tate Education Department

Notes

All of Blake's paintings discussed in the text are referred to by their 'B number' in M. Butlin, *The Paintings and Drawings of William Blake*, vol.1, New Haven and London, 1981. All those in the Tate Collection have an allocated 'T number' from M. Butlin, *William Blake 1757–1827*, Tate Gallery Collections: vol.5, London, 1990. Tate accession numbers with six characters are also given for these works.

PART ONE: INTRODUCTION

William Blake at Work: 'Every thing which is in Harmony' pp.12–39

1 D.V. Erdman, *The Complete Poetry and Prose of William Blake*, Berkeley and Los Angeles, 1982, p.695: *Notebook*, p.92.
2 Erdman 1982, pp.692–3.
3 G.E. Bentley Jr, *Blake Records*, Oxford, 1969, pp.421–31. (Second edition forthcoming.)
4 G.E. Bentley Jr, *Blake Books*, Oxford, 1977, no.32.
5 Bentley 1977, nos.31, 36.
6 See M. Butlin, *The Paintings and Drawings of William Blake*, 2 vols., New Haven and London, 1981; no.653.
7 Erdman 1982, p.527: *Advertisement of the Exhibition*.
8 Erdman 1982, p.529: *A Descriptive Catalogue*, 1809, p.iii.
9 Bentley 1969, p.422.
10 R. Wark (ed.), *Sir Joshua Reynolds: Discourses on Art*, 3rd edn., New Haven and London, 1997, p.218 (*Discourse 12*, 1784).
11 R. Wornum (ed.), *Lectures on Painting by the Royal Academicians, Barry, Opie, and Fuseli*, London, 1848, p.123 (Barry, *Lecture 3*).
12 John Flaxman, *Lectures on Sculpture*, London, 1829, pp.326–7.
13 Wornum 1848, p.377 (Fuseli, *Lecture 2*).
14 Erdman 1982, p.649: annotation to Reynolds *Discourse 3*, p.71.
15 Erdman 1982, p.559: *A Vision of the Last Judgement*, p.82.
16 Erdman 1982, p.270: *On Virgil*.
17 Erdman 1982, p.646: annotation to Reynolds *Discourse 2* (p.43).
18 Erdman 1982, p.575: *Public Address*, p.39.
19 Erdman 1982, p.576: *Public Address*, p.62.
20 Erdman 1982, p.661: annotation to Reynolds *Discourse 8* (p.251).
21 Erdman 1982, p.545: *Public Address*, p.24.
22 Erdman 1982, p.576: *Public Address*, p.62.
23 Erdman 1982, p.574: *Public Address*, p.57.
24 Bentley 1969, p.422.
25 Wark 1997, p.51 (*Discourse 3*, 1770).
26 Wark 1997, p.50 (*Discourse 3*).
27 Wark 1997, p.275 (*Discourse 15*, 1790).
28 R.N. Essick, *The Separate Plates of William Blake: A Catalogue*, Princeton, 1983, no.I.
29 Erdman 1982, p.639: 'Annotations to the Works of Sir Joshua Reynolds, vol.I', p.xlvii.
30 A. Gilchrist, *The Life of William Blake*, 2 vols., London, 1863, vol.I, p.96; Bentley 1969, p.31.
31 By Adamo Ghisi (*c*.1530–74), which had been republished in 1773. See Butlin 1981: B167–70.
32 Using fifty-four etchings in the *Historia del Testamento Vecchio . . .* of 1603. See R. Hamlyn and M. Phillips et al., *William Blake*, exh. cat., Tate Britain, 2000, no.142 (illus.).
33 J. Ingamells, *A Dictionary of British and Irish Travellers in Italy 1701–1800*, New Haven and London, 1997, p.58.
34 See Humphrey's studio sale, Christie's, London, 29 June 1810; J. Romney, *Memoirs of the Life and Works of George Romney*, London, 1830, pp.100, 102.
35 Now attributed to Spinello Aretino (active 1373–d. 1410/11). See M. Davies, *National Gallery Catalogues: The Early Italian Schools before 1400*, rev. D. Gordon, London, 1988, pp.94–6.

36 G.E. Bentley Jr, *The Stranger from Paradise: A Biography of William Blake*, New Haven and London, 2001, p.181.
37 J. Alexander and P. Binski (eds.), *Age of Chivalry: Art in Plantagenet England 1200–1400*, exh. cat. Royal Academy, London, 1987, no.329, pp.340–1.
38 Alexander and Binski 1987, no.680, pp.498–9.
39 W. Aglionby, *Choice Observations upon the Art of Painting. Together with Vasari's Lives of the Most Eminent Painters, from Cimabue to the Time of Raphael . . .*, London, 1719: 'Life of Cimabue', p.131. Aglionby's translation, first published in 1685, from the Italian of Vasari was the first in English and would have been known to Blake.
40 Erdman 1982, p.549: *A Descriptive Catalogue*, 1809, p.62.
41 Gilchrist 1863, pp.8, 13.
42 J. Ford, *Ackermann 1783–1983, The Business of Art*, London, 1983, p.21; and D.G.C. Allan, *William Shipley, Founder of the Royal Society of Arts: A Biography with Documents*, London, 1979, p.85.
43 Formerly *Part of a Face, Copy from the Antique?* I am grateful to Ian Jenkins for suggesting the subject.
44 Measurements kindly supplied by William Clarke, Head of Paper Conservation, Courtauld Institute of Art, London.
45 Gilchrist 1863, p.30.
46 Bentley 1969, pp.552–6; Survey of London, vol.XXXI, Part 2, London, 1963, pp.203–4, where plans and elevation are illustrated.
47 Gilchrist 1863, p.9.
48 Bentley 1969, p.556.
49 See also Bentley 1969, pp.562–3, illus. pl.lviii a.
50 See also Bentley 1969, pp.235; Gilchrist 1863, p.358.
51 Erdman 1982, p.710: Blake to Flaxman, 21 Sept. 1800.
52 Erdman 1982, pp.752–3, 759–60: Blake to Hayley, 22 June 1804 and 28 Dec. 1804. The cartoons were approx. 40 x 50in (1015 x 1270mm); see A. Kidson, *George Romney 1734–1802*, exh. cat., National Portrait Gallery, London, 2002, pp.118ff.
53 For information about Fountain Court see Bentley 1969, pp.349, 542, 564–7, illus. pl. lviii b; Gilchrist 1863, pp.303, 348–9; Gilchrist 2nd edn, 2 vols., 1880, vol.I, pp.321–2 (illus.), 348–9 (illus.); G.E. Bentley Jr, *Blake Records Supplement*, Oxford, 1988, p.109; Linnell's *Journal*, 22 and 30 Aug. 1827.
54 Erdman 1982, pp.730–1: Blake to Thomas Butts, 6 July 1803.
55 Erdman 1982, p.7.
56 D. Bindman, *The Complete Graphic Works of William Blake*, London, 1978, pl.91.
57 Erdman 1982, p.774: Blake to Linnell, 7 June 1825.
58 R.N. Essick, *William Blake's Commercial Book Illustrations*, Oxford, 1991, Appendix 1, F3, fig. 291; the plates are in the Bodleian Library, Oxford.
59 Essick 1983, no.XVI.
60 Bentley 1977, p.67: *All Religions are One*, 1788/1794, pl.7.
61 *Job*: Essick 1983, no.V.
62 Essick 1991, no.XX.
63 B161.
64 B654.
65 Erdman 1982, p.582: *Public Address* p.24.
66 Erdman 1982, p.531: *A Descriptive Catalogue*, pp.5–6 (no.II).
67 Erdman 1982, p.643: annotation to Reynolds *Discourse 1*, 1778, p.13; Erdman 1982, p.662: *Discourse 8*, p.284.
68 Erdman 1982, p.549: *A Descriptive Catalogue*, p.62.
69 Gilchrist 1863, pp.314–15.
70 Bentley 1969, p.529.
71 Erdman 1982, p.775: Blake to Linnell, 1 Feb. 1826.
72 Erdman 1982, p.780: Blake to Linnell, 29 July 1826.
73 Erdman 1982, p.757: Blake to Hayley, 23 Oct. 1804.
74 Bentley 1969, p.422.
75 A figure from Michelangelo's *Last Judgement* painted in oil (B50; Huntington Library, Art Collections and Botanical Gardens) and once attributed to Blake is not by him.

76 R. Hamlyn, '"Sword Play": Turner and the Idea of Painterliness as an English National Style', in L. Parris (ed.), *Exploring Late Turner*, exh. cat., Salander O'Reilly Galleries, New York, 1999, pp.117–30.

77 Lady Burlington, quoted in R. Wendorf, *Sir Joshua Reynolds: The Painter in Society*, London and Harvard, 1996, p.115.

78 J.T. Smith, *Nollekens and his Times* (first published 1828), ed. W. Whitten, 2 vols., London, 1920, vol.II, p.86, Gainsborough.

79 J. Knowles, *The Life and Writings of Henry Fuseli, Esq. M.A. R.A.*, 2 vols., London, 1831, vol.I, pp.405–6.

80 W. Thornbury, *The Life of J.M.W. Turner R.A.*, 2 vols., London, 1862, vol.II, p.186.

81 From a contemporary account of the making of *A First-Rate Taking in Stores* of 1818, from M. Butlin, A. Wilton and J. Gage, *Turner 1775–1851*, exh. cat., Tate Gallery and Royal Academy of Arts, London, 1974–5, cat. no.194, p.84.

82 Thornbury 1862, vol.II, pp.188–9.

83 Smith 1920 (1828), vol.II, p.332, G.H. Harlowe. The original picture is 403.9 x 276.9cm (160 x 110 in).

84 Smith 1920 (1828), vol.II, p.76, J.K. Sherwin.

85 Gilchrist 1863, p.251.

86 Bentley 1969, p.305, n.1.

87 R. Lister (ed.), *The Letters of Samuel Palmer*, 2 vols., Oxford, 1974, 1, p.476: Palmer to an unknown addressee, ?Sept. 1849.

88 Smith 1920 (1828), vol.II, p.382; Bentley 1969, p.467.

89 Formerly *Charon. Copy from the Antique?*

90 Bentley 1969, pp.421–31, (p.423): B.H. Malkin, *A Father's Memoirs of His Child*, London, 1806.

91 Gilchrist 1863, p.370.

92 Erdman 1982, p.747: Blake to Hayley, 27 April 1804.

93 Erdman 1982, p.752: Blake to Hayley, 22 June 1804.

94 Erdman 1982, p.576: *Public Address*, p.60.

95 Erdman 1982, p.653: *Annotations to the Works of Sir Joshua Reynolds*, vol.I, *Discourse 5*, p.123.

96 Smith 1920 (1828), vol.II, p.382; Bentley 1969, p.467.

97 Bentley 1969, p.72: John Flaxman to William Hayley, 19 Aug. 1800.

98 Gilchrist 1863, p.315.

99 D. Bindman, *William Blake: Catalogue of the Collection in the Fitzwilliam Museum*, Cambridge 1970, no.56, p.60.

100 Erdman 1982, p.576: *Public Address*, p.62.

101 Erdman 1982, p.782: Blake to Linnell, Feb. 1827.

102 Erdman 1982, p.547: *A Descriptive Catalogue*, p.55 (no. IX).

103 Thornbury 1862, vol.2, p.172.

104 A.H. Palmer, *The Life and Letters of Samuel Palmer*, London, 1892, p.101.

105 D. Goldring, *Regency Portrait Painter*, London, 1951, p.314.

106 A. Pasquin (John Williams), *Memoirs of the Royal Academicians …*, London, 1796, p.107.

107 M.T.S. Raimbach (ed.), *Memoirs and Recollections of the late Abraham Raimbach, Esq. Engraver …*, London, 1843, p.15.

108 Bentley 1969, p.267.

109 Wark 1997, p.19 (*Discourse 1*).

110 Gilchrist 1863, p.267.

111 Erdman 1982, p.712: Blake to Butts, 2 Oct. 1800.

112 For Felpham see Bentley 1969, pp.561–2, pl. LVII.

113 Erdman 1982, p.545: *A Descriptive Catalogue*, p.50.

114 Ibid.

115 Bentley 1969, p.217.

116 I am grateful to C. Lidgate Ltd, London butchers, for confirming this description.

117 Erdman 1982, p.545: *A Descriptive Catalogue*, p.50 (no.V).

118 Erdman 1982, p.541: *A Descriptive Catalogue*, p.37 (no.IV).

119 W.B. Pope (ed.), *The Diary of Benjamin Robert Haydon*, 5 vols., Cambridge, Mass., 1960, vol.1 (1960), p.259 (2 Dec. 1812).

120 K. Garlick and A. Macintyre (eds.), *The Diary of Joseph Farington*, New Haven and London, 1978, vol.III (Sept. 1796–Dec. 1798), p.1075 (24 Oct. 1798).

121 Flaxman to his wife, 18 June 1783, quoted in M. Phillips, 'William Blake and the "Unincreasible Club": The Printing of "Poetical Sketches"', *Bulletin of the New York Public Library*, vol.80, no.1 (Autumn 1976), pp.6–18 (p.15). The fullness of the inscription, unique for this period of Blake's

career, on the 1783 watercolour *The Witch of Endor Raising the Spirit of Samuel* (B144) suggests that this might be the 'capital drawing'.

122 Erdman 1982, p.582, *Advertisement of the Exhibition*, 1809, p.2.

123 Bentley 1969, p.522; see also Hamlyn and Phillips et al.2000, pp.100–3. I am grateful to M. Phillips for drawing my attention to the house plan reproduced here.

124 *Edward and Elenor*, plate mark 14¾ x 19⅛in (375 × 487mm), Essick 1983, IV; *Job*, plate mark 18⅛ × 21¼in (460 × 540mm), Essick 1983, V; *Ezekiel*, plate mark 18¼ × 21¼in (464 × 540mm), Essick 1983, VI.

125 Erdman 1982, p.783: Blake to George Cumberland, 12 April 1827.

126 Wark 1997, p.21 (*Discourse 2*, 1769).

127 Wark 1997, pp.30–1 (*Discourse 2*, 1769).

128 Wornum 1848, p.234 (Barry *Lecture 6*).

129 J. Richardson, 'Your Show of Shows', *New York Review of Books*, vol.27, no.12, 17 July 1980, pp.16–24 (p.24).

130 J. Northcote, *The Life of Sir Joshua Reynolds*, 2 vols., London, 1818, vol.2, pp.22–3.

131 Wornum 1848, p.322 (J. Opie, *Lecture 4*).

132 Bentley 1969, p.333; R. Lister, *Edward Calvert*, London, 1962, pp.31–2.

133 D.V. Erdman and D.K. Moore (eds.), *The Notebook of William Blake: A Photographic and Typographic Facsimile*, New York 1977, p.N4 (10); Erdman 1982, p.694.

134 See E.S. Jacobowitz and S.L. Stepanek, *The Prints of Lucas van Leyden and his Contemporaries*, exh.cat., Princeton, 1983, pp.23, 199; A.M. Hind, *A History of Engraving and Etching from the 15th Century to the Year 1914*, 3rd edn, London, 1923, p.80.

135 Erdman 1982, p.548: *A Descriptive Catalogue*, p.59 (no.IX).

136 W. Pressly, 'A Memoir of John Francis Rigaud', *Walpole Society*, 50, 1984, pp.92–5.

137 Erdman 1982, pp.527–8: *Advertisement of the Exhibition*, p.2.

138 Northcote 1818, vol.I, pp.305–16.

139 Garlick and Macintyre 1978, vol.II (Jan. 1795–Aug. 1796), p.507 (12 March 1796), and 1979, vol.III, pp.745–6 (14 Jan. 1797).

140 Erdman 1982, p.531: *A Descriptive Catalogue*, 1809 (no.II).

141 Erdman 1982, p.692: *To The Public*, 1793.

142 Ibid.

143 Erdman 1982, p.549: *A Descriptive Catalogue*, 1809, pp.60–1 (no.XIV).

144 Erdman 1982, p.756: Blake to Hayley, 23 Oct. 1804.

145 Erdman 1982, p.528: *Advertisement of the Exhibition*, 1809, p.i.

146 Bentley 1969, p.95: Hayley to J.C. Walker, 25 March 1802.

147 Bentley 1969, p.282.

148 Bentley 1969, p.542.

149 Bentley 1969, p.291.

150 Bentley 1988, p.107: Linnell's *Journal*, 5 March 1825.

151 A.T. Story, *James Holmes and John Varley*, London, 1894, p.157.

152 Gilchrist 1863, p.18; Bentley 1969, p.42.

153 Gilchrist 1863, pp.6–7.

154 Bentley 1969, pp.422, 428–9: Malkin 1806.

155 Gilchrist 1863, p.59.

156 Gilchrist 1863, p.69.

157 Erdman 1982, p.705: Blake to Hayley, 6 May 1800.

158 Gilchrist 1863, pp.69–70; Bentley 1969 p.33; Bentley 1988, pp.8–9; Palmer letter 29 Oct. 1866.

159 Erdman 1982, p.701: Blake to Revd Dr Trusler, 16 Aug. 1799. The quotation was slightly mis-remembered by Blake from *Paradise Lost*, Book 7, ll.29–30.

160 Formerly known as *A Vision: The Inspiration of the Poet*.

161 Erdman 1982, p.724: Blake to Butts, 10 Jan. 1803.

162 Bentley 1969, pp.542–3.

163 Gilchrist 1863, p.7.

164 Reproduced in Knappe 1965, no.276.

165 Reproduced in Knappe 1965, no.71.

166 Reproduced in Jacobowitz and Stepanek 1983, p.44, fig.3b.

167 Reproduced in Knappe 1965, no. 239.

168 See C. Blagden, *The Stationers' Company: A History 1403–1959*, London, 1960.

169 Alexander and Binski 1987, no.254.

170 Alexander and Binski 1987, nos.151, 683.

171 J.J. Alexander, *Mediaeval Illuminators and Their Methods of Work*, New Haven and London, 1992, figs.25, 26.

172 Reproduced in A. Martindale, *The Rise of the Artist in the Middle Ages and Early Renaissance*, London, 1972, p.69, fig. 44.

173 S. Bening (1483–1561) was an illuminator. The selfportrait, watercolour on vellum on oak, 8.1 x 5.8cm, is in the Victoria and Albert Museum, London; reproduced in Alexander 1992, fig.51.

174 Reproduced in M. Camille, *Gothic Art: Visions and Revelations of the Medieval World*, London, 1996, p.178, fig.130.

175 Erdman 1982, p.710: Blake to Flaxman, 21 Sept. 1800.

176 D.G. Rossetti, *Poems and Translations 1850–1870*, Oxford, 1913, p.325; or, as 'Here begins the period of my boyhood', Dante Alighieri, *La Vita Nuova*, trans. B. Reynolds, London, 1980, p.29 (1).

177 Rossetti 1913, p.327.

178 Rossetti 1913, p.374.

179 Erdman 1982, p.147: *Jerusalem: The Emanation of The Giant Albion*, 1804, plate 5, line 16.

180 Erdman 1982, p.567: *Prospectus*, 1809.

181 Reproduced in K.A. Knappe, *Dürer: The Complete Engravings, Etchings and Woodcuts*, London, 1965, no.9.

182 Reproduced in Knappe 1965, no.72.

183 J.K. Stemmler, 'Cennini, Cumberland, Blake and Early Painting Techniques', *Blake: An Illustrated Quarterly*, vol.17, no.4, Spring 1984, pp.145–9.

184 Cennino d'Andrea Cennini, *The Book of Art (Il Libro dell' Arte)*, trans. D.V. Thompson Jnr, New York, 1960, p.2.

185 Gilchrist 1863, p.369.

186 Erdman 1982, p.770: Blake to Cumberland, 19 Dec. 1808.

187 Erdman 1982, p.527: *Advertisement of the Exhibition*, 1809, p.2.

188 Gilchrist 1863, p.298.

189 Richardson 1980, p.24.

190 Bentley 1969, p.27: Flaxman to Hayley, 26 April 1784; G. Keynes (ed.), *The Letters of William Blake*, 3rd edn, Oxford, 1980, p.3.

191 Erdman 1982, p.718: Blake to Butts, 22 Nov. 1802.

192 Erdman 1982, p.528: *Advertisement of the Exhibition*, 1809, p.2.

193 Keynes 1980, p.128: R.H. Cromek to Blake, May 1807; Bentley 1969, p.195.

194 Aglionby 1719, *Life of Raphael*, p.254.

195 Erdman 1982, p.644: annotations to Reynolds's *Discourse 2*, 1769, p.23.

196 1 Timothy 6: 17–19.

197 Numbers 24: 13; for Blake and his slight misquotation from this see his letter to Revd Dr Trusler, 16 Aug. 1799: Erdman 1982, p.702.

198 Erdman 1982, p.707: Blake to Flaxman, 13 Sept. 1800.

199 Erdman 1982, p.38: *The Marriage of Heaven and Hell*, 1790, pl.12.

200 Gilchrist 1863, p.303.

201 Gilchrist 1863, p.302.

202 Reproduced in Knappe 1965, nos 73, 107.

203 Erdman 1982, p.274: *The Laocoön*, c.1820.

204 Gilchrist 1863, pp.319–31.

205 M. Wilson, *The Life of William Blake*, London, 1948, pp.301, 347–50, 388–9.

206 Bentley 1988, p.8: *Daily Universal Register*, 23 May 1785.

207 Garlick and Macintyre 1978, vol.II, p.589 (24 June 1796).

208 Erdman 1982, p.528: *Advertisement of the Exhibition*, p.2.

209 Bentley 1969, p.223.

210 Bentley 1969, p.229.

211 Bentley 1969, p.106: Hayley to Lady Hesketh, 15 July 1802.

212 Bentley 1969, p.112: Hayley to Lady Hesketh, 20 Dec. 1802.

213 Gilchrist 1863, p.370.

214 I am grateful to Juliet Manzini for this suggestion. A vivid example of a single error disastrously disrupting scrupulous order in art as a reflection of the artist's mind might be seen in the work of the mental patient J.H. Grebing (d. 1940?). See fig. 65 in M. Caiger Smith and A. Patrizio, *Beyond Reason. Art and Psychosis: Works from the Prinzhorn Collection*, exh. cat. Hayward Gallery, London, 1996, pp.32–3, 84–92.

215 Gilchrist 1863, p.370.

216 Erdman 1982, p.582: *Public Address*, p.24.

The State of Knowledge on William Blake the Painter pp.40–4

1 J.T. Smith, *Nollekens and his Times*, 2 vols., London, 1828, vol.II, pp.454–88; J.T. Smith, *Nollekens and his Times*, ed. and annot. W. Whitten, 2 vols., London, 1920, vol.II, pp.366–95; Bentley 1969, pp.455–76.

2 Gilchrist 1863.

3 Butlin 1981, p.156.

4 R. Hamlyn and N. Cahaner McManus in Hamlyn and Phillips 2000, p.194.

5 See Hamlyn and Phillips et al. 2000 for a selective bibliography of scholarship on Blake's art.

6 R. Essick, *William Blake Printmaker*, Princeton, 1980; J. Viscomi, 'Recreating Blake's Illuminated Prints: The Facsimiles of the Manchester Etching Workshop', *Blake: An Illustrated Quarterly*, 19, 1985, pp.4–23; J. Viscomi, *Blake and the Idea of the Book*, Princeton, 1993; R.N. Essick and J. Viscomi, 'An Inquiry into Blake's Method of Color Printing', *Blake: An Illustrated Quarterly*, 35, 2002, pp.74–103 (hereafter Essick and Viscomi 2002a); M. Phillips, 'Color-printing *Songs of Experience* and Blake's Method of Registration: A Correction', *Blake: An Illustrated Quarterly*, 36, 2002, pp.44–5; M. Butlin, '"Is This a Private War or Can Anyone Join In?": A Plea for a Broader Look at Blake's Color-Printing Techniques', *Blake: An Illustrated Quarterly*, 35, 2002, pp.45–9; R.N Essick and J. Viscomi, 'Blake's Method of Colour Printing: Some Responses and Further Observations', *Blake: An Illustrated Quarterly*, 36, 2002, pp.49–64 (hereafter Essick and Viscomi 2002b).

7 R. Lister, *Infernal Methods: A Study of William Blake's Art Techniques*, London, 1975, pp.35–57.

8 A. Maheux, 'An Analysis of the Watercolour Technique and Materials of William Blake', *Blake: An Illustrated Quarterly*, 17, 1984, pp.124–9, see p.129.

9 S.L.Vallance, B.W. Singer, S.M. Hitchen and J.H. Townsend, 'The development and initial application of a gas chromatographic method for the characterization of gum media', *Journal of the American Institute for Conservation*, 37, 1998, pp.294–311.

10 S.L. Vallance, B.W. Singer, S.M. Hitchin and J.H. Townsend, 'The Analysis of Proteinaceous Artists' Media by High Performance Liquid Chromatography,' *LC-GC International*, 10, 1997, pp.49–53.

11 J.W. Twilley, 'The Analysis of Exudate Plant Gums in their Artistic Applications: An Interim Report', *The American Chemical Society, Advances in Chemistry Series*, 1984, pp.357–94.

12 Essick 1980, Appendix 2, pp.259–60.

13 M. Phillips, *William Blake: The Creation of the 'Songs' from Manuscript to Illuminated Printing*, London, 2000, p.108.

14 Lister 1975, p.56.

15 Gilchrist 1863, p.70.

16 M. Cohn, *Wash and Gouache: A Study of the Development of the Materials of Watercolour*, exh. cat., Fogg Art Museum, Boston, 1977, p.32.

17 Maheux 1984, p.125.

18 Bentley 1969, p.472.

19 Bentley 1969, p.517: Tatham MSS, 'Life of Blake'.

20 Gilchrist 1863, pp.69–70.

21 Gilchrist 1863, p.369.

22 Thomson 1960.

23 Stemmler 1984, pp.145–9.

24 Gilchrist 1863, p.368.

25 M. Abley (ed.), *The Parting Light: Selected Writings of Samuel Palmer*, Manchester, 1985, pp.213–4: to Henry Wentworth Acland, dated 29 Oct. 1866.

26 Lister 1975, p.37.

27 Lister 1975, p.39.

28 Gilchrist 1863, p.358; Bentley 1969, p.468.

29 Lister 1975, p.38.

30 Tate Conservation Department records.

31 D. Bindman, *Blake as an Artist*, Oxford, 1977, pp.117–18.

32 Bentley 1969, p.472: J.T. Smith.

33 Bentley 1969, p.517: Tatham MSS 'Life of Blake'.

34 P. Mason, 'Framing Prints in England 1640–1820', *Museum Management and Curatorship*, 11, 1992, pp.117–32.

35 Gilchrist 1863, p.369; Bentley 1969, p.472; Smith 1920 (1828), vol.II, p.389.
36 Keynes 1980, p.173: Mrs Blake to the Earl of Egremont, 1 Aug. 1829.
37 Keynes 1980: Mrs Blake to the Earl of Egremont, 4 Aug. 1829.
38 Gilchrist 1863, pp.375–6.
39 Gilchrist 1863, p.376.
40 Butlin 1981, p.156, quoting from Tatham to W.M. Rossetti, 6 Nov. 1862, in W.M. Rossetti, *Rossetti Papers 1862 to 1870*, London, 1903, pp. 16–17.
41 Butlin 1981, p.156.
42 Lister 1975, pp.58–62.
43 Bentley 2001, p.157-8.
44 Essick 1980, pp.131, 134.
45 Lister 1975, pp.36–7, 40–1.

Analytical Methods pp.45–51

1 J.H. Townsend, 'Analysis of chalk and pastel materials', *The Paper Conservator*, 22, 1998, pp.21–8.
2 M. Clarke and M.J. Meijers, 'Simplification of near-infra-red visualisation techniques for identifying blue pigments in-situ on manuscripts', *Proc. 6th Int. Seminar on the Care and Conservation of Manuscripts*, The Royal Library, Copenhagen, 2000, unpaginated.
3 The film is Kodak Ektachrome Professional Infrared EIR Film 2236, produced from 1996 and processed by the AR-5 or E-6 methods. Kodak Technical Information Data Sheet TI2323. Copyright, Eastman Kodak Company, 1997.
4 T. Moon, M.R Schilling and S. Thirkett, 'A Note on the Use of False-Color Infrared Photography in Conservation', *Studies in Conservation*, 37, 1992, pp.42–52; C. Hoeniger, 'The Identification of Blue Pigments in Early Sienese Paintings by Color Infrared Photography', *Journal of the American Institute for Conservation*, 30, 1991, pp.115–24.
5 B.W. Singer and N. Cahaner, 'Analysis of pigments in Indian miniature paintings using non-destructive methods', *art '99*, Rome, 1999, pp.1087–98.
6 G.M. Smith and R.J.H. Clark, 'Raman microscopy in art history and conservation science', *Reviews in Conservation*, 2, 2001, pp.92–106.
7 L. Burgio and R.J.H. Clark, 'Library of FT-Raman spectra of pigments, minerals, paint media and varnishes, and supplement to existing library of Raman spectra of pigments with visible excitation', *Spectrochimica Acta*, Part A 57, 2001, pp.1491–1521.
8 A Bruker FT-Raman microspectrometer, with 1064nm excitation, was used Sept.–Oct. 1999, followed by a Renishaw System 1000 micro-Raman spectrometer, using 632.8nm and 514.5nm lasers (June 2000).
9 N. Cahaner, 'Analysis of Pigments in Indian Miniature Paintings Using Non-Sampling Methods', *Post-Prints of the 16th Gerry Hedley Student Symposium*, Cambridge, 1998.
10 K.L. Brown, 'Raman microscopic and computational studies of artists' pigments and molecular inorganic compounds', unpublished Ph.D. thesis, University of London, 2002.
11 B.A. Ormsby, 'The Materials and Techniques of William Blake's Tempera Paintings', unpublished Ph.D. thesis, University of Northumbria at Newcastle, Newcastle-upon-Tyne, 2002.
12 Vallance et al. 1998.
13 Cohn 1977, p.80 notes 8, 9.
14 J.H. Townsend, 'The Analysis of Watercolor Materials, in particular Turner's Watercolors at the Tate Gallery (1790s to 1840s)', in H.K. Stratis and B. Salvesen (eds.), *The Broad Spectrum: Studies in the Materials, Techniques, and Conservation of Color on Paper*, London, 2002, pp.83–8.
15 Cohn 1977, p.54.
16 Vallance et al. 1998.

PART TWO: WATERCOLOURS

The Vivid Surface: Blake's Use of Paper and Board pp.54–60

1 Bentley 1977, pp.71–3; Essick 1980, pp.71, 105, 160 and 257; Butlin 1981, p.627; M. Butlin, 'A Newly Discovered Watermark and a Visionary's Ways with his Dates', *Blake: An Illustrated Quarterly*, 15, 1981–2, pp.101–3; Bentley 1995, p.40; P. Bower, 'Blake's Papermakers: Watermarks Found in Papers Used by William Blake', *The Oxford Papers*, Studies in British Paper History, vol.1, BAPH, London, 1996, pp.72–4.
2 P. Bower, 'Tone, Texture and Strength: Girtin's Use of Paper', *Thomas Girtin: The Art of Watercolour*, exh. cat., Tate Britain, London, 2002, pp.140–1; P. Bower, 'Displaying the Colours to Advantage: The Papers Used in the Oppé Collection', *British Watercolours from the Oppé Collection*, exh. cat., Tate Gallery, London, 1997, pp.32–7.
3 Bower 1996.
4 Bentley 1995, p.40; Phillips 2000, p.108.
5 Bentley 1977, pp.72, 305.
6 Bentley 1977, p.372.
7 Erdman 1982, p.693: To The Public.
8 Library of the Society of Antiquaries of London, f.10 (b), f.24 (t), f.25 (t & b), f.26 (t), f.28, f.29 and f.30A.
9 B3–47.
10 Butlin 1981, p.156: Tatham to W.M. Rossetti, 6 Nov. 1862, in W.M. Rossetti, *Rossetti Papers 1862 to 1870*, London, 1903, p.16.
11 A. Katlan, *American Artists' Materials Vol.II: A Guide to Stretchers, Panels, Millboards, and Stencil Marks*, Madison, Connecticut, 1992, pp.262–4.
12 R.N. Essick, 'Review of Martin Butlin, *The Paintings and Drawings of William Blake*, 1981', *Blake: An Illustrated Quarterly*, no.16, 1982, pp.22–65 (p.34).
13 P. Bower, *Turner's Papers: A Study of the Manufacture, Selection and Use of his Drawing Paper 1787–1829*, exh. cat., Tate Gallery, London, 1990, pp.73–4.
14 Palmer 1892, pp.9–10.

Watercolour Methods, and Materials Use in Context pp.61–79

1 A. Wilton and A. Lyles, *The Great Age of British Watercolours 1750–1880*, exh. cat., Royal Academy of Arts, London, 1993.
2 R. Rosenblum, *Modern Painting and the Northern Romantic Tradition*, Leipzig, 1994, p.43.
3 Gilchrist 1863, p.370.
4 Lister 1975, p.39.
5 Cohn 1977, p.26.
6 Cohn 1977, p.42.
7 R.D. Harley, *Artists' Pigments: A Study in English Documentary Sources*, 2nd edn, Butterworth, 1982, p.163.
8 C.Z. Penn, *Decorative and Protective Finishes, 1750–1850*, reprinted in *Materials, Process, and Craft*, APT Bulletin, 1984, vol.16, no.1, p.17.
9 Erdman 1982, p.719: Blake to Butts, 22 Nov. 1802.
10 J.H. Townsend, 'Turner's "Drawing Book", the *Liber Studiorum*: Materials and Techniques', *ICOM-CC 11th Triennial Meeting Preprints, Edinburgh*, ed. J. Bridgland, 1996, pp.376–80; Townsend, 'Analysis', in Stratis and Salvesen 2002.
11 Gilchrist 1863, p.389.
12 M. Hardie, *Watercolour Painting in Britain: II: The Romantic Period*, London, 1967, p.106.
13 W.H. Pyne, 'The Rise and Progress of Water Colour Painting in England: II', *Somerset House Gazette*, no.VI, 15 Nov. 1824, pp.83–4.
14 J.H. Townsend, 'The Materials of J M W Turner: Pigments', *Studies in Conservation*, no.38, 1993, pp.231–54.
15 Erdman 1982, p.216, pl.65, line 9.
16 R.M. Ryan, 'Poisonous Blue', *Blake: An Illustrated Quarterly*, vol.7, no.4, 1974, p.87.
17 B. Berrie, 'Prussian Blue', in E.W. Fitzhugh (ed.), *Artists' Pigments: A Handbook of their History and Characteristics*, vol.3, 1997, New York, pp.193–5.
18 H. Schweppe, 'Indigo and Woad', in Fitzhugh 1997, pp.82–3.
19 H. Schweppe, in Fitzhugh 1997, pp.87, 20.
20 B. Berrie, in Fitzhugh 1997, p.200.
21 Townsend 1993.
22 Maheux 1984, p.128.
23 Harley 1982, p.138.
24 Harley 1982, p.127.

25 Harley 1982, pp.131–47.
26 Penn 1984, p.5.
27 J. Kirby and R. White, 'The Identification of Red Lake Pigment Dyestuff and a Discussion of their Use', *National Gallery Technical Bulletin*, vol.17, 1996, pp.56, 64.
28 Harley 1982, pp.143–6.
29 Penn 1984, p.11.
30 Harley 1982, pp.90–1.
31 J. Winter, 'Gamboge', in Fitzhugh 1997, pp.143–7.
32 Maheux 1984.
33 Robin Hamlyn, Tate, is carrying out research into this.
34 Harley 1982, pp.87–8.
35 Cohn 1977, pp.42–3.
36 Penn 1984, p.17.
37 Harley 1982, p.161.
38 S. Lehner, *Ink Manufacture*, London, 1902; H.A. Bromley and J. Shore, *Articles of Stationery and Allied Materials: Their Chemistry and Technical Examination*, London, 1939.
39 R.J. Gettens and G.L. Stout, *Painting Materials: A Short Encyclopaedia*, New York, 1966, pp.115–16.
40 Maheux 1984, pp.126–7.
41 Ormsby 2002.
42 B469, T44.
43 Ibid., no.52.
44 Anon., *Exhibition of Works by the Old Masters and Deceased Masters of the British School*, exh. cat., Royal Academy of Arts, London, 1893.
44 W.M. Rossetti, *Rossetti Papers*, London, 1903, p.18, J. Linnell Jnr to W.M Rossetti, 2 Dec. 1862. This refers to B812 101 apparently being stored loose in a folio.

PART THREE:
LARGE COLOUR PRINTS

The Large Colour Prints:
Methods and Materials pp.82–99

1 See Butlin 1981, pp.156–77, for all information in this paragraph.
2 Butlin 1981, pp.156–8.
3 Butlin 1990, pp.83, 90, 94.
4 Essick 1980, p.132.
5 Peter Bower, pers. comm. 2002.
6 Butlin 1981–2, p.103, note 4.
7 Keri Davies, pers. comm. 2002.
8 Phillips 2000.
9 Essick and Viscomi 2002a.
10 Essick and Viscomi 2002a, p.91.
11 Butlin 1981, plates 387, 391.
12 Butlin 1981, plates 392, 404.
13 Essick 1980, pp.131–5.
14 Butlin 1981, B289–329.
15 Essick 1980, p.134.
16 Essick 1980, p.133.
17 P.K. Zegers, 'In the Kitchen with Paul Gauguin: Devising Recipes for a Symbolist graphic Aesthetic', Stratis and Salvesen 2002, pp.138–44.
18 Essick and Viscomi 2002a, p.63.
19 Lister 1975, p.59.
20 Essick and Viscomi 2002a, p.78.
21 Modern oil tube paints are carefully formulated to dry at the same rate, which makes them unsuitable as substitutes for historic paints when re-creating historic methods.
22 M. Butlin, 'The Physicality of William Blake: The Large Colour Prints of "1795"', *The Huntington Library Quarterly*, no.52–1, Winter 1989, pp.1–17, see p.6.
23 IRFC results and UV fluorescence were consistent with the one sample of genuine dragon's blood available for comparison.
24 J.S. Mills and R.White, *The Organic Chemistry of Museum Objects*, 2nd edn, Butterworths, Oxford, 1994, p.37.

25 Essick 1980, p.126.
26 R. Mayer, *The Artists' Handbook of Materials and Techniques*, 5th edn, London, 1991, p.557.
27 Erdman and Moore 1977, p.N112.

The Conservation of a Large Colour Print:
Satan Exulting over Eve pp.100–7

1 Gilchrist 1963, II, p.230, no.179.
2 Examined by Dr Jennifer Pilc, National Gallery, with FTIR microscopy to identify cellulose and animal glue. The alum (potassium aluminium sulphate) was suggested by the quantity of potassium detected with EDX, the largest yet seen by us in any nineteenth-century paper.
3 Bower 1990, p.17.
4 Identified by optical and chemical microscopy.
5 D. Alexander, 'The Historic Framing of Prints: The Treatment of English Prints in the Eighteenth Century', *Historic Framing and Presentation of Watercolours, Drawings and Prints*, ed. N. Bell, Institute of Paper Conservation, Worcester, 1997, pp.1–9.
6 B291.
7 H. Dagnell, *The Marking of Textiles for Excise & Customs*, London, 1996. *Register of Stamps of Linen Manufactures in Scotland*, Scottish Record Office.
8 B291.
9 By Kasia Szeleynski, then Head of Paper Conservation at Tate.
10 By Dr Jennifer Pilc, National Gallery, with FTIR microscopy.
11 A conservation-grade, water-absorbent material that does not bleed colour.
12 Townsend 1993, p.246.
13 This consists of the water extract of the sugars found in paper that has been degraded by ultraviolet light. P. Townshend, 'Toning with "Paper Extract"', *The Paper Conservator*, 2002, no.26, pp.21–6.

PART FOUR: TEMPERAS

The Painting of the Temperas pp.110–33

1 Butlin 1981.
2 Erdman 1982, p.527: *Advertisement of the Exhibition*, p.2.
3 Erdman 1982, p.549: *A Descriptive Catalogue*, p.60–1 (no.xiv).
4 Erdman 1982, p.550: *A Descriptive Catalogue*, pp.63–4 (no.xv).
5 Bentley 1969, p.515: Tatham MS, 'Life of Blake', c.1832, pp.507–35.
6 Erdman 1982, p.530, *A Descriptive Catalogue*.
7 Erdman 1982, p.538. *A Descriptive Catalogue*, pp.26–7, (no.III) quoted by Gilchrist 1863 II, p.119.
8 Gilchrist 1863, p.166; vol.II: W.M. Rossetti, 'Annotated Lists of Blake's Paintings, Drawings, and Engravings', pp.201–39.
9 Gilchrist 1863, p.369, reporting a 'friend' of Blake's.
10 Gilchrist 1863, pp.368–9.
11 Erdman 1982, p.704.
12 Ormsby 2002.
13 Butlin 1981, p.318.
14 Reproduced in colour in Hamlyn and Phillips et al. 2000, p.181.
15 Butlin 1989, p.472.
16 D. Bomford, J. Dunkerton, D. Gordon and A. Roy, *Art in the Making: Italian Painting before 1400*, exh. cat., National Gallery, London, 1989, p.18.
17 Ibid.
18 Lister 1974, Letter ?Sept. 1849 (12), p.476: Palmer to unknown addressee.
19 Bentley 1969, p.272: J.T. Smith *Nollekens and his Times*.
20 Bentley 1969, p.472.
21 Bentley 1969, pp.515, 517.
22 P.F. Tingry, *The Painter and Varnisher's Guide*, 2nd edn, London, 1816, pp.7, 8, 13.
23 G. Field, *Chromatography*, London, 1835, pp.198.
24 Mayer 1991, p.396.
25 Ormsby 2002, chap.5.
26 Bentley 1969, p.472: J.T. Smith *Nollekens and his Times*.

27 Field 1835, pp.198.
28 Cohn 1977, p.40.
29 T.J. Gullick and J. Timbs, *Painting Popularly Explained*, London, 1859, p.294.
30 Abley 1985, pp.213–14; Bentley 1988, pp.8–9.
31 Abley 1985, p.213; Bentley 1988, p.9, note 1.
32 Lister 1974 I, p.38: Palmer to Richmond, Sept.–Oct. 1828; Bentley 1988, p.9.
33 Lister 1975, p. 45.
34 L. Carlyle, *The Artist's Assistant*, London, 2001, pp.73–97.
35 Carlyle 2001, p.83.
36 Identified by X-ray fluorescence.
37 V. and R. Borradaile (trans.), *The Strasbourg Manuscript*, London, 1966, pp.20, 43, 47, 49, 51, 65, 89.
38 M. Doerner, *The Materials of the Artist and their Use in Painting, with Notes on the Techniques of the Old Masters*, Granada, 1977, pp.221, 223, letter dated 4 January 1867.
39 Butlin 1981, p.297.
40 Erdman 1982, p.714.
41 Butlin 1981, p.297.
42 Gilchrist 1863, p.166.
43 Butlin 1981, p.298.
44 Erdman 1982, pp.529–51.
45 Erdman 1982, p.531: *A Descriptive Catalogue*, pp.54–5 (no.ix).
46 H.G. Clarke, *Handbook of the Elements of Painting in Water Colours: Practical Instructions for Mixing and Shading the Same*, London, 1843, p.25.
47 Tate Conservation Department Record.
48 Butlin 1981, p.471.
49 Gilchrist 1863, p.358.
50 Thomson 1960, p.95.
51 Gilchrist 1863, p.139.
52 Erdman 1982, p.547: *A Descriptive Catalogue*, pp.54–5 (no.IX).
53 Erdman 1982, p.547: *A Descriptive Catalogue*, pp.54.
54 M. Eaves, *William Blake's Theory of Art*, Princeton, 1982, p.113.
55 R. Essick, pers. comm., March 2002, Los Angeles.
56 Erdman 1981, p.547.
57 Ormsby 2002, chap.7.
58 B674.
59 Butlin 1981, p.552.
60 Erdman 1981, p.784.
61 Butlin 1981, p.549.
62 G. Keynes, *Blake Studies: Essays on his life and work*, 2nd edn, Oxford, 1971, p.198.

Blake's Use of Tempera in Context pp.134–49

1 M. Hardie, *Watercolour Painting in Britain: I: The Eighteenth Century*, London, 1966, p.17.
2 Ibid.
3 W.T. Whitely, 'Current Art Notes, "Relics of Turner"', *The Connoisseur*, 1931, vol.88, no.361, p.198.
4 Hardie 1966, vol.I, p.19.
5 Which was more than half the sum: half a crown was 2s 6d or 12.5p in terms of current UK currency.
6 Gilchrist 1863, p.69.
7 Carlyle 2001.
8 Carlyle 2001, appendices 20, 21 and pp.423–46.
9 L. Carlyle and J.H. Townsend, 'An Investigation of Lead Sulphide Darkening of Nineteenth Century Painting Materials', in *Dirt and Pictures Separated*, UKIC, London, 1990, pp.40–3.
10 Carlyle 2001, pp.166–9; J. Gage, *Colour and Meaning: Art, Science and Symbolism*, London, 1999, pp.153–61.
11 C. Proudlove, 'London Artists' Colourmen. Part I: A to D', *The Picture Restorer*, 10, 1996, pp.10–12.
12 J.H. Townsend, 'The Materials and Techniques of JMW Turner RA 1775–1851', unpublished Ph.D. thesis, Courtauld Institute of Art, University of London, 1991, chap.2.
13 *The Horse*, c.1805?, B366, Yale Center for British Art, New Haven.
14 Gage 1999, pp.144–52.
15 Townsend 1993, pp.231–54.
16 J.H. Townsend, 'Painting techniques and materials of Turner and other British artists 1775–1875', *Historical Painting: Techniques Materials and Studio Practice*, ed. A. Wallert, E. Hermens and M. Peek, Getty Conservation Institute, Los Angeles, 1995, pp.176–86.
17 Townsend in 'Painting', Wallert et al., p.183.
18 Essick and Viscomi 2002, p.96.
19 Lister 1975, pp.52–3.
20 Erdman 1982, p.529: *A Descriptive Catalogue* (title-page), 1809.
21 J. Stevenson, *The Materials and Techniques of Painting*, London, 1977, p.51; R. Dossie, *The Handmaid to the Arts*, vol.1, 1st edn, London, 1758, p.209; Carlyle 2001, p.236.
22 Borradaile and Borradaile 1966, pp.20, 43, 47, 49, 51, 65, 89.
23 H. Peacham, *The Gentleman's Exercise or An Exquisite Practice*, London, 1634, pp.66–70, 81.
24 R. James, *Pharmacopoeia Universalis or A New Universal English Dispensatory*, London, 1764, p.228.
25 C. de Massoul, *A Treatise on the Art of Painting, and the Composition of Colours*, London, 1797, pp.222–3.
26 Field 1835, pp.200.
27 Ormsby 2002, chap.6.
28 Mayer 1991, p.396; Ormsby 2002, chap.7. Karaya gum was retained as a possible interpretation for GC-MS, as in mixture with gum tragacanth it cannot be distinguished from a mixture of gums Arabic and tragacanth.
29 Vallance et al. 1998; J.H. Townsend, 'William Blake (1757–1827)', in *Paint and Purpose: A Study of Technique in British Art*, ed. S. Hackney, R. Jones and J. Townsend, London, 1999, p.68.
30 Essick 1980, Appendix 2, pp.259–60.
31 Mayer 1991, p.427.
32 Borradaile and Borradaile 1966.
33 Doerner 1977, pp.221, 223, letter dated January 4, 1867.
34 C. Eastlake, *Materials for a History of Oil Painting*, vol.1, 1847, p.549.
35 Ibid.
36 Ormsby 2002, chap.7.
37 W. Peacham, *The Art of Drawing with the Pen, and Limming in Water Colours, more exactlie then heretofore Taught and Enlarged*, London, 1607.
38 Anon., *Reports by the Juries' Exhibition of the Works of Industry of all Nations*, London, 1851, p.72.
39 Field 1835, p.198.
40 Roberson Archive, MS.789-1993, Hamilton Kerr Institute, Cambridge, England.
41 Doerner 1977, pp.221, 223, letter dated 4 January, 1867.
42 Anon., *The Art of Drawing and Painting in Water-Colour*, London, 1770.
43 F. Haynes, *A Treatise on Portrait Painting from Life*, London, 1887, p.56.
44 Field 1835, p.200.
45 Field 1835, p.198.
46 Carlyle 2001, p.234.
47 Ormsby 2002, chap.6.
48 B. Poole, *Statistics of British Commerce, Being a Compendium of the Productions, Manufactures, Imports and Exports of the United Kingdom in Agriculture, Minerals, Merchandise, &c., &c., &c.* London, 1852, p.176.
49 Anon. 1770; J.H. Clark, *A Practical Essay on the Art of Colouring and Painting Landscapes in Water Colours*, London, 1807, pp.9, 24–6.
50 Anon., *Hand Book of the Elements of Painting in Water Colours: With Practical Instructions for Mixing and Shading the Same*, London, 1770, p.20.
51 Peacham 1634, pp.66–70, 81; Anon. 1770.
52 Field 1835, p.198.
53 Ormsby 2002, Appendix 2; Roberson Archive, Hamilton Kerr Institute, Cambridge: recipes reproduced with the permission of the Fitzwilliam Syndicate, Inc.
54 Anon. 1770, p.54.
55 P.F. Tingry, *The Painter and Varnisher's Guide*, London, 1804, p.12.
56 Dossie 1758, p.210.
57 J. Smith, *A Short and Direct Method of Painting in Watercolours Written by the Late Ingenious Mr. Smith*, London, 1730, p.3.
58 Anon. 1843, p.54.
59 Carlyle 2001, pp.233–6.
60 Lister 1975, pp.38–9; M. Goodwin, *Artist & Colourman*, Bristol, 1966, pp.17–18.

61 Owned by Dr Fumio Yokoshima, Japan, who gave permission for the images and results to be published.

62 Townsend 2002.

63 Goodwin 1966, p.28.

64 Provided by the Museum of London, 2000.

65 Provided by the Hamilton Kerr Institute, Cambridge, and the Courtauld Institute of Art, London, and published with permission.

66 Provided by the University of Northumbria at Newcastle.

67 R. Essick, pers. comm. 1999. The Victoria and Albert Museum, London, owns a palette (P.57-1927)reputed to have been used by Blake c.1780 for oil painting. Donated in 1927, it may have belonged to Frances Harvey of St James St, a dealer in Blake's works from Tatham: Mark Evans pers. comm. 2003. But our analysis of the pigments suggests an earliest date of c.1820.

68 Access by kind permission of the Royal Academy of Arts, London; Ashmolean Museum, Oxford; and a private collector.

69 Hardie 1966, vol.I, p.202.

70 Tate Conservation Department.

71 Keynes 1980, p.213.

72 Bentley 1988, p.9.

73 R. Lister, *George Richmond: A Critical Biography*, London, 1981, p.122.

74 Ormsby 2002, chap.9.

75 Tate Conservation Department. Label removed from reverse of painting.

76 Carlyle 2001, pp.165-83, 423-46.

The Appearance of the Temperas Today pp.150-9

1 Erdman 1982, p.530: *A Descriptive Catalogue*, p.2 (no.II).

2 Erdman 1982, p.531: *A Descriptive Catalogue*, p.6 (no.II).

3 Ibid.

4 Ibid.

5 Bentley 1969, p.472: J.T. Smith, *Nollekens and his Times*.

6 Gilchrist 1863, p.225.

7 Gilchrist 1863, p.211.

8 Gilchrist 1863, p.207.

9 Butlin 1981, pp.318, 330.

10 Tate Conservation Department, 1934 report, referring to *The Body of Christ Borne to the Tomb*, Tate NO1164.

11 Tate Conservation Department, 1937 report, referring to *Bathsheba at the Bath*, Tate NO3007.

12 Tate Conservation Department, 1940 report, referring to *The Spiritual Form of Pitt Guiding Behemoth*, Tate NO1110.

13 Gilchrist 1863, p.358.

14 Butlin 1981, pp.470-1.

15 L. Maclehose (trans.) and G. Baldwin Brown (ed.), *Vasari on Technique*, New York, 1960, p.222.

16 Erdman 1982, p.548.

17 URLs: http://fst.rdg.ac.uk/people/aamesjm/maillard.htm; http://food.orst.edu/colour/maillard/ph.html

18 Gilchrist 1863, p.166.

19 Bentley 1969, p.517 (from Frederick Tatham MSS, 'Life of Blake').

20 Bindman 1977, p.118.

21 Erdman 1982, p.720: Blake to Butts, 22 Nov. 1802.

22 Butlin 1981, pp.324-5.

23 Gilchrist 1863, p.368.

24 P. Ackroyd, A. Phenix, C. Villers and N. Wade, 'Structural Treatments for Canvas Paintings in 2002: Summary of Questionnaire Replies', *ICOM-CC 13th Triennial Meeting Rio De Janeiro*, ed. R. Vontobel, 2002, pp.321-7. P. Ackroyd, 'The Structural Conservation of Canvas Paintings: Changes in Attitude and Practice since the early 1970s', *Reviews in Conservation*, 3, 2002, pp.3-14.

25 T59.

26 L. Binyon and S. Colvin, 'The Late Stanley William Littlejohn', *The Burlington Magazine*, vol.32, January 1918, pp.16-19.

27 *The Tempera Paintings of William Blake*, introduced by G. Keynes, exh. cat., Arts Council Gallery, London, June-July 1951, pp.7-9.

28 J.H. Stoner, 'Hell vs Ruhemann: The Impact of Two German Conservators on US Painting Conservation Theory', *American Institute for Conservation Paintings Specialty Group Postprints*, 28th AIC Annual Meeting, Philadelphia, Pennsylvania, 8-13 June 2000, p.20.

29 P. Hartley, pers. comm., 2000, Manchester City Art Gallery.

30 Yale Center for British Art, Conservation Record, notes by Jane Douglass.

31 Gilchrist 1863, pp.375-6.

32 M. van Eikema Hommes, 'Discoloration in Renaissance and Baroque Oil Paintings: Instructions for Painters, Theoretical Concepts, and Scientific Data', unpublished Ph.D. dissertation, University of Amsterdam, 2000, p.159.

PART FIVE: EPILOGUE

The Presentation of Blake's Paintings pp.162-74

1 P. Mitchell and L. Roberts, *Frameworks: Form, Function and Ornament in European Portrait Frames*, London, 1996, pp.353-402; J. Simon, *The Art of the Picture Frame: Artists, Patrons and the Framing of Portraits in Britain*, exh. cat., National Portrait Gallery, London, 1996-7; E. Mendgen, *In Perfect Harmony: Picture + Frame 1850-1920*, Van Gogh Museum and Kunstforum Wien, 1995; N. Bell (ed.), *Historic Framing and Presentation of Watercolours, Drawings and Prints*, Institute of Paper Conservation, Worcester, 1997.

2 D. Alexander, 'Grand Gilt and Simple Pine', *Country Life*, vol.189, no.10, 1995, pp.68-9; D. Alexander, 'The Historic Framing of Prints: The Treatment of English Prints in the Eighteenth Century', Bell 1997, pp.1-9.

3 Mason 1992, pp.117-32.

4 C. James, C. Corrigan, M.P. Enshaian and M.R. Green (trans. by M. Cohn), 'The History of Preservation of Works of Art on Paper', *Old Master Prints and Drawings: A Guide to Preservation and Conservation*, Amsterdam, 1997, pp.140-69; B. Clarke, 'A Study of Traditional and Contemporary Techniques for Mounting and Assembling Prints at the Fitzwilliam Museum', in Bell 1997, pp.33-42.

5 D.V. Erdman, J. Grant, E. Rose and M. Tolley, *William Blake's Designs for Edwards' Night Thoughts*, 2 vols., Oxford 1980, vol.1, p.63.

6 At 13 Lincoln's Inn Fields.

7 H. Dorey, 'The Historic Framing and Presentation of Watercolours, Drawings and Prints at Sir John Soane's Museum', in Bell 1997, pp.20-32.

8 Hardie 1967, vol.II, p.112.

9 G. Smith, *Art on the Line: The Royal Academy Exhibitions at Somerset House 1780-1836*, ed. D.H. Solkin, New Haven and London, 2001, p.196.

10 J. Fletcher (ed.), *Conversations of James Northcote, R.A., with James Ward*, 1903, pp.163-4.

11 S. Hyde, 'Printmakers and the Royal Academy Exhibitions, 1780-1836', in Solkin 2001, pp.217-28, see p.218.

12 G. Smith, 'Watercolourists and Watercolours at the Royal Academy, 1780-1836', Solkin 2001, pp.189-200, see p.197.

13 A guinea was £1 1s, or £1.05 in terms of present UK currency.

14 G. Keynes (ed.), *The Letters of William Blake with Related Documents*, 3rd edn, Oxford, 1980, p.113.

15 Erdman 1982, p.771.

16 Bentley 1988, p.122.

17 Alexander 1997, p.4.

18 Bentley 1977, p.404.

19 Bentley 1988, pp.114 and 118.

20 Bentley 1969, p.582.

21 Butlin 1981, p.142.

22 Viscomi 1993, pp.160-1.

23 Viscomi 1993, p.303.

24 Details from catalogues *The Exhibition of the Royal Academy* for these years.

25 Solkin 2001, p.223.

26 Erdman 1982, p.527: *Advertisement of the Exhibition*, p.2.

27 T.R.C. Patenaude, 'Recovering William Blake's 1809 Exhibition', *The British Art Journal*, vol.4, no.1, 2003, pp.52-63.

28 Gilchrist 1863, p.57.

29 R.N. Essick, 'Blake's 1812 Exhibition', *Blake: An Illustrated Quarterly*, vol.27, no.2, 1993, pp.36-42.

30 J. Bayard, 'Introduction: History and Style', *Works of Splendor and Imagination: The Exhibition Watercolor, 1770-1870*, exh. cat., New Haven, 1981, pp.1-14, see p.6.

31 Hardie 1967, vol.II, p.112.

32 Essick 1993.

33 S. Jaques, 'A glance at the history of display and mounting of British watercolours', *The Paper Conservator*, vol.24, 2000, pp.35–43.

34 Bayard 1981, 'Technique', pp.14–24.

35 For reproductions see *William Blake: visiones de mundos eternos (1757–1827)*, exh. cat., Fundació "la Caixa", Madrid and Barcelona, 1996, pp.17–120.

36 For illustrations see M. Butlin, 'New Risen from the Grave; Nineteen Unknown Watercolors by William Blake', *Blake: An Illustrated Quarterly*, vol.35, no.3, 2002, pp.68–73, and R.N. Essick and M.D. Paley, *Robert Blair's 'The Grave' Illustrated by William Blake: A Study with Facsimile*, London, 1982, supplementary illus. no.23.

37 J. Viscomi, 'Blake in the Marketplace 1852: Thomas Butts, Jr. and Other Unknown Nineteenth-Century Collectors', *Blake: An Illustrated Quarterly*, 29 (2), 1995, pp.40–68, see pp.47–51; J. Viscomi, 'A "Green House" for Butts? New Information on Thomas Butts, his Residences, and Family', *Blake: An Illustrated Quarterly*, vol.30, no.1, 1996, pp.4–21.

38 A. Lyles and R. Hamlyn, *British Watercolours from the Oppé Collection*, exh. cat., London, 1997, pp.60–1, shows an impressive example, *Classical Landscape* by James Deacon (1740–3), Tate T08256, with four washed borders interspersed with three inked ones, and several pin-holes in each corner. See A. Sumner and G. Smith, *Thomas Jones (1742–1803)*: an Artist Rediscovered, New Haven and London, 2003, for further excellent examples.

39 Alexander 1997, p.2.

40 Bayard 1981, 'Framing and Galleries', pp.25–33, see p.26.

41 Bentley 1969, p.565.

42 Gilchrist 1863, p.225.

43 K. Preston, *The Blake Collection of W. Graham Robertson*, London, 1952, p.10.

44 N. Blondel, *Mary Butts: Scenes from the Life*, New York, 1998, p.16.

45 Erdman 1982, p.724: Blake to Butts, 10 Jan. 1803; Viscomi 1996, p.15.

46 Alexander 1997.

47 Bentley 1969, pp.215–18.

48 Illustrated in Viscomi 1995, p.51.

49 Viscomi 1995, p.50.

50 First listed in the 1846 catalogue for Winsor and Newton the colourman, and listed in 1862 by Reeves, and even later by Newman. Information from Peter Bower, 2003, who has (now unique) copies of some of the catalogues.

51 Butlin 1981.

52 Analysed by optical microscopy and EDX, and FTIR carried out by Drs Bronwyn Ormsby, Herant Khanjian and Tom Learner.

53 *Annual Report of the Director of the National Gallery to the Lords Commissioners of Her Majesty's Treasury, for the Year 1878*, pp.1, 2, 6.

54 *Annual Report of the Director… for the Year 1882*, pp 8–9, 10.

55 *Annual Report of the Director … for the Year 1884*, pp.2, 13.

56 Mason 1992, p.119.

57 Lister 1974, vol.1, pp.475–6: Palmer to unknown addressee, ?Sept. 1849, which suggests that Palmer only owned two sketches by Blake (B772).

58 R Lister, 'The National Gallery & Blake's "Spiritual Form of Pitt Guiding Behemoth"', *Blake: An Illustrated Quarterly*, vol.17, no.3, 1983–4, pp.105–6.

59 Lister 1974, vol.2, p.690 and n.2; Simon 1977, pp.90, 135, 173, 174, 175; D. Bindman (ed.), *William Blake's Illustrations of the Book of Job*, William Blake Trust, London, 1987, p.140 et seq. James and Henry Chance, Carvers and Gilders, were at 84 Charlotte Street, Fitzroy Square, 1839.

60 Bentley 1969, pp.320–1, 364–5, 401; Bindman 1987, p.112 et seq.

61 Bentley 1995, p.545; Butlin 1981, pp.92, 247, 526, 859.

62 Lister 1983–4, p.106.

63 *Report of the Director of the National Gallery, for the Year 1909 …*, p.4.

64 R. Hamlyn, 'Blake's Fate at the Tate', *Blake: An Illustrated Quarterly*, vol.23, no.4, 1990, pp.211–13.

65 Illustrated in Hamlyn 1990, p.212.

66 *The Tate Gallery 1978–80: Illustrated Biennial Report*, p.20.

67 By John Anderson, Head of Frame Conservation.

68 Examples can be seen in James 1991 for Reynolds's and Lawrence's collections, in Bell 1997 and in D. Alexander, *Affecting Moments. Prints of English Literature made in the Age of Romantic Sensibility 1775–1800* , exh. cat., University of York, 1993, p.62 (also fig.5, p.69). The popular and similar 'Hogarth' frame is illustrated in Mason 1992.

69 A. Summerfield, 'Hanging Matters: The Revolution in the Display of National Collections', *Apollo*, vol.134, no.358, 1991, pp.387–93.

Appendix 1: Watercolours Discussed in the Text [1]

Tate number[2]	Butlin 1981	Butlin 1990	Title	Butlin 1981 date	Butlin 1990 date	Support	Dimensions in inches [3]	Dimensions in cm [3]	Colour Change
T01128	B127	T3	An Allegory of the Bible	c.1780-5	c.1780-85 (recto)	2 laid papers joined	24¼ x 13¾	61.5 x 34.9	badly faded pink lake
N02686	B161	T5	Oberon, Titania and Puck with Fairies Dancing	c.1785	c.1785	J Whatman paper	13¾ x 26½	47.5 x 62.5	probably not
N05183	B91	T8	Age teaching Youth	c.1785-90	c.1785-90	wove paper	4¼ x 3⅛	10.8 x 8	none obvious
T00547	B255	T13	Los and Orc	c.1792-3	c.1792-3	wove paper	8⁹/₁₆ x 11⅝	21.7 x 29.5	none obvious
N05898	B69	T14	The Penance of Jane Shore in St Paul's Church	c.1793	c.1793	wove paper	9⅝ x 11⅝	24.5 x 29.5	none obvious
N05897	B515	T51	The Four and Twenty Elders Casting their Crowns before the Divine Throne	c.1803-5	c.1803-5	wove paper	13¹⁵/₁₆ x 11½	35.4 x 29.3	blue has probably faded
N02230	B462	T41	David Delivered out of Many Waters: 'He Rode upon the Cherubim'	c.1805	c.1805	smooth wove paper	16⅜ x 13¹¹/₁₆	41.5 x 34.8	traces of blue at left and right edges
N05892	B469	T44	Satan in his Original Glory: 'Thou wast Perfect till Iniquity was Found in Thee'	c.1805	c.1805	smooth wove paper	16⅞ x 13⅜	42.9 x 33.9	unfaded, modulated blue at edges
N05895	B497	T47	The Crucifixion: 'Behold thy Mother'	c.1805	c.1805	very smooth wove paper	16⅞ x 13⅝	42.9 x 33.9	unfaded blue at edges
N05887	B525	T52	The River of Life	c.1805	c.1805	wove paper	12 x 13¼	30.5 x 33.6	paper yellowed; faded red lake and indigo
N02231	B770	T71	Epitome of James Hervey's 'Meditations among the Tombs'	c.1820	c.1820-5	very smooth wove paper	16¹⁵/₁₆ x 11½	43.1 x 29.2	loss of blue from mixed blue?
N03351	B812.2	T131	Dante and Virgil Penetrating the Forest	1824-7	1824-7	'Divine Comedy' paper	14⁹/₁₆ x 20¾	37.1 x 52.7	none obvious
N03352	B812.4	T132	The Inscription Over the Gate	1824-7	1824-7	'Divine Comedy' paper	20¾ x 14¾	52.7 x 37.4	none obvious
N03353	B812.8	T133	Homer and the Ancient Poets	1824-7	1824-7	'Divine Comedy' paper	14⁹/₁₆ x 20¾	37.1 x 52.8	faded red lake
N03354	B812.12	T134	Cerberus	1824-7	1824-7	'Divine Comedy' paper	14⅝ x 20¾	37.2 x 52.8	none obvious
N03356	B812.24	T136	The Wood of the Self-Murderers: The Harpies and the Suicides	1824-7	1824-7	'Divine Comedy' paper	14⅝ x 20¾	37.2 x 52.7	paper yellowed but no fading
N03357	B812.35	T137	The Simoniac Pope	1824-7	1824-7	'Divine Comedy' paper	20¾ x 14½	52.7 x 36.8	none obvious
N03358	B812.40	T138	The Devils with Dante and Virgil by the Side of the Pool	1824-7	1824-7	'Divine Comedy' paper	14⅝ x 20¾	37.2 x 52.7	paper yellowed; indigo faded
N03359	B812.44	T139	The Hypocrites with Caiaphas	1824-7	1824-7	'Divine Comedy' paper	14⅝ x 20¾	37.3 x 52.7	paper may have been bleached, blue faded, green too yellow, red lake faded
N03360	B812.46	T140	The Laborious Passage along the Rocks	1824-7	1824-7	'Divine Comedy' paper	14¹¹/₁₆ x 20¾	37.3 x 52.7	paper yellowed from light exposure; red lake faded,
N03361	B812.53	T141	The Serpent Attacking Buoso Donati	1824-7	1824-7	'Divine Comedy' paper	14¹¹/₁₆ x 20¾	37.2 x 52.7	none obvious
N03362	B812.58	T142	The Pit of Disease: The Falsifiers	1824-7	1824-7	'Divine Comedy' paper	14⅝ x 20¾	37.2 x 52.7	none obvious
N03365	B812.70	T144	Virgil Girding Dante's Brow with a Rush	1824-7	1824-7	'Divine Comedy' paper	20¾ x 14⅝	52.7 x 37.1	paper yellowed from light exposure
N03366	B812.74	T145	The Ascent of the Mountain of Purgatory	1824-7	1824-7	'Divine Comedy' paper	20¾ x 14⅝	52.8 x 37.2	red lake faded
N03367	B812.78	T146	Dante and Virgil Approaching the Angel who Guards the Entrance of Purgatory	1824-7	1824-7	'Divine Comedy' paper	20¾ x 14¹¹/₁₆	52.7 x 37.3	none obvious
N03369	B812.88	T148	Beatrice Addressing Dante from the Car	1824-7	1824-7	'Divine Comedy' paper	14⅝ x 20¾	37.2 x 52.7	none obvious
N03370	B812.98	T149	Dante in the Empyrean, Drinking at the River of Light	1824-7	1824-7	'Divine Comedy' paper	20¾ x 14⅝	52.8 x 37.1	none obvious

[1] Listed chronologically according to the date given in Butlin 1990 [2] All works are at Tate [3] Height followed by width [taken from Butlin 1981]

Appendix 2: Watercolours – Analytical Results [1]

Tate number	Butlin 1981	Butlin 1990	Butlin 1990 date	Prussian Blue	Indigo	Vermilion	Brazil-wood	Gamboge	Indigo in Green	Yellow Ochre	Brown Ochre	Red Ochre	Lead White	Chalk	Carbon Black	Other	Medium
N02231	B770	T71	c.1820–5		IRFC	IRFC	IRFC		IRFC	IRFC					IRFC	blue verditer?; green lake, unID red lake	
N03351	B812.2	T131	1824–7	IRFC, Raman			IRFC								Raman		
N03352	B812.4	T132	1824–7	IRFC, LM	IRFC	IRFC	IRFC		IRFC	LM?							
N03353	B812.8	T131	1824–7	IRFC	IRFC	IRFC	IRFC		IRFC								
N03354	B812.12	T134	1824–7			IRFC	IRFC		IRFC							chrome yellow?; unID 2nd red lake	
N03356	B812.24	T136	1824–7				LM	LM			LM						
N03357	B812.35	T137	1824–7		IRFC	IRFC	LM	LM	IRFC								tragacanth[2]
N03358	B812.40	T138	1824–7	IRFC					IRFC								
N03359	B812.44	T139	1824–7		IRFC		LM	LM?									
N03360	B812.46	T140	1824–7	IRFC	IRFC		LM	IRFC									
N03361	B812.53	T141	1824–7	IRFC	IRFC	IRFC	IRFC	IRFC, LM									
N03362	B812.58	T142	1824–7	IRFC	IRFC	IRFC, Raman											
N03365	B812.70	T144	1824–7	IRFC	IRFC, Raman		IRFC	IRFC									
N03366	B812.74	T145	1824–7	IRFC	IRFC	IRFC	LM	LM							IRFC		
N03367	B812.78	T146	1824–7	IRFC		IRFC, Raman	IRFC	LM					IRFC	Raman	unID 2nd red lake		
N03369	B812.88	T148	1824–7	IRFC	IRFC	IRFC	IRFC	LM						Raman	unID 2nd red lake		
N03370	B812.98	T149	1824–7	IRFC		IRFC	IRFC	IRFC, LM							chrome yellow?, unID 2nd red lake		
N05183	B91	T8	c.1785–90	Raman		Raman			no, Prussian blue mix	IRFC	IRFC	IRFC?		LM	Raman		
N05887	B525	T52	c.1805	IRFC, Raman													
N05892	B469	T44	c.1805			LM						LM					
N05895	B497	T47	c.1805			LM				LM?		LM?					
N05897	B515	T51	c.1803–5	LM		LM											
N05898	B69	T69	c.1793	IRFC	IRFC	IRFC	IRFC					IRFC					
T00547	B255	T13	c.1792–3		IRFC, Raman	Raman		IRFC, Raman, microFTIR, LM			EDX		IRFC				
T01128	B127	T3	c.1780–85 (recto)	IRFC, Raman		IRFC, Raman	IRFC			IRFC	EDX	IRFC		LM	Raman	blue verditer?	

[1] Listed by Tate accession number [2] Vallance, pers. comm.

184

Appendix 3: *Large Colour Prints Discussed in the Text*[1]

Location	Accession number	Butlin 1981	Butlin 1990	Title	Butlin 1981 date	Butlin 1990 date[1]	Dimensions in inches[3]	Dimensions in cm	Signature[3]
Tate	N03373	B264	T21	*Frontispiece to Visions of the Daughters of Albion*	c.1795	1793/c.1795	6¾ x 4¼	17 x 12	
Tate	N03374	B265	T22	*Plate 4 Visions of the Daughters of Albion*	c.1795	1793/c.1795	2⅞ x 4⅝	7.5 x 11.5	
National Gallery of Art, Washington	B-11060	B326		*Christ Appearing to the Apostles after the Resurrection*	c.1795		17 x 22⅝	43.1 x 57.5	Fresco W Blake inv
Tate	N05875	B326	T34	*Christ Appearing …*	c.1795	c.1795	17 x 22⅝	43.1 x 57.5	
Yale Center for British Art	1929.298	B325		*Christ Appearing …*	c.1795		17 x 22½	43 x 57.3	WB inv [in monogram]
Tate	N05055	B289	T25	*Elohim Creating Adam*	1795	1795/c.1805	17 x 21⅛	43.1 x 53.6	1795 WB inv [in monogram]
Metropolitan Museum of Art	16.38	B295		*God Judging Adam*	1795		16¾ x 20 11/16	42.6 x 52.6	Fresco. W Blake inv
Tate	N05063	B294[2]	T26	*God Judging Adam*	1795	1795	17 x 21⅛	43.2 x 53.5	WB inv [in monogram] 1795
Robert Essick, Los Angeles		B298		*Lamech and his Two Wives*	c.1795		15⅛ x 18 15/16 cut down	38.5 x 48	
Tate	N05061	B297	T27	*Lamech and his Two Wives*	1795	1795	17 x 23¼	43.1 x 60.8	WB inv [in monogram] 1795
Fitzwilliam Museum, University of Cambridge		B300		*Naomi and Orpah*	c.1795		14¾ x 19¼ cut down	37.5 x 49	Fresco W Blake inv
Victoria and Albert Museum, London (V&A)	69-1894	B299		*Naomi and Orpah*	c.1795		16⅞ x 22⅞	42.8 x 58	Fresco W Blake inv
Minneapolis Institute of Arts		B303		*Nebuchadnezzar*	1795		16 15/16 x 23¾ cut down?	43 x 60.3	W Blake 1795
Tate	N05059	B301	T28	*Nebuchadnezzar*	1795	1795/c.1805	17⅝ x 24⅜	44.6 x 62	WB inv [in monogram] 1795
Philadelphia Museum of Art		B307		*Newton*	c.1795		17⅜ x 22¾ sight size	44.2 x 57.8	Fresco W Blake inv
Tate	N05058	B306	T29	*Newton*	1795	1795/c.1805	18⅛ x 23⅝	46 x 60	WB inv [in monogram]
Metropolitan Museum of Art	58.603	B311		*Pity*	c.1795	c.1795	16 9/16 x 20¼	42.1 x 52.8	W Blake inv
Tate	N05062	B310	T30	*Pity*	c.1795	c.1795	16¼ x 21¾	42.5 x 53.9	Blake
Getty Museum		B292		*Satan Exulting over Eve*	1795		16 11/16 x 20 15/16	42.5 x 53.2	W Blake 1795
Tate	T07213	B291		*Satan Exulting over Eve*	c.1795		17 x 21	43.2 x 53.4	Blake
Tate	N05057	B323	T33	*The Good and Evil Angels Struggling for Possession of a Child*	1795	1795/?c.1805	17½ x 23⅜	44.5 x 59.4	WB inv [in monogram] 1795
British Museum	1885-5-9-1616	B321		*The House of Death*	1795		18⅝ x 23¼	42.7 x 59	W Blake 1795
Tate	N05060	B320	T32	*The House of Death*	1795	1795/c.1805	19⅛ x 24	48.5 x 61	WB 1795
Huntington Library and Art Gallery, San Merino, California		B318		*The Night of Enitharmon's Joy (formerly 'Hecate')*	c.1795		16 7/16 x 22 1/16	41.7 x 56	
Tate	N05056	B316	T31	*The Night of Enitharmon's Joy (formerly 'Hecate')*	c.1795	c.1795	17¼ x 22⅞	43.9 x 58.1	Blake
National Gallery of Scotland, Edinburgh	D(NG)1011	B317		*The Night of Enitharmon's Joy (formerly 'The Triple Hecate')*	c.1795		16 15/16 x 22⅝	43 x 57.5	Fresco W Blake inv
Tate	N03696	B261.5[2]	T23	*Urizen, plate 2 Teach these Souls to Fly*	1796	1794/?1796	4 5/16 x 4	10.9 x 10.2	

[1] This date was used in the text when it was available [2] Colour printed relief etching [3] From Butlin 1981

Appendix 4: Large Colour Prints – Analytical Results [1]

Tate number	Butlin 1981	Prussian Blue	Ultra-marine	Vermilion	Red Lakes	Gam-boge	Indigo in Green	Yellow Ochre	Brown Ochre	Red Ochre	Lead White	Chalk	Carbon Black	Other	Medium
N03373	B264	IRFC		IRFC		LM				IRFC, Raman	IRFC, Raman	IRFC, Raman	IRFC, Raman	unknown brown	
N03374	B265	IRFC, Raman		IRFC, Raman						IRFC, Raman	IRFC, Raman	IRFC, Raman	IRFC, Raman		
N03696	B261.5	IRFC		IRFC					IRFC	IRFC					
N05055	B289													dragon's blood	
N05056	B316	IRFC, Raman		IRFC, Raman				IRFC, Raman			Raman	IRFC, Raman	IRFC, Raman		
N05057	B257	IRFC		IRFC				IRFC		IRFC	IRFC	Raman		blue verditer?	
N05058	B306	IRFC, Raman		IRFC, Raman				IRFC, Raman		IRFC, Raman	Raman	Raman	Raman		
N05059	B301	IRFC		IRFC										dragon's blood	Astragalus verus gum[2]
N05060	B320	IRFC		IRFC				IRFC	IRFC				IRFC		Astragalus verus gum[3]
N05061	B297	IRFC						IRFC	IRFC?					dragon's blood	
N05062	B310	IRFC, Raman		IRFC, Raman						IRFC, Raman	IRFC, Raman	Raman	IRFC, Raman		Arabic/karaya, tragacanth and sugar
N05063	B294	IRFC, Raman		IRFC, Raman, EDX						EDX	IRFC, Raman	IRFC, Raman, EDX	IRFC, Raman		Arabic/karaya, tragacanth and sugar
T07213	B291	EDX		EDX, Raman		LM?		EDX	EDX		EDX	EDX	Raman	bone black, Naples yellow, red lead	gum, glue varnish, non-orig shellac varnish
Essick 'Lamech'	B298	LM		LM	LM	LM?				LM	LM			bone black, unID red lake	karaya or Astragalus verus gum[3]
V&A	B299	EDX	EDX					EDX		EDX	EDX	EDX	EDX	china clay	gum

[1] Listed by Tate accession number [2] J.W. Twilley, Uni of California, in Tate conservation record [3] J.W. Twilley, Uni of California, published by Essick [see 'The State of Knowledge ...', note 12]

Appendix 5: Temperas Discussed in the Text [1]

Location	Accession number	Butlin 1981	Butlin 1990	Title	Dimensions in inches [3]	Dimensions in cm [3]	Butlin 1981 Date [3]	Support
Victoria and Albert Museum, London	V&A P8-1950	B661		Satan calling Up His Legions – An experiment Picture	21 1/2 x 16 1/2	54.5 x 42	c.1795–1800	canvas
Tate	N05893	B419	T37	Christ Blessing the Little Children	10 1/4 x 14 3/4	26 x 37.5	1799	canvas
Carnegie Museum of Art	CMOA 74.7.3	B428		Faith, Hope and Charity	10 5/16 x 14 3/4	26.6 x37.5	1799	paper on canvas
Victoria and Albert Museum, London	V&A P28-1953	B379		Eve Tempted by the Serpent	10 3/4 x 15 1/8	27.3 x 38.5	c.1799–1800	metal
Yale Center for British Art	YCBA B.1977.14.89	B382		Abraham and Isaac	10 1/4 x 14 3/4	26 x 37.5	c.1799–1800	canvas
Tate	T04134	B387	T35	Moses Indignant at the Golden Calf	15 x 10 1/2	38 x 26.6	c.1799–1800	canvas
Tate	N03007	B390	T36	Bathsheba at the Bath	cut down from c.10 1/2 x 15	cut down from c.26.5 x 38	c.1799–1800	canvas
Rhode Island School of Design	RISD 32.219	B415		The Baptism of Christ	12 5/8 x 19 5/16	32.1 x 48.9	c.1799–1800	canvas
Yale Center for British Art	YCBA B.1977.14.90	B420		Christ Giving Sight to Bartimaeus	10 1/4 x 14 13/16	26 x 37.5	c.1799–1800	canvas
Tate	N05894	B425	T38	The Agony in the Garden	10 5/8 x 15, diagonals cut off	27 x 38	c.1799–1800	tinned iron
Tate	N01164	B426	T39	The Body of Christ Borne to the Tomb	10 1/2 x 14 7/8	26.7 x 27.8	c.1799–1800	canvas on card
Robert Essick, Los Angeles		B416		The Miracle of the Loaves and Fishes	12 13/16 x 19 7/16	32.7 x 49.4	c.1800	copper
Manchester City Art Gallery	MCAG1918	B343.2		Demosthenes	16 1/2 x 42	42 x 106.6	c.1800–03	canvas
Manchester City Art Gallery	MCAG 1885.14	B343.6		Luiz vaz de Camoens	16 3/8 x 22 1/4	41.5 x 56.5	c.1800–03	canvas
Manchester City Art Gallery	MCAG 1885.18	B343.3		Marcus Tullius Cicero	16 3/8 x 40 1/2	41.5 x 10.3	c.1800–03	canvas
Yale Center for British Art	YCBA 1885.4	B343.5		Geoffrey Chaucer	16 3/4 x 25 1/8	42.5 x 63.7	c.1800–03	canvas
The National Trust, Petworth House	NT	B662		Satan Calling up his Legions	21 x 16	53.5 x 40.5	c.1800–05	canvas
Tate	N01110	B651	T59	The Spiritual Form of Pitt Guiding Behemoth	29 1/8 x 24 3/4	74 x 62.7	1805 (?)	canvas
Tate	N03006	B649	T58	The Spiritual Form of Nelson Guiding Leviathan	30 x 24 5/8	76.2 x 62.5	c.1805–9	canvas
Glasgow Museums	GM PC.89	B653		Sir Jeffery Chaucer and the nine and twenty Pilgrims on their journey to Canterbury	18 3/8 x 53 15/16	46.7 x 137	1808 (?)	canvas
Tate	N03551	B655	T60	The Bard, from Gray	23 5/8 x 17 3/8	60 x 44.1	1809 (?)	canvas
Glasgow Museums	GM PC.94	B667		Adam Naming the Beasts	29 1/2 x 24 1/2	75 x 62.2	1810	fine linen canvas
Victoria and Albert Museum, London	V&A P25-1953	B669		The Virgin and Child in Egypt	30 x 25	76.2 x 63.5	1810	canvas
Glasgow Museums		B668		Eve Naming the Birds	28 3/4 x 24 1/4	73 x 61.5	c.1810	fine linen canvas
Fitzwilliam Museum, Cambridge	FM PD27-1949	B673		An Allegory of the Spiritual Condition of Man	59 5/8 x 47 3/4	151.5 x 121.3	1811 (?)	canvas
untraced since 1827		B648		The Last Judgment	c.84 x 60	c.204 x 153	c.1810–27	canvas?
Tate	N05889	B750	T64	The Ghost of a Flea	8 7/16 x 6 3/8	21.4 x 16.2	c.1819–20	panel
Tate	T02387	B808	T68	Winter	35 1/2 x 11 11/16	90.2 x 29.7	c.1820–5	pine
Private collection, USA		B809		Evening	36 7/16 x 11 11/16	91.8 x 29.7	c.1820–5	pine
The National Trust, Arlington Court	NT	B803		The Sea of Time and Space	15 3/4 x 19 1/2	40 x 49.5	1821	mahogany
Yale Center for British Art	YCBA B.1977.14.91	B674		The Virgin and Child ('The Black Madonna')	12 x 9 1/8	30.5 x 23.9	1825(?)	panel with a Davy stamp
The National Trust, Petworth House	NT	B811		The Characters in Spenser's 'Faerie Queene'	18 x 53 1/2	45.7 x 135.8	c.1825	very fine canvas on panel
Tate	N05888	B806	T69	The Body of Abel Found by Adam and Eve	12 13/16 x 17 1/16	32.5 x 43.3	c.1826	mahogany
Tate	N03340	B807	T70	Satan Smiting Job with Sore Boils	12 7/8 x 17	32.6 x 43.2	c1826	mahogany
Fitzwilliam Museum, Cambridge	FM PD152-1986	BC1	BLAKE,Catherine	Agnes	5 3/8 x 7 1/8	13.7 x 18.1	c.1800	canvas
Tate	N05858		RICHMOND	Abel the Shepherd	9 1/8 x 12 1/16	22.9 x 30.5	1825	panel
Tate	T04164		RICHMOND	The Creation of Light	18 15/16 x 16 1/4	48 x 41.7	1826	panel with a Davy stamp
Tate	N01492		RICHMOND	Christ and the Woman of Samaria	16 1/4 x 19 5/8	41 x 49.8	1828	panel
Tate	N03697		PALMER	Coming from Evening Church	11 7/8 x 7 7/8	30.2 x 20	1830	paper on auxiliary support

[1] Listed chronologically according to the date given by Butlin (1990) [2] From Butlin 1981 [3] Butlin (1990) gives the same date for all Tate temperas

Appendix 6: Temperas – Analytical Results[1]

Accession number	Butlin 1981	Prussian Blue	Ultra-marine	Vermilion	Red Lead	Red Lakes	Gam-boge	Yellow Ochre	Brown Ochre	Red Ochre	Lead White	Chalk	Carbon Black	Bone Black	Other	Medium
N01110	B651	LM		EDX, LM	LM	LM	GC-MS		EDX, LM			LM, EDX		LM	shell gold; ink has oil-based medium	animal glue, Arabic or karaya, tragacanth, honey
N01164	B426	LM		LM, Raman	LM?	LM	LM?		LM	LM		LM, EDX			yellow lake, sienna	animal glue, Arabic or karaya, tragacanth, honey
N03006	B649	LM		EDX, LM	LM?	LM			LM		LM			LM	shell gold	animal glue, Arabic or karaya, tragacanth, honey
N03007	B390	LM	LM	LM					LM					LM		animal glue, Arabic or karaya, tragacanth, honey
N03340	B807	LM														animal glue, Arabic or karaya, tragacanth, honey
N03551	B655	LM		EDX, LM		LM					LM	LM			madder, Naples? yellow, gold/silver alloy, shell gold	animal glue, Arabic or karaya, tragacanth, honey
N05888	B666			LM							LM			LM		animal glue, Arabic or karaya, tragacanth, cherry gum, honey
N05889	B750	EDX, LM	LM				LM?								gold/silver alloy, shell gold	animal glue, Arabic or karaya, tragacanth, honey
N05893	B419	LM					EDX?		LM					LM	madder, Naples? Yellow	animal glue, Arabic or karaya, tragacanth, cherry gum, honey
N05894	B425	LM		EDX, LM			LM?	LM	LM				LM	LM	green lake?, sienna	animal glue, Arabic or karaya, tragacanth, honey
T04134	B387	LM	LM	EDX, LM		LM	EDX?	LM	LM		LM	EDX		LM	madder	animal glue, tragacanth and Arabic or karaya, honey
YCBA	B674						EDX?		EDX?			EDX			shell gold, resinous brown material	animal glue, Arabic or karaya, tragacanth, honey
V&A	B379											EDX			shell gold	animal glue, Arabic or karaya, tragacanth, honey
GM	B653	LM	LM	EDX		LM, EDX?	LM, GC-MS					EDX				Arabic or karaya, tragacanth, honey
NT	B662						GC-MS								pure silver leaf and 'shell silver', indigo gold/silver alloy leaf, shell gold	animal glue, Arabic or karaya, tragacanth, honey
V&A	B661									EDX?					gold/silver alloy leaf	animal glue, Arabic or karaya, tragacanth, honey
GM	B667	LM, EDX?	EDX?	LM, EDX		EDX?	GC-MS		EDX	EDX?		EDX	EDX			animal glue, Arabic or karaya, tragacanth, honey
FM	B673	EDX	EDX?	EDX		EDX?	GC-MS		EDX	EDX?		EDX	EDX		resinous brown material	animal glue, Arabic or karaya, tragacanth, honey; also tragacanth and honey
NT MCAG N03697	B811 B343.2 PALMER	LM?	LM	LM	LM	LM	LM	LM				EDX	LM		indigo shell gold	animal glue, Arabic, cherry and honey
N01492	RICHMOND	IRFC, LM	LM	LM		LM			LM		X-radiography	EDX	LM		shell gold, Naples yellow?	animal glue, Arabic/karaya, tragacanth, honey
T04164	RICHMOND	IRFC, LM	IRFC, LM	LM		LM					X-radiography	x-radiography	LM		shell gold	animal glue, Arabic/karaya, tragacanth, honey

[1] Listed by Tate accession number or by institution

Index